MW00581644

TURNER
The Great Watercolours

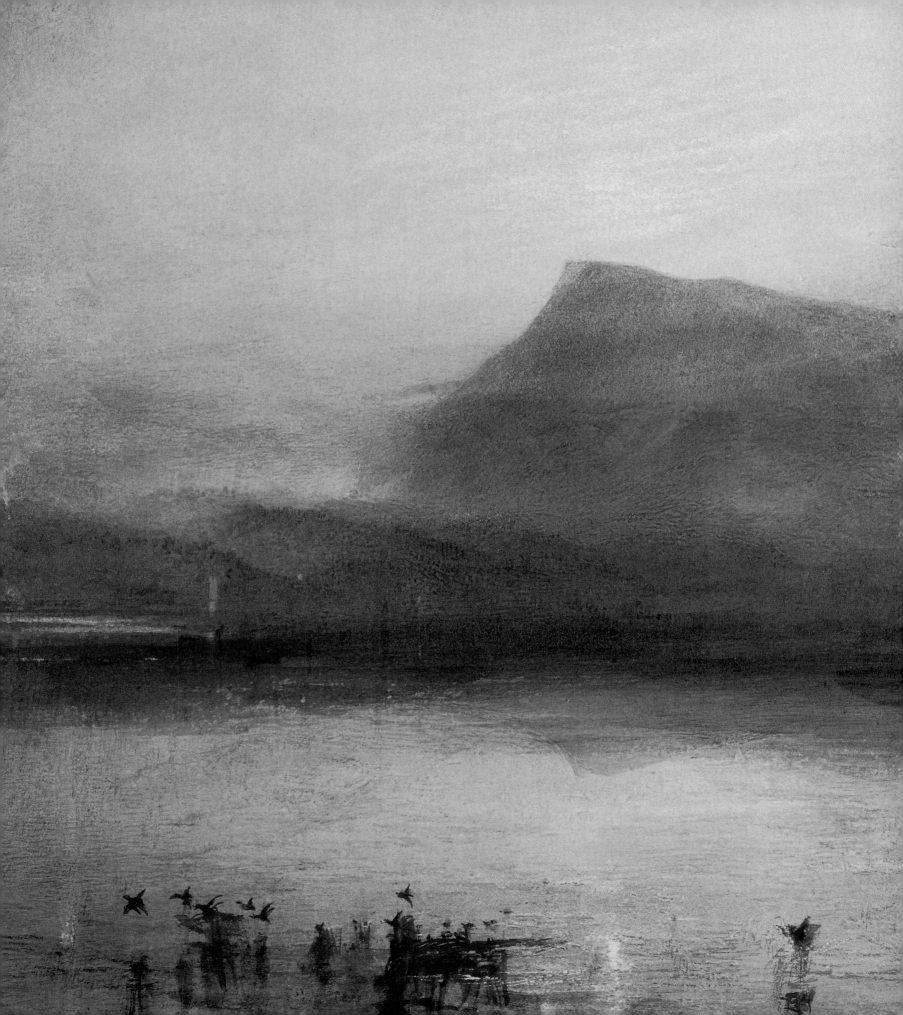

TURNER
The Great Watercolours

Eric Shanes

with essays by Evelyn Joll,
Ian Warrell and Andrew Wilton

ROYAL ACADEMY OF ARTS

First published on the occasion of the exhibition
Turner: The Great Watercolours

Royal Academy of Arts, London
2 December 2000 – 18 February 2001

The exhibition is generously supported by
The Eugene V. and Clare E. Thaw Charitable Trust
and the International Music and Art Foundation.

The Royal Academy of Arts is grateful to
Her Majesty's Government for its help in
agreeing to indemnify the exhibition under
the National Heritage Act 1980, and to the
Museums and Galleries Commission for their
help in arranging this indemnity.

SELECTION COMMITTEE
Evelyn Joll
Norman Rosenthal
Eric Shanes
MaryAnne Stevens
Ian Warrell
Andrew Wilton

EXHIBITION ORGANISATION
Harriet James

PHOTOGRAPHIC AND COPYRIGHT COORDINATION
Miranda Bennion
Andreja Brulc
Roberta Stansfield

CATALOGUE
ROYAL ACADEMY PUBLICATIONS
David Breuer
Fiona McHardy
Soraya Rodriguez
Peter Sawbridge
Nick Tite

DESIGN
Isambard Thomas

COPY-EDITOR
Celia Jones

PICTURE RESEARCH
Kathy Lockley

COLOUR ORIGINATION
DawkinsColour Ltd, London

Printed in Italy

British Library Cataloguing-in-Publication Data
A catalogue record for this book is available from the British Library

Distributed in the United States and Canada
by Harry N. Abrams, Inc., New York
ISBN 0-8109-6634-4

Distributed outside the United States and Canada
by Thames & Hudson Ltd, London
ISBN 0-900-94689-X

Exhibition softback edition
ISBN 0-900-94695-4

FRONTISPIECE: detail cat. 104
pp 8–9: detail cat. 70
pp 56–7: detail cat. 6

Editorial note

Turner's idiosyncratic spellings – and especially his original spellings of place
names as used in the titles of his works – are followed throughout, even if those
spellings vary from usage to usage, and differ from modern ones.

Titles of publications for which Turner produced watercolours for engravings to
be issued as partworks over several years (although subsequently issued as one
volume) are given in quotation marks, as in 'Picturesque Views in England and
Wales'; those that were published in a single volume are italicised, as in Samuel
Rodgers, *Poems*.

Abbreviations used in the catalogue
BJ: Martin Butlin and Evelyn Joll, *The Paintings of J. M. W. Turner*, 2 vols,
London, 1977; revised ed., New Haven and London, 1984

R: W. G. Rawlinson, *The Engraved Work of J. M. W. Turner, R.A.*, 2 vols,
London, 1908–13

W: Andrew Wilton, *The Life and Work of J. M. W. Turner,* Fribourg, 1979
(including a catalogue of watercolours)

Acknowledgements

Many people have assisted in the realisation of this exhibition and its accompanying catalogue. In particular, the Royal Academy would like to acknowledge the unstinting help in securing loans of Evelyn Joll, Lowell Libson of Spink-Leger, Ronald Radford of the National Gallery of South Australia, Adelaide, Susan Sloman and Andrew Wyld of Agnew's, Alistair Smith and Charles Nugent of the Whitworth Art Gallery, Manchester, Ian Warrell of Tate Britain, and Henry Wemyss of Sotheby's and Co., London. Directors of institutions, curators and individuals have also been of great support and assistance in making major works available for loan, including Dr Alan Borg and Dr Mark Evans of the Victoria and Albert Museum, Anthony Griffiths, of the Prints and Drawings Department of the British Museum, Sir Nicholas Serota of Tate and Andrew Wilton of Tate Britain, London, Virginia Tandy and Andy Loukes of the Manchester City Art Gallery, Julian Treuherz of the Walker Art Gallery (National Museums and Galleries on Merseyside), Colin Harrison of the Ashmolean Museum, Oxford, Richard Green of York City Art Gallery, James Cuno of the Fogg Art Museum, Cambridge, Mass., Brett Waller of the Indianapolis Museum of Art, Patrick McCaughey and Scott Wilcox of the Yale Center for British Art, New Haven, and Dr Gerard Vaughan of the National Gallery of Victoria, Melbourne. In addition, the Royal Academy wishes to acknowledge John Bodkin, Doreen Bolger, Desmond Corcoran, Jacky Darville, Alf and Geraldine Florio, Dr John Gage, Hilary Gerrish, Thomas Gibson, Richard Hallam, James Miller, Harry Robertson, Albin and Annie-France Salamin, Eldon Smith, Abigail Wandell, Claude Whistler and Edward Yardley.

For the editorial aspects of the catalogue, the Royal Academy acknowledges, in addition to the contributors themselves, Anne Lyles, David Breuer, David Brown, Peter Sawbridge, Greg Smith and Nick Tite.

President's Foreword

Joseph Mallord William Turner RA, arguably Britain's greatest artist and the most distinguished Member of the Royal Academy of Arts, was born in 1775. He died on 19 December 1851 and was buried with full national honours in St Paul's Cathedral eleven days later. The Royal Academy recognised the bicentenary of Turner's birth with a major retrospective exhibition held at Burlington House in the winter of 1974–75. It now seems fitting that this institution with which he had a long and sustained relationship – study in the Royal Academy Schools from 1789, regular representation in the Annual Exhibitions from 1790, Membership from 1797 and the position of Professor of Perspective from 1807 to 1837 – should mark the 150th anniversary of his death with an exhibition celebrating his finished watercolours. We are most grateful to Eric Shanes, who has researched and published widely in the field of Turner studies, for proposing the exhibition to the Royal Academy.

Surprisingly, since Turner's death there has not been an exhibition devoted exclusively to his finished watercolours – a major part of his remarkably prolific output – despite their being, aside from his oil paintings, both available to the public and critically acclaimed during his lifetime. Over his long life Turner created an extensive body of work in watercolour, many being sketches, studies and colour beginnings. A significant number, however, were destined for the public domain, including highly worked and often large-scale watercolours made for exhibition at the Royal Academy and elsewhere, commissions from specific patrons, and images for engravings, ranging from topographical views of Britain to book illustrations for the Bible and texts by, among others, Walter Scott, Lord Byron and the less well-remembered Samuel Rogers. In breadth of subject, scale of presentation and range of technique, these works proclaim the genius of the artist and stand at the summit of the art of watercolour.

This exhibition benefits enormously from the commitment and insight of scholars who have worked to increase our knowledge and understanding of Turner and his work. In particular, I wish to mention Evelyn Joll, the senior figure of Turner studies, without whose expertise neither this exhibition nor its accompanying catalogue could have been realised. Eric Shanes has written the major part of the catalogue, which also includes essays by Evelyn Joll, and two other Turner scholars, Ian Warrell and Andrew Wilton, who, together with Greg Smith, also advised on the catalogue. All worked closely with two senior members of Royal Academy staff, Norman Rosenthal, Exhibitions Secretary, and MaryAnne Stevens, Collections Secretary and Senior Curator Together, they have created an exhibition of outstanding quality and exceptional insight.

Many individuals and institutions have helped us to realise this achievement. Most importantly, we thank Eugene and Clare Thaw, and their son Nicholas, for their exceptional generosity in supporting the exhibition through their two foundations, The Eugene V. and Clare E. Thaw Charitable Foundation and the International Music and Art Foundation. The Thaws are no strangers to the Royal Academy. Four years ago they gave us the privilege of exhibiting a selection of outstanding master drawings from their collection, now housed at the Pierpont Morgan Library, New York.

Many of Turner's finished watercolours are still owned by private collectors. We are especially grateful to them for their generosity in making their works available to the exhibition. In addition, major institutions have supported this endeavour: the British Museum, the Courtauld Gallery, Tate Britain and the Victoria and Albert Museum in London; regional museums and art galleries, including those in Bedford, Birmingham, Leeds, Liverpool, Manchester, Nottingham, Oxford, Plymouth, Preston and Wolverhampton; and many institutions abroad, including the Yale Center for British Art, New Haven, and the National Galleries of Victoria and South Australia. We thank all our lenders most sincerely.

Watercolour appears to be a simple art. This is deceptive. To bring it to the level of representation and evocation achieved by Turner requires an exceptional mastery of subject matter, composition and pictorial effect. This anniversary exhibition should not only kindle renewed admiration for the artist's achievements but also encourage those less familiar with his work to admire and seek further acquaintance with the work of one of our most illustrious Royal Academicians.

Professor Phillip King President, Royal Academy of Arts

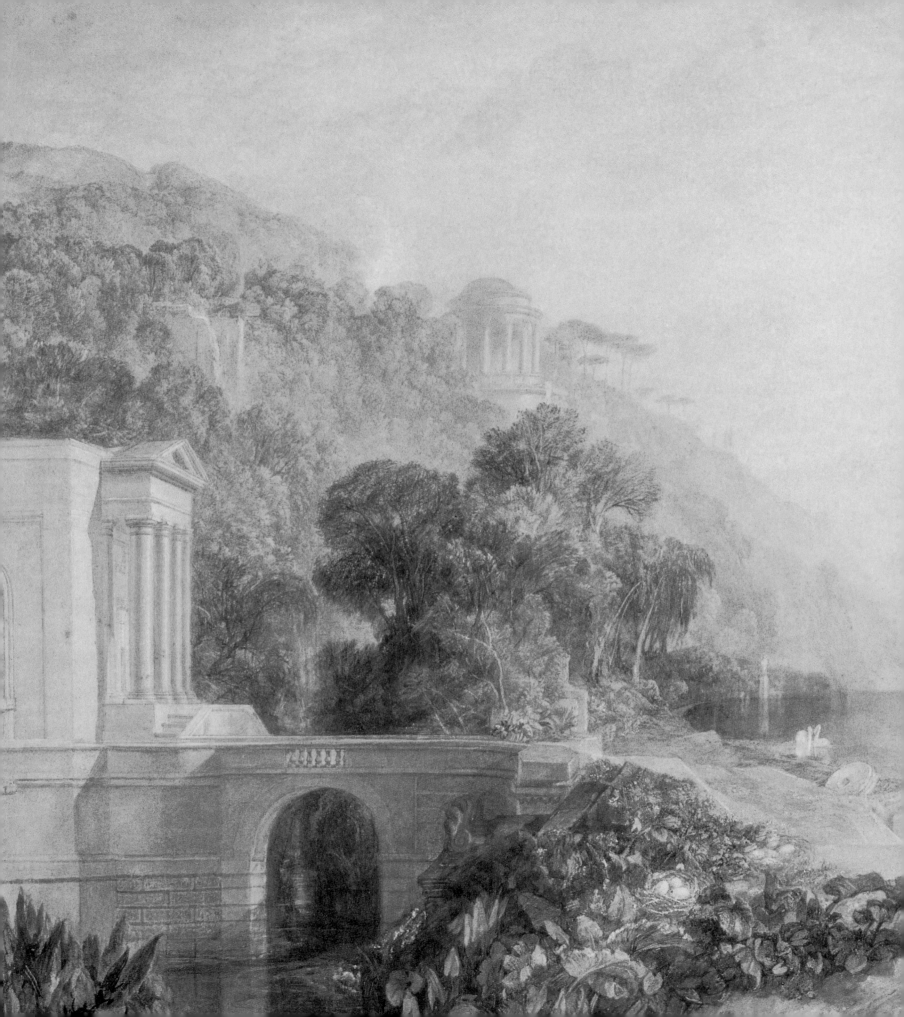

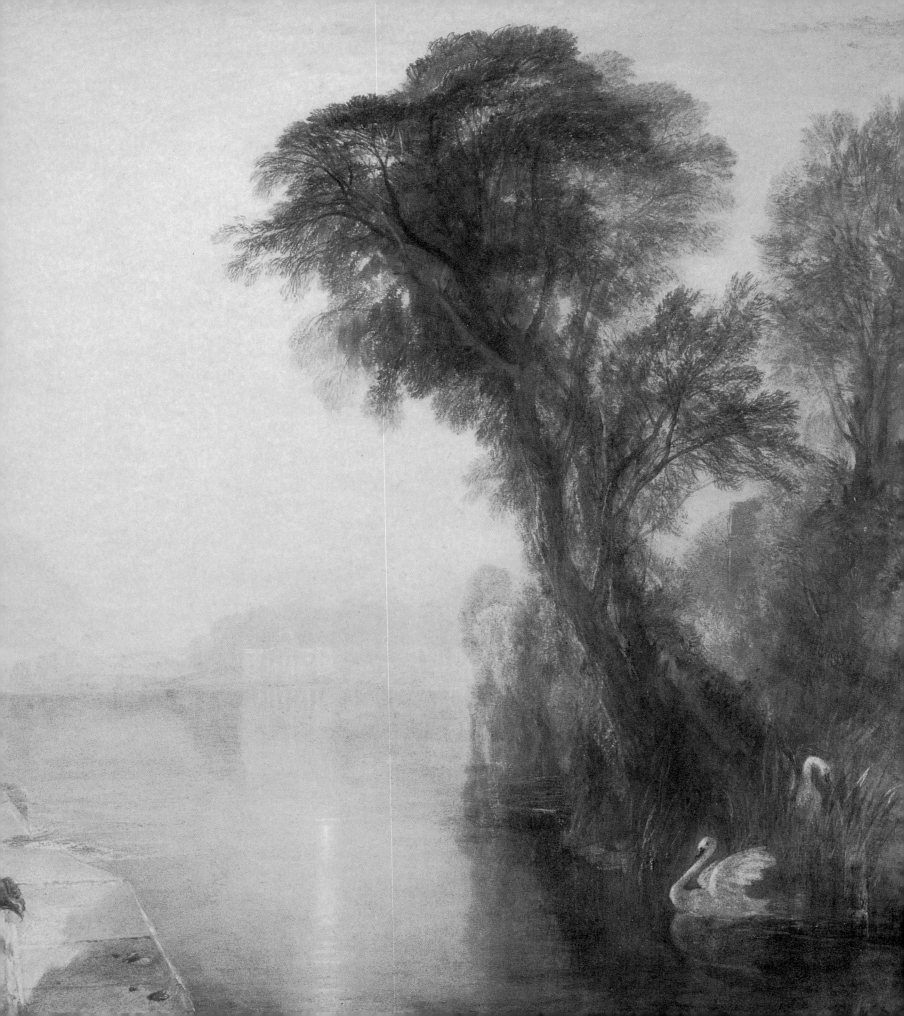

J.M.W. Turner: The Finished Watercolour as High Art

ERIC SHANES

Throughout his life Turner was the master of a distinctive type of drawing: the finished watercolour. Often he produced such works for possibly overlapping reasons: they could be displayed in public exhibitions; they could be commissioned by patrons who prized them for the impressive effect they created on the wall; and they could be reproduced through engraving.

Although Turner's rough watercolour sketches and studies are highly regarded today, they remained unseen until after his death. During his lifetime his reputation as a watercolourist was established by his finished drawings. These designs were elaborated with great technical care and with much attention paid to the building of complex compositions; to the creation of subtle narrative and associative meanings that require careful analysis; to the representation of figures, animals and other staffage; and to innumerable fine details. In all, Turner created over 1,800 such watercolours, and through sales and commissions, exhibitions and engraved reproductions, he sent more of them into the world than any other type of image.

TURNER AND THE FINISHED WATERCOLOUR

When Turner first employed watercolour in the late 1780s the medium had been taken up by serious artists in Britain only fairly recently, having previously been used mainly by architects, military topographers, mapmakers and amateurs. The transparency of watercolour afforded an uncomplicated tonal control (and even colouristic intensity when required), while its speed of drying, portability and relative technical ease facilitated a new directness of contact with a given subject, combined with speed of application. Naturally, this spontaneity made watercolour the perfect medium for capturing the fleeting light and weather effects of Britain. It was also the ideal vehicle with which to bridge the gap between the simpler drawing processes and painting in oils (and, as such, it therefore proved most attractive to amateur artists, who could master it much more easily than oil paint).[1] In consequence, more watercolours were produced and exhibited, not least of all at the Royal Academy. The inclusion of increasing quantities of watercolours in exhibitions previously taken up primarily by oil paintings had an effect on those drawings, for the same levels of detail and finish came to be expected. Turner met those demands without difficulty, and occasionally spent months elaborating finished designs.[2]

The increasing use of watercolour in turn broadened the market for such works . They were cheaper than slow-drying oils, for they could be supplied far more quickly. They were also easier to display and store; they could readily be created in sets, which made for satisfying hangs in domestic surroundings; and they could depict various facets of a particular house, district, larger geographical area or country. Designs of this type appealed especially to collectors who wanted the mansions and areas in which they lived to be represented in the best possible light, or who required records of places visited.

Initially Turner's prices for his finished watercolours were modest, but when he realised he could obtain more for them he charged accordingly. The originality, inventiveness and virtuosity of his exhibited finished watercolours, in particular, led to growing numbers of commissions for further designs. Even by the end of his first decade as a professional artist Turner had acquired a loyal following for his finished watercolours: in 1799 he had orders for 60 drawings in hand, while in 1803 it was reported he 'had no pictures [in his studio], gone as fast as he paints them, commissions for twenty years'.[3] Among Turner's earliest patrons were prominent supporters of the arts from the aristocracy and landed gentry, such as Edward Lascelles of Harewood House, Yorkshire (who owned, *inter alia, Harewood House*, cat. 9); William Beckford of Fonthill, Wiltshire; Sir Richard Colt Hoare of Stourhead, Wiltshire (whose collection included *The Chapter House, Salisbury Cathedral,* cat. 16); and, most importantly of all, Walter Ramsden Fawkes of Farnley Hall, Yorkshire (one of whose works was *Mont Blanc from Fort Roch*, cat. 21). As the new century unfolded, collectors whose wealth was based on trade and the professions also emerged: the retired coachmaker Benjamin Godfrey Windus of Tottenham, London; the stockbroker, antiquary and geologist Charles Stokes FSA; the surgical instrument manufacturer

Fig. 1
SIR WILLIAM RICHMOND
Caricature of J.M.W. Turner,
drawn from memory
c. 1884

Pencil on paper
18 × 11.3 cm

National Portrait Gallery
(Reserve Collection)

and amateur artist J. H. Maw of Guildford and Hastings; and the amateur artist James Munro of Novar, Ross-Shire, Scotland (who owned *The Red Rigi*, cat. 105). Fawkes and these four collectors eventually amassed enormous holdings of finished Turner watercolours.

Turner exhibited watercolours at the Royal Academy annually between 1790 and 1804, but between 1806 and 1830 – when he last displayed a watercolour there – he hung only fourteen watercolours in the annual exhibitions (in the same 24-year period he produced hundreds of these works). The cause of this gradual withdrawal is not difficult to discern. Because the Academy limited the numbers of paintings and drawings an Academician could exhibit in any one year, Turner must have preferred to show oils, which could fetch much higher prices. He also had very few finished watercolours to sell: usually they went straight from his studio to the walls of collectors, or, in the case of drawings made for reproduction, to the engravers who then sold them on immediately after copying. By the mid-1810s Turner had neither time nor need to make watercolours speculatively (for exhibition), and in any event the reproduction of many of his designs was already extending his reputation far more widely than sporadic displays of single drawings could ever have done. Moreover, watercolours were exhibited in the ancillary rooms of Somerset House, then the home of the Royal Academy, whereas oils were

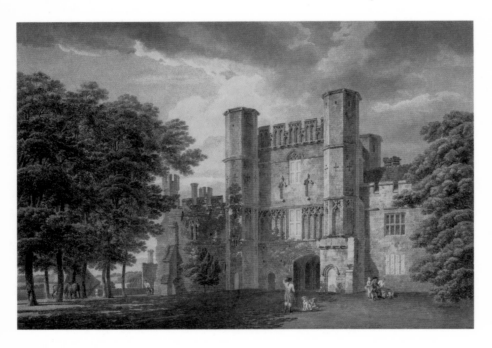

mostly displayed in its Great Room, with Turner's canvases usually being well sited. Although his drawings were of a superb quality, more crowded hanging conditions in the lesser rooms meant that it was difficult for them to stand out. This surely explains why Turner returned to making large watercolours, such as the four designs he hung at the Academy in 1815 (see cats. 18, 22 and fig. 6) and the four further watercolours he displayed there singly in 1818, 1825, 1829 and 1830 (see cats. 68, 70 and 71).

A far more satisfactory way of displaying Turner's finished watercolours emerged in 1819, when Walter Fawkes exhibited over sixty of the artist's drawings at his London residence (see fig. 20). Viewed *en masse*, in an exquisitely balanced hang and with satisfactory lighting,[4] the watercolours looked far better than they could ever have done at the Academy, where they were necessarily hung in a less considered way. In 1822, 1823, 1824, 1826, 1829 and 1833 Turner also permitted the exhibition of groups of his watercolours in commercial galleries in London and professional exhibition bodies outside the metropolis. In particular, the 1829 show at the Egyptian Hall, Piccadilly – in which 41 drawings created a dazzling impression – must have confirmed his growing disillusionment with exhibiting watercolours at the Academy. In 1830 therefore, with a fine drawing commemorating his recently deceased friend Sir Thomas Lawrence PRA (cat. 71), Turner took leave of the Royal Academy as a venue for displaying watercolours.

The finished watercolour not only reached the public through being exhibited; its imagery was also disseminated much more widely by means of engraved reproduction. Turner made his first designs for subsequent engraving in 1794, and over the course of his career he produced hundreds of finished drawings for that purpose, deriving a significant part of his income from the activity. Often the engraved watercolours were created in sets of common, distinctive dimensions on identical types of paper. Many were made the same size as the planned prints, to obviate the need to alter the scale of the images when reproducing them. In the monochromatic, line-engraved transcriptions of the watercolour images, fine detailing often compensated for the loss of colour and painterly expressivity. Ultimately, Turner's close involvement with the copying of his images trained up a school of engravers that raised reproductive printmaking to a new level.

TURNER'S WATERCOLOUR TECHNIQUE

During his formative years in the 1790s Turner had encountered the work of some of the figures who had pioneered the artistic use of watercolour: Thomas Malton Jr (1748–1804); Edward Dayes (1763–1804); Thomas Hearne (1744–1817); John Robert Cozens (1752–1797); Thomas Girtin (1775–1802); and Michael Angelo Rooker (1746–1801). Of these, Rooker made the most enduring impression.

In the 1792 Royal Academy Exhibition the seventeen-year-old Turner was so struck by Rooker's watercolour of *Battle Abbey* (fig. 2) that he copied it in the same medium (fig. 3).[5] Rooker specialised in minutely differentiating the tonalities of masonry, and the unusually wide range of tones deployed in his *Battle Abbey* pointed a crucial way forward for Turner. In subsequent Rooker-influenced designs of his own, such as a 1792 view of Christ Church, Oxford (cat. 3), Turner subtly varied the colours and tones of innumerable masonry slabs with confidence. The 'scale practice', the technical procedure he employed to effect these tonal variations, was rooted in the very nature of watercolour itself, and it harboured profound implications for his art.

The inherent transparency of watercolour necessitates working from light to dark (for it is easy to place a dark mark over a lighter one, but not vice versa). Accordingly, the amassing of a large number of subtle tonal and colouristic variations at different points across a given image meant that in his Rooker-influenced representations of buildings Turner needed to darken and alter his palette slowly, and in minute stages, for it would have been wasteful of time and pigment to work down a sheet constantly varying the tones and colours. It was more efficient to apply areas of a single tone-colour to *different* parts of the drawing before slightly darkening the palette (and possibly altering its colour) to progress to the next tone-colour required elsewhere. This method was known as the 'scale practice' because of the tonal and colouristic scales that were gradually encompassed, and it governed Turner's creation of watercolours throughout his life (as well as much of his later oil technique). Indirectly, such control also permitted the production of vast numbers of drawings and, indeed, necessitated their creation, for it made no sense to work upon one image at a time – waiting for paint to dry before continuing with a design would have wasted hours, especially with relatively slow-drying, saturated watercolour washes. The scale practice greatly simplified the organisation of the palette and the rate of production: while one drawing was drying the artist could apply dabs or washes of a recently used mix of paint to a large number of other designs before eventually returning to the initial – by-now dry – image and a new mixing of darker paint upon the palette to continue that work and its successors. Turner adopted this production-line technique in the early 1790s when he was slowly elaborating the extensive tonal variations of his architectural subjects, and it explains how he was able to create over 1,800 finished watercolours, plus the several thousand rough watercolours in the Bequest.

Even before the first decade of Turner's career had passed, his ability to differentiate finely from light to dark began to pay dividends. For example in *The Chapter House, Salisbury Cathedral*, shown at the Academy in 1799 (cat. 16), we can see how the image was initially underpainted with an extremely pale yellow ochre wash at the top,

Fig. 3
J.M.W. TURNER
Free transcription of part of
M.A. Rooker's *Battle Abbey*
1792

Watercolour on paper
17.2 × 14.6 cm

Tate. Bequeathed by the artist, 1856
XVII-R

and a burnt sienna wash for the floor. When those washes had dried, just a few, slightly darker washes of yellow ochre, or of a somewhat greyer colour, were added in the upper part to indicate the masonry. Finally the entire image was tied together with a few sets of deeper accents to denote the figures and architectural detailing. The majority of tones are ranged within a very narrow band from light to dark, and their restriction lends the image great brightness, airiness and spaciousness without sacrificing the solidity of the architecture.

Eventually Turner's incomparable tonal control would allow him to suggest a glowing radiance of light, and to move into new realms of colour as he did so. Drawings such as *Kidwelly Castle* (cat. 99) and *Flint Castle* (cat. 98) of 1835, *Heidelberg: sunset* of about 1841(cat. 103), vistas of Lake Lucerne from above Brunnen of 1842 (cats. 106 and 107), and *The Lauerzersee, with the Mythens* of around 1848 (cat. 110), are all flooded with areas of pure colour, within which Turner employed slightly lighter or darker variations of the same colour to represent forms. In many works the distances are indicated with such outstanding tonal delicacy as to be hardly visible (see cats. 57 and 106).

In 1791 Turner embarked on the first of more than 56 tours throughout Britain and the Continent, undertaken to gain topographical material for his images. When touring he made rapid pencil sketches and more careful, detailed pencil line drawings in sketchbooks or on loose sheets. These would then form the basis of finished works back in London. Eventually Turner amassed over three hundred sketchbooks, comprising more than ten thousand sketches and studies. He always took his watercolour box with him, so as to be able to make colour notes and quick sketches on the spot, or an occasional finished drawing in his lodgings. He never created finished watercolours outdoors; it was far quicker and more productive to make them in batches in his studio.

In his sketches Turner tested colour relationships and unfamiliar types of paper, experimented with ideas and even moved pigment around until inspiration came. The studies were more purposeful, being intermediate stages between the initial topographical material in the sketchbooks, and a fully thought-out, finished design. In both sketches and studies the imagery is fairly loose, with only occasional indications of staffage. Generally Turner elaborated his early drawings over flat washes that had been brushed on to dry sheets of paper. This technique usually sufficed while his work was predominantly tonal and monochromatic, as it was until the mid-1810s. From then on he increasingly conceived his designs in terms of bright colour, and consequently made test drawings ('colour beginnings'), in which he worked out the colour structures of ensuing designs.[6] When embarking on such drawings he would usually saturate entire sheets of paper with water, and then flood them with pigment, either by brushing or dropping wet colours on to the damp paper. This would cause them to diffuse, usually into each other. In the elaborated designs these diffusions would then be worked over, although they could denote forms in their own right (as with the clouds in *Mainz and Kastell*, cat. 41). Even when subsequently covered, the basic colour-diffusions often remain very evident (see *Heidelberg: sunset*, cat. 103).

From the mid-1810s onwards Turner began attaching his sheets of paper to boards with handles. These supports could be partially or entirely immersed in water, either to introduce or to remove colour. The watercolours could also be hung on clothes-lines to dry. Turner would dye sheets by placing them in pails of precoloured water. He also prepared batches of paper with a single colour, which could subsequently be rubbed or washed off to reveal the original, brighter surface beneath (see *The Loreleiberg*, cat. 38, and *Rolandswerth*, cat. 39, both of which were elaborated on white paper washed with grey). In addition to developing production lines of watercolours on individual sheets, Turner occasionally created different designs on a single sheet and separated them afterwards.

Turner used or tested an enormous range of watercolour papers. In his day these were all made from rags, which gave them great internal strength. He also utilised high-quality writing papers as watercolour supports. In the final third of his career many of these writing papers were strengthened to resist scratching by the recently invented steel nib.[7] For his most detailed images

Turner employed a very hard, gelatine-sized watercolour paper that was fairly non-absorbent; as a result such drawings enjoy a diamantine sharpness of definition and brilliance of colouring (see, for example, *Norham Castle*, cat. 55). In later years he also used prepared watercolour boards, which furnished him with an almost ivory-like smoothness of surface. From the mid-1820s onwards Turner selected different kinds of manufactured coloured papers for different series of watercolours. This created uniformity within a given series while simultaneously extending painterly range by setting technical problems that required solution (see, for example, *Boulevards, Paris,* cat. 67, which belongs to a group of gouache watercolours drawn on blue paper).

The strength of rag-made papers guaranteed that their surfaces could be wetted or scratched without the underlying strata buckling or ripping (which is what usually happens with modern wood-pulp papers). A sharp instrument such as a scalpel and his sharpened thumbnail were variously used to scratch out highlights (see *Temple of Minerva Sunias, Cape Colonna*, cat. 84, for scratches drawn by knife and ruler; *Alnwick Castle, Northumberland*, cat. 92, for large numbers of tiny highlights picked out with a scalpel; and, among innumerable examples, *West Cowes, Isle of Wight*, cat. 91, for the odd flecks scratched off with the thumbnail).

Turner would often begin his watercolours with stopping-out varnish, a fluid that protected paper from subsequent overlays of wet pigment. This film could finally be rubbed off to reveal the untinted surface below, and the virgin areas partially coloured in turn (for an especially clear use of stopping-out, see the lightest parts of the waves across the foreground of *First-Rate, taking in stores,* cat. 47). Stale breadcrumbs were used to take out small highlights, as were fingers (see the clouds in *Mainz and Kastell,* cat. 41, where Turner's 'dabs' are particularly apparent). Both blotting paper and sponges proved useful in varying textures and removing areas of colour (for the use of a sponge see *Weathercote Cave when half filled with water*, cat. 32, where a rainbow was wiped from the underlying colour, as well as *Flint Castle, North Wales*, cat. 98, in which the sun and its reflection were taken out). Turner also used sponges to soften outlines.

Grainy textures were often obtained by dragging semi-dry pigment across the surface of a sheet (see the foreground of *Mainz and Kastell,* cat. 41). Probably influenced by portrait-miniature painting, from the 1820s onwards vast numbers of tiny, stippled marks were deployed across watercolour surfaces to denote forests, raindrops or ripples of water, as well as to add textural variety and vibrancy. This last was automatically supplied in oil technique by dragging thick pigment over the pronounced weave of a canvas, and stippling clearly compensated for the absence of that grainy texture in extremely smooth paper surfaces.

Turner would increase the viscosity of his pigment by adding gum, and frequently he drew lines with the handle of a brush through the thickened paint while it remained tacky (as in the lower part of *Bolton Abbey, Yorkshire*, cat. 43). He would employ new pigments when they became commercially available, as he did with chrome yellow and cobalt blue in the late 1810s, and Schweinfurt (or emerald) green, chrome orange and French ultramarine in the mid-1820s. The intensity of Turner's colours increased dramatically after his first visit to Italy in 1819, and soon afterwards – especially in the finished watercolours – he was obtaining colour relationships that have never been matched (see, for example, *Kidwelly Castle*, cat. 99).

Turner preferred his finished watercolours to be close-framed or shown with a narrow gold flat placed between the edge of the image and the frame. There can be no doubt that he thought his larger finished watercolours looked best in such surrounds. His representation of the hang in Walter Fawkes's townhouse in 1819 (fig. 20), and John Scarlett Davis's 1835 depiction of the library of one of his major collectors, B. G. Windus (fig. 23), show how Turner's drawings were mounted and displayed by the more discriminating of his collectors. The watercolours were close-framed without a neutral cream border, as is now the fashion, and the works were arranged symmetrically, in Windus's case upon a richly coloured wall. Such frames and settings indubitably focused the eye and made the images sparkle.

TURNER'S AESTHETIC LANDSCAPE

Turner's finished watercolours not only constitute some of his most complex works in terms of technique, form and colour; their content is equally rich. To understand this more fully we need to examine the painter's artistic motivations.

Of the many figures who helped shape Turner during the formative years of the 1790s, one set his lifelong artistic agenda: the first President of the Royal Academy, Sir Joshua Reynolds (1723–1792). The influence of this great painter and teacher is unsurprising, for Sir Joshua not only admitted Turner to the Royal Academy Schools in 1789 and presided over the institution during the student's first years there, but he was also the most influential British artistic thinker of his day. When Turner was later elected Professor of Perspective at the Royal Academy – a post that required him to lecture publicly – he attested to his almost complete identification with the theory of Poetic Painting as promulgated by Reynolds and earlier thinkers.[8] This doctrine considered painting and poetry to be 'Sister Arts', and urged artists to match poets and dramatists in making humanity their prime object of concern (especially on the moral plane). Such an end was to be attained with the maximum visual grandeur, invention and consonance, in order to match the most exalted poetry, drama and literature.

The most direct way for Turner to realise the theory of Poetic Painting was to link his images directly to poetry or literature, something he found easy, as he was deeply attracted to poetry. Above all, he was drawn to John Milton and the Augustan poets, John Dryden, Alexander Pope, James Thomson, David Mallet and Mark Akenside, both for their versification and for their moralism (especially the libertarian strain in Thomson's work). After 1798, when the Royal Academy altered its rules to permit the introduction of verses beneath the titles of works listed in its exhibition catalogues, Turner was able to use poetry to augment the imaginative scope of his publicly displayed images. As a result, in the 1798, 1799 and 1800 exhibitions he methodically explored the ability of verse to enhance the imagery of various oil paintings and watercolours both directly – by means of its explication of human events and natural effects – and indirectly, through the mental associations it called forth.[9] Six of the seventeen watercolours shown in those three exhibitions formed part of that enquiry (see *The Dormitory and Transcept of Fountain's Abbey – Evening,* cat. 10, and *Caernarvon Castle, North Wales*, cat. 12). However, after this concentrated investigation Turner attached verses to the titles of his watercolours less regularly (although he continued to link them to the titles of oils for the rest of his life). Instead, and especially by a decade or so later, he began increasingly to imbue his watercolours with associative significance, by means of pictorial metaphors and their extensions into allegory, as well as through pictorial puns, similes and vertical alignments of component elements (whose connections might be considered the equivalent to consonant line endings in verse). All these devices could be deemed 'poetic' because of their parallels with similar associative vehicles in poetry. Consequently, Turner needed to depend less upon verse to underpin his imagery.

In pursuing this associative course the painter was both building upon his extensive reading of poetry and directly following Reynolds, who in his seventh Discourse had recommended that visual artists should employ 'figurative and metaphorical expressions' to widen the imaginative dimensions of their art, just as poets had done.[10] Many of Turner's finished watercolours created for topographical engraving projects after 1811 enjoy associative levels, as he explored the social, economic and historical ramifications of the places depicted. From the 1820s onwards his associative mind was also given free rein in the many designs he made to illustrate the poetry of Scott, Rogers, Byron, Campbell and others (cats. 73–83). As has justly been stated, 'The association of ideas was, for Turner ... one of his most consistent and deeply rooted habits of mind',[11] and it proved vital in helping the artist meet various other challenges posed by the theory of Poetic Painting.

Naturally, Turner felt impelled to address the humanism that formed the principal focus of that theory. People are rarely absent from his images, especially those made for exhibition or reproduction (and when they are missing it is often to emphasise that the places represented are utterly hostile to mankind). Even in his first exhibited work, *The Archbishop's Palace, Lambeth,*

of 1790 (cat. 1), the role and importance of the figures demonstrate Turner's precocious wish to place people at the forefront of his artistic agenda, as recommended by academic doctrine, for he distributed clearly differentiated social types across the design to display the human range of the place. That emphasis became even more apparent in 1792, with *The Pantheon, the morning after the fire* (cat. 2), and by 1796, when *Woolverhampton, Staffordshire* (cat. 7) was shown at the Academy, figures could even dominate a composition, as they would occasionally thereafter (see *Boulevards, Paris,* cat. 67). Yet even when Turner's vistas lack crowds – or perhaps contain no people at all – they can be inspired by the associations of some aspect of humanity within a place. This is because, in their public guises at least, landscape and marine painting were ultimately moral genres for Turner.

In investing his images with moral dimensions Turner was closely following Reynolds, who regarded painting and sculpture as forms of moral communication that were best served by *Istoria*, or the representation of historical, mythological, religious, literary or poetic subjects. This lofty moral purpose made *Istoria* the most elevated of artistic genres. For Turner, with his pronounced moral instincts and desire to raise the status of landscape and marine painting, it was easy to moralise, especially by means of historical subjects, including those taken from contemporary history. Yet Turner's ambition to be a moral landscape painter would paradoxically lead to his singular and most extreme divergence from the exhortations of Reynolds.

The theory of Poetic Painting necessitated the idealisation of the human form. Termed 'imitation', this process demanded the artist should either imagine perfect archetypes and then create imitations of those 'Ideas' or conceptual paradigms, or should synthesise the finest features of a number of models and, through such compound imitation, attain a greater perfection of form. Turner certainly believed in pictorialising conceptual models; indeed, he called the Idea 'the noblest part of art'.[12] However, he refused to ennoble human appearances. Instead, he consistently made his figures look imperfect and transferred the idealising process from the human frame to the forms of architecture and nature beyond man.

Although the style of the figures in Turner's earliest works was briefly influenced by Edward Dayes and others, from the late 1790s onwards the most lasting hold upon their formation was exerted by David Teniers the Younger (1610–1690), whose genre scenes, with their socially humble and occasionally doltish-looking figures, were widely admired and collected in Britain. By making his own figures look equally 'common', Turner captured the most widespread human characteristics of an era in which mankind was predominantly unwashed and uneducated. In the process he certainly fulfilled the demand voiced by Reynolds and others that an artist should state something essential about our species, and do so in the most universal terms. Yet the commonality and imperfection of Turner's humanity equally fulfilled a vital, parallel function: it maximised the central moral contrast of his art. For Turner, external nature was infinitely perfect, beautiful, immense and powerful, whereas humanity was the opposite and was therefore exceedingly hubristic in its attempts to dominate creation. The painter may often have given mankind a central position in his works, but he always put us in our place when doing so.

Turner began investing his finished watercolours with moral dimensions very early in his career, as we can judge from a 1797 view of a derelict church interior, with its ironic perspective on the destructiveness of the Reformation (*Trancept of Ewenny Priory, Glamorganshire,* cat. 8). Ruined churches, monasteries and castles were easily pressed into moral service, for they acted not only as testaments to the loss of an ancient architectural past and the spiritual convictions it embodied, but also stated the familiar moral that everything is transient. This message clearly appealed to Turner throughout his life, and often led him to propound the related view that all is vanity. In several 'England and Wales' series watercolours he contrasted ruined castles with the simple and more abiding pleasures of maternal love, and thereby afforded us a moral perspective upon the vainglorious motives that had led to the creation and destruction of those buildings (see, for example, *Kilgarren Castle, Pembrokeshire*, cat. 90). Similarly, ancient ruins

Fig. 4
J.M.W. TURNER
Marxbourg and Brugberg
on the Rhine
1820

Watercolour on paper
29.1 × 45.8 cm

W 692
The British Museum, London

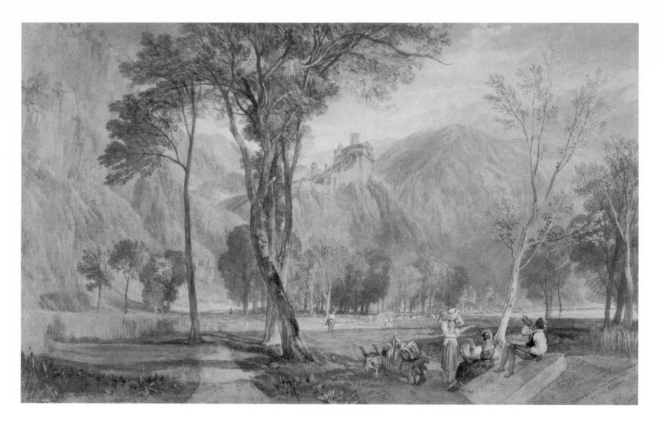

located by the sea were frequently juxtaposed with modern wrecks created by those selfsame waters, to highlight the ruin of human ambitions implied by both (see, for example, *Whitby*, cat. 61).

Moreover, Turner was not only responsive to medieval ruins; contemporary ones attracted him equally, especially in his early years. Towards the end of the eighteenth century an awareness was emerging in Britain that the characters of city and countryside were being eroded by the uniformity and ugliness of industrialisation, which simultaneously led to a loss of spiritual, psychological and social certainties. These erosions prompted responses from many artists, Turner included. His desire to fix the character of a vanishing Britain before it disappeared forever can be witnessed in many views of forlorn and wearied, but highly characterful or 'picturesque' buildings, such as ageing taverns, farmhouses, watermills and bridges. A fine example of the first type of rickety old structure dominates *Woolverhampton, Staffordshire*, of 1796 (cat. 7), and, indeed, does much to fortify the composition with its angular shapes and internal straight lines. An equally good instance of the last type of idiosyncratic near-ruin is evident in *Welsh Bridge at Shrewsbury*, exhibited at the Academy in 1795 (cat. 6).

The Shrewsbury view shows a bridge bearing the road to Wales, and it links to a portrayal of the bridge on the far side of the town whose roadway led to central England (w 136, Private collection). Here Turner simply constructed a geographical contrast; later he often created moral contrasts through the twinning of images. For example, *The Battle of Fort Rock, Val d'Aoste, Piedmont, 1796*, of 1815, and *Mont Blanc from Fort Roch, Val d'Aosta*, of around 1814 (cats. 22 and 21), both depict the same view, and Turner surely elaborated the first drawing to complement the second and thereby create an overall 'War and Peace' statement. 'War' is placed firmly in the past through the date contained in its title, while 'Peace' is located in the present, when the Napoleonic wars were thought or hoped to have ended.[13] Two later views of naval towns contrast the approach of war and the coming of peace (*Yarmouth*, cat. 88, and *Dock Yard, Devonport, Ships being paid off*, cat. 89), while *First-Rate, taking in stores* and *Loss of an East Indiaman*, of 1818 (cats. 47 and 48), balance a warship at peace with a merchantman battling with the elements.

One of Turner's pioneering moral landscapes was *Caernarvon Castle, North Wales*, exhibited at the Academy in 1800 (cat. 12). Here a historical subject – the approaching demise of the legendary last Welsh bard – was amplified by accompanying lines of verse in the Academy catalogue and was probably intended to warn of the harmful effects of territorial expansionism at the very moment that Napoleon was enlarging French hegemony on the Continent. Yet the design also enjoys a subtle dramatic unity that again grew directly out of academic doctrine, for in it we see a precise matching of the internal timing of the scene – and therefore its lighting – with the predicament of its protagonist: in keeping with the imminent end of the bard, the day also nears its end. This congruence of human situation and time of day and, indeed, the creation of a correspondence between all of the dramatic and visual elements of an image, was known as 'Decorum' in the post-Renaissance aesthetic literature with which Turner was familiar, and it can be witnessed throughout his art (and especially in the finished watercolours).

We encounter Decorum most frequently in Turner's extremely rough-hewn figures with which, for moral reasons touched on above, he aimed to match our outer appearances to our inner shortcomings. He could also match types of figures to their surroundings, as in the Salisbury cathedral views (cats. 15, 16 and 17) in which he aptly drew his staffage from one of Christ's most moving utterances. Weather-effects, too, could supplement light and times of day or night to demonstrate Decorum. For example, in the Fort Rock battle scene (cat. 22), warring humanity is paralleled by a storm and shattered natural forms that amplify the human destruction, while in the complementary view (cat. 21) peaceful travellers are matched by a sublimely peaceful landscape. Then there is the hectic breeze that blows through *Borthwick Castle* of around 1818 (cat. 36); it took its cue from the Scots word 'brizz' which described the territorial encroachment that the castle had originally been erected to serve. In *Ely Cathedral, Cambridgeshire* of 1831–32 (cat. 95), an approaching storm may have been intended to denote the threat posed to the Church of England by contemporary demands for parliamentary reform, while in *Nottingham, Nottinghamshire* of mid-1832 (cat. 96), a storm passes away, and does so after the recent stormy passage of that reform legislation through Parliament. Even two late Rigi drawings (cats. 104 and 105) enjoy a measure of associative matching, for loud noise is implied in *The Blue Rigi* and is fully congruent with a world bursting into life at daybreak, just as the quiet suggested by *The Red Rigi* matches a world preparing for sleep at sunset. This contrast between noisiness and peace furthers a point about human intrusiveness and destruction within a beauteous natural world.

Light could advance meaning with equal appropriateness. For example in *Goldau* (cat. 108) Turner depicted a landscape of death, for the rocks in the foreground rest upon a village buried by an avalanche in 1806. Ruskin was surely correct in surmising that the crimson sky in the drawing amplifies the associations of death through its colour, for Turner frequently equated crimson with blood, and blood with death.[14] In many late works, such as *The Fighting Temeraire* of 1839 (BJ 377; National Gallery, London), Turner likened the coming of night to the approach of death, and the sunset in *Goldau* was surely intended to allude to that end as well.

Turner's sense of physical and pictorial scale might equally have been influenced by the theory of Poetic Painting. From the start of his career he constantly sought out vast architectural and natural subjects. His attraction to immensity within landscapes and the sea derived from deep-seated emotional and spiritual needs, for in those subjects he encountered an intensity of beauty, sense of space and overwhelming scale that substituted for conventional religious belief. Turner undoubtedly agreed with the sentiments expressed in Canto III of Byron's *Childe Harold's Pilgrimage*, which he knew well:

Fig. 5
J.M.W. TURNER
The Bell Rock Lighthouse
Signed, 1819

Watercolour and gouache on paper
30.6 × 45.5 cm

W 502
National Gallery of Scotland,
Edinburgh

Where rose the mountains, there to him were friends;
Where rolled the Ocean, thereon was his home;
Where a blue sky, and glowing clime extends,
He had the passion and the power to roam;
The desert, forest, cavern, breaker's foam,
Were unto him companionship; they spake
A mutual language, clearer than the tome
Of his land's tongue, which he would oft forsake
For Nature's pages glassed by sunbeams on the lake …

I live not in myself, but I become
Portion of that around me; and to me
High mountains are a feeling …

Turner's innate affinity with the immensity of the natural world may have been refined in the 1790s by discussion of writings popular at the time. One such source of debate was Edmund Burke's 1757 treatise *An Enquiry into the Origin of our Ideas of the Sublime and Beautiful*, which argues that sublimity resides in our perception of subjects whose vastness and mystery generate astonishment, even terror.[15] Although there is no evidence Turner ever read Burke – and certainly he accorded no space to the discussion of sublimity in his perspective lectures in which he avowed his major aesthetic interests – he can hardly have remained unaware of Burke's ideas during his formative years. In the 1790s he was definitely appreciative of painters such as Nicolas Poussin (1594–1665) and Salvator Rosa (1615–1673), who had expressed responses to landscape in sublime terms. Throughout the latter half of the 1790s and well into the next century, many of his oil paintings are dark-hued, and project a vastness of scale and terrifying natural forces.

Darkness, however, is not often encountered in the finished watercolours, where brightness and an exultant grandeur became increasingly dominant. This may have been inspired by Reynolds, who greatly extolled the artistic attainment of grandeur in his Discourses, and especially in his final lecture – on Michelangelo – that Turner heard him deliver in December 1790. Given his acute responsiveness to Reynolds's other teachings, it seems very likely that Turner's attempts to transform landscape and marine painting into high art by means of the creation of pictorial grandeur drew even more upon this demand than it did upon indirectly received Burkean notions of the Sublime. (And of course it could have been boosted by Reynolds's parallel call for the reaching of an equivalence to the grandeur of epic poetry.)

Large images acted as obvious vehicles for projecting the grandeur of landscape, and throughout his career Turner periodically created them in watercolour (for example, *The Battle of Fort Rock, Val d'Aoste, Piedmont, 1796*, cat. 22). Yet he also used a number of more subtle pictorial methods to amplify the grandeur of his subjects.

One was the enhancement of scale through the adoption of a very low viewpoint, which necessarily makes things tower over us and therefore seem more imposing. We can observe this technique as early as 1794, in the *Inside of Tintern Abbey, Monmouthshire* (cat. 5), where we not only view the scene from very low down, but even the figures, bushes and blocks of masonry that dot the foreground extend above our viewpoint. Similarly, in the 1802 *South View from the Cloisters, Salisbury Cathedral* (cat. 17), our eye is placed on a level with the seated boy in the foreground and, as a consequence, the vast building in the distance fills most of the image above us. Again, in 1818, when Turner was invited to make a representation of a man-of-war that would convey the sheer size of such a ship (*First-Rate, taking in stores,* cat. 47), he located our viewpoint almost at sea level, to maximise the dominance of the vessel.

Another device for attaining grandeur was the amplification of size, and especially height: most of Turner's tall structures – and especially his hills or mountains – are doubled or trebled in height. He began to use this technique very early in his career, as is made clear by a 1794 Canterbury Cathedral view (cat. 4). In reality the south-east corner of Canterbury Cathedral is much lower and more spread out than Turner depicted it. By adopting a low viewpoint, by heightening and compressing the building, and by thrusting it into an upright format, he greatly augmented its scale, which he then further enhanced by placing before it some slightly undersized people, animals and carts, thus making it appear even larger and more exalted by

comparison. (At the same time he intensified our sense of the sophistication of the architecture by having his staffage look as unsophisticated as possible.)

Turner habitually amplified scale and height to similar or much greater degrees. Thus in *Marxbourg and Brugberg on the Rhine* of 1820 (fig. 4), and *Kaub and the Castle of Gutenfels* of around 1824 (cat. 42), the banks of the Rhine are so greatly heightened that they bear no resemblance to reality. Moreover, Turner would also boost quite small forms, such as tree-trunks, which are often elevated to six or more metres before their first branchings, to thrillingly grand effect (as in *Kirkby Lonsdale Churchyard*, cat. 33, and fig. 4). Not only buildings and natural forms benefited from this treatment: in *Portsmouth* (cat. 60) Turner doubled the size of a man-of-war in relation to the adjacent town, thereby enhancing its grandeur.

As well as amplifying size in large watercolours, small sheets could contain immensities (for example, *Edinburgh from Blackford Hill,* cat. 78), as could tiny designs (for example, *Marengo,* cat. 73). Here Turner suggested hugeness by packing much visual data into a small space while retaining the breadth of the scene portrayed. His sense of scale usually makes his landscapes and seascapes seem vaster than those of lesser artists, who could cover acres of support in their attempts to express sublimities. As Turner was well aware (but as many of his

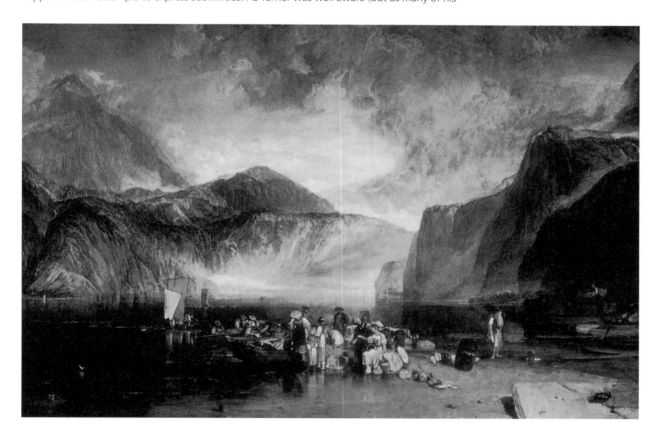

Fig. 6
J.M.W. TURNER
Lake of Lucerne, from the Landing Place at Fluelen, looking towards Bauen and Tell's Chapel, Switzerland
c.1809, exh. RA, 1815

Watercolour, gouache and scratching-out on paper
67.3 × 100.3 cm

W 389
Untraced

contemporaries and successors would never discover), pictorial size and imaginative area do not have to tally.

Turner's finished watercolours capture both the terror and beauty of the natural world. Watercolours such as the *Fall of the Reichenbach*, of around 1804 (cat. 18), and *The Devil's Bridge, St Gothard*, of about ten years later (cat. 20), vividly communicate the threatening aspects of landscape, while views of Lake Geneva and Lake Lucerne, dating respectively from around 1805 and 1809 (cat. 19 and fig. 6), bring immensity and beauty into perfect balance. And in the 'War and Peace' pendants (cats. 22 and 21), darkness and light, the terrifying and the beautiful, are contrasted with one another in order to parallel contrasts in human behaviour. Here the enhancement of scale serves a moral purpose, for by increasing the immensity of our

surroundings Turner could maximise their contrast with what he once termed 'all the littleness of man'.[16] And our 'littleness' is not just physical; in the 1820 *Passage of Mont Cenis* (cat. 54) petty human behaviour contrasts with immense natural forces and surroundings.

Although Turner responded to the terrifying aspects of nature throughout his career (especially in his oil paintings), in the main he produced more works evoking beauty than terror, and did so increasingly as he aged because beauty afforded him greater solace (for example, *Lake Lucerne: the Bay of Uri from above Brunnen*, cat. 106). Yet Turner's responsiveness to beauty is apparent on another, far more subtle and widespread level as well, for even in his many terrifyingly sublime landscapes and seascapes he none the less articulated a type of beauty. This is not loveliness as we conventionally understand it, but a more subtle form of beauty.

Reynolds and other theorists had stated that artists should attempt to portray the human figure in its most ideal form, and to capture our most universal behavioural characteristics. For Turner, with his refusal to idealise the human figure, idealisation meant capturing the underlying behavioural characteristics of natural forms and phenomena through an understanding of their 'qualities and causes, effects and incidents'.[17] He termed these essentials 'Ideal beauties',[18] and from the mid-1790s onwards began to express them. He did so initially in his representations

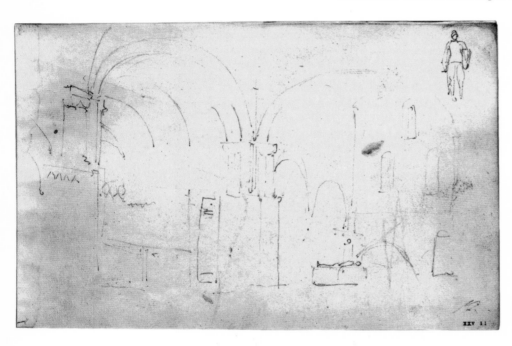

of architecture. Thus by 1797, in the *Trancept of Ewenny Priory, Glamorganshire* (cat. 8), and even more by 1799, in the *Chapter House, Salisbury Cathedral* (cat. 16) – the very subject of which is an outstanding example of organic architecture – he made apparent the fundamental tensions and interdependencies of inert stonework. He achieved this by stressing the essential structure of the fabric, by subtly enhancing scale and by creating refined or dynamic plays of light and shade. With the Ewenny Priory drawing we can even precisely gauge the degree to which his profound understanding of architectural form was fully internalised, for the design is based upon a pencil study (fig. 7) that barely indicates its subject; Turner not only remembered the architectural detailing but also the broader structure. Rapidly, his grasp of architecture facilitated an acute awareness of the basic structures of natural architecture, the underlying dynamics, stratifications, fissurings and erosions of geological form (for example, *Fall of the Reichenbach,* cat. 18).

Parallel to this, Turner's growing sense of underlying form gradually emerged in his representation of the sea. We can already detect the beginnings of it in the *Conway Castle* of around 1800 (cat. 13), with its suggestion of the ebb and flow of a large body of stormy water. Within just a few years Turner's expression of the underlying energy and physical dynamics of water would move far beyond anything witnessed elsewhere in art. Similarly, by about 1805 the painter began to abandon the Poussinesque formula he had adopted earlier for the rendition of cloud forms, which in works such as the *Fall of the Reichenbach* makes the sky look like a series of stage flats. Certainly by 1811, when he created *Weymouth, Dorsetshire* (cat. 25), and more especially by the time he made *First-Rate, taking in stores* of 1818 (cat. 47), *Hastings from the Sea* of 1818 (fig. 8), the *Bell Rock Lighthouse* of 1819 (fig. 5), or *Dover Castle* of 1822 (cat. 56), and *A Storm (Shipwreck)* of 1823 (fig. 9), Turner had finally attained the ability to move beyond appearances and depict the inner patterns and energies of meteorological and hydrodynamic form with profound insight. Much of the communicative strength of his marine images, in particular, derives from that unmatched power.

Around 1813 Turner's trees also began to reveal his understanding of their inner life. Whereas his earlier depictions remain rather conventionally stylised (as attested by the sapling in *Battle*

Abbey, cat. 24), by the time he made *Ivy Bridge, Devonshire* (cat. 28) a new burgeoning is apparent. In later drawings (for example, *Landscape: Composition of Tivoli,* cat. 68) the trees seem even more florescent and, because of their compositional dominance, do much to project an ideal world throughout each image.

During the 1810s Turner began to address the universal truths of the human condition, by alluding to the history, prevalent social behaviour, economic realities and other characteristics of places depicted. Such truths received articulation in many of the finished watercolours, a particularly inventive example being the 1810 *Battle Abbey* (cat. 24), which hints strongly at the decisive clash of arms in 1066 that had given rise to the original abbey. However, Turner's desire to reveal human truths became more intense after 1811 when he embarked upon the 'Picturesque Views on the Southern Coast of England' series for engraving and quickly deemed it vital that the watercolours intended for that partwork and similar schemes should project the essential truths of place. Such drawings include the 1816 'Views in Sussex' *Vale of Ashburnham* (cat. 29), with its structuring of the composition around the fundamental economic prop of the family whose mansion forms the focal point of the design; the 'Southern Coast' *Boscastle, Cornwall* of around 1824 (cat. 27), with its subtle explication of the ship-handling problems endemic to that harbour; and the 'Ports of England' series *Portsmouth* of about 1825 (cat. 60), with its allusions to maritime control and its momentary loss in one of Britain's three great naval bases.

In addition to the 'imitation' of ideal forms through the close observation of behavioural characteristics, Reynolds and his fellow theorists had also recommended a less exalted form of imitation, namely the stylistic emulation of the great masters. Turner certainly believed in such a practice, and he drew upon the styles of a great many artists during his career. Claude Lorrain proved especially inspirational, for stylistic imitation of the French master afforded a natural short-cut to the creation of ideal landscapes.

Fig. 8
J.M.W. TURNER
Hastings from the Sea
Signed and dated 1818

Watercolour on paper
39.8 × 59.1 cm

W 504
The British Museum, London

From as early as the 1790s Turner idealised his landscapes in general terms, and certainly attained that end by means of synthesis. Reynolds and many of the theorists upon whom he drew had denied that landscape painting could transcend its reliance upon arbitrary experience and thereby depict the universals deemed central to artistic idealism. However, Reynolds did allow that Claude Lorrain had overcome that problem by synthesising the finest features of several views in his images, and throughout his career Turner followed this procedure, creating landscapes and seascapes by amalgamating several vistas, and introducing light effects and staffage often witnessed elsewhere and independently of one another. Occasionally this synthesis would result in portrayals of particular places looking little like actuality. A good example of this divergence – and in exactly the type of landscape in which we should expect to find it – occurs in *Rise of the River Stour at Stourhead* (cat. 70).

Turner began to imitate Claude from the mid-1790s, as we can see in *Harewood House from the South-East* of 1798 (cat. 9). By the 1810s and 1820s he was able to imbue Claudian methods of pictorial synthesis with his awareness of natural process, and thus raise landscape imagery onto another plane of idealisation altogether (see, for example *Landscape: Composition of Tivoli*, cat. 68, *Rise of the River Stour at Stourhead*, cat. 70, and *Lake Albano*, cat. 63). Turner would never lose his admiration for Claude and even as late as the 1840s, in watercolours such as *Oberwesel* (cat. 101), he still employed Claudian methods to project a perfect world.

Turner's idealism has long been recognised. Ruskin understood it intuitively, and wrote stirringly about the underlying truths of architecture, geology, meteorology, hydrodynamics and botany in Turner's work (and he was, of course, highly responsive to the artist's moralism and associationism too). Moreover, J. E. Phythian, the Edwardian author of a book on Turner, went even further and linked the painter's idealism to Plato:

> all we need is to affirm that Turner … was a worshipper, that he bowed down before, and therefore exalted himself in the contemplation of, the invisible within the visible. This is why there is in his work a beauty that nature cannot show; a beauty, one must hasten to say, not surpassing but different from that of nature, no mere imitation of what nature sets before us … Is not every artist, consciously or unconsciously, a Platonist, seeking everywhere the types of which visible things are but the imperfect forms? Could Plato have seen a Turner landscape would he not at once have given to painting a place in his Republic?[19]

Phythian's response was especially acute, for many passages in Turner's lectures (which were unknown to that writer) are strongly Platonic in tone. Although Turner evidently took his cue

Fig. 10
J.M.W. TURNER
Inverary Pier. Loch Fyne. Morning
c. 1844–8

Oil on canvas
91.5 × 122 cm

BJ 519
Yale Center for British Art,
New Haven, Conn.

from Platonic elements in Reynolds,[20] there is no reason to believe he was mindlessly echoing his great teacher: he genuinely held Platonic convictions. This is underlined by his early affinity with the poetry of Mark Akenside, lines of whose highly Platonic verse he frequently cited in his lectures to articulate his shared belief in the existence of a universal, Platonic geometry. It is possible that such a conviction might well have developed in his mid-teens.[21]

Given these avowed identifications and the fact that much of Turner's art is openly idealistic in both its imagery and synthesising creative processes, it seems logical to conclude that he wished to articulate the Platonic Ideas, by attempting to depict archetypal forms or 'Ideal beauties', as well as through transforming actual places into idealised, perfected realms. Perhaps this latter wish received its supreme articulation in late oils such as *Inverary Pier. Loch Fyne. Morning* (fig. 10). Yet in a contemporaneous or slightly later group of watercolours typified by *The Lauerzersee, with the Mythens* (cat. 110), the artist possibly went even further. All these images were elaborated with turbulent brushwork that projects a sense of pulsing energy. Within them colours glow hauntingly, form dissolves and movement seizes everything, acting behind the visible fixities of matter to suggest some greater, dynamic continuum. Turner must have intended that drive to be much more than just a materialistic force, for towards the end of his life he is supposed to have declared – and on the available evidence did say – 'The Sun is God'.[22] It therefore follows that in his late, vibrant landscapes he moved beyond the purely physical realm and filled the universe with divine light and its metaphysical energies. Given that the sun is the prime source of earthly powers, here, surely, was the ultimate essential for a painter who had attempted to reveal essentials ever since his late teens. The forces of that spiritual orb flow through contours, activating and unifying forms, and finally they transport us to some higher and more consummate reality.

The Market for Turner's Finished Watercolours in His Lifetime

EVELYN JOLL

As is well known, Turner was born in humble circumstances but died a very rich man. He left £140,000, the equivalent of about £4 million today, far more than any British artist before him. Although a portion of his wealth was due to his investments, both in government stocks and in land, the vast majority came from the sale of his paintings and watercolours.

He began modestly enough: one of his early patrons was Edward Lascelles junior, later Viscount Lascelles (1764–1814), who collected watercolours. Lascelles's first Turner was *St Erasmus in Bishop Islip's Chapel, Westminster Abbey*, exhibited at the Royal Academy in 1796, for which he paid three guineas on 17 May 1797. This is now in the British Museum (fig. 11; its inscription WILLIAM TURNER NATUS 1775, confirms the year Turner was born). Later, in 1797, Lascelles paid ten guineas for each of two views of Harewood House and, in 1798 (see cat. 9), the same amounts for two more views of the house and two of Harewood Castle.

By this time Turner had already been commissioned by Viscount Malden, later Earl of Essex, to paint watercolours of Hampton Court and Cassiobury, his seats in Herefordshire and Hertfordshire respectively, while Sir Richard Colt Hoare had also ordered a series depicting Salisbury and its cathedral (cats. 15-17). The seventeen Salisbury watercolours occupied Turner intermittently from 1796 to 1806.

The diarist Joseph Farington recorded on 24 October 1798 that Turner had 'more commissions at present than he could execute' and on 6 July 1799 that Turner had '60 drawings now bespoke by different persons'. These must have included the prestigious commission from the Delegates of the Clarendon Press to provide ten drawings for the *Oxford Almanack*, the University's annual calendar. Turner was paid ten guineas for each of them and although the last payment was made as late as 1804, by which time he had been elected to full Membership of the Royal Academy, Turner, perhaps surprisingly, had not increased his prices.

An equally important commission came from the fabulously rich William Beckford for five large watercolours of Fonthill Abbey, his great Gothic house in Wiltshire. These were shown at the Royal Academy in 1800 and Turner received 35 guineas for each of them. In the same year Beckford bought the large oil of *The Fifth Plague of Egypt* (BJ 13) for 150 guineas, which was the start of a sharp increase in the prices for Turner's oils.[1]

The high figure that Turner obtained for the drawings of Fonthill (W 355–9; each *c.* 70 × 105 cm) was probably prompted by his sale of the smaller *Caernarvon Castle* (W 254; 57 × 82.5 cm), exhibited in 1799, to John Julius Angerstein (whose collection was to form the nucleus of the National Gallery in 1824) for 40 guineas 'the price fixed by Mr A. and was greater than Turner would have asked', as Farington recorded.[2]

Size appears to have been the determining factor in fixing Turner's prices: for instance he recorded the hefty sum of 60 guineas in the *Greenwich* sketchbook of 1808–09 (TB CII-1) from Edward Lascelles for the very large *Mont Blanc from Fort Roch, in the Val d'Aosta* (66 × 100 cm, cat. 21), which never seems to have entered the Harewood collection but was bought by Lascelles's neighbour Walter Fawkes instead. However, for the 24 much smaller drawings (*c.* 14 × 23 cm) to be engraved in the 'Picturesque Views on the Southern Coast of England', from 1814 to 1826, Turner charged the engraver W. B. Cooke only £7 10s each for the first seven watercolours; this was later increased to ten guineas each, and Turner was asked to supply 40 watercolours in all.

Fig. 11
J.M.W. TURNER
St Erasmus in Bishop Islip's Chapel, Westminster Abbey
exh. RA 1796

Watercolour
54.6 × 39.8 cm

W 138
The Trustees of the British Museum (1958-7-12-402) as part of the R. W. Lloyd Bequest

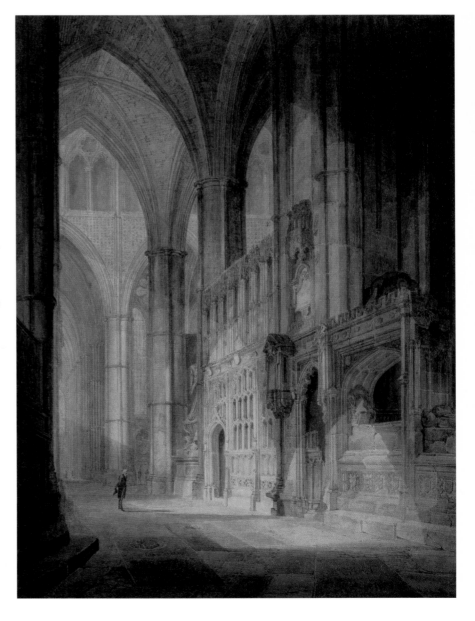

After Turner built his own gallery in Harley Street in 1804 he exhibited watercolours at the Royal Academy far less frequently (he had shown 65 watercolours there from 1790 to 1803), ten between 1805 and 1815 with only four thereafter until his final watercolour exhibit there in 1830 (*Funeral of Sir Thomas Lawrence,* cat. 71). This has resulted in our knowing less about the buyers of his drawings, with the exception of his most important patron, Walter Fawkes, who bought so many of the finished watercolours which resulted from Turner's visit to the Continent in 1802 (cats. 18 and 21). Some of these were ordered by Fawkes after looking through Turner's sketchbooks; for example on page 69 of the *Academies* sketchbook of 1804 LXXXIV there is a note of three drawings including *Fall of the Reichenbach* (cat. 18) with Fawkes's name against them and the price '50 G.e'. Fawkes was such a favoured customer that when Turner returned from his trip to Holland and Germany in 1817 he sold Fawkes 50 views of the Rhine for £10 apiece within a few minutes of arriving at Farnley Hall, Fawkes's house in Yorkshire (see *the Loreleiberg,* cat. 38, and *Rolandswerth Nunnery and Drachenfels,* cat. 39). This was a wonderful acquisition by Fawkes although the whole Rhine series was sold[3] and is now widely dispersed among private and public collections (see fig. 12).

Turner was constantly employed from 1815 to 1838 in painting watercolours to be engraved in a wide variety of publications. One of the most ambitious of these was Dr Whitaker's projected history of Yorkshire, for which Turner was to provide 120 drawings. In the event only 'The History of Richmondshire' was published, for which Turner made twenty drawings between 1816 and 1818 for 25 guineas each, involving him in a tour of the area in July and August 1816 when the weather was so wet that Turner wrote to his friend James Holworthy that 'I shall be web-footed like a drake'.[4]

Turner was paid the same sum for the twenty drawings he produced to illustrate Hakewill's 'Picturesque Tour of Italy' (see cat. 5). No journey was involved here except an imaginative one, for Turner had to transform the pencil drawings of James Hakewill (1778–1843) into watercolours of views of a country he had yet to visit. These were published in 1818–20 and reveal Turner's amazing skill at reinterpretation, something he was called upon to do on several occasions subsequently, for Finden's 'Landscape Illustrations of the Bible' (see *Corinth*, fig. 13, based on

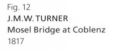

Fig. 12
J.M.W. TURNER
Mosel Bridge at Coblenz
1817

Watercolour
19.9 × 31.1 cm

W 659
Private collection

a drawing by Charles Robert Cockerell and cats. 81 and 82) and Lieutenant George Francis White's 'Views in India', for example, both in the 1830s.

His work for Hakewill may have acted as an added inducement to Turner to go to Italy himself, which he did in 1819. He brought back nineteen or twenty sketchbooks from which Fawkes ordered a number of watercolours of Rome, Naples and Venice (see cats. 52 and 53).

In 1822, 1823 and 1824 the engraver W. B. Cooke held exhibitions of Turner's watercolours at his Soho Square gallery. Although he showed mainly his own 'Southern Coast' drawings, a few others were lent by other collectors, notably by Turner's stockbroker, Charles Stokes (1785–1853), who also owned some early drawings and, later, some of the Loire series. These exhibitions must have introduced Turner's work to new collectors and no doubt led to further sales.

In 1825 Turner embarked on his most ambitious series, the 'Picturesque Views in England and Wales', 120 watercolours commissioned by the publisher Charles Heath for 30 guineas each. This commission occupied Turner for the next twelve years and, again, the series was publicised by two exhibitions: 38 drawings were shown at the Egyptian Hall, Piccadilly, in June 1829 and a further 67 at the Moon, Boys and Graves Gallery in Pall Mall in June and July 1833. The 1833 catalogue includes the names of lenders (we do not know how much Heath charged them). Among them, besides Turner's agent Thomas Griffith, Thomas Tomkinson, a piano-maker in Soho, lent five; John Hornby Maw, a surgical instrument manufacturer, lent three and Benjamin Godfrey Windus (1790–1867), a coachmaker in Tottenham, lent sixteen (he later owned at least 36 of the series). It seems certain that this exhibition generated considerable interest among collectors and so more drawings were sold. When Eric Shanes's book on the series was published in 1979, it was accompanied by a loan exhibition at Agnew's of 55 of the original watercolours which were not for sale. However, the combination of book and exhibition must have stimulated interest among potential buyers with the result that prices for 'England and Wales' drawings then shot up during the 1980s.

Turner's output for a decade from 1827 was prodigious: although apparently not keen on the 'Annuals' that were so popular he contributed to several, especially *The Keepsake*, also published by Charles Heath, for which he supplied seventeen illustrations between 1827 and 1837 (cat. 63). These reached a very wide audience: the 1827 volume, in which Turner's *Florence from San Miniato* (w 726) appeared, sold 15,000 copies at a guinea apiece.

Turner's illustrations to Samuel Rogers's *Italy* (25 vignettes, 1830; see cats. 73 and 74) and *Poems* (33 vignettes, 1834; see cats. 75–77) were even more popular: 6,800 copies of *Italy* had sold by 1832 and 50,000 copies of the two books by 1847. Turner told Rogers that no lady's boudoir would be complete without a copy of the *Poems*. Moreover it was Turner's illustrations to *Italy* (a thirteenth-birthday present) that sparked the young Ruskin's lifelong enthusiasm for the artist's work.

Turner also illustrated Sir Walter Scott's *Poetical Works* (1833–34) and *Prose Works* (1834–36; cat. 78). Scott did not at first take to Turner, accusing him of having 'an itchy palm' and of being someone who would do nothing except for money.[5] But Scott's shrewd publisher, Robert Cadell, was aware of Turner's immense importance in these ventures, writing to Scott that, 'with his pencil I shall ensure the subscription of 8,000 [for the *Poetical Works*] – without not 3,000'.[6] This involved Turner in a long visit to Scotland in autumn 1831 when he and Cadell toured the countryside choosing subjects for illustration. Based at Abbotsford, Scott's house on the Tweed, they were sometimes accompanied by Scott himself who finally came to respect Turner.

Windus later bought 67 of the Scott illustrations for twelve guineas each but the Rogers drawings remained with Turner; he marketed them in a different way, lending them to the publisher, Edward Moxon (1801–1858) for a fee of five guineas each. Moxon was also the publisher of the last important book that Turner illustrated, the *Poetical Works of Thomas Campbell* (1837). The circumstances surrounding this commission for twenty vignettes are very confused, but it seems likely that the poet bought the drawings for 25 guineas each, being assured they were 'like bank notes'.[7] In 1842, however, Campbell, short of money, tried to sell them but found no buyers and eventually sold them back to Turner for £200, a deal that would

Fig. 13
J.M.W. TURNER
Corinth, Cenchrea
1832–34

Watercolour
14 × 20.2 cm

W 1257
Private collection

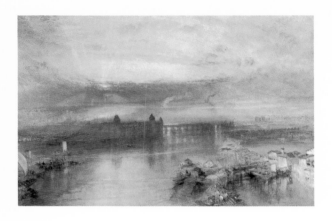

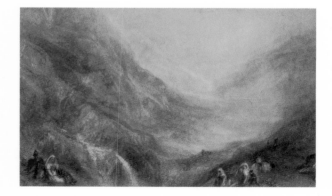

have surely appealed to the artist. Turner must then have resold them but there is then a gap in their provenance until they were acquired by Sir Donald Currie (1825–1909), who was buying mainly in the 1890s. The watercolours are now all in the National Gallery of Scotland.

By 1837 even the market for Turner's prints was sated. This is hardly surprising for, besides those publications mentioned, he had also illustrated works by Byron (cats. 79 and 80), Milton and Moore as well as the three volumes of *Turner's Annual Tour* (1832–34) covering his journeys along the Loire and the Seine. By the time of his death in 1851, Turner had been involved in the production of over eight hundred prints based on his paintings and watercolours. This means that there were plenty of watercolours available and a number of collectors must have taken advantage of this besides Windus who, in addition to his 'England and Wales' and Scott holdings, also owned twenty 'Southern Coast' drawings, eighteen vignettes for Byron's *Works* and twenty illustrations to Finden's *Bible*.

How did Turner sell his watercolours other than to established clients? It is clear that he distrusted dealers with the exception of Thomas Griffith (b. 1795), his agent from perhaps as early as 1827 but particularly from 1840. Turner's other contact among dealers was Dominic Colnaghi (1790–1879); in 1834 Turner's 26 illustrations to *The Life and Work of Lord Byron* were shown at Colnaghi's gallery, many of them bought by Griffith. This, however, was probably due to Colnaghi's friendship with the publisher John Murray rather than to any close link between Colnaghi and Turner. Colnaghi also handled sales of the *Liber Studiorum*, although Turner was very stingy about discounts to print-dealers until, in 1848, he told Colnaghi that he had finally decided 'no discount to the trade'. Colnaghi asked: 'In that case how are we to live?' 'That's no concern of mine,' replied Turner, upon which they shook hands and parted.[8]

Griffith played a crucial role in marketing the sets of ten watercolours, mainly of Swiss subjects, in 1842, 1843 and 1845. His account of their genesis, reported by Ruskin, is well known but bears retelling. Late in 1841 Turner showed Griffith fifteen sketches from four of which he had painted finished watercolours; he offered to finish six more if Griffith could get orders for them. When asked what they were worth, Griffith replied: 'Well, perhaps, commission included, 80 guineas each.' Turner: 'Ain't they worth more?' Griffith: 'Yes – they *are* worth more, but I could not *get* more.'[9] Griffith approached only four collectors: the whaling entrepreneur Elhanan Bicknell, Munro of Novar, a close friend of Turner and an avid collector of his work, the Ruskins, father and son, and Windus. First to arrive was Windus. It would be fascinating to know if this was just chance or whether Griffith thought that, as Windus owned more Turners than the others, he deserved first pick. Windus, however, said that he did not care for Turner's latest style so chose nothing, thereby missing the greatest opportunity in the history of British watercolour-collecting. Eventually Munro chose five, Bicknell and the Ruskins two each and Griffith took the tenth, *Constance* (see fig. 14), as his commission. This set is often considered to contain Turner's very finest watercolours so it is indeed a great triumph that four of them – *Lake Lucerne: the Bay of Uri*, cat. 106, *Brunnen, Lake of Lucerne,* cat. 107, and the 'Blue' and 'Red' *Rigis* (cats. 104 and 105) – are exhibited here.

In the following year Griffith could obtain orders for only five drawings, three from Munro and two from the Ruskins. It is not known whether Griffith then approached any other collectors in the hope of further orders – J.H. Maw and Thomas Tomkinson for example, already mentioned as buyers of 'England and Wales' watercolours, seem possible candidates in this context. Although Bicknell chose nothing in 1843, he afterwards bought six oils on *one* day in March 1844, perhaps encouraged to do so by the publication of the first volume of *Modern Painters*, which must surely have prompted both old and new collectors to try to acquire Turners.

By this time Turner was also using Griffith as his agent to sell his oils and clearly relied on his advice, although others were suspicious of him to judge from Windus's warning to Ruskin's father: '*Be on your guard*. He is the cleverest and deepest man I ever met with.'[10] Turner painted two more sets of finished watercolours in 1845 and from 1846 onwards, many of them acquired by Ruskin. Curiously enough, however, two of the 1845 set were commissioned by Windus whose

sale in 1859 also included two of the 1843 series, *Lake Zug* (w 1535) and *Bellinzona* (w 1539). Windus must have acquired both of these from Munro, but one should no longer be surprised how often drawings changed hands between collectors in those days.

The highest sum recorded that Turner received for a watercolour was the 100 guineas that Ruskin paid for each of *The Descent of the St Gothard* (fig. 15) and *The Brunig Pass, from Meiringen* (w 1550) which he commissioned in 1847–48. When one recalls that Beckford paid 35 guineas each for his admittedly large watercolours in 1799, an increase of all but three times in almost fifty years seems far from grasping, considering Turner's reputation, while, over the same period, the rise in the price of his oils was equally reasonable.

Although this survey provides some information about the prices for Turner's watercolours and how they were sold, some questions remain unanswered. Andrew Wilton's catalogue *The Life and Work of J. M. W. Turner* (1979) lists 1,578 watercolours, between five hundred and six hundred of which had been bought by just three collectors: Fawkes and Windus, who each owned more than two hundred, and Munro, who had at least 130 (Griffith may also have owned a considerable number).

Wilton's list explicitly excludes pencil and monochrome wash drawings and many early minor works from 1792 to 1799. Since 1979, when Wilton's catalogue appeared, a good many watercolours have turned up and these, together with those purposely omitted by Wilton, must add up to a total of at least 2,500 watercolours and pencil drawings outside the Turner Bequest. We simply do not know why many of these are *not* in the Bequest; there were of course rumours of pilfering from the studio after Turner's death but these, if true, were probably confined to only a few dozen drawings. Therefore collectors unknown to us today must have had access either to Turner himself (as James Marshall of Leeds did in 1835 when he visited Turner's studio and bought *The Burning of the Houses of Parliament*, BJ 364) or to Griffith, or other unrecorded outlets for Turner's work must have existed (although it must be remembered that Turner did not exhibit with any of the new watercolour societies that flourished during the second half of his career). It is only thus that we can account for so many watercolours being 'at large', and they still keep turning up: in 1999 *A Glacier in the Alps* (see

fig. 16), an unpublished drawing dating from Turner's trip to the Val d'Aosta with Munro in 1836, was exhibited at Agnew's after many years hidden in a private collection. But, however these drawings changed hands during Turner's lifetime, there are so many of them that, coupled with our knowledge of Turner's prices, they show that his watercolour sales must have contributed handsomely to his very considerable fortune.

'The wonder-working artist':
Contemporary Responses to Turner's Exhibited and Engraved Watercolours

IAN WARRELL

Assessments of the nature of Turner's reputation during his own lifetime have, for the most part, concentrated almost exclusively on evaluations of his oil paintings, with the result that the most common image of him is as a disturbingly innovative artist, whose pictures were habitually mocked and misunderstood. According to this version of Turner's life, only a small circle of enlightened patrons nurtured and appreciated his genius, and it was not until the young John Ruskin intervened on his behalf, by writing the first volume of *Modern Painters* (1843), that his sullied reputation was at last rescued from the hands of unjust and insensitive critics.

Although there is undoubtedly substance to this Romantic portrait of the artist, it conflicts with other contemporary perceptions of Turner, which celebrated him as the greatest landscape artist of his generation, and very probably the finest England had produced. Such anomalies are, to some extent, attributable to the undue emphasis placed on the more 'difficult' paintings of the 1830s and 1840s, but just as significant is the omission of an understanding of the part Turner's watercolours played in sustaining a bedrock of support for his art throughout his career. For it was, in fact, common, even in the 1840s, to refer to him as one of the founding fathers of the native tradition of 'painting in water colours' (as the art of watercolour was called at the time). Further discrepancies come to light once one explores the context in which these works were considered, perhaps the most striking of which is the fact that some journals and newspapers praised Turner's watercolours in one column, before going on to take him to task elsewhere for his oil paintings. Since these conflicting viewpoints may well have been penned by the same journalist, it is apparent that Turner's critics had quite different expectations from his productions in these two media.

I am concerned here with this alternative history of Turner's reputation. Obviously, this is a huge subject, covering the full extent of Turner's long working life, which began and ended with work in watercolour. Inevitably, the constraints on space mean that it is possible only to deal with some aspects of the responses to this work here. Ruskin's writings about Turner, for example, dominated perceptions of the artist in the 1840s, but are a subject in themselves, and hence are largely put to one side.[1] Thanks to the endeavours of Martin Butlin and Evelyn Joll, we now have a fairly detailed account of the contemporary criticisms provoked by Turner's individual oil paintings, but nothing comparable yet exists for the watercolours that he exhibited at the Royal Academy and elsewhere, though this is a rich seam awaiting thorough exploration.[2] I have deliberately concentrated on the key arenas in which Turner's drawings were shown, focusing where possible on drawings included in the present exhibition. This provides a means of teasing out some of the themes that recur in evaluations of his watercolour productions.

When writing *Modern Painters* Ruskin was particularly concerned to demonstrate that Turner's works were true to nature, and it is therefore no surprise to find that this was one of the most frequent charges made against the watercolours from the beginning of the 1820s. But, as is also the case with Turner's oil paintings, not all critics assessed artworks simply on their effectiveness as literal re-creations of a given scene. Many were prepared to view Turner's drawings as something poetic and magical. Regrettably, only a few of these reviews carried the name or the initials of the author, so it is invariably impossible to discover anything about the men (and, quite probably, women) who made these pronouncements. Whatever motives they had for the prominence they gave to Turner's works are now obscure. Nevertheless, their words offer us the chance to recapture something of the excitement and bewilderment of confronting Turner's watercolours for the first time.

ESTABLISHING A REPUTATION:
TURNER'S WATERCOLOURS AT THE ROYAL ACADEMY, 1790–1818

When Turner began to exhibit at the Royal Academy the institution was the principal, and practically the only, place in London where artists could show their work and gain patronage, providing the focal point of all artistic debate in the capital.[3] As well as paintings, which took pride of place in the Great Room on the top floor of Somerset House, the Academy exhibitions included

the work of sculptors, architects, miniaturists, watercolour painters and engravers. At this stage these latter categories were less highly rated in the academic hierarchy and hence received far less attention from the press. Despite this, these more modest exhibits were invariably popular with the public, especially once the annual exhibition expanded onto the floor below from 1792 onwards.[4] It is possible to calculate that during the early 1790s the average attendance figures were in the region of 40,000, but by 1850, when Turner's last paintings were seen (in the building that is now the National Gallery), the total very probably exceeded 100,000.[5]

Turner's first exhibit was a watercolour that appeared in the annual exhibition of 1790, barely a couple of weeks after his fifteenth birthday (cat. 1). The show that year contained just over seven hundred works, and, not surprisingly, Turner's small, almost monochrome drawing remained unnoticed by the critics in its location in the Exhibition Room of Sculpture and Drawings, on a different floor from the main display in the Great Room. Undaunted, he continued his studies, submitting further works in the succeeding years.

Turner's public profile was raised for the first time when he won the Silver Palette at the Royal Society in 1793, but it was apparently not until the following year that his exhibits at the Academy attracted the attention of the critics. The exhibition in 1794 included five of his drawings; far more

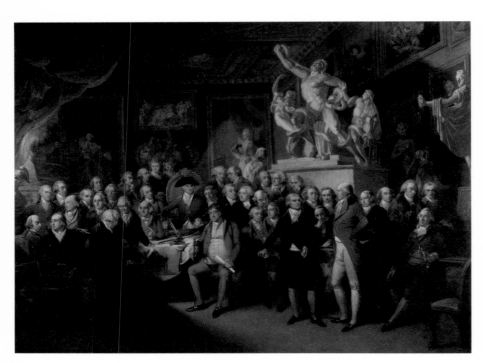

than he had shown previously, which were this time grouped in the Antique Academy (normally used for the study of plaster copies of Antique sculptures). One of the exhibited drawings was a view of Tintern Abbey (cat. 5). These works were judged by the critic of the *St James's Chronicle* to have 'great precision in the outlines; are well chosen and well coloured'.[6] Only eleven days later the *Morning Post* singled out three of the drawings as 'amongst the best in the present exhibition'. Aware that Turner's name would be unfamiliar to his readers, the critic continued, 'they are the productions of a very young artist, and give strong indications of a first-rate ability, the character of Gothic architecture is most happily preserved, and its profusion of minute parts massed with judgment and tinctured with truth and fidelity'. Concluding these remarks, the review ends with a gentle warning to Turner to pursue an independent course of study, and not to ape the styles of his contemporaries: 'His present effort evinces an eye for Nature, which should scorn to look to any other source.'[7]

Buoyed up by this first success, Turner's submissions to the annual exhibition increased thereafter and were rewarded by being given more prominence in the slightly less crowded Council Room (fig. 17). It was in this important room, at the heart of the institution, on the floor below the Great Room, that 45 of the 66 drawings that Turner exhibited at the Academy (between 1795 and 1806) were shown.

Turner's work soon caught the eye of more senior members of the Academy. Joseph Farington, for example, had clearly noted his success in 1795, but expressed some reservations when reviewing the exhibits of the following year, which included *Woolverhampton* (cat. 7): 'the drawings of Turner are very ingenious, but it is a manner'd harmony which He obtains.'[8]

In terms of critical coverage, the year 1797 marked a real breakthrough for Turner, establishing him among the artists regularly monitored by critics. This occurred very largely because this was the second year in which he had included works in oils among his exhibits, one of which was displayed in the Great Room; so the recognition was as much for his higher ambitions as for his achievements as a painter in watercolours. Though this new interest sets a pattern for future years, some critics continued to champion his performances in watercolours. The *St James's Chronicle*, for example, considered the view of the *Trancept of Ewenny Priory* (cat. 8) 'one of the grandest drawings he had ever seen, and equal to the best pictures of Rembrandt'.[9]

While he continued to gain ground in the public press, not all of the drawings that Turner produced at this period met with approval. The subdued, but atmospheric view he painted of Fountains Abbey in 1798 (cat. 10) was criticised in the *Whitehall Evening Post* for being too dark: 'the scene is so totally obscured and involved in gloom, that it has a heavy appearance and the colouring is lowered to absolute dirtiness, which renders the picture unattractive and even repulsive.'[10]

In the published comments about the watercolours of the following years, there was an increasing insistence on Turner's ability to give his works the 'force' and 'harmony' of pictures painted in oils. The *Monthly Magazine* for one was amazed to discern such a mature 'strength of mind' in Turner's works in either medium: 'their effect in oil or on paper is equally sublime. He seems thoroughly to understand the mode of adjusting and applying his various materials.'[11] The work that most epitomised Turner's transforming powers was the 1799 drawing of Caernarvon Castle (fig. 18), which prompted one visitor to the exhibition to remark that, although it was painted in watercolours, Turner had effected in this work a 'depth and tone, which I had never before conceived attainable with such untoward implements'.[12] The appearance of drawings such as this encouraged tremendous interest about Turner's techniques and materials, and even speculations that some form of alchemy was involved. Indeed, from this point on, reviewers habitually referred to the artist as a 'magician' in recognition of the transformations he effected from base materials.[13]

More traditional viewers, such as Sir George Beaumont and Benjamin West, resisted the expressive innovations in watercolour painting pursued by Turner and his comrade Thomas Girtin, considering their pictures mannered.[14] But Turner had already won many admirers, and by July 1799 had a backlog of orders for 60 drawings. Many of these came from patrons who valued his skills as an architectural draughtsman, and who commissioned him to make views of their country houses (*Hampton Court, Herefordshire, seen from the south-east,* cat. 23). However, it was perhaps his continuing efficacy in this line of work that earned him the reproaches of Edward Lascelles the younger, of Harewood House in Yorkshire (cat. 9), who protested that, in comparison with the breadth of Girtin's watercolours, Turner's style was too painstaking, too finished.[15] Yet these bread-and-butter topographical drawings do attempt to transcend the limitations of this genre by deliberately encouraging the viewer to focus on an atmospheric effect, or the time of day depicted.

As the new century began, press criticism of the Academy exhibitions became increasingly concerned with Turner's oil paintings, even though he continued to exhibit drawings. There were six in 1800 (see *Caernarvon Castle, North Wales,* cat. 12), four in both 1801 and 1802 (see *Kilchern Castle,* cat. 14), two in 1803, one in 1804, another in 1806, and then no more until 1811 (*Scarborough Town and Castle,* cat. 44). Having achieved his ambition of becoming a full Academician in 1802, Turner soon afterwards began to turn away from the Academy, pursuing a variety of new ways of generating interest in his work. Foremost among these was the opening of his own gallery on Harley Street, which from 1804 gave him the chance to show his works more sympathetically, and in greater quantity. The visionary image of the *Fall of the Reichenbach* (cat. 18) is one of two impressive large-scale drawings that were probably among the first exhibits there in 1804, but reviews generally give little information about what was displayed.

The only other works on paper that can with any certainty be identified as having been shown in Turner's gallery during these years is a group of 50 sepia drawings relating to the mezzotints known as the *Liber Studiorum*. These are mentioned in a long appreciation of Turner's work by John Landseer that appeared in the *Review of Publications of Art* in 1808.[16] Although Turner's pictures had already been engraved for serial publications, this was the first substantial project to be shaped and closely overseen by the artist himself. Yet, despite Turner's awareness of the need to generate publicity for this venture, there seem to have been problems in getting any form of regular coverage when parts were issued.[17] This is all the more extraordinary in that it occurred at a time when interest in engraving and draughtsmanship was growing as a consequence of the founding of the Society of Painters in Water Colours in 1804.

After a break of five years Turner resumed his practice of exhibiting watercolours at the Royal Academy in 1811 with a group of five works. As well as the justly acclaimed view of Scarborough (cat. 44), this group included two genre subjects, a collaboration with Sawrey Gilpin and, most significantly, a historical subject entitled *Chryses* (fig. 19). Such Classical subjects had been undertaken in watercolours by Richard Westall and members of Girtin's Sketching Society many years earlier, but Turner had seldom sought to challenge so overtly the accepted view of watercolour as most fitted to factual topography. Writing in the *Examiner*, Robert Hunt was particularly warm in his praise for this work, claiming that (among other things) 'the depth and clearness of the shadows, the brilliancy of the lights, and above all, the poetic character of the whole, rank this performance with the most celebrated paintings of landscape'.[18]

In the meantime, Turner had also begun to produce his topographical series 'Picturesque Views on the Southern Coast of England' (cats. 23, 26, 27), which from 1814 was regularly reviewed in the press.[19] Inevitably, in such pieces, critics tended to confine themselves to the engravings based on the watercolours, as neither they, nor the public, had the opportunity of seeing the originals, which were sold after the engravers had finished with them. Nonetheless,

the persistent recommendation of Turner's engraved work made an important contribution to his increasingly unquestioned status as the key figure in English watercolour painting. Ironically, between 1810 and 1818 only ten of his watercolours were exhibited at the Royal Academy, where, if they were discussed at all, they seem to have received a politely favourable response. The latest of these, the *Landscape: Composition of Tivoli* (cat. 68), for example, was welcomed by the *Literary Gazette* as 'one of Mr Turner's most delightful drawings'.[20]

THE 1819 EXHIBITION AT 45 GROSVENOR PLACE

The idea of Turner as the presiding genius of the English watercolour school was in effect crowned in 1819 with an exhibition at the London home of Walter Fawkes (1769–1825). Since buying his first work by Turner, sometime around 1804, Fawkes had become a close friend, and by this date owned the most complete survey of the artist's best finished drawings, covering the period from Turner's first Continental tour to the present. Much of his collection had been specially commissioned and had not previously been exhibited in public (cats. 18, 21, 43, 44, 47, 48 and 49). Forty of these watercolours were shown in the East Drawing-Room at 45 Grosvenor Place (fig. 20), where their impact was set off by two further rooms filled with drawings by contemporaries, such as John Glover, Joshua Cristall, John Varley, David Cox, Samuel Prout, Peter De Wint, Copley Fielding and the talented amateur Edward Swinburne. The range of material on display was also significantly extended by the inclusion of a group of twenty bodycolour sketches of views made at Fawkes's Farnley Hall estate in Wharfedale, Yorkshire, which were shown in the smaller Bow Drawing-Room (cats. 45 and 46).[21]

The event, lasting from 13 April to mid-June, received much press coverage, but although it was very well attended, access was in some ways more limited than at the Royal Academy. Visitors could see the collection on Fridays only, and had to obtain a free ticket in advance. Another restriction stipulated that they would be admitted only if the weather was not 'dirty or wet' – something that, when two wet Fridays had prevented access to the display, caused one critic to fear that foreign visitors would 'think there is some truth in the oft-repeated assertion that our variable atmosphere and frequent bad weather have in fact considerable effect upon British Taste and National Genius'.[22]

This was the post-Waterloo period, when the swagger of national pride was at its fullest, and it is not difficult to discern this kind of spirited patriotism as an underlying factor in the wholesale celebration of Turner's works. The *Sun*, for example, adopting a bullish stance its later namesake might be proud of, noted that the exhibition was 'the work of British Artists, and it therefore constitutes a delightful repast for Patriotism as well as Taste'.[23] But the chief satisfaction for such viewers was their perception that watercolour was a uniquely English (not British) art form. The *British Press* was not alone in insisting that 'Foreign artists are either comparatively unacquainted with, or, indifferent to this branch of Art, they affect an ignorance of its capabilities'.[24] Similar views were aired by the critic of the *London Chronicle*, who was pleased to note that Fawkes's home was furnished according to the 'solid and pure taste of England', and who saw Turner (then still Professor of Perspective at the Royal Academy) as the epitome of the national school: 'no man has ever thrown such masses of colour upon paper … The art itself is *par excellence* English, no continental pencil [i.e. brush] can come near the force, freedom, and nature of our professor's.'[25] Even more ardent in its praise was the *Champion*, which believed the exhibition vindicated Turner's art completely: 'For design, for colouring, for strength of conception, for depth of feeling and felicity of execution – for originality, truth and variety, it places him, indisputably *in this department of the art*, at the head of all English (and in saying so we necessarily include all living) artists.'[26]

Elsewhere, the *Repository of Art* articulated the idea that although it was more accurate to see Paul Sandby as the father of watercolour painting in England, Turner had been the one to give it life: 'Turner has surpassed them all in the variety and extent of his powers, in his knowledge of character, of chiaroscuro, perspective and colour … His poetical feeling in his oil pictures would

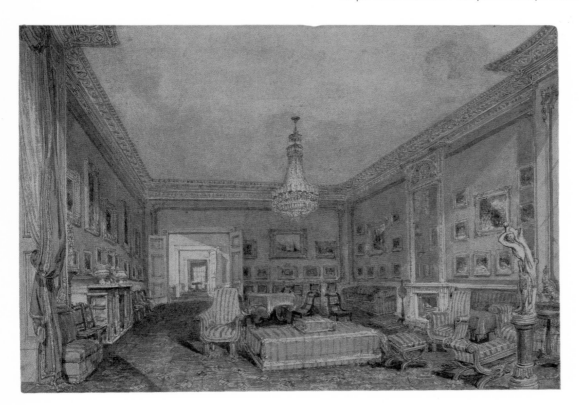

Fig. 20
**The East Drawing-Room
of Walter Fawkes's Home at
45 Grosvenor Place, Showing
the Exhibition of Turner's
Watercolours in 1819**
1819

Watercolour and bodycolour
15.5 × 21.8 cm

Private collection

sufficiently establish his fame, but his water-coloured drawings excite continual surprise, for the admirable truth and nature which pervade them.'[27]

In its strikingly quizzical review, the *British Freeholder* also considered the differences between Turner's work in the two different media, beginning its remarks with the common apprehension that the watercolours were equal in power to the oil paintings: 'The vehicle in which they are executed is only thought on with wonder at its astonishing effect in the hands of this astonishing magician.' As was the case for other contemporary critics, however, this writer clearly had increasing reservations about the effects Turner produced in oils. He refers to them as '*experimental and gaudy flimsies*', or the 'intoxicated freaks of a giant', which he fears may have a corrupting influence on students. It is perhaps most interesting that the review ends with a possibly ironic rhetorical inflection that insists (perhaps too keenly) that criticisms such as these surely 'cannot shake the proud fabric of [Turner's] fame, or start a question of his pre-eminent powers'.[28]

Another observation made by this critic was that 'in aiming at a noble breadth and freedom', Turner was 'sometimes too copious in his omission of details, and too vague in his penciling [*sic*] for particular character'. This point develops William Hazlitt's famous remark, published in the *Examiner* three years earlier: 'Some one said of [Turner's] landscapes that they were *pictures of nothing, and very like*.'[29] Such comments seem to the modern viewer strangely inappropriate for the elaborately finished pictures they castigate, while at the same time accurately anticipating the direction Turner's art would pursue in later years.

Faced with such a complete survey of Turner's draughtsmanship, almost every review drew its reader's attention to the spectacular group of Alpine scenes (cats. 18 and 21). The *Literary Gazette* wrote: 'By the magic of this pencil, we are brought into regions of such bold and romantic magnificence, and introduced to effects of such rare and awful grandeur, that criticism, were it fit for such a place, is baffled.'[30] On a less sublime note, the 'breadth, force and light' of the view of Scarborough was pronounced 'pleasing and agreeable' (cat. 44),[31] and the pair of dramatic shipping subjects also attracted much admiration (cats. 47 and 48). The critic of the *Examiner* used *First-Rate, taking in stores* (cat. 47) to demonstrate how Turner succeeded where others failed in bringing a sense of vastness to his views: 'he has painted only the hulk or body of that great object. This has afforded him the comparative size of the vessels, – the mast of the sloop reaching scarcely as high as the gunwale of the ship, – shews with due effect the stupendous dimensions of the main part of a man of war.'[32]

There was also considerable interest in the bodycolour views of the environs of Farnley Hall (cats. 45 and 46), because informal works, such as these 'vigorous Sketches', were not usually included in public exhibitions.[33] While welcoming the chance to see them, the *Repository of Art* believed that they were unlikely to be understood except by other artists, who might prefer them to the more finished works shown nearby. Nevertheless, the critic was inclined to endorse them as 'the best examples we have seen of the unrivalled powers of this artist in landscape views'.[34] In its pages, the *Literary Gazette* insisted also on the need for a different aesthetic in evaluating such

works by noting that 'the sketches of a master possess more charms than the laboured results; and to all men of taste they afford grounds for the imagination to fill up, as fancy willeth, every vacant space and unfinished outline'.[35]

Though Turner later managed to persuade Ruskin that he was largely indifferent to the opinions of the press, it seems unlikely that he could have ignored this surge of approval in 1819. Even had he managed to sidestep the journals at first-hand, he would eventually have been aware of extracts from these reviews, because they were included by Fawkes in a special catalogue, with a personal dedication, that was collated once the exhibition had closed.

EXHIBITIONS ORGANISED BY W. B. COOKE, 1821–24

The exhibition of Fawkes's collection had been something of a novelty, making available some of Turner's finest drawings at a time when there was tremendous curiosity about, but apparently very little recent experience of, his work in this medium by the public. In view of this, it is surprising that it took W. B. Cooke, the engraver-publisher most involved in the dissemination of Turner's work through high quality reproductions, a couple of years to capitalise on this interest. It is possible that he had made Turner's designs for the engravings available at his showroom throughout the 1810s, but records of proper exhibitions, including the original watercolours as well as the prints, survive only from 1822 to 1824. These ensured that the pinnacle to which Turner's reputation had been raised was sustained well into the 1820s.

In 1821 the first of Cooke's displays at his newly refurbished premises in Soho Square (fig. 21) was made up entirely of prints, and included many of the latest subjects from the 'Southern Coast' series. More successful, at least in terms of the number of reviews it generated, was the exhibition of 1822, which announced in its accompanying literature that it intended to present 'a connected view of the Progress of the Art of Drawing in this Country, from the time of Paul Sandby to the present day'. Though only 24 of the 300 works were by Turner, the reviews tended to reserve special attention for his watercolours. Most of these were the small, intensely coloured views for the 'Southern Coast' project, but the display also included items painted in the 1790s (w 96 and 134), two drawings of Vesuvius (w 698 and 699), a view of Cologne (w 690), and the large, stomach-turning depiction of *Hastings from the Sea* (w 504; this is the large watercolour on the left in fig. 23).

As in the Fawkes exhibition, the effect of including Turner's watercolours alongside examples by earlier artists and those of his contemporaries had the effect of suggesting that Turner represented a point of progress to which all else had been leading. This was the opinion of the *Gazette of Fashion and Magazine of the Fine Arts*, which reported that Turner's works 'form an epoch in the history of this branch of the art'.[36]

Back in 1819 the *Literary Gazette* had questioned the extent to which the 'exalted style' of Turner's watercolours was an accurate reflection of the subjects they depicted.[37] Three years later, similar demands for a more faithful presentation of nature came increasingly to the fore, as is plain among the comments of the otherwise favourable review in the *Englishman*: 'The fault we find with Mr. Turner in general, is, that he presents to us colours and not colouring, that he gives us the pure and brilliant contents of his palette, but forgets to veil them in that harmoniousness of tint, which, we uniformly find, even in the brightest scenes of Nature.'[38]

In 1823 the *Literary Chronicle* took this theme up once again in its review of the current display at Cooke's gallery. Its critic was prepared to admit that though the nine drawings then on display (of which three were early works) generally possessed merit, 'there is an extravagance in the colouring not always to be discovered in the general appearances of nature'.[39] The emerging pattern of this kind of response indicates that the critical concerns that had been volubly growing about the colouring of Turner's oil paintings had begun to spill over and affect reactions to his watercolours. In particular, his preference for yellow was an increasing critical preoccupation. In drawing attention to this characteristic the critic of the *London Magazine* also showed that he recognised Turner's higher aims: 'He is the artist, beyond all others, who throws over the

Fig. 21
9 Soho Square
1838

Engraving
11.5 × 8.6 cm

Guildhall Library

Formerly W. B. Cooke's Gallery, where Turner's watercolours were regularly exhibited between 1822 and 1824

atmosphere finely imagined and poetic colours. He is not real, perhaps, always; but he is a fine idealist, like Milton. We see his landscapes through a golden haze, as the traveller looks on the Pontine marshes at sunset.'[40] Another appreciative response appeared in the *Examiner*: 'Connected, blended, and sometimes delicately contrasted as these colours are, resembling the sweet melody of soft music, his effects are exquisitely tender, but not without sufficient force, from a certain magic arrangement, a graphic secret of his own; or rather from a correct and highly wrought sensibility.'[40]

Other reviews of the 1823 exhibition focused on the drawings themselves, and on two works in particular: *Dover Castle* (cat. 56) and the *Rainbow [on the Rhine]* (cat. 40). The former was hung as the centrepiece of the display, but few critics were entirely happy with what Turner had achieved. The *Literary Gazette* ranked it 'among the vagaries of a powerful genius, rather than among the representations of nature', and in its columns the *Morning Chronicle* considered it 'a view spiritedly drawn, rich in the details, but in the general effect feeble, and with some tawdry and affected colouring, particularly on the sea'.[42] Another critic felt that, 'There is something in the effect of it, which reminds us too immediately and strongly of tapestry'. Having made this point he continued his analogy, while seeming to concede that 'It is nevertheless a gorgeous and splendid assemblage of rich colour, managed with consummate skill, and although constantly approaching, never passing that line, beyond which all is meretricious glare and gaudiness'.[43] In his review in the *Examiner*, Robert Hunt offered what he considered to be deferential advice on the faults in the drawing: 'The principle and practice are beautiful, and feed and satisfy the hungry imagination, but almost to repletion and satiety … for were the number of shapes diminished in the sky, so as to render it less disturbed, the requisite bustle throughout the other parts … would be heightened in character.'[44]

By contrast, the Rhine scene (cat. 40) fared much better, although it has to be admitted that, because this work is essentially a repetition of a drawing Turner had originally painted in 1817, it is more conservative in tone than some of his most recent productions. This skilful fusion of Turner's new and older styles certainly pleased the *European Magazine*, which remarked that the drawing was 'exquisitely finished; but retains all that breadth and that daring juxta-position of cold and warm hues for which Mr. Turner is so celebrated'. The *Courier*, however, was not convinced by Turner's delineation of the rainbow in which it felt the colouring was 'too much out of keeping with the whole performance', arising from Turner's decision to make white 'the predominant colour in those parts where there ought to be a vivid and varied admixture'. For its part, the *British Press* quipped that the well-known, romantic scenery bordering the river was in reality 'scarcely more beautiful than TURNER's imitation'.[45]

If these detailed comments perhaps suggest a slight falling off in the general warmth towards Turner's productions, they should be seen against the broader overview of comments such as that in *British Press*, which described Turner's drawings as 'the principal ornaments' of the Cooke exhibition, and an achievement in which the nation ought to, and did feel tremendous pride.[46]

Whatever gains Turner had made for the appreciation of watercolour as an independent art were nonetheless thrown into relief in a couple of the reviews that year, which persisted in seeing the medium as of only secondary importance beside the force and scale of oil painting. The metaphor both critics used was a feminine one of undress, suggesting incompletion and a lack of finesse, even though the works under consideration were fully developed watercolour conceptions.[47]

Interest in the display at Cooke's gallery was revived in June 1823 by the arrival of two additional works: *A Storm (Shipwreck)* (fig. 9), and its companion scene of *Calm* (cat. 57). Once again, it fell to the *Examiner* to expound the beauties of the latter work:

Mr TURNER has attempted, we believe more successfully than any painter before him, to produce a delightful effect with scarcely anything but colour – an effect of exquisite light, and of what is transparent and untransparent in colour, without offending the eye tutored to the harmonies of colour and light. The boats floating at distance, and most of the objects, appear so beautiful in the still radiance, as to fill our minds with moral, physical, and imaginative analogies.[48]

A further group of seventeen drawings, again a mixture of the new and the old (including, in many cases, drawings borrowed back from the current owners), was shown at Cooke's rooms in 1824. One of the most recent works was a twilight scene off Folkestone (w 509), with a boat full of smugglers retrieving their smuggled cache of gin. The prominence of this foreground activity caused critics to offer their now standard lamentations about Turner's inability to draw figures convincingly. Only the *Examiner* was prepared to allow that 'though Mr TURNER draws figures badly, he manages, in spite of this drawback, to give them very expressive action'.[49]

Many of the drawings in the display were actually quite small, measuring approximately 14 by 21 cm (5½ × 8"), such as *Lake Nemi* from the set of designs produced to illustrate Hakewill's *Italy* (cat. 51), or those displayed from the 'Southern Coast' series. Yet the powerful effects introduced in these works made the reviewer of the *Somerset House Gazette* 'forget that the dimensions of these fine compositions are bordered by the narrow limits of a few inches'.[50]

Turner was sufficiently close to Cooke at this point in the 1820s for us to feel that he was directly involved in discussions about which of his drawings were to be included in this group of exhibitions. But it was also during this decade that the acclaim he was enjoying meant that he was no longer able to exert complete editorial control about how and where his works were presented. Exhibition organisers seeking works to include in the shows at the principal regional cities frequently sought them from private collections, rather than from Turner himself.[51] One example is the watercolour of Tivoli he had sent to the Royal Academy exhibition of 1818 (cat. 68), which appeared in a loan exhibition at the Society of Painters in Water Colours in 1823. By way of a response, Turner seems to have submitted its companion piece, a scene of archly English classicism, to the Academy show of 1825 (*Rise of the River Stour at Stourhead,* cat. 70). Critics can be wilfully perverse, for this was very much an idealised composition, derived in every sense from Claude Lorrain's poetic fantasies. Nevertheless, the *Literary Gazette* praised this drawing as expressive of Turner's 'power of sweetness – nature, without being overlaid with the embellishments of art'.[52]

During the 1820s W. B. Cooke also acted as the entrepreneur for the two topographical series of mezzotint views of the 'Rivers of England' and 'Ports of England' (cats. 55, 59 and 60). Like the 'Southern Coast', these prints had the advantage of bringing Turner's name to an increasing audience, but it can be argued that they also contributed to the perception that there was something problematic about Turner's use of colour. Seen in isolation, the prints offered the viewer a black-and–white translation of the original design that allowed the imagination the freedom to augment the finely realised chiaroscuro of the print with its own colours. The reaction to this disjunction is neatly expressed by the *Literary Gazette* in its review of an instalment of the 'Rivers of England': 'The pencil of Mr Turner appears to infinite advantage, simply rendered in black and white, divested of the meretricious display of colours that to our plain view of things do not seem to belong to any or at least to very few of the objects of nature that have met our eye in a general way.'[53] Yet this same critic was usually impressed with the images themselves, as is plain from his comments about the view of Portsmouth in the 'Ports of England' set (cat. 60), which he considered a fine representation of 'one of the noblest sights in the world'.[54]

THE MARKETING OF 'ENGLAND AND WALES'

As we have seen, Turner's decision to exhibit fewer new watercolours after the mid-1820s was largely a result of his increasing involvement with engraving projects. The most ambitious of these, entitled 'Picturesque Views in England and Wales', got under way in 1825. Four years later at least five parts of the publication had been issued, and its publisher, Charles Heath, was keen to generate further interest in the project. To this end, he hired the Egyptian Hall on Piccadilly (fig. 22) – a venue that had presented every kind of popular sideshow, as well as Géricault's *Raft of the Medusa* in 1820 – and placed on view probably 38 of the watercolours from the series between early June and mid-July. Included among this group were catalogue numbers 63, 87–90, 92 and 93.

News of this event seems to have prompted an attack of spleen by the frustrated history painter Benjamin Robert Haydon (1786–1846), who watched indignantly as landscape painting continued to enjoy acclaim at the expense of his own more elevated type of subject. (This bitterness was no doubt compounded by the failure of his own exhibition at the Egyptian Hall some years earlier.) Just as the display was about to open, he wrote tartly in his diary: 'Turner was originally a Water Colour Painter, and this mis-fortune sticks to him & will stick to him through Life. No Water Colour Painter can manage oil Colours – or ever gets rid of the washy meagreness of their early habits … If the Academicians think they deceive by their heroic defence of Turner's insanities, they are mistaken.'[55]

But the extremity of Haydon's protest was still an exception, even if (as he suggests) there were mumblings of disquiet from others about Turner's recent paintings. By contrast, the printed notices about the exhibition at the Egyptian Hall offered a largely unanimous opinion that this was a rare feast for art-lovers to enjoy. The information presented in these notices is so consistent that one suspects Heath may have issued an official statement, but such 'puffing' devices were not new (as is evident in Sheridan's play *The Critic* of 1779). A comment in the *Examiner* is, however, worth recording here, as it possibly marks a shift in attitudes to the purpose

of Turner's watercolours. The reviewer is generous in discussing the merits of the majority of the exhibited works, but begins his comments with the remarkably inaccurate observation that these 'are by no means finished drawings'. He develops this point by stating that 'they are extremely picturesque, and well adapted for the object in view, – that of being engraved'.[56] It seems that some viewers quashed their reservations about the vivid nature of Turner's watercolours by seeing them as part of the process of producing a finished engraving, though this detracted from an evaluation of the drawings as independent works of art.

The last of Turner's watercolour exhibits at the Royal Academy appeared there in 1830 (*The Funeral of Sir Thomas Lawrence*, cat. 71). This was in effect a modern history painting, executed in watercolours, and was self-evidently a deeply felt tribute to the recently deceased President of the Academy. This fact may have deterred critics from seizing the rich opportunity the drawing provided for making capital at Turner's awkwardness in his depiction of the human figure. In their reviews of the contemporary 'England and Wales' series, even sympathetic commentators admitted that some of the figures seemed to have been modelled from 'Rag Fair dolls' rather than real people.[57]

Other informal opportunities to see watercolours from the 'England and Wales' series seem to have occurred from time to time during the first years of the 1830s, occasioned as much by the pride of the owners of the works, as by the marketing instincts of the publishers. At the Artists and Amateurs Conversazione in January 1831, for example, a small group of the drawings was displayed as part of an evening's entertainment, while towards the end of 1832 two collectors apparently brought their prized 'England and Wales' drawings together in a display for public delectation that was featured in the *Spectator*.[58] Like Robert Hunt before him in the *Examiner*, this unnamed critic was an appreciative and thoughtful observer of Turner's drawings. He believed that seeing a large group of them together tended to work to their favour, and he was also sensitive to

how the drawings should be framed. Like many of his colleagues, he referred to these works as 'gems' that required an appropriate setting. In this review of November 1832 he attempted to scotch some of the accepted ideas about Turner's pictures: 'It is a vulgar error to suppose that TURNER exaggerates in his water-colour drawings: and even his landscapes painted in oil are overcharged only when viewed in detail. The general effect is true to nature – nature in her brightest looks, radiant with sunny smiles, and clothed in her most gorgeous robe.' As far as the complaints about colour were concerned, he protested that 'what struck us as most remarkable in the majority of TURNER's drawings, was their chasteness of colour … His outlines, his shadows, are colour – as it is in nature; for shade is the neutralization of colour, not its negation.' There is the suggestion that one of the works he had seen was the view of Alnwick Castle (cat. 92), for he then gives an evocative account of Turner's realisation of moonlight.

This critic was also on hand a few months later in June 1833, at the time of an exhibition in the Pall Mall gallery of the publishers Moon, Boys and Graves (fig. 24). This consortium had taken the 'England and Wales' project off Heath's rather overstretched books, and, in an attempt to promote their new acquisition, organised the most comprehensive show of this series ever put before the public.[59] Sixty-six drawings from the 'England and Wales' views were included in the display (cats. 87–96), as well as twelve of the smaller designs produced for the new edition of Sir Walter Scott's *Poetical Works* (see, for example, cat. 78). While the *Observer* disliked the effect of seeing so many drawings by Turner together, exclaiming in its pages, 'Hot! hot! hot!', the *Spectator*'s critic once again gave the event extensive, and very considered, coverage.[60] Among many points of interest is the revision of this critic's attitude towards Turner's oil paintings, which leads him to agree with the multitude that in these, Turner's 'eye is intoxicated with colour, and he revels Bacchus-like in its intensity'. In contrast, he felt that Turner's watercolours needed no apologist: 'When he sets about painting a real scene, he is sure to include in the picture so much of its peculiar beauty – so many little bits of nature, gleaned here and there, introducing some accidental effect, rare perhaps, though true – that the observer of nature recognizes with delight some appearance that he himself remarked; and the locality instantly becomes invested with an interest far beyond what a mere dry though more literal transcript would possess.' Though Turner was indeed guilty of exaggerations, the critic believed, 'these tricks of art are exercised poetically, and give that grandeur to the scene which perhaps it wore in the painter's eye … As we said before, these are poetical views of real scenes'.

Other journals and newspapers were similarly celebratory about this exhibition, listing the individual merits of the drawings, amongst which the novelty of the moonlit *Alnwick Castle* (cat. 92) again attracted special comment. The *Atlas* viewed it as a 'magnificent specimen of the artist's extraordinary ability to grapple with the most swelling subject', and concluded its coverage with the following remarks: 'We urge those who love to see good drawings, or desire to be pressed into purchasing good engravings, not to fail in making their appearance at 6, Pall-mall. They will not be disappointed.'[61]

PAINTING AND POETRY IN THE 1830s

The designs that Turner produced to illustrate volumes of poetry by some of his most celebrated contemporaries – Sir Walter Scott, Samuel Rogers, Thomas Moore, Thomas Campbell and Lord Byron – served to enhance and sustain his reputation throughout the 1830s and beyond (cats. 50 and 73–80). These were the editions that impressed the young Ruskin and many others of his generation, and which endured in their affections at a time when they felt bewildered by the extravagance of Turner's full-scale productions in oils.

Against this background, it is interesting to note that Turner himself was celebrated in a poem, published in the *Literary Gazette* just a couple of months after the exhibition at Moon, Boys and Graves closed. This piece, annotated with the initials 'J.A.B.', takes the form of five stanzas, the first four of which sing Turner's praises for his realisation of the effects of morning, noon, evening and night. The fifth is as follows:

But chiefly thy spirit
Shines out wild and bright;
When storms have unfolded
Their banners of night;
When mountains are severed,
And forests are shivered,
And lightnings are shaking
Their ribands of light –
Thy spirit is there,
And earth, sea, and air,
Rejoicing under thy pencil's might.[62]

Doggerel this may be, but it indicates the high esteem in which Turner was held in the wake of the publication of the volumes of Rogers and Byron decorated with his work.[63] Ironically, Scott at first resisted his publisher's suggestion that the new edition of his collected works should be illustrated by Turner, but was forced to relent when Robert Cadell told him, 'With his pencil, I shall insure the subscription of 8,000, without, not 3,000'.[64]

These more modest productions of Turner's were perfectly tailored to the requirements of the keepsake or pocket-book industry, and critics were quick to recognise that they were among the finest of the genre. The *Literary Gazette*, in its note on the latest part of the Byron series, sums up the reaction: 'This great artist, unlike the minors of the race, finds time for everything; and amidst the … all-engrossing demands of his more serious avocations, contrives to throw out, without difficulty, such little gems as these – as worthy, to be sure, as any things can be of his high genius – by the dozen; just as Byron himself jotted down carelessly in *diaries* thoughts which would have made the fortune of any ordinary poet.'[65] Criticism was almost always positive to these sets of prints, and sometimes ecstatically so, whether this was for the miniature landscapes designed for the Scott series (cat. 78), the powerful compressions of French scenery for the three volumes of Turner's own *Annual Tour* (cats. 64–7) or the reworkings of other draughtsmen's preliminary outlines for volumes focusing on India, or the landscapes of the Bible (cats. 81–3, 198 and 203).[66]

However, the tide of popularity seems to have begun to turn against Turner at this point for the very reason implied in the comments of the *Literary Gazette* above – his prolific output. Given his involvement in so many projects, engravings based on his drawings were suddenly to be found everywhere, effectively flooding the market and cheapening his reputation. Rival publishers contributed to this effect by producing their own versions of some of his images (which Turner was quick to denounce), while across the Channel his designs were beginning to be regularly plagiarised.[67]

Unfortunately, the relentless competition from the range of publications for which Turner created designs meant that the real merits of some of these were eclipsed. He and his publishers also had to contend with the appeal of rival works by traveller-artists, such as David Roberts and John Frederick Lewis, whose more exotic views of Spain and the Near East began to appear on the market in the mid-1830s. Something of all this is evident in a review of the second volume of *Turner's Annual Tour* at the end of 1834, when the *Literary Gazette* valiantly attempted to refresh public interest. It reported: 'The days are gone when [the injunction] "Try Turner" decorated the walls of every suburb of this vast metropolis. It is an exhortation, however, which we would address to those of our readers (and we know the class to be numerous) who are lovers of the fine arts; – "Try Turner!"'[68]

This summary of the 1830s inevitably blurs the distinction between appraisals of the watercolours themselves and the prints based on them, but it is apparent that Turner's contemporaries tended to view them as inseparably linked. Publishers made further opportunities for the public to see

Fig. 23
JOHN SCARLETT DAVIS
(1804–44)
The Library at Tottenham, the Seat of B. G. Windus, Esq., Showing His Collection of Turner Watercolours
1835

Watercolour with gum arabic
28.8 × 55.1 cm

The British Museum

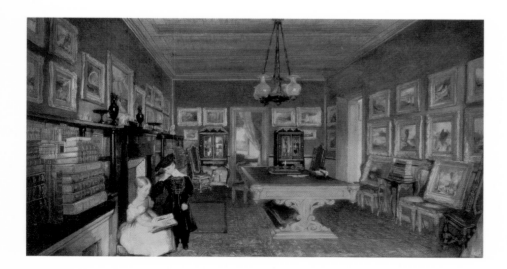

the original drawings as a means of stimulating print sales, but, for the most part, reviewers tended to focus increasingly on the final, monochrome product, rather than the source of these compositions. Evaluation of the drawings was also hindered when the long-standing objections to Turner's idiosyncratic traits became more sustained, pervading much criticism of his work. It was the sneering tone adopted by the most hostile critics that famously ignited the young John Ruskin's desire to defend his hero in 1836.

Looking back on this period from the late 1880s Ruskin was perhaps inclined to exaggerate how difficult it had been to see Turner's watercolours, attributing this to a lack of appreciation by the public. Yet, though Turner, now in his sixties, no longer exhibited new watercolours at any of the main exhibition venues, it was often possible to gain admittance to the homes of important collectors. By far the most accessible and the most extensive of these was that of B.G. Windus, at Tottenham, which was open each week (fig. 23).[69] Other important collectors, most notably the Fawkes family, were generous lenders to temporary exhibitions, such as that at Leeds in 1839, and it is possible that a full survey of the journals of the period would not indicate so clearly that the artist had lost the support of the public.

Without fuller records it is also difficult to assess the part played by Thomas Griffith, Turner's agent, in the promotion of the watercolours of the last decade. He was hardly an obscure figure, running his business from rooms in Waterloo Place, in the heart of clubland (fig. 24). Even from the entries in Ruskin's diary, this seems to have become a magnet to which admirers were drawn in pursuit of acquisitions of existing works, and it was here also that new watercolours were made available, such as the sets of Swiss drawings of the 1840s (cats. 104–110). However, in the absence of more specific information, we have to rely almost entirely on Ruskin's account of how these works were marketed, which does imply a diminished, or closed circle of active patrons.[70]

With the writings of Ruskin in the early 1840s Turner's reputation took a new course that thereafter bound the names of artist and critic together for the next generation. However, the originality of Ruskin's response lay essentially in its scope, for the particulars of his defence of Turner had in many instances been anticipated by the public debate of the preceding twenty years, not least as voiced by the *Spectator*'s critic. But it is apparent that Ruskin was not in fact Turner's only champion at this point. Even a year before the first volume of *Modern Painters* appeared, Turner was described in terms that rate him as one of the cherished Old Masters of English watercolour painting. This piece in the *Art Union*, made no apologies for its belief that it was largely due to Turner's leadership that watercolour had 'in our own time been revived with such extension of its capabilities, and such novelty in its manipulations, as to render it almost a new art'.[71] Such views revise and add something to the familiar stereotype of Turner's later career, and suggest the complexities of the responses to his works in this medium. Thus, while it is undoubtedly true that a new generation needed the books of Ruskin to elucidate the merits of these works of art, there were also clearly many who already cherished him as 'the wonder-working artist'.[72]

Fig. 24
THOMAS SHOTTER BOYS
(1803–74)
The View down Pall Mall from Waterloo Place, Looking towards Trafalgar Square
c. 1842

Pencil and watercolour, with bodycolour and gum arabic
31 × 44.5 cm

Private collection

The publisher-dealers Moon, Boys and Graves had a gallery further up Pall Mall, and from the later 1830s Turner's agent, Thomas Griffith, was based in Waterloo Place.

The Legacy of Turner's Watercolours

ANDREW WILTON

Three and a half decades after Turner's death, the Royal Academy mounted two displays of his watercolours in its Winter Exhibitions of 1886 and 1887. In an introduction to the second of these displays, W. G. Rawlinson, cataloguer of the vast corpus of prints by and after the master, summed up his view of 'England's greatest landscape painter': 'So much has been written … about Turner's art, that … it will be sufficient, without in any way detracting from the value of his pictures in oil colours, to say that, on the whole, his career can be better followed, and his aims and successes better understood, in his water-colour pictures.' Rawlinson acknowledged that oil was a 'greater' medium than watercolour, but, he maintained, it is 'inherently less suited to depict those evanescent changes on the face of Nature, which from the first Turner's genius led him to seize upon and to record … ' Furthermore,

his oil pictures … have deteriorated so seriously, sometimes from the defects of the pigments he employed, but more frequently from the extraordinary methods which he adopted in using them, that in a large number of cases they can no longer be regarded as in any true sense what he intended them to be … His water-colour pictures, on the other hand, where they have been carefully treated, and protected from undue exposure to light and damp, have preserved their original colouring absolutely intact … [1]

Rawlinson's account, accurate as it is, does not entirely explain the fact that, although Turner's standing as a painter remained consistently high during the second half of the nineteenth century, his influence on other artists was much greater among watercolourists than among painters in oil. Condition was not the sole consideration. The flamboyant sublimities of his later pictures had attracted their share of criticism, even ridicule, in an age that was moving away from the eighteenth-century idea of a 'grand style'. Thanks at least partly to the German taste of Prince Albert, during the reign of Victoria, who had been on the throne some fourteen years when Turner died in 1851, the general preference was for descriptive precision over allusive 'effect', and for intimate, domestic scale over grandiose conceptions. Heroic landscape might be admired but it was no longer to be imitated.[2] Grandeur was to be achieved by means of careful observation rather than expansive gestures. The 'second order of the middle classes, more accurately expressed by the term "bourgeoisie"',[3] as John Ruskin put it, became enthusiastic collectors of watercolours, though Ruskin criticised them for their 'mild demands', which had the effect of putting the members of the Old Water-Colour Society (founded in 1804) in 'a position much more corresponding to that of the firm of Fortnum and Mason, than to any hitherto held by a body of artists'.[4]

The new market favoured watercolour, and if watercolourists felt obliged to acquiesce in this economy, they nevertheless recognised Turner as the supreme technician. Since the beginning of the century stories had proliferated, relating how Turner 'drove the colour about', of how he 'tore, he scratched, he scrubbed … in a kind of frenzy',[5] of his layering of colour upon colour, his manipulation of the pigment with his fingers, of his use of a long thumbnail for cutting out highlights, or his advice to a pupil to put her drawing 'in a jug of water'. These fragments of hard-won gossip were collected and treasured by artists both professional and amateur. No painter contributed more to the mystique of the watercolour than Turner, and the extraordinary range of subtle effects in his views was envied and imitated by anyone who essayed the medium.

Turner's finished watercolours were collected throughout his life by dealers and connoisseurs, who made them accessible to the interested public, or at different times exhibited groups of them. The coachmaker Benjamin Godfrey Windus, for instance, built up a large collection round an exceptional series of the watercolours of the 'Picturesque Views in England and Wales'. As a journalist noted in 1852, 'Mr Turner had many patrons but it is at Mr Windus's on Tottenham Green that Turner is on his throne. There, he may be studied, understood, and admired – not in half-a-dozen or twenty instances, but in scores upon scores of choice examples.'[6] (fig. 23) Samuel Palmer cannot have been the only watercolourist who was in the habit of recommending his friends to visit the collection.[7] Palmer perpetually referred to Turner and his art in his thought and conversation. On his honeymoon in Italy in 1838, for instance, he frequently compared what he saw with Turner's pictures, recalling odd anecdotes such as that 'Turner said he did not like Subiaco'[8] or concluding that 'The plenitude of light gives a coolness of shadow and a glow

Fig. 25
SAMUEL PALMER (1805–80)
**Robinson Crusoe Guiding His Raft
into the Creek**
1850

Watercolour
52.7 × 73.4 cm

The Potteries Museum and Art
Gallery, Stoke-on-Trent

Fig. 26
SAMUEL PALMER (1805–80)
Towered Cities Please Us Then
1868

Watercolour, bodycolour, gum arabic
and scraping-out
51.1 × 70.8 cm

Amsterdam, Rijksmuseum,
Rijksprentenkabinet (1978-39)

of reflection which we have no notion of in England. No one has done it but Turner.'[9] In David Cecil's opinion, it was 'not for long' that Palmer fell under Turner's influence,[10] but it is clear from Palmer's copious letters, and from the work he produced from the late 1830s until the end of his career, that Turner remained the crucial model, both for his choice of subject matter and for the processes that he evolved for expressing himself in watercolour (figs. 25 and 26).

The complexity of those processes testifies to his admiration. Palmer's declared intention was to render the inner spiritual dimension of his relationship with landscape, to paint the 'mystery, and intricacy' of natural phenomena.[11] His early devotion to the visionary art of William Blake had fostered this determination, and he developed a panoply of elaborate procedures to achieve that: combining watercolour with layers of gum arabic and gouache in complicated sequences worked on laboriously over long periods. If he did not imitate Turner literally, he certainly derived the confidence to proceed from the master's example. As Ruskin wrote in 1853: 'You will never meet any truly great living landscape painter who will not at once frankly confess his obligations to Turner, not, observe, as having copied him, but as having been led by Turner to look in nature for what he would otherwise not have discerned, or discerning, not have dared to represent.'[12]

Turner, intentionally or not, left an invaluable practical legacy. In addition to the finished works scattered among private collectors, his life's accumulation of working drawings, notes, sketches and preparatory studies came into the possession of the nation in 1856 when a ruling of the Court of Chancery allocated all original works in his estate to the National Gallery. His will (an involved affair the precise meaning of which has been much debated) indicated that he wished only the hundred finished oil paintings in his house to go to the nation. But the will was contested by his family, and the Chancery ruling, simplifying a complicated situation, awarded Turner's realisable assets to his relations, and the works of art, without distinction of finish, to the public.[13]

The sketchbooks, almost three hundred of them, and thousands of loose leaves were kept in tin boxes in the National Gallery's basement. Ruskin, whom Turner had named as one of his executors, was appointed to put this mass of material into order. He was in any case clearly the best-qualified person for the job. Since his youth he had himself been a keen draughtsman, having such worthies as Samuel Prout and James Duffield Harding as his mentors. He had first been drawn to Turner by the gift to him as a thirteen-year-old boy of Samuel Rogers's poem *Italy*, illustrated with finely engraved vignettes after Turner's designs (see cats. 73 and 74), and among the countless drawings that he was to produce in the course of his life many would take the form of accomplished imitations of these and other examples of the master's virtuosity. His twin interests in geology and architecture made him particularly appreciative of Turner's studies of the Alps and of the ancient Swiss towns in their mountain settings, and these he frequently used as models for his own work (fig.27).

During the 1830s his interest intensified and was brought to a head by an adverse review of pictures shown by Turner at the Academy in 1836. He penned an angry rebuttal, which he sent to Turner who advised him not to publish it. Instead, the impassioned young man developed it into a lengthy book, *Modern Painters*, which appeared in five volumes between 1843 and 1860, and was a mighty paean of praise to Turner, 'the only perfect landscape painter whom the world has ever seen'.[14]

One of Ruskin's main tasks among the tin boxes in the National Gallery basement was to select drawings for exhibition, and these selections were shown at Marlborough House, at the new South Kensington (later the Victoria and Albert) Museum in Brompton, and in due course at the National Gallery itself and elsewhere. Samuel Palmer was among the many artists who hailed this development with joy. 'As soon as the Turners come,' he wrote in 1859, 'I shall be out enough you may be sure, in the direction of Brompton.'[15] He would find many supreme works of art there; but the Turner Bequest (as it came, somewhat misleadingly, to be called) was also a comprehensive lesson in the art of watercolour, for it revealed Turner's working methods stage by stage, through all the various procedures that he adopted in the course of his career.

Ruskin made it his business to recommend this wellspring of knowledge (or at least his selections from it) to all who entered the lists as artists, whether amateur or professional. His influence on the perception of Turner in the decades after his death was immense. In his pamphlet endorsing the innovations of the Pre-Raphaelite Brotherhood, published in 1851, he held up Turner as the prototype of their fidelity to nature. He embodied some of his arguments for Turner's supreme importance in the history of art into his *Lectures on Architecture and Painting, Delivered at Edinburgh in November 1853*, and incorporated much practical advice as to the copying and imitation of Turner's watercolours in *The Elements of Drawing in Three Letters to Beginners* (1855). In this popular manual he held up particular examples of Turner's art for close analysis and imitation. The later nineteenth century is littered with students' copies after Turner: some, executed by Ruskin's own pupils and protégés, such as William Ward and J.W. Bunney, are remarkable facsimiles, capturing much of the glow and shimmer of the originals; most are in varying degrees plodding paraphrases.

Fig. 27
JOHN RUSKIN (1819–1900)
A View of Baden in Switzerland
c. 1863

Pencil, watercolour and bodycolour
with pen and coloured inks
on buff paper
29.2 × 37.2 cm

Yale Center for British Art
New Haven, Conn.

A particularly interesting figure among this crowd of copyists is the American painter Thomas Moran. Moran was born in Bolton, Lancashire, in 1837 and emigrated to the United States with his family when he was still a small child. While many of the American landscape painters acknowledged some debt to Turner, Moran made his devotion a foundation stone of his career, and continued to paint pictures in a Turnerian idiom, notably Venetian subjects, well into the twentieth century (he died in 1926). These were oil paintings; among them are some of the most intelligent pastiches of Turner's mature style to have been made by any artist.[16] More relevantly to our purposes, he made a number of copies of works in the Turner Bequest, probably on his second visit to London in 1869. They are accurate transcripts of the gouache designs on blue

paper that Turner made for the 'Rivers of France' series, infused with an intensity of colour that gives them a vivid life of their own.[17]

The originals of these copies by Moran were in fact finished works, albeit on the very small scale of the 'French Rivers' designs. It was just such drawings that Ruskin singled out for study. In the famous and widely influential peroration of the first volume of *Modern Painters* he had laid down principles on which many serious-minded painters based their practice:

> making the early works of Turner their example, as his latest are to be the object of emulation, [young artists] should go to Nature in all singleness of heart, and walk with her laboriously and trustingly, having no other thoughts but how best to penetrate her meaning, and remember her instruction; rejecting nothing, selecting nothing, and scorning nothing; believing all things to be right and good, and rejoicing always in the truth. Then, when their memories are stored, and their imaginations fed, and their hands firm, let them take up the scarlet and the gold, give the reins to their fancy and show us what their heads are made of.[18]

Ruskin went into considerable detail in providing his recipe for the landscape artist. His leading precept is a clear statement of his principal concern: 'Let then every picture be painted with earnest intention of impressing on the spectator some elevated emotion, and exhibiting to him

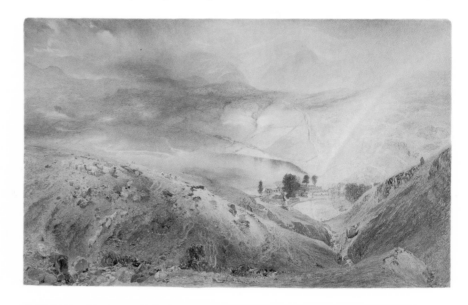

Fig. 28
ALFRED WILLIAM HUNT
(1830–96)
The Tarn of Watendlath between Derwentwater and Thirlmere
1858

Watercolour and bodycolour
with scraping–out
32.2 × 49.2 cm

British Museum, Department of
Prints and Drawings (1969-9-20-1)

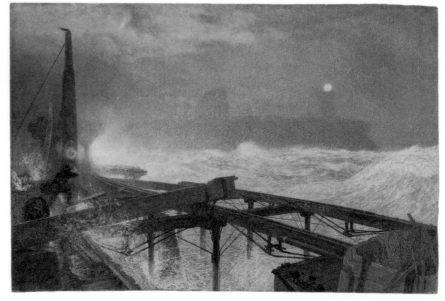

Fig. 29
ALFRED WILLIAM HUNT
(1830–96)
**Blue Lights, Tynemouth Pier –
Lighting the Lamps at Sundown**
1868

Watercolour, bodycolour, gum and
scraping-out
36.2 × 52.7 cm

Yale Center for British Art,
New Haven, Conn. (B1980.3)

some one particular, but exalted, beauty.' He elaborates: 'Let a real subject be carefully selected, in itself suggestive of, and replete with, this feeling and beauty.' Light, colour, sky and foreground details must be chosen to 'harmonise' with these, and studied carefully from nature, or, in the case of skies, painted from recollection of a particular effect.

Finally, when his picture is thus perfectly realised, in all its parts, let him dash as much of it out as he likes; throw, if he will, mist round it, darkness, or dazzling and confused light, whatever, in fact, impetuous feeling or vigorous imagination may dictate or desire. The forms … will come out … with an impressive truth which the uncertainty in which they are veiled will enhance rather than diminish; and the imagination, strengthened by discipline and fed with truth, will achieve the utmost of creation that is possible to finite mind.[19]

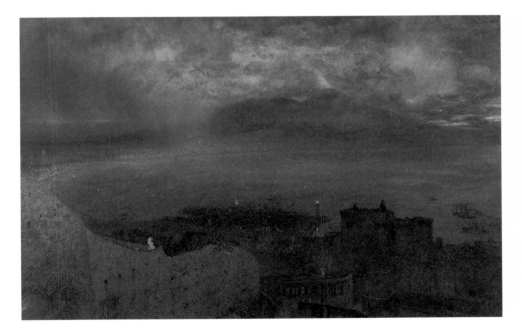

Ruskin, then, did not deny the need for grandeur and 'vision' in landscape, despite his earnest assertion that 'I have never praised Turner highly for any other cause than that he *gave facts* more delicately, or Pre-Raphaelitically, than other men' and that 'nobody was so certain, so *un*-visionary'.[20] It was precisely the visionary quality in Turner that had attracted Palmer. Just such a fusion of minute observation and sublime feeling was the object of the watercolourists who took Ruskin's injunctions most closely to heart.

An artist who exemplifies this generation is Alfred William Hunt, the son of a Liverpool artist who had been an associate of David Cox. In the course of the 1850s, while he was preparing at Oxford for an academic career, Hunt evolved from a follower of Cox into a 'Ruskinian' painter, a Pre-Raphaelite in essentials. A bird's-eye view of the *Tarn of Watendlath* (fig. 28) in the British Museum shows him, in 1858, experimenting with broad atmospheric effects executed with fine, precise brushwork, a quintessentially Ruskinian blend of Pre-Raphaelite exactitude with Turnerian grandeur. By about 1860 Hunt had decided to abandon the academic life to become a full-time painter. Much of his work records the scenery of the north-east of England, and he often painted Durham, the valleys of North Yorkshire, or the Yorkshire coastal town of Whitby, which, clustered at the foot of its high cliffs, afforded him plenty of scope for dramatic compositions of a type that Turner had favoured in his views of Fribourg and Geneva – views that Ruskin especially admired and had included in his selections from the Turner Bequest.

Hunt's viewpoints are often, like Turner's, high and commanding, and his willingness to emphasise the clutter of a busy foreground, as in some of his views over Whitby or Naples, seems to draw its authority from Turner. He loved to depict rooftops glowing in sunset light. There is a diversity of means, an interest in the texture of the medium, that is absent from true Pre-Raphaelite painting. The concern with medium went hand in hand with his developing love of subtle atmospheric effects. Like Palmer, he evolved a flexible and experimental technique; according to his daughter Violet, Hunt's creative processes were 'murderous. He sponged [Whatman's Imperial paper] into submission; he scraped it into rawness and a fresh state of smarting receptivity'.[21] He became a specialist in rendering the diffusion of dim light through early mist or dusk, suffusing his subjects with a subdued glow, or dissolving them in a grey haze. There is often the suggestion of a brilliant radiance about to break through, the promise of light amidst crepuscular gloom (fig. 30). Hunt loved the ambiguities of sea-spray, and was eager to pit himself against the example of Turner as a painter of rough seas. *Blue Lights, Tynemouth Pier – Lighting the Lamps at Sundown* (fig. 29), dated 1868, but probably exhibited at the Old Water-Colour Society in 1866, two years after he had been elected a full member, dramatises the idea of a

saving light piercing the darkness of nature. It is a *tour de force* in which all the Turnerian tricks, and many of his own, are pressed into service. The composition, with its cinematic viewpoint among the beams and girders of the half-constructed pier, is one that could never have been conceived by Turner, and yet without Turner the work would itself have been inconceivable.

The emphasis on complex, even tormented, process betrays the Turnerian inheritance even of artists whose work borrowed little from Turner in terms of subject matter. The 'Idyllists', who had begun their careers as designers of illustrations for magazines, made watercolours that reflect the narrative and genre origins of their art, but in their domestic scenes set in lush farming country or in the courtyards of warm-stoned West Country manor houses they sought a density of texture and an intensity of feeling that can, once again, be traced to the visionary sentiment of Palmer, through the intermediary influence of a Pre-Raphaelite watercolourist such as George Price Boyce. Fred Walker, George Pinwell and John William North all used technical devices of considerable complexity. In a long encomium of North for the *Magazine of Art* in 1893 Hubert von Herkomer frequently invokes Turner:

Mr North strikes a note that is out of harmony with the noise of modern fashion in art … Wait until the noise of the mechanical, commercial art has subsided, and Mr North's art will stand forth like a revelation, like a gospel of tenderness, truth, and even of love. Thousands may not believe in the tenderness, or in the truth, and fail to see the love of nature that he inspires through his work; but one man in the thousand may see it all, and he will be the gainer. Was not Turner accused of painting colours that nobody else saw in nature? … Mr North is a seer, privileged by his natural gifts to open out a secret view of nature, and this is the mission of the poet … [22]

North outlived the others by some decades, and was attracted to bleak, wan winter afternoons as much as to summer green. His soft landscapes, usually seen in a somewhat flat light (even when they record his experience of North Africa), have a muffled quality that seems to reflect a more world-weary appreciation of the fertile beauties of nature than Palmer's (fig. 31). To express this *fin-de-siècle* disillusion he seems to have needed to attack his paper as though it was to blame for the world's wrongs. He went so far as to develop a new type of 'O.W.S.' paper, extremely tough and made from pure linen, that would tolerate his obsessive working. 'The almost indestructible surface was ideal for his elaborate technique, by which his work was very much wrought with a sharp knife and submitted to all kinds of processes, such as re-sizing and burnishing, and even the fine linen in its metamorphosis often suffered again the ordeal of the box-iron!'[23] North's repeated sizing, scraping and resizing, his washing layers of gouache over layers of watercolour, appear as punitive rather than loving acts, though the close of the century's decadent mood may have made it possible for him to encompass both attitudes in the same creative process.

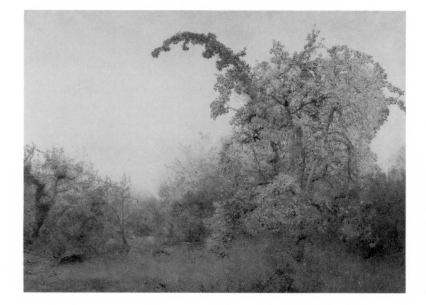

Fig. 31
JOHN WILLIAM NORTH
(1842–1924)
The Old Pear Tree
1892

Watercolour
72.4 × 96.4 cm

Southampton Art Gallery

The *fin-de-siècle* unease manifested itself in a rather more obscure way in the work of another painter who began his career under the aegis of Ruskin and the Pre-Raphaelites, and who perpetuated a Turner-inspired manner until his death well into the twentieth century. The first watercolours of Albert Goodwin are rendered in true Pre-Raphaelite style with intense concentration on the particularity of place, light and natural detail. Their vivid, revelatory nature owes much to the initial influence of the Pre-Raphaelite follower Arthur Hughes, with whom Goodwin became friends at an early age. They are already imbued with an implication of Palmeresque epiphanies:

bursts of light amid warm effusions of boskage (fig. 32); picturesquely jumbled roofs flushed with sunset, rather like Hunt's; or concentrated meditations on the transparent surface of limpid streams. His mature philosophy is adumbrated already: 'The whole natural world, down to the smallest details, is one great allegory, typical of the spiritual world. Our business is to study the natural world as the continued revelation of God, guiding us for ever into fresh revelation of himself.'[24] As his life progressed this Ruskinian position strengthened; he became extremely, one might say obsessively, religious, indulging in rather self-conscious and self-dramatising metaphysical speculations, which pepper the journal he began keeping in the 1880s. When he wrote, 'I wonder sometimes if the spirit of old Turner makes use of my personality',[25] he was imagining what to him was a real possibility. Ford Madox Brown, another Pre-Raphaelite friend and influence, must have given early encouragement to his sense of high destiny, for he saw him as potentially 'one of the greatest landscape painters of the age'.[26]

Goodwin looked long and hard not only at the finished watercolours of Turner, but also at those late colour studies in the Bequest, often of Swiss mountain subjects (fig. 33), in which loose washes are combined with intense areas of hatching and flickering penwork. It is the presence of all three elements in many of Goodwin's characteristic drawings, as much as their dramatic

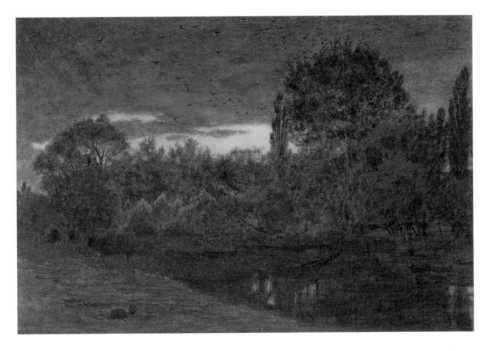

Fig. 32
ALBERT GOODWIN (1845–1932)
Sunset Through Woodland
1865

Watercolour and bodycolour
34.2 × 47.5 cm

Chris Beetles Gallery

skies and expansive panoramas, that makes them so reminiscent of Turner. Goodwin's diary, like Palmer's letters, is full of references to Turner's methods of work.[27] Hammond Smith has recorded that the late Lord Clark remembered going on sketching expeditions with Goodwin, who encouraged him to try the method of working 'simultaneously in colour and pen and ink (waterproof ink of course)'. Clark drew attention to Turner's use of the same technique in his later watercolours.[28]

Goodwin's virtuosity has about it something that goes beyond an intense concentration on landscape facts. It is self-consciously concerned with design, with the opposition of crowded detail with atmospheric void – an almost literal interpretation, perhaps, of Ruskin's double injunction to observe and to express. The sensuous atmospheric vacancies of his most mannered compositions are clearly at least partly indebted to Whistler and Aestheticism. Although Whistler's atmospheric *Nocturnes* seemed in many ways the logical continuation of Turner's more private meditations, ironically Ruskin, and even Whistler himself, did not acknowledge the connection. Ruskin's well-publicised attack on Whistler made that all too clear.[29] When that arch-Aesthete Aubrey Beardsley wrote that 'Turner is only a rhetorician in paint. That is why Ruskin likes him',[30]

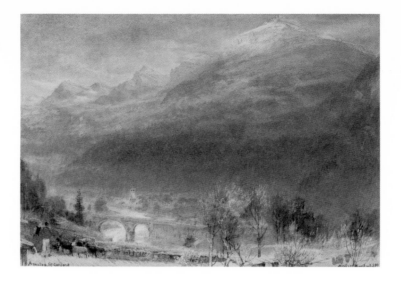

he spoke for his generation, reducing the Turnerian glory to a tawdry flash of self-conscious effect. But in doing so, he (with equal unconscious irony) characterised Turner as though he were an Aesthetic painter too. Although many of the protagonists were violently partisan in these matters, it was possible to reconcile the Turnerian and the Whistlerian, the Pre-Raphaelite and the Aesthetic, and for Goodwin the polarity was a vital source of creative energy. Late in life, he was still arguing the case of Whistler versus Ruskin to himself: 'The plane on which Ruskin stood was immeasurably higher and its way the upward one. Whistler's tended downward. Ruskin with all his seeming arrogance in his writing was in Art and in feeling humility itself, while Whistler's thought was mostly, see how dextrous I am, who can do it like this?'[31]

The artists whom Ruskin promoted were inclined to base their conception of watercolour on the idea of the finished work as it had been promulgated by the exhibiting societies since 1804. Turner's exhibited or engraved watercolours, exemplified by his celebrated 'England and Wales' designs, were their undisputed touchstone. Towards the end of the century, as the riches of the Turner Bequest became better known, the informal, unfinished colour studies began to make their mark. Ruskin had never discouraged the imitation of the studies, but had usually specifically recommended finished subjects for copying. Hercules Brabazon Brabazon formed his whole style on the studies (fig. 34), and in doing so brought out the links between Turner, the student of fleeting impressions, and the late nineteenth-century concern for breadth of technique and allusiveness of content. Like Moran, Brabazon copied the colour studies in the Bequest, and, also like Moran, he favoured those in which Turner employed bodycolour. Rather than the published 'Rivers of France' designs, though, he imitated less finished examples, interpreting Turner's strong, almost expressionist colour with a freedom that gives these sheets something of the status of independent works. More characteristically, perhaps, he took as his model the drawings on grey paper that Turner made in Venice in 1840, making generous use of Chinese white. Certainly Brabazon's contemporaries were impressed by the results. Even Ruskin was influenced by him. In 1880 they went abroad together and Ruskin inscribed one of his drawings as sketched in his company. E.T. Cook and Alexander Wedderburn considered that it 'shows an impressionist "breadth" not always characteristic of Mr Ruskin's work'.[32]

Brabazon's most interesting role is in fact as the transmitter of Turnerian atmospherics to the generation of younger artists who had absorbed French Impressionism. Philip Wilson Steer and John Singer Sargent, two of the leading young Turks of the movement in England, acknowledged their debt to him, and Steer proposed him for membership of the New English Art Club, which Brabazon himself had been active in bringing about in 1886. In 1892 Sargent organised an exhibition of Brabazon's work at the Goupil Gallery, which brought him to general notice. Sargent's introductory note in the catalogue praised Brabazon's 'gift of colour, together with

an exquisite sensitiveness to impressions of Nature', [33] and D. S. McColl, reviewing the show in the *Spectator*, spoke of the 'peace and relief' of passing from the 'mild, firm pedantry' of the Old Water-Colour Society to the work of Brabazon, who had 'gathered from Turner the hints that extraordinary genius flung out of a technique partly transparent, partly opaque, embracing the full range of resource in the medium, and adapted to express by its speed and suggestiveness the most fleeting actions and exquisite surprises of colour'. [34]

So Turner's influence on the art of watercolour was steadily modified, and the resources of his output pillaged and reassessed with each new phase of changing taste. By the early twentieth century the value of his atmospheric sketches was consistently rated higher than that of the finished watercolours. As models for the artist, the finished works, indeed, went decidedly out of fashion. Alfred William Rich considered that 'the attempt to copy the water-colours executed by Turner in his later years has only resulted in utter failure, the best that has been achieved being a miserable imitation" [35] He may well have had in mind not only the highly wrought products of the Ruskinians but also the freer and often technically lax performances of Brabazon. Rich found it more natural to learn from other Romantics – De Wint and Cox for instance. He particularly recommended the clean flat planes and clear outlines of John Sell

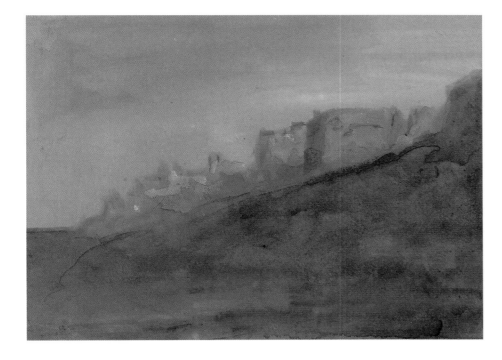

Fig. 34
HERCULES BRABAZON
BRABAZON (1821–1906)
**A View on the Corniche
(after Turner)**
Date unknown

Bodycolour on blue paper
13.6 × 17.8 cm

Private collection

Cotman, who now came into his own as the preceptor of a pure modern aesthetic: 'There is a chance of copying the great Norwich man, but not the slightest of imitating the subtleties of Turner.' [36]

Despite, or even perhaps because of, the radical developments of the Modern movement, many artists have continued to draw inspiration, both theoretical and practical, from Turner's work until the present day. Even a sculptor of the human figure such as Henry Moore was able to claim the lifelong inspiration provided by youthful visits to the drawings in the Turner Bequest. [37] Some contemporary exponents of watercolour continue to demonstrate the modern preoccupation with the more abstract aspects of natural phenomena by borrowing simultaneously the breadth of Turner's informal studies and the elaborate procedures of his finished drawings. The marriage between technical complexity and spiritual intensity that Turner's art pre-eminently exemplified has remained an elusive but nonetheless vigorously pursued ideal.

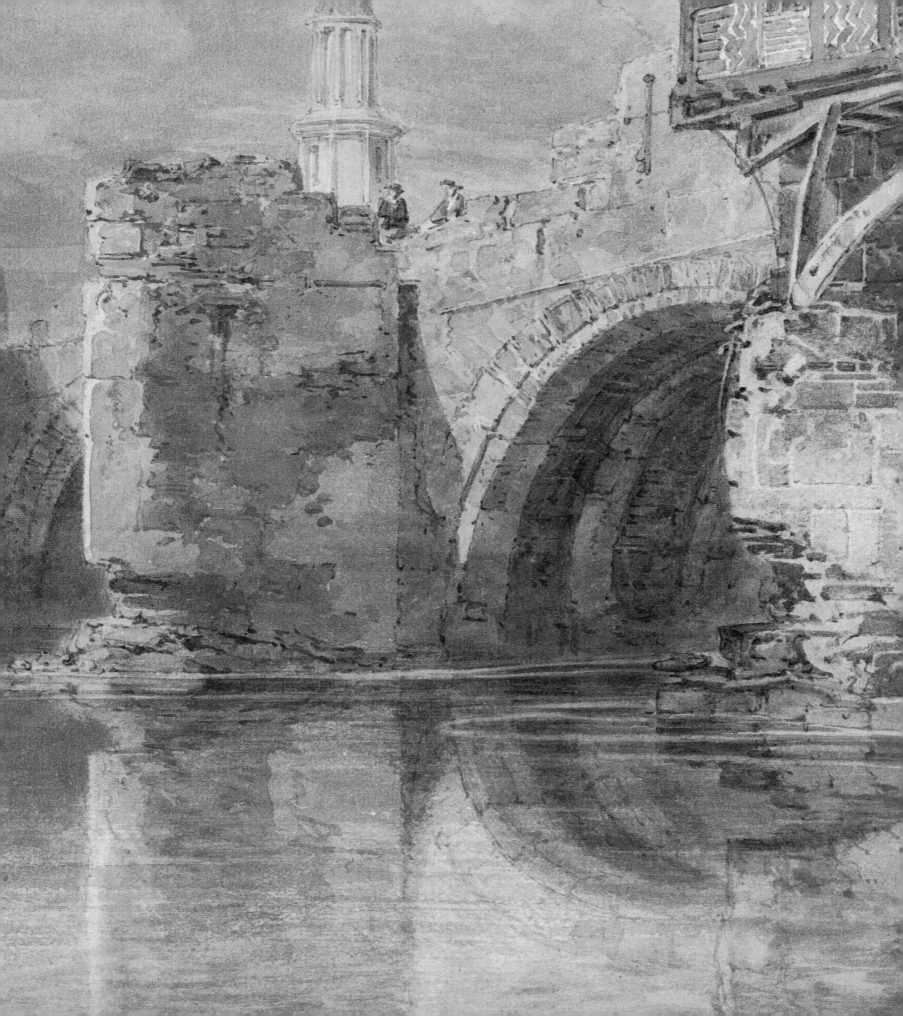

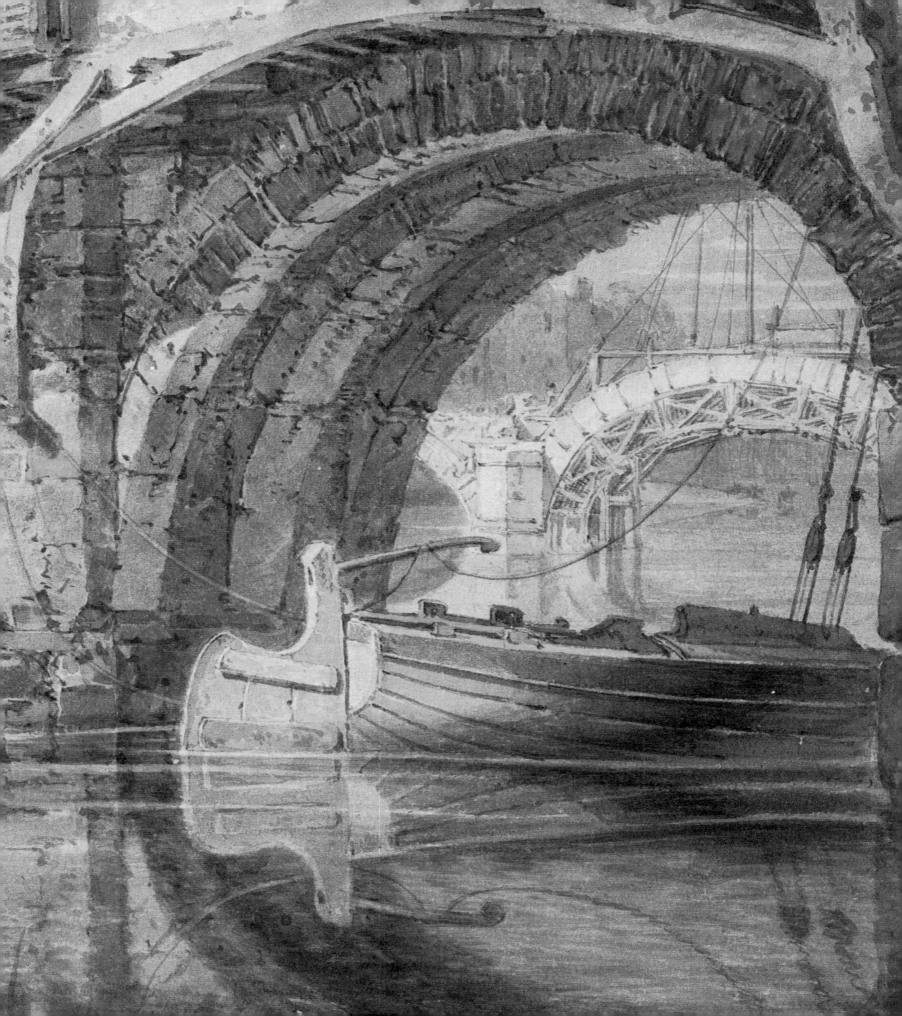

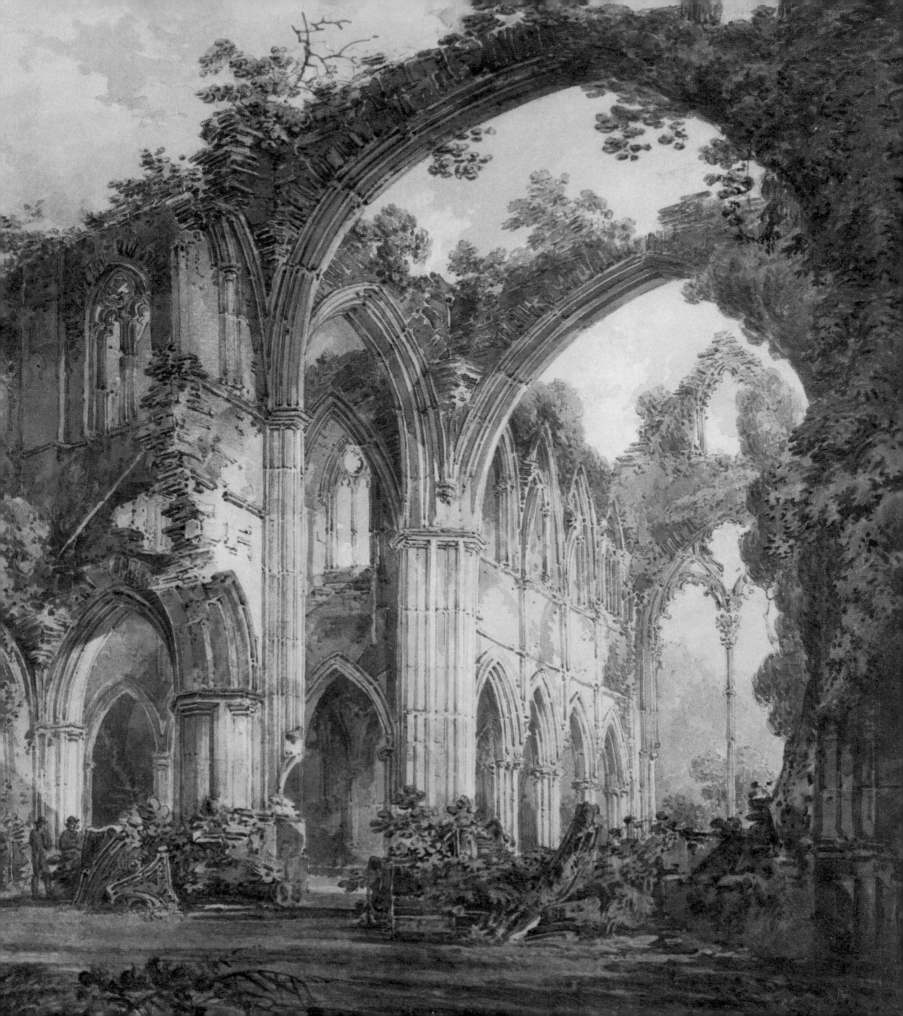

The Royal Academy and Early Patronage 1790–1802

By the 1790s the Royal Academy provided the best venue in Britain for public attention, patronage and critical notices in the press. Between 1790 and 1795 Turner displayed only finished watercolours in the Royal Academy Annual Exhibitions, and of the 21 drawings concerned, four were landscapes and the rest architectural subjects. Five are exhibited here (cats. 1, 2, 4, 5 and 6). In 1796 he displayed his first oil at the institution, and up to 1802 he showed a further 39 watercolours on its walls (see cats. 7, 8, 10, 11, 12, 14 and 16). Generally Turner's watercolours were hung in the Council Room of the Royal Academy at Somerset House, where they suffered from crowding and unsatisfactory lighting, and faced stiff competition from other watercolours and oils. In 1798, for example, his six drawings accepted for display hung alongside 147 other works, including designs by his great contemporary Thomas Girtin and more established artists like Richard Westall RA and Michael Angelo Rooker RA. Several of the exhibited Turner watercolours had already been sold; as the 1790s progressed the artist showed drawings that not only impressed viewers with their quality but also made it clear that he was being supported by leading patrons. Such critical and social prestige contributed to Turner's election as an Associate Academician in 1799 and as a full Academician in 1802.

Turner's success in attracting a large number of patrons from the aristocratic and landowning classes for his finished watercolours marked him out from many contemporary watercolourists, who were forced to take whatever work they could. Some of the more important early Turner patrons included Edward Lascelles of Harewood House, Yorkshire (see cat. 9); the banker John Julius Angerstein; William Beckford of Fonthill, Wiltshire; and Sir Richard Colt Hoare of Stourhead, Wiltshire (cats. 15, 16, 17 and 23). Such patrons were prepared to pay high prices for the works they commissioned. As early as 1797 Edward Lascelles paid ten guineas and Turner's prices had risen to 35 guineas by 1800 when William Beckford commissioned five views of Fonthill Abbey.

detail: cat. 5

Cat. **1**

The Archbishop's Palace, Lambeth

c. 1790

Pencil and watercolour
26.3 × 37.8 cm

W 10
Indianapolis Museum of Art, Gift in memory of Dr and Mrs Hugo O. Pantzer by their children

EXHIBITED: Royal Academy, 1790 (644)

The fifteen-year-old Turner wanted to show off his precocious command of perspective in this, his first publicly exhibited work, for the buildings depicted were aligned at differing angles and were therefore difficult to project spatially. While the representation of architecture reflects the influence of Thomas Malton, the shaping of the figures displays the influence of Edward Dayes. From left to right are a boatman, with Westminster Bridge beyond; some boys playing with a hoop; a washerwoman perhaps carrying her laundry to the Thames; a dandy and his lady taking the evening air; customers conversing through a window of the Swan Inn; and a cart approaching from the direction of the nearby market gardens.

Cat. **2**

The Pantheon,
the morning after the fire
1792

Pencil and watercolour
39.5 × 51.5 cm
Signed lower left: *W Turner Del*

W 27
Tate. Bequeathed by the
artist, 1856 IX A

EXHIBITED: Royal Academy, 1792 (472)

The Pantheon Opera House in Oxford Street, London, burnt down on 14 February 1792, having been torched at the behest of its management committee who wanted to improve business at a rival theatre in which they also had a financial interest.[1] Turner may have worked there as a scene-painter in 1791–2.

In the foreground firemen fill and empty their buckets, while crowds view the aftermath of the fire. Despite the timing specified by the title, Turner played freely with the direction of light here, for it falls from the west. Although the sun has been up for some hours, few of the icicles have melted. As in the view of Lambeth Palace (cat. 1), the painter's alertness to wall stainings and to reflected light playing across shadowed areas is already apparent.

Cat. **3**
Tom Tower, Christ Church, Oxford
1792

Pencil and watercolour
27.2 × 21.5 cm

(not in Wilton)
Tate. Bequeathed by the artist, 1856
XIV B

PRELIMINARY MATERIAL: Pencil drawing
1792 (TB XIV A)

Although this watercolour was never exhibited in Turner's lifetime, its detailing and staffage suggest that it may have been made with public display or private sale in mind. Turner also created a slightly larger version of the design, now in a private collection (W 38). Both images were developed from a pencil study dating from the summer of 1792 and reflect the strong impact of Rooker's *Battle Abbey* (fig. 2). The suggestion of reflected sunlight around the upper windows of the building on the right is especially deft.

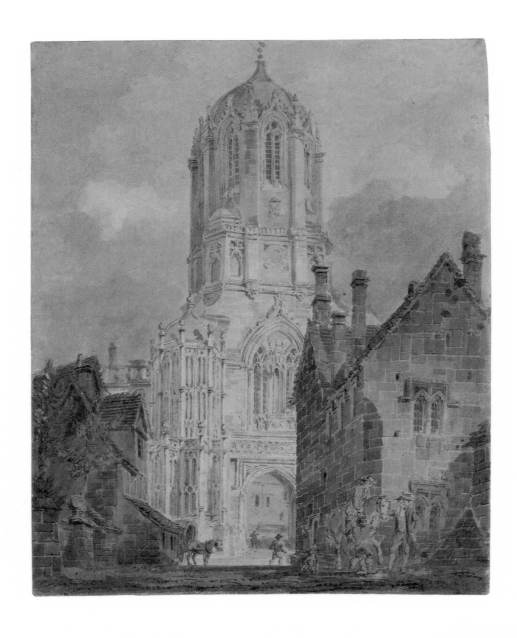

Cat. **4**
St Anselm's Chapel,
with part of
Thomas-à-Becket's crown,
Canterbury Cathedral
c. 1794

Pencil and watercolour
51.7 × 37.4 cm
Signed and dated lower right:
Turner 179 (last digit trimmed)

W 55
The Whitworth Art Gallery,
The University of Manchester

EXHIBITED: Royal Academy, 1794 (408)

Turner visited Canterbury in both 1792 and 1793, although
no preliminary sketches for this watercolour have yet
been identified. We look in a north-easterly direction
towards the octagon known as the 'corona' or crown in
which were once enshrined relics of Saint Thomas Becket,
who had been murdered in another part of the cathedral in
1170. By the late Middle Ages the octagon had become the
leading pilgrimage shrine in England, as Chaucer's *Canterbury
Tales* testifies.

The angularities of this section of the cathedral posed
difficult perspectival problems, although Turner solved them
with ease. The tonal differentiation of the masonry again
reflects the influence of Rooker. Turner's depiction of the
architecture is discussed more fully on pp. 20–21.

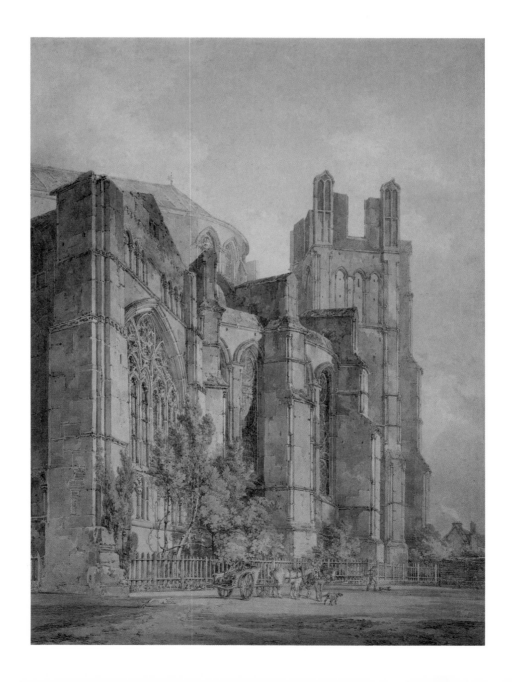

Cat. **5**

Inside of Tintern Abbey, Monmouthshire

c. 1794

Pencil and watercolour
32.1 × 25.1 cm

W 57
The Victoria and Albert
Museum, London

EXHIBITED: Royal Academy, 1794 (402)

PRELIMINARY MATERIAL: Pencil drawing
1792 (B XII E); uncompleted trial
watercolour (TB XXIII A)

Tintern Abbey was a twelfth-century Cistercian foundation destroyed during the Reformation. Turner visited the ruin in 1792, on his first tour of Wales. The tonal and compositional stresses placed upon the arches at the top demonstrate his early flair for creating unifying framing devices, while his penchant for leading the eye into the centre of the image by placing his lightest tones there is equally apparent. For comments on Turner's adoption of a low viewpoint, see p. 20.

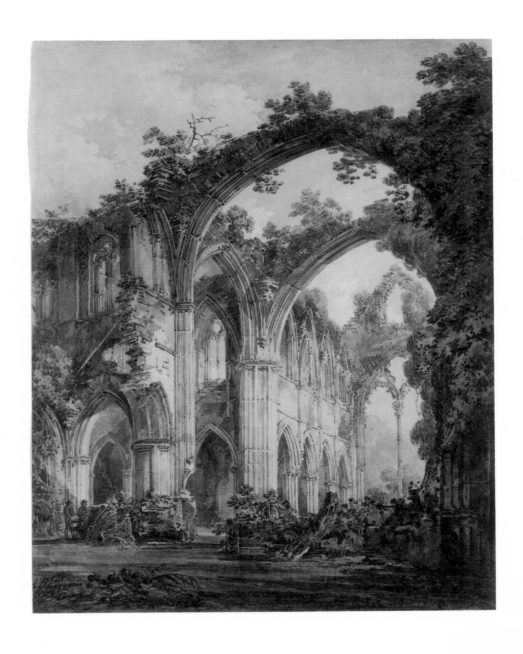

Cat. **6**
Welsh Bridge
at Shrewsbury
1794

Pencil and watercolour
22.4 × 27.4 cm
Signed and dated lower left:
W Turner / 1794

W 82
The Whitworth Art Gallery,
The University of Manchester

EXHIBITED: Royal Academy, 1795 (593)

PRELIMINARY MATERIAL: Pencil drawing,
1794 (TB XXI D)

This medieval bridge crossed the River Severn on the Welsh side of the town and was about to be demolished when Turner viewed it in 1794; its utilitarian replacement can be seen under construction through the nearest arch. A rich series of interconnecting curves is deployed on the right, and the enormously varied tones of the masonry again reflect the influence of Rooker.

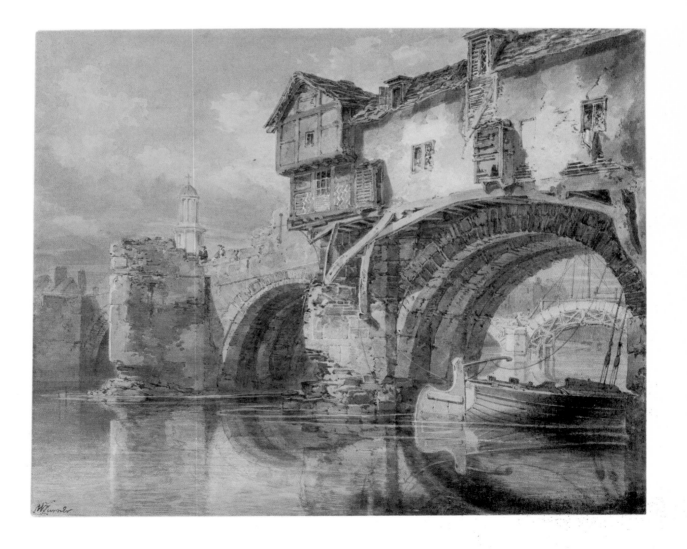

Cat. **7**

**Woolverhampton,
Staffordshire**

c. 1796

Pencil and watercolour
31.8 × 41.9 cm

W 139
Wolverhampton Art Gallery

EXHIBITED: Royal Academy, 1796 (651)

PRELIMINARY MATERIAL: Pencil drawings
Matlock sketchbook, 1794
(TB XIX, ff. 21 and 22)

detail pp. 68–9

An annual fair has taken place every July on High Green in Wolverhampton since medieval times and Turner visited the town on a 1794 tour of the Midlands. In the distance is the parish church of St Peter. On the right, the timber-framed building with a sign reading SMITH FOREIGN SPIRITOUS LIQUORS is a brandy tavern, Bevan's Tot Shop. At the far, western end of High Green a travelling theatre was possibly modelled upon Holloway's combined music hall, pantomime and vaudeville, known to have visited Wolverhampton Fair regularly. On the left, before a banner sporting the legend THE [IRON?] GIANT, a large tent bears the words SURPRISEING and [L?]ION FROM AFRICA, and it might have been based upon Wombwell's Menagerie, which is also known to have visited the fair. Near the sunlit corner of the Tot Shop, a banner depicting an elephant bears the inscription TO BE SEEN ALIVE and possibly further advertises the menagerie.

In front of the tavern musicians draw attention to a harlequin who whips his dogs into begging positions, while in the right foreground a market-trader persuades her dog to perform the same trick – but for free. Beyond her, two women peer through the eyepieces of a waxworks, and customers purchase GAME, SPICE, NUTTS, as well as gingerbread. On the right a banner suspended from a side-window of the pub celebrates KING AND CONSTITUTION. The tavern is thrown into brilliant relief by the dark tents on the left, and by the cool tones of the church, and these contrasts assist its angular rooflines and straight timbers in acting as firm foils to the disorder of humanity.

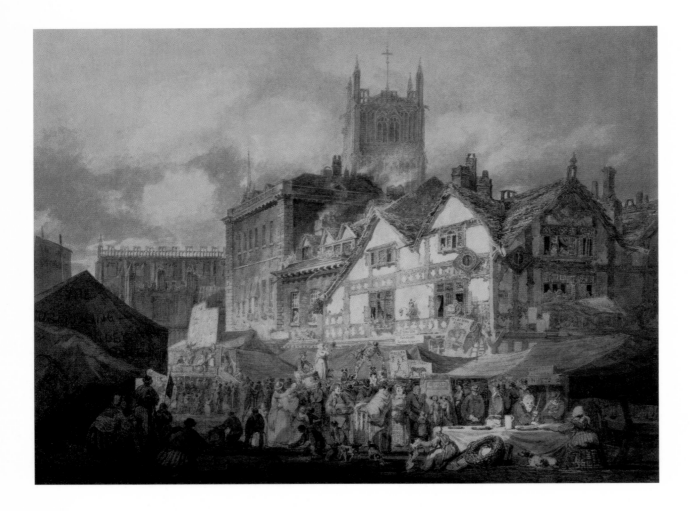

Cat. **8**

**Trancept of Ewenny
Priory, Glamorganshire**
c. 1797

Pencil, watercolour, scratching-out
and stopping-out
40 × 55.9 cm

W 227
National Museums and
Galleries of Wales

EXHIBITED: Royal Academy, 1797 (427)

PRELIMINARY MATERIAL: Pencil drawing
Smaller South Wales sketchbook,
1795 (TB XXV, f. 11)

Ewenny Priory was a Benedictine monastery situated near Bridgend in Glamorganshire. It was founded in 1141 and suppressed in 1539. Turner visited it in 1795, on his third tour of South Wales. As figure 7 reveals, the preliminary drawing contains no indications of light, people, animals or implements, and even the architecture is sketched only cursorily. However, the sheet does contain a separate study of the twelfth-century effigy resting on the tomb of Sir Paganus de Turbeville of Coity. This figure provides the key to the final image.

The eye is led to the tomb by the triangular end of the makeshift hen-house placed in the foreground directly opposite our viewpoint, as well as by the light streaming through the doorway in front of the sepulchre. Given the total absence of animals, people and objects in the original pencil drawing, we might safely conclude that the artist invented them to add an ironic note to the sublime setting: Sir Paganus may have sought eternal peace in Ewenny Priory church but its present use as a pigsty, chicken-run and toolshed destroys that calm. By implication, the design also comments on the destructiveness of the Reformation that had laid the building low in the sixteenth century.

With its balance of cool and warm light sources, the design reflects the influence of a work by Rembrandt, *Rest on the Flight into Egypt,*[1] which then hung at Stourhead in the collection of Sir Richard Colt Hoare, for whom Turner was working when he made this watercolour. The 'offstage' light sources, dramatic tonal contrasts and architectural stresses may have derived from the prison scenes of Piranesi, one of which Turner may have copied around this time.[2]

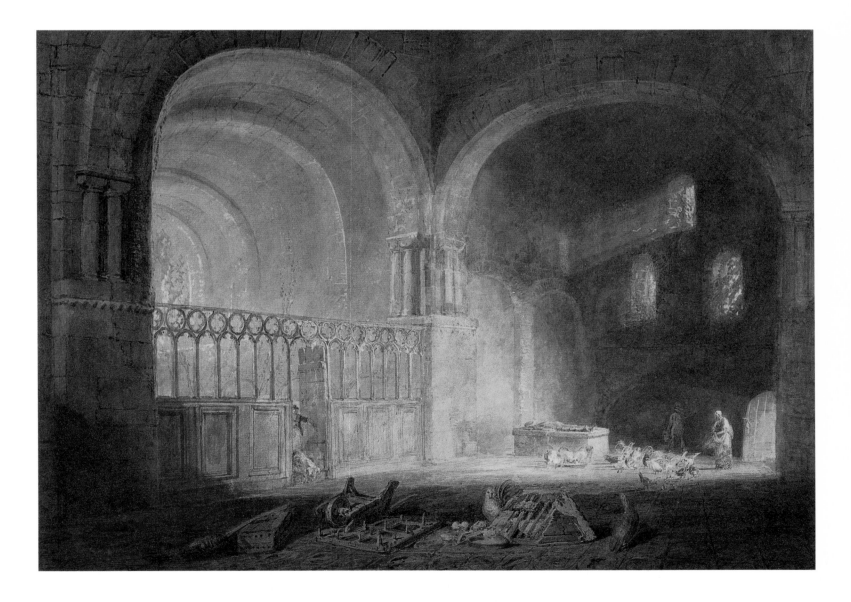

Cat. **9**

Harewood House from the South-East

1798

Pencil and watercolour
47.4 × 64.5 cm
Signed and dated: *W Turner 98*

W 217
Lent by kind permission of the
Earl and Countess of Harewood
and the Trustees of the
Harewood House Trust

PRELIMINARY MATERIAL: Pencil outline
(TB LIL)

One of Turner's earliest important patrons was Edward Lascelles the Younger, the son of the 1st Earl of Harewood. The collector purchased his first Turner in 1796, and in the summer of 1797 he invited the painter to visit his family home, Harewood House in Yorkshire, to gather preliminary material from which to elaborate views of the house and grounds. The patron was drawn to the breadth of landscape in Turner's art, for it is a marked feature of all the drawings he purchased from the artist. Harewood House is shown in evening light; the nearby trees and Almscliffe Crag just beyond the mansion catch the last rays of the summer sun.

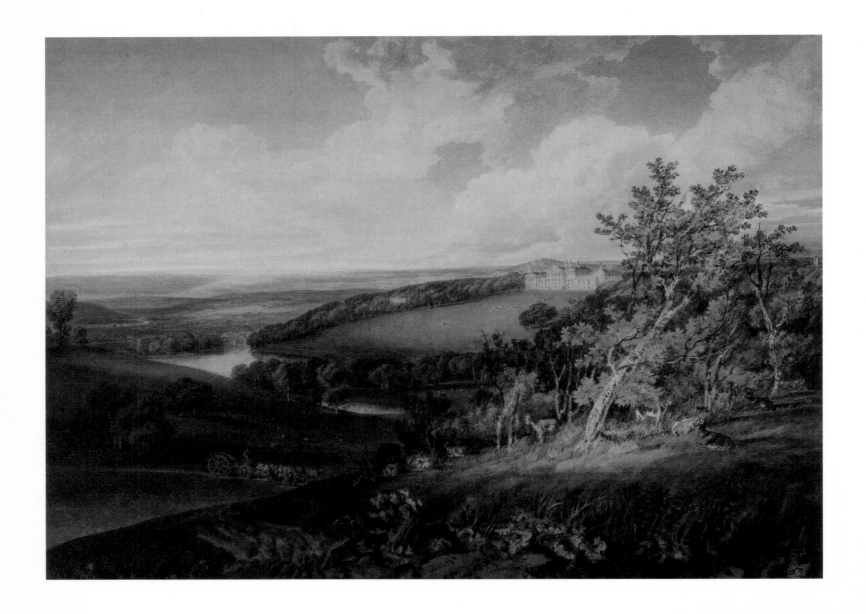

Cat. **10**
**The Dormitory and
Transcept of Fountain's
Abbey – Evening**
c. 1798

Watercolour
45.6 × 61 cm
Signed: *W Turner*

W 238
York City Art Gallery (purchased
with the aid of the Victoria and
Albert Museum and the National
Art Collections Fund)

EXHIBITED: Royal Academy, 1798 (435)

PRELIMINARY MATERIAL: Pencil drawing
North of England sketchbook,
1797 (TB XXXIV, f. 89)

ENGRAVED: James Basire, *Whitaker's
History and Antiquities of Craven in
the County of York*, 1812 (R 77)

detail pp. 72–3

Fountains Abbey was a twelfth-century Cistercian foundation destroyed in the Reformation. Turner visited the ruins in 1797, on his first tour of the north of England. Despite the title, the abbey transept is not represented here, but rather the cellarium and lay brothers' dormitory spanning the River Skell, with the refectory to the right.

When this watercolour was exhibited at the Royal Academy its title was accompanied in the catalogue by lines from James Thomson's *The Seasons*:

All ether soft'ning sober evening takes
Her wonted station on the middle air;
A thousand shadows at her beck –
In circle following circle, gathers round,
To close the face of things.

The lines augment our sense of the shifting movement of light in time, which painting cannot convey directly. The drawing typifies the expansion of technical boundaries the artist had effected by 1798, for it is one of a number of finished watercolours created around that time in which the depths of tone resemble those more usually encountered in oil paintings.

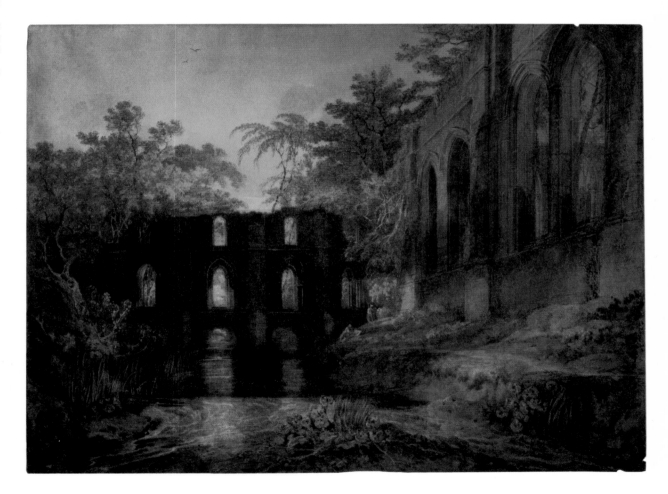

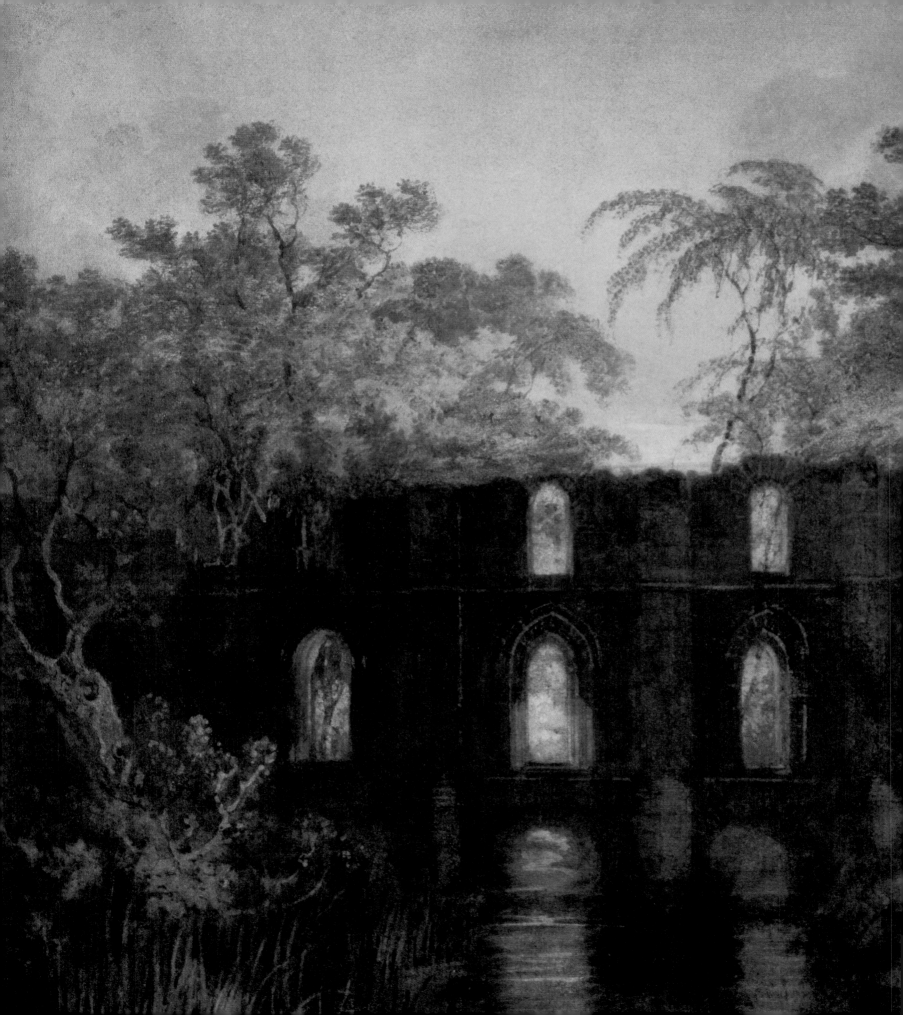

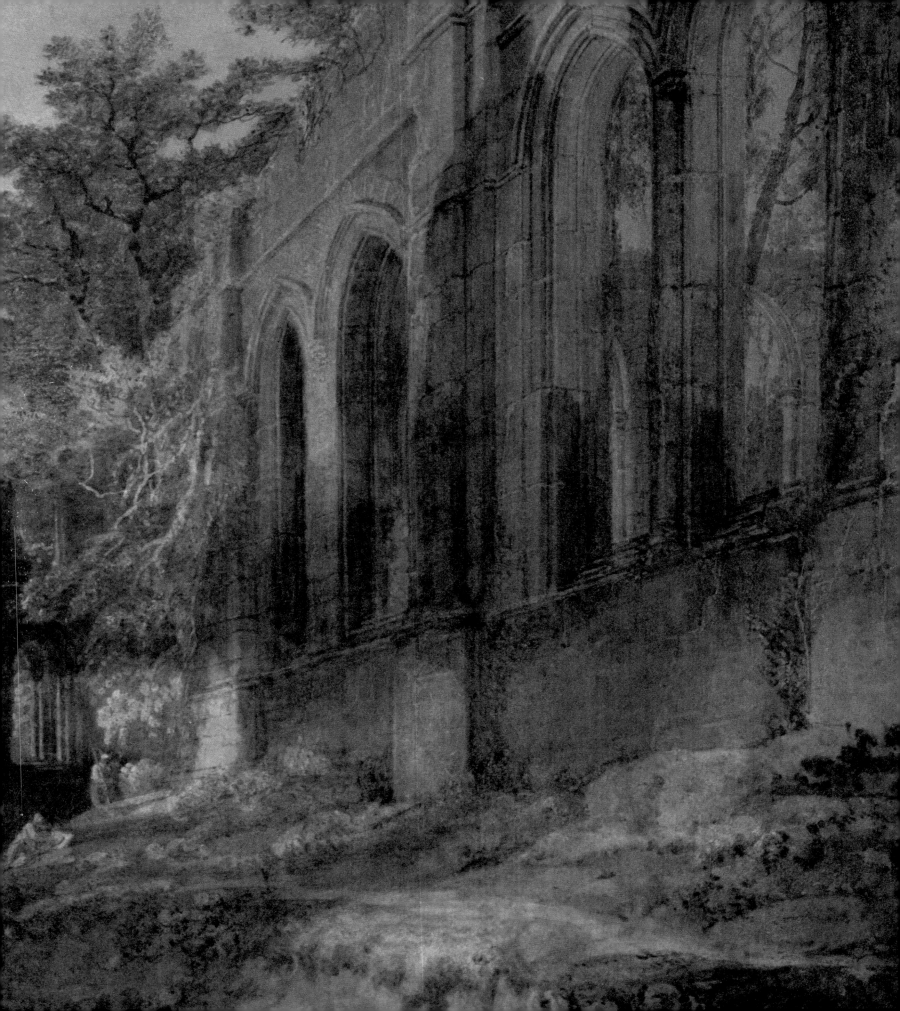

Cat. **11**
Abergavenny Bridge,
Monmouthshire, clearing
up after a showery day
c. 1799

Pencil, watercolour, gouache,
scratching-out and stopping-out
41.3 × 76 cm

W 252
The Victoria and Albert Museum,
London

EXHIBITED: Royal Academy, 1799
(326)?

PRELIMINARY MATERIAL: Pencil drawing
Dynevor Castle sketchbook,1798
(TB XL, ff. 20v and 21r)

Turner visited Abergavenny in 1798, on his fourth tour of
Wales. He may have been commissioned to make this
watercolour by Thomas Lawrence.[1]

Two other drawings could have been the 1799 RA
exhibited watercolour.[2] However, two factors suggest that
this was the work displayed. Firstly, the span depicted is the
medieval Llanfoist bridge at Abergavenny and, judging by
its relationship to the river Usk, we are gazing in a westerly
direction near sunset, as implied by the wording of the 1799
title. Moreover, the 'clearing up' of the title is matched by
the heavy clouds, damp atmosphere and bright sunlight.
The weather explains why Turner did not introduce people
into the scene, for herdsmen or travellers would surely have
sought shelter from recent showers.

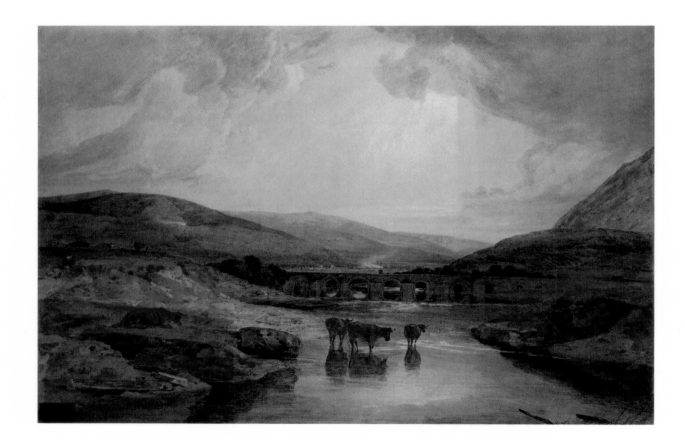

Cat. **12**

**Caernarvon Castle,
North Wales**

c. 1800

Pencil, watercolour, scratching-out
and stopping-out
66.3 × 99.4 cm

W 263
Tate. Bequeathed by the
artist, 1856 LXX M

EXHIBITED: Royal Academy, 1800 (351)

The title of this watercolour was accompanied in the 1800 Royal Academy catalogue by verses possibly penned by the artist himself:

> And now on Arvon's haughty tow'rs
> The Bard the song of pity pours,
> For oft on Mona's distant hills he sighs,
> Where jealous of the minstrel band,
> The tyrant drench'd with blood the land,
> And charm'd with horror, triumph'd in their cries,
> The swains of Arvon round him throng,
> And join the sorrows of his song.

They identify the harpist beneath the pine tree on the left as the selfsame final Welsh bard commemorated by Thomas Gray in his famous poem of 1757, which the painter knew well.[1] Turner's bard sings his 'song of pity' to heap imprecations upon King Edward I of England, both for crushing the Welsh and for building Caernarfon Castle in order to do so. The underlying theme of the watercolour is therefore the threat to national liberty and, by implication, its destruction, for eventually the bard will commit suicide in the face of the English menace.

This drawing was one of Turner's first compositions in the manner of Claude Lorrain, and it seems probable that it derived pictorially from a close analysis of Richard Earlom's set of engravings after Claude's *Liber Veritatis*, in which the French artist had recorded the majority of his compositions. Claude's use of trees as associative devices is imitated too, with the dominant pine made to lean away from its companions, so as to amplify the gesture made by the outstretched arm of the bard. For Turner's matching of timing to the dramatic subject of this design, see pp. 18–19.

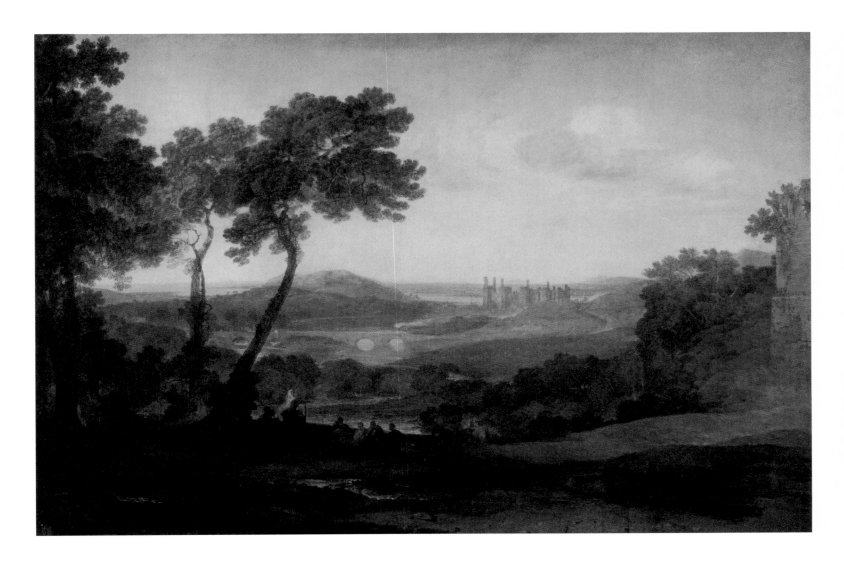

Cat. **13**

Conway Castle

c. 1800

Watercolour
41.9 × 62.2 cm
Signed: *W Turner*

W 268
By kind permission of the Duke of
Westminster OBE, TD, DL

PRELIMINARY MATERIAL: Pencil drawings
Hereford Court sketchbook,1798
(TB XXXVIII, ff. 50v, 51)

Turner elaborated this watercolour from pencil outlines made on his fourth tour of Wales. Those studies formed the basis of two more drawings and an important oil.[1] The present work was commissioned by William Blake of Newhouse, to whom Turner had given lessons in the late 1790s.

We look north–westwards at dawn, with the sun just brightening the castle and the distant hills at the northern end of Anglesey. In order to open out the vista the artist has omitted the eastern banks of the River Conwy on the right. The twisted tree on the left both offsets the squareness of the castle and amplifies the wildness of the scene.

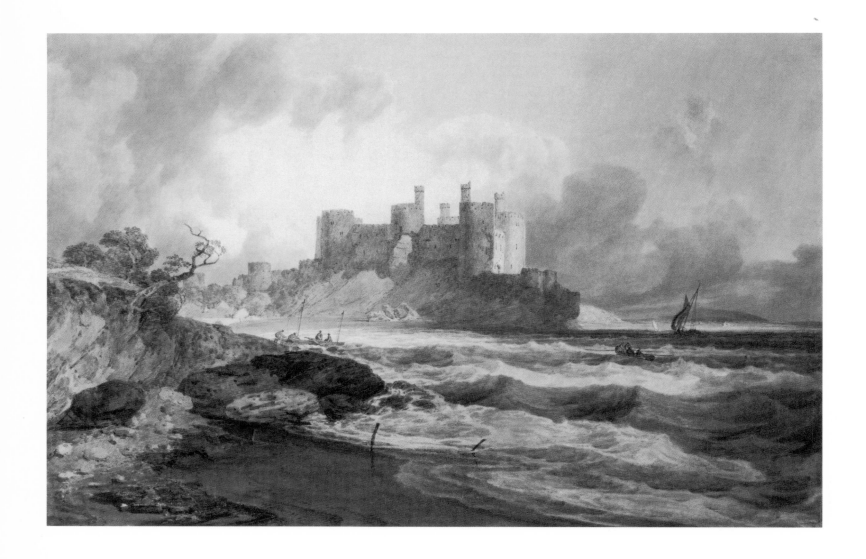

Cat. **14**

Kilchern Castle, with the
Cruchan Ben mountains,
Scotland: Noon

c. 1802

Watercolour
53.3 × 77.2 cm

W 344
Plymouth City Museum
and Art Gallery

EXHIBITED: Royal Academy, 1802 (377)

PRELIMINARY MATERIAL: Pencil drawings
Dunbar sketchbook, 1801 (TBLIV, ff.
42v and 43r, 51, 59v and 60r)

detail pp. 78–9

This is arguably the most spectacular image to have emerged
from Turner's tour of Scotland in July and August 1801; its cool
colouring probably reflects the cloudiness he had encountered
on his trip. We look in a north-easterly direction towards
Kilchurn Castle, with the 2062-metre, snow-covered Beinn
Mhic Mhonaidh on the right.

Rain moves off to the north, although it has not touched the
nearby landscape, as the locals taking their noontime ease on
dry ground make clear. The rainbow was mostly rubbed out
from the underlying colour.

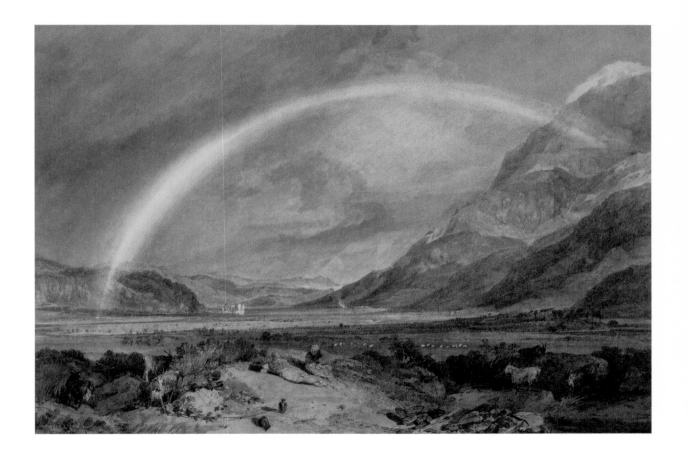

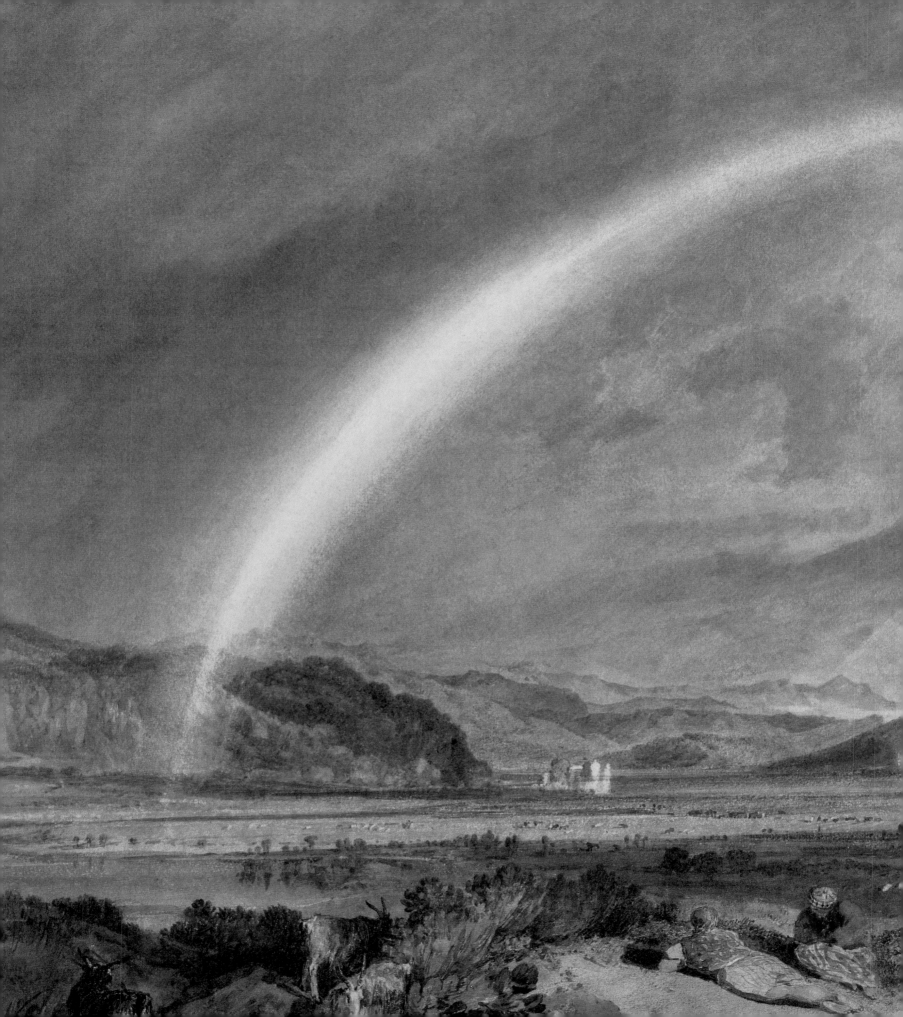

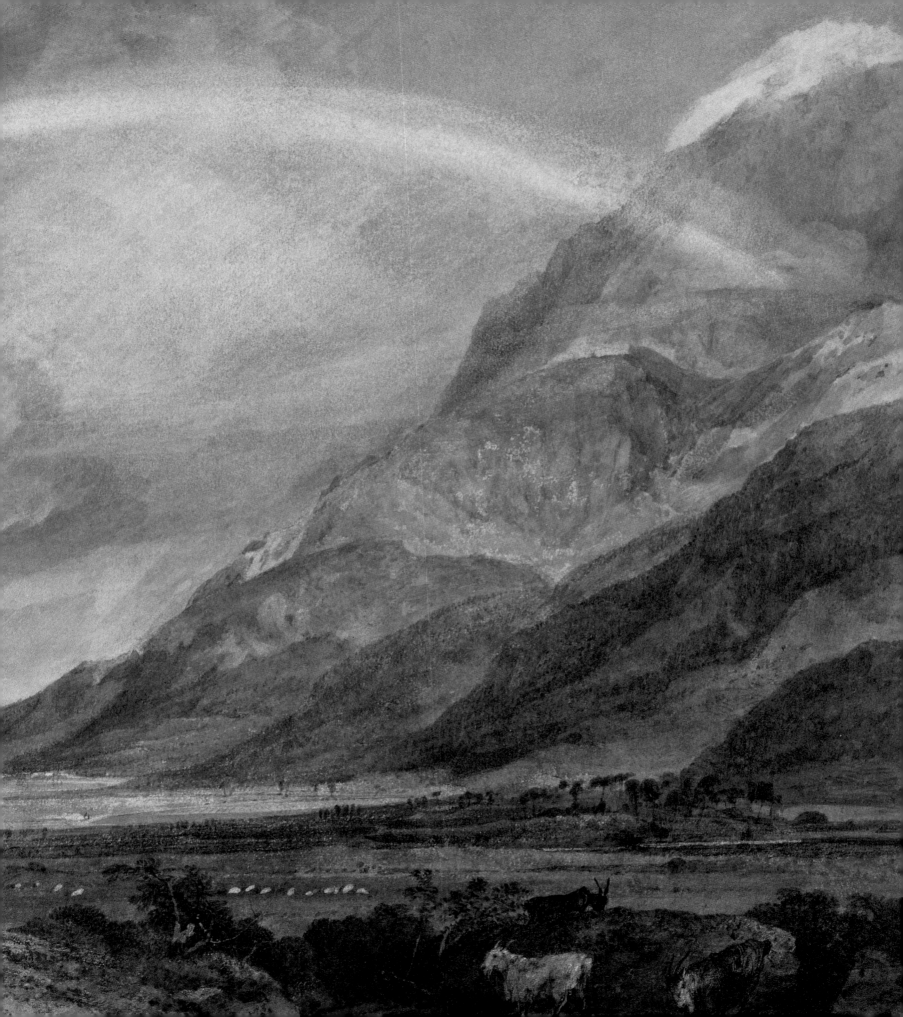

Cat. **15**

**View of Salisbury
Cathedral from the
Bishop's Garden**

c. 1798

Pencil and watercolour
51.3 × 67.8 cm

W 200
Birmingham Museums and Art
Gallery

Turner created this watercolour and catalogue numbers 16 and 17 for Sir Richard Colt Hoare as part of a set of ten large views of Salisbury Cathedral commissioned in 1795. Apparently only eight of the group were ever made (w 196–203). Eventually they all hung together in Colt Hoare's family seat at Stourhead, and their owner thought them unsurpassable.[1]

In this view from the Bishop's Garden we see the cathedral from the south. The artist has specifically seated his figures in order to maximise the scale of the building. In the view from the cloisters (cat. 17), Turner reinforced the verticality of the cathedral's tower and spire by contrasting their straight lines with a series of circles spread across the foreground. These are formed by both the trefoil and quatrefoil apertures and surrounds in the upper part of the image, and by the top being spun by a boy lower down, as well as by a nearby basket-handle and two hoops, one of which is clutched by a distant chorister.

Although it might be thought that the playful children in the *Chapter House* and the *South View* (cats. 16 and 17) demonstrate youthful indifference to hallowed surroundings, the artist may have had in mind Christ's injunction 'Suffer little children to come unto me and forbid them not: for of such is the Kingdom of God' (Luke 18:16), a message highly appropriate to a portrayal of ecclesiastical surroundings.

For a discussion of the Chapter House view, see pp. 13–14 and p. 22.

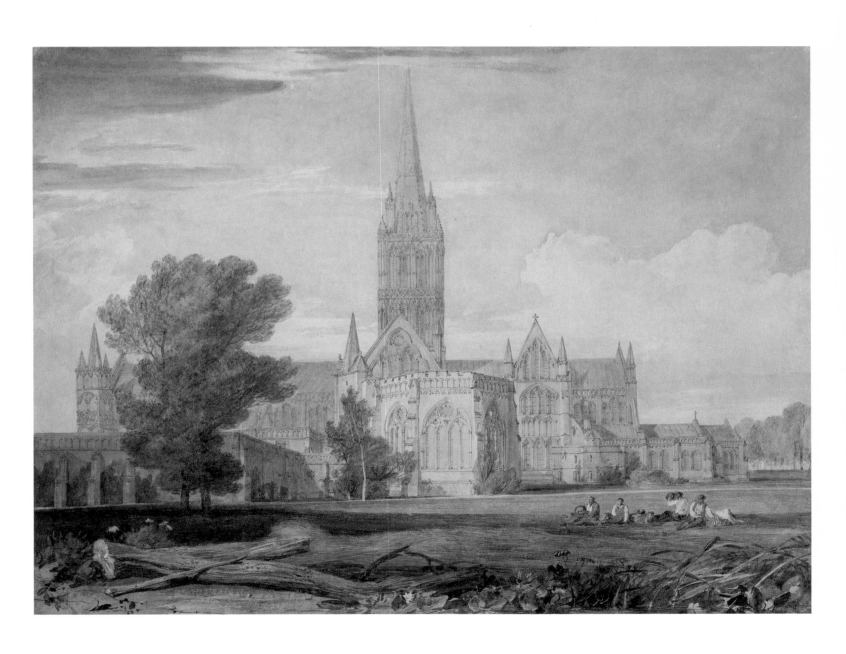

Cat. **16**
The Chapter House,
Salisbury Cathedral
c. 1799

Pencil, watercolour, pen and ink,
scratching-out
64.5 × 51.2 cm

W 199
The Whitworth Art Gallery,
The University of Manchester

EXHIBITED: Royal Academy, 1799 (327)

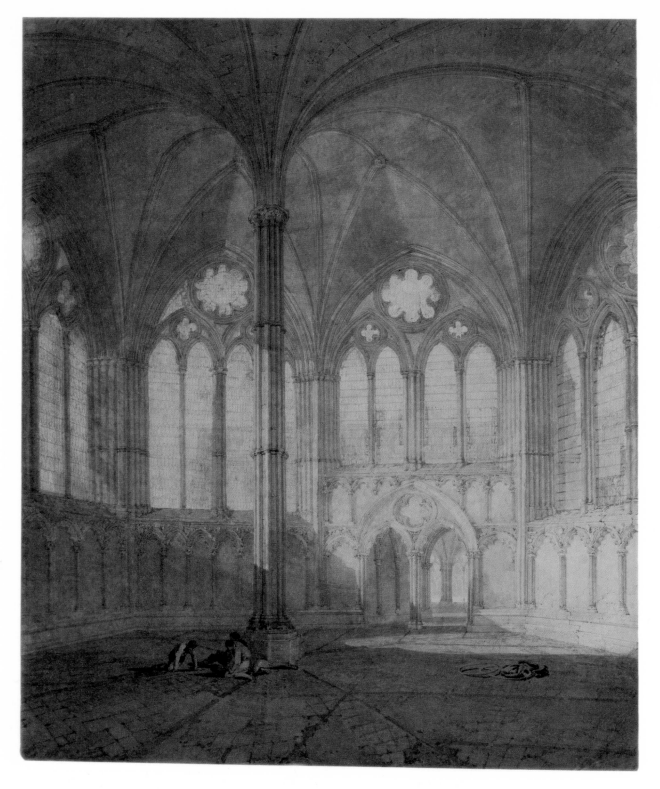

Cat. **17**
South View from
the cloisters,
Salisbury Cathedral
c. 1802

Pencil and watercolour
68 × 49.6 cm
Signed lower left: *JMW Turner RA*

W 202
The Victoria and Albert
Museum, London

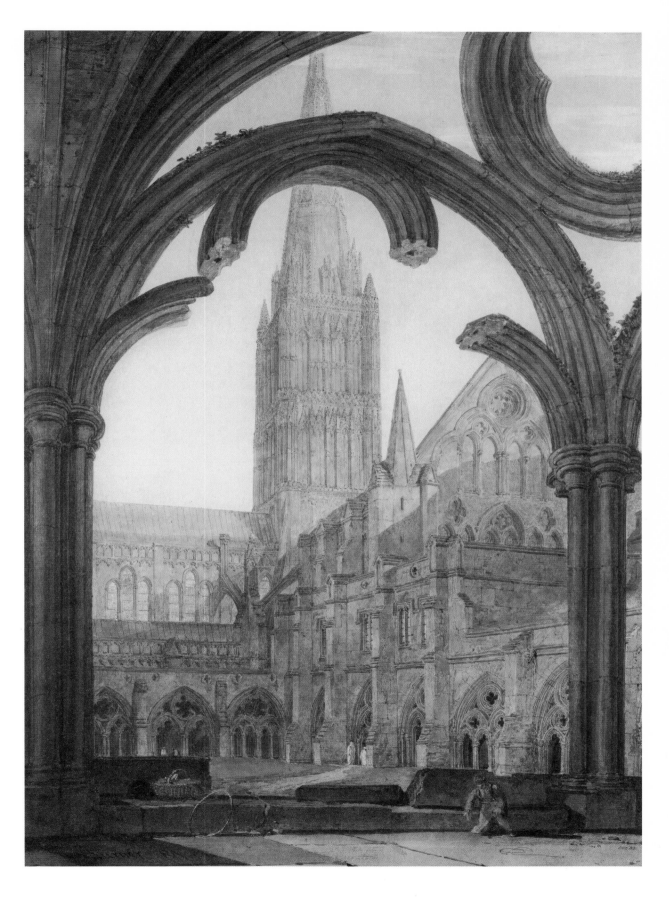

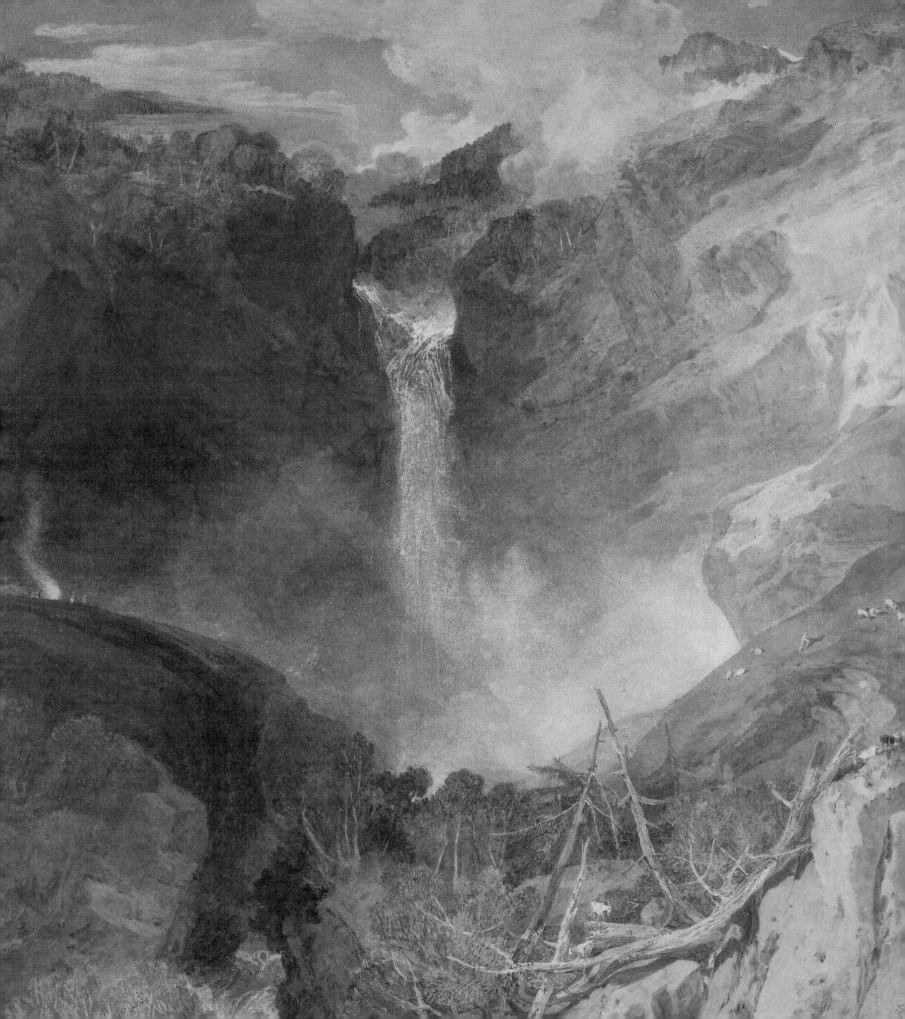

Works Resulting from the 1802 Swiss Tour

The brief peace between Britain and France created by the Treaty of Amiens (1802) permitted Turner to visit the Continent for the first time. By that date he had explored the most mountainous areas of Wales and Scotland. However, he knew that far more magnificent scenery could be found in French Savoy, Switzerland and the Val d'Aosta, and consequently he explored those regions in the summer of 1802. Over the next fifteen or so years he drew extensively upon the topographical material he had gleaned there (see cats. 18–22), exhibiting a number of the resultant images at the Academy and in his own gallery.

One of Turner's patrons, Walter Fawkes, had once toured Switzerland and he acquired a considerable number of watercolours based upon the 1802 Alpine Tour, including *Fall of the Reichenbach* (cat. 18) and *Mont Blanc from Fort Roch* (cat. 21). Several of these drawings were shown at Fawkes's London house in 1819 (see fig. 20), where they provided the public with another and much more comprehensive opportunity to evaluate fully Turner's first experience of Alpine scenery. Many judged his Alpine drawings to be the highlights of the show and therefore at the forefront of a triumphant school of English watercolour painting (see pp. 37–9).

detail cat. 18

Cat. **18**

**Fall of the Reichenbach,
in the valley of Oberhasli,
Switzerland**[1]

1804

Watercolour, scratching-out
and stopping-out
103 × 70.4 cm
Signed and dated lower right:
IMW Turner RA 1804

W 367
Trustees of the Cecil Higgins
Collection, Bedford

EXHIBITED: Turner's Gallery, 1804;
Royal Academy, 1815 (292);
Grosvenor Place, 1819 (2);
Music Hall, Leeds, 1839 (23)

PRELIMINARY MATERIAL: Monochrome
study, National Gallery of Ireland
(W 361), which originally formed
a leaf in the *St Gothard and
Mont Blanc* sketchbook, 1802
(TB LXXV)

The upright format enhances the overpowering scale of this
landscape, as do the distant, tiny figures. A sense of
disorientation is imparted by the straying goats, whose
herdsman clambers after them. The geological stratification of
the escarpment is subtly evident, while the fine spray at the
base of the waterfall also demonstrates Turner's keen eye for
detail. In the foreground smashed forms are sharply delineated
without sacrificing anything of the overall sense of chaos.

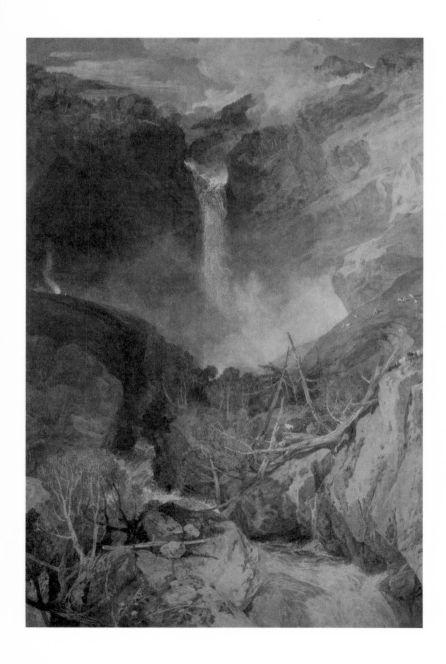

Cat. **19**

Lake of Geneva, with Mont Blanc from the Lake

c. 1805

Watercolour and scratching-out
71.5 × 113 cm
Signed lower left: *JMW Turner RA*
and *JMWT*

W 370
Yale Center for British Art,
Paul Mellon Collection

PRELIMINARY MATERIAL: Pencil drawings
France, Savoy, Piedmont sketchbook
1802 (TB LXIII, ff. 5 and 35)

This idealised landscape reflects the influence of Claude and the Dutch artist Aelbert Cuyp. The bathers add a further classical note to the composition. Turner possibly developed the image from a smaller version of the subject (W 382, Salar Jung Museum, Hyderabad, India). We look in a southerly direction from the lakeside garden of the Hotel d'Angleterre at Secheron, about two kilometres from Geneva, where Turner had presumably stayed in 1802.

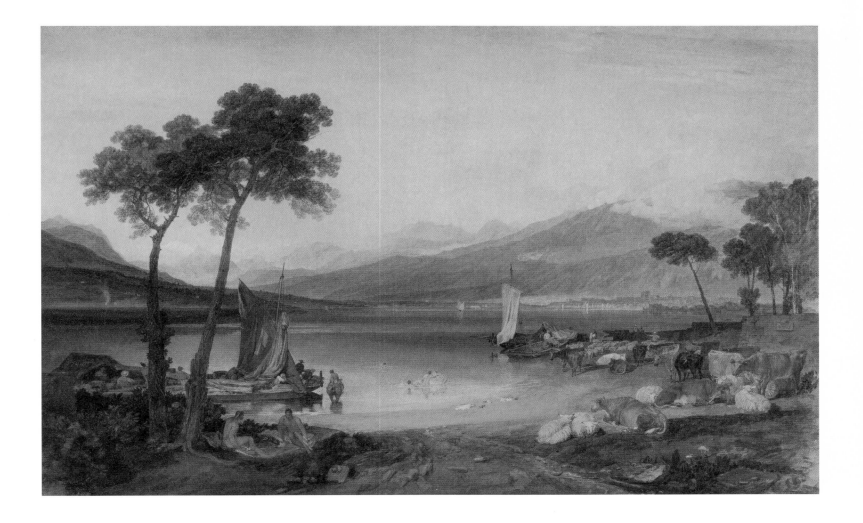

Cat. **20**

**The Devil's Bridge,
St Gothard**

c. 1814

Watercolour, wax crayon and
scratching-out
106 × 76.2 cm

W 368
Yale Center for British Art,
Paul Mellon Fund

Although this watercolour has been thought to date from around 1804, stylistically it could have been created about ten years later. In particular, the clouds are not shaped in the somewhat flattened and theatrical manner encountered around 1804, as, for instance, in the *Fall of the Reichenbach* (cat. 18). Instead, they demonstrate the spaciousness and dynamism commonly apparent from the early 1810s onwards.

The Devil's Bridge, in the Schollenen Gorge of the St Gotthard Pass above Andermatt in southern Switzerland, was one of the most extraordinary manmade structures in the Alps. Turner had painted the bridge and the view from that span several times around 1804, and he would do so again later.

We view the bridge from the Andermatt road, across the falls of the River Reuss, with distant, snow-covered peaks appearing through the clouds. The tiny figure on the bridge lends scale to the enormous, desolate and terrifying landscape.

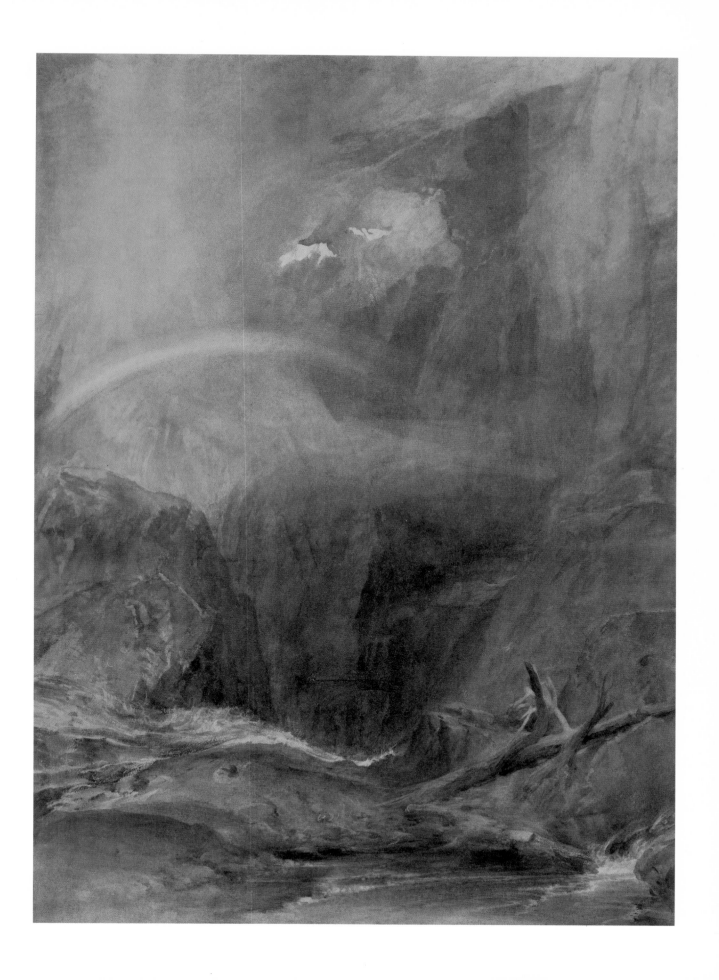

Cat. **21**

Mont Blanc from
Fort Roch, Val d'Aosta

c. 1814

Watercolour
69 × 104 cm

W 369
Private collection

EXHIBITED: Grosvenor Place, 1819 (33);
?Music Hall, Leeds, 1839
(75, although see cat. 22)

PRELIMINARY MATERIAL: (for both works)
watercolour study
Fitzwilliam Museum, Cambridge
(W 360), which originally belonged
in the *St Gothard and Mont Blanc*
sketchbook, 1802 (TB LXXV)

detail pp. 92–3

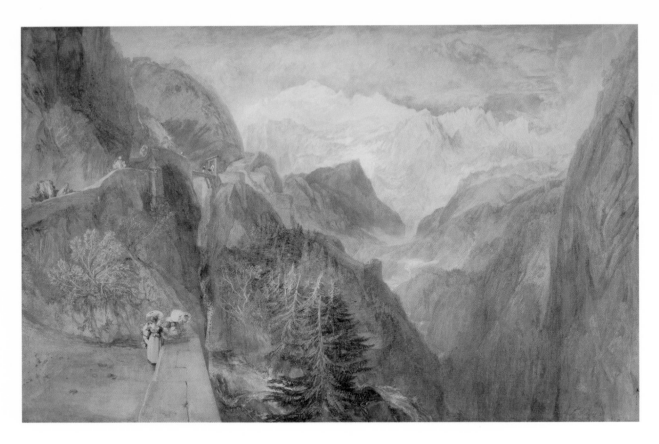

Cat. **22**

The Battle of Fort Rock,
Val d'Aoste,
Piedmont, 1796

1815

Watercolour, gouache, scratching-
out and stopping-out
69.6 × 101.5 cm
Signed and dated lower left:
IMW Turner 1815

W 399
Tate. Bequeathed by the artist, 1856
LXXX G

EXHIBITED: Royal Academy, 1815 (192);
?Music Hall, Leeds, 1839 (75)

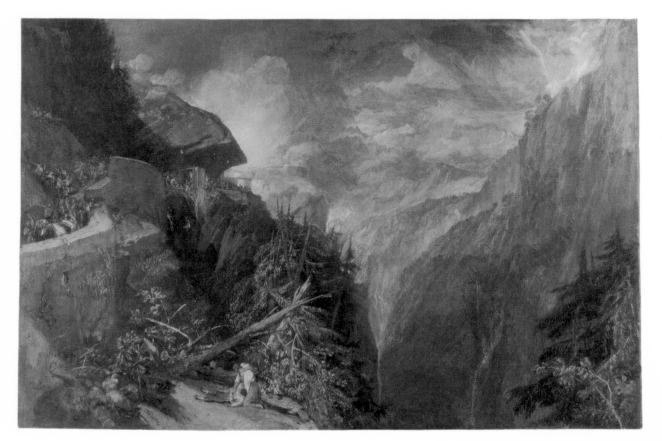

These two watercolours are virtually identical in size and depict exactly the same landscape. We look up the Val d'Aosta from Fort Roch on the section of road known as the Pierre Taillée between Derby and Runaz, near the village of Lavergogne, about eleven kilometres south-east of Mont Blanc. As no known battle took place there during the French invasion of Italy in 1796, it seems possible that Turner invented the engagement depicted in *The Battle of Fort Rock* (although he may have heard of a skirmish there from a local inhabitant when passing through in 1802). The title of the battle scene was accompanied in the 1815 Royal Academy catalogue by verses from Turner's fragmentary manuscript poem, *Fallacies of Hope*. These tell of how Napoleon's 'van progressive' had overcome alpine barriers to pour like a river, strewing the plains of Italy 'with woe'.

Stylistically *Mont Blanc* dates from around 1814, and so was made earlier than the dated *Battle of Fort Rock*. However, given the identical landscapes and complementary activity of the two vistas, it seems likely that Turner created the *Battle of Fort Rock* to pair with the *Mont Blanc*, so that the two watercolours would respectively act as 'War and Peace' pendants.[1] Such a juxtaposition was relevant in 1815. We know that during the period in which Turner elaborated these watercolours he was thinking hard about paired images, for between 1813 and 1817 he painted two oils that are thematically complementary but which were again completed at different times.[2] Other linked images include catalogue numbers 34 and 35, 47 and 48, 102 and 103, and 104 and 105.

In the battle scene the savagery of humanity is paralleled by the storm and the wildness of the mountains. The foreground contains a dead body and two grieving figures; an adjacent, shattered tree amplifies the associations of death. By contrast, in the scene depicting peace, three girls peer hesitantly but safely over a parapet at the enormous drop. Now the sky is calm, the mountains serenely beautiful.

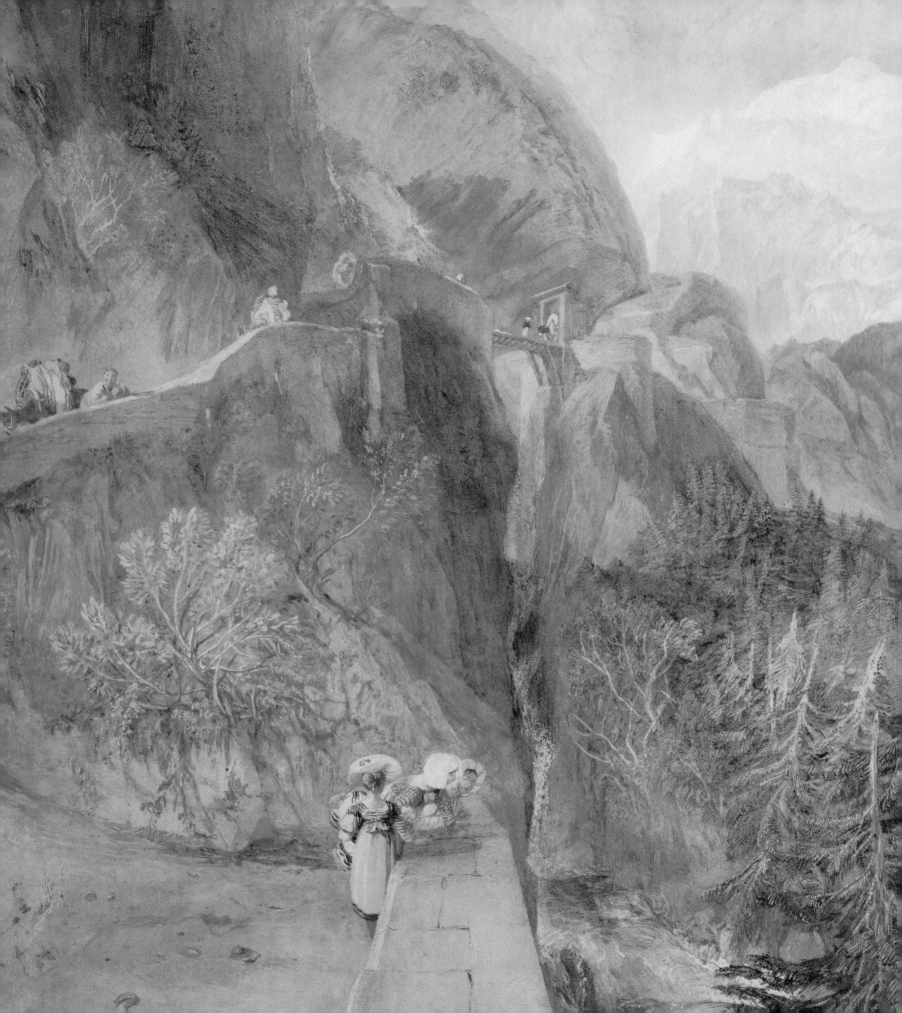

Illustration and Reproduction after 1806

Occasionally a finished watercolour would be commissioned by one of Turner's leading patrons to illustrate a book; for example, *Hampton Court* (cat. 23) was ordered by Sir Richard Colt Hoare for just such a purpose. Other patrons might require watercolours that could be reproduced via the medium of engraving, as with catalogue number 24. Initially this work was hired by a Sussex landowner, John Fuller, for the purpose of producing an aquatint that could be distributed to his friends.

Turner had made his first designs for subsequent engraving in 1794, and most of the prints created in the following years were pedestrian affairs. However, in 1811 the quality of reproduction of one of his oil paintings obtained by the engraver John Pye alerted him to the fact that such prints could constitute expressive images in their own right. In the same year he was invited by the engraver brothers, William Bernard and George Cooke, to contribute designs to their planned partwork, 'Picturesque Views on the Southern Coast of England', which appeared between 1813 and 1826 (see cats. 25–27).

Turner's contributions to the 'Southern Coast' scheme greatly aided its financial success, and led to many more requests from the Cooke brothers to create series of watercolours for engraving; in turn, those schemes prompted invitations from other print publishers. Eventually the task of engraving was given out to large numbers of skilled craftsmen, with Turner controlling the quality of the prints by carefully marking proof copies. The series were usually issued in parts and later collected together with a text, although not all of the publications were completed as originally planned. Some of the schemes were merely topographical in intent (see cats. 25–29), while others, such as the 'History of Richmondshire' (cats. 30–33), the 'History of Durham' (cats. 34 and 35) and the 'Provincial Antiquities and Picturesque Scenery of Scotland' (cats. 36 and 37) employed topographical views to antiquarian ends.

detail cat. 25

Cat. **23**

Hampton Court,
Herefordshire, seen from
the south-east

c. 1806

Watercolour and scratching-out
20.2 × 30.5 cm

W 216
Yale Center for British Art,
Paul Mellon Fund

PRELIMINARY MATERIAL: pencil drawing
South Wales sketchbook, 1795
(TB XXVI, f. 51)

Although Hampton Court, Herefordshire, was owned by
one of Turner's early patrons (Viscount Malden, later 5th Earl
of Essex), Turner created this watercolour for Sir Richard Colt
Hoare, along with a view of the same house from the north-
west (W 215, Yale Center for British Art). Both designs were
commissioned to adorn Hoare's copy of the Earl of
Coningsby's privately published *Account of the Manor
of Marden in Herefordshire*.

The design typifies the degree of breadth and imaginative
detailing Turner brought to country-house views by the mid-
1800s. The complex foliage at the lower-right offsets the
squareness of the mansion, while the welling of the River
Lugg adds a welcome dash of movement to the otherwise
calm scene.

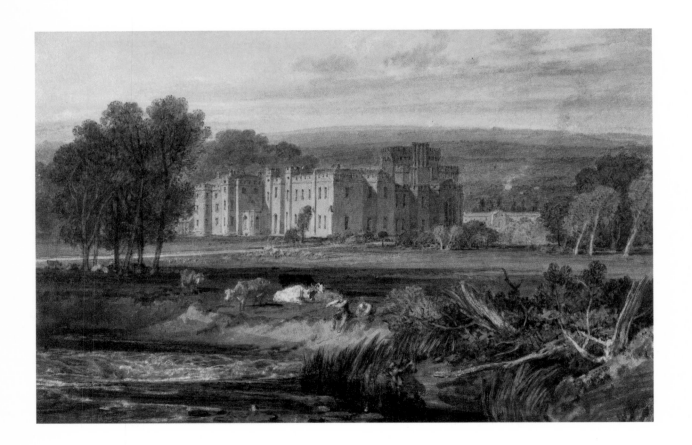

Cat. **24**
Battle Abbey
1810

Watercolour
37.5 × 55.2 cm

W 435
Private collection

PRELIMINARY MATERIAL: Pencil drawing
Views in Sussex sketchbook, 1810
(TB CXXXVIII, f. 2)

ENGRAVED: Aquatint by Joseph
Stadler, *c.* 1818
'Four Large Coloured Views in
Sussex' (R 825)

This drawing was made at the behest of the East Sussex Member of Parliament, landowner and slaveowner John ('Mad Jack') Fuller, who first hired it, and then purchased it. Battle Abbey was erected on the site of the Battle of Hastings by William the Conqueror to celebrate his victory of 1066; it was largely demolished in the Reformation.

In the foreground two boys stone an adder that slithers up a declivity towards a rabbit-burrow. The hole is paired with another, in a manner reminiscent of a pair of eyes. Above and between the boys and the snake is the circular, flat top of a tree-trunk that resembles the pupil and iris of an eye, and this too is a paired form, with another, circular cut-down trunk placed to the right. Neither the burrows nor the tree-trunks appear in the original pencil drawing, so Turner must have invented them and made them look like eyes.

The resemblance is surely not fortuitous, given the accepted belief that it was in his right eye – that is, the left eye as it faces us – that King Harold II of England was fatally wounded in 1066. The declivity in the roadside suggests that the snake is slithering towards the leftmost burrow. Equally, it seems likely that Turner emphasised the V-shape of the tree on the right so as to allude to the fateful arrow, just as the implied, imminent entry of the venomous creature into a circular aperture was designed to summon forth appropriately horrible associations.

Such an interpretation receives support from Turner's own explanation of the imagery in another view of the same subject he later made for Fuller, in which animals again symbolise death.[1]

Cat. **25**

Weymouth, Dorsetshire

c. 1811

Watercolour and scratching-out
14 × 21.3 cm
Signed lower right: *JMW Turner RA*

W 448
Yale Center for British Art,
Paul Mellon Collection

EXHIBITED: W. B. Cooke Gallery,
1822 (111)

PRELIMINARY MATERIAL: Pencil drawings
Devonshire Coast No. 1 sketchbook
1811 (TB CXIII, ff. 44 and 44v)

ENGRAVED: William Bernard Cooke,
1814, 'Picturesque Views on the
Southern Coast of England' (R 91)

Turner toured the West Country in 1811 and 1813 (and possibly 1814) to gather material for the 'Southern Coast' series, and between 1811 and 1825 he produced 39 designs, including this work, *Falmouth Harbour* and *Boscastle* (cats. 26 and 27).

Weymouth was an obvious subject for inclusion in the 'Southern Coast' series. Beyond bathers, washerwomen, lobster-pots doubling as weights, and beached and working fishing boats, the fashionable holiday resort stretches round to the Isle of Portland. The sky is especially fine, with a host of tiny scratched highlights lending sparkle, and some superbly confident tonal washes outlining the beams of sunlight. The pigment used to depict the topsail of a cutter passing in front of the Portland peninsula has become increasingly transparent with age.

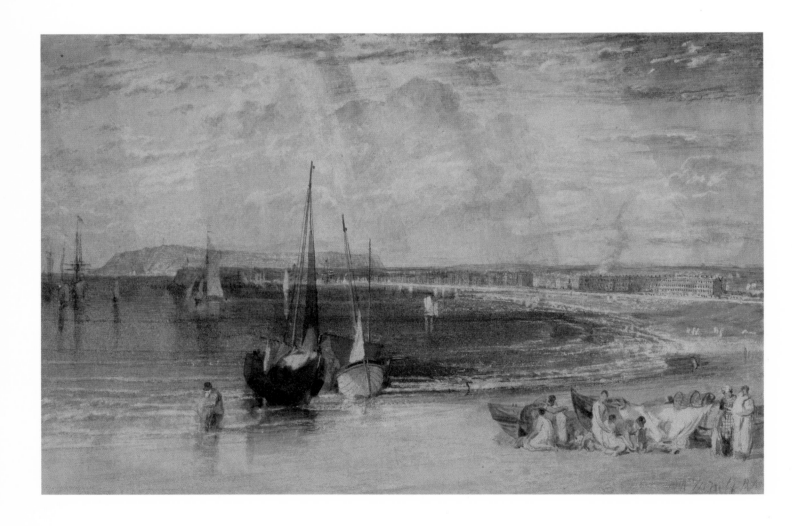

Cat. **25a**
Weymouth, Dorsetshire
1814

Copper engraving
14.7 × 21.8 cm

R 91
The British Museum, London

STATE: Engraver's proof touched
by Turner

ENGRAVED: William Bernard Cooke,
1814, for 'Picturesque Views on the
Southern Coast of England',
1814–26 (Vol. II, pl. 45)

Cat. 26

**Falmouth Harbour,
Cornwall**

c. 1813

Watercolour, gouache
and scratching-out
15.2 × 22.9 cm

W 455
Board of Trustees of the National
Museums and Galleries on
Merseyside (Lady Lever Art Gallery,
Port Sunlight)

PRELIMINARY MATERIAL: Pencil drawings
Devonshire Coast No. 1 sketchbook
1811 (TB CXIII, ff. 110 and 111)

ENGRAVED: William Bernard Cooke
1816, 'Picturesque Views on the
Southern Coast of England' (R 98)

Turner would have witnessed Falmouth harbour crowded with both civilian and military shipping in 1811, when the war with France was still in progress. However, it seems likely that the drunken revelry in the foreground – to music provided by a peg-legged fiddler – was introduced to typify the spirit of place, rather than being behaviour actually witnessed, since Turner customarily placed such antics in his representations of naval bases. The smoking chimney on the right may be a rather Hogarthian visual pun; certainly it seems appropriate in this sexually charged context.

In afternoon light we look across to Pendennis Castle in the centre, and to St Mawes in the distance on the left. The straightness and regularity of the white lines denoting waves in Carrick Roads were obtained by scratching-out with a scalpel drawn along the edge of a ruler.

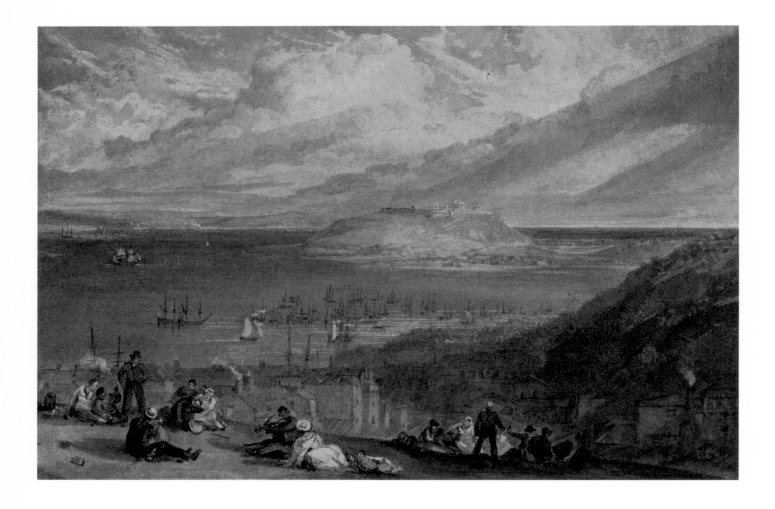

Cat. **27**

Boscastle, Cornwall

c. 1824

Pencil, watercolour, pen and ink
14.2 × 23.1 cm

W 478
The Visitors of the Ashmolean
Museum, Oxford

PRELIMINARY MATERIAL: Pencil drawing
Devonshire Coast No. 1 sketchbook
1811 (TB CXXIII, f. 182)

ENGRAVED: Edward Goodall, 1825,
'Picturesque Views on the Southern
Coast' (R 121)

In Turner's day Boscastle was a small but important trading port, although strong tidal flows in and out of the harbour rendered entry and exit extremely dangerous for shipping in stormy weather. Large vessels had to have their motion restrained by hawsers, and here a partially dismasted brig is being controlled in this way. Turner emphasised the imminent check on its progress by placing a small boat immediately beneath its bow; presumably the slack is about to be taken up, thus preventing collision. At the bottom right a mother and child play with a hoop whose circle is reiterated by the mooring-ring below; probably Turner wanted the maternal security they epitomise to project the security of the harbour more generally. A sequence of increasingly curved semicircles from lower left to top right imparts a sense of motion and unity to the windswept scene.

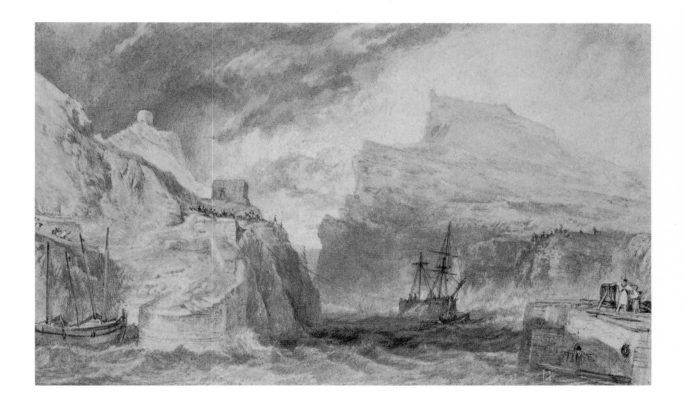

Cat. **28**

Ivy Bridge, Devonshire

c. 1813

Watercolour
28 × 40.8 cm

W 442
Tate. Bequeathed by the artist, 1856
CCVIII X

PRELIMINARY MATERIAL: Pencil drawing
Devonshire Coast No. 1 sketchbook
1811 (TB CXXIII, f. 153)
Devon Rivers No. 2 sketchbook
1813 (TB CXXXIII, f. 45)

ENGRAVED: James C. Allen, 1821,
'Rivers of Devon' (R 139)

This watercolour was made for engraving in a 'Rivers of Devon' scheme, although the project never appeared and its three constituent prints were published separately.[1]

Ivybridge is located some thirteen kilometres east of Plymouth. A figure rushing to catch the waiting Plymouth coach adds a touch of urgency to the afternoon scene, whose tempo is otherwise established by the gentle surges and eddyings of the River Erme. However, the focus of the design is the mass of foliage in the centre, for here Turner attained a new-found ability to depict such entanglements with the utmost clarity, while simultaneously investing them with a sense of their inner, organic life.

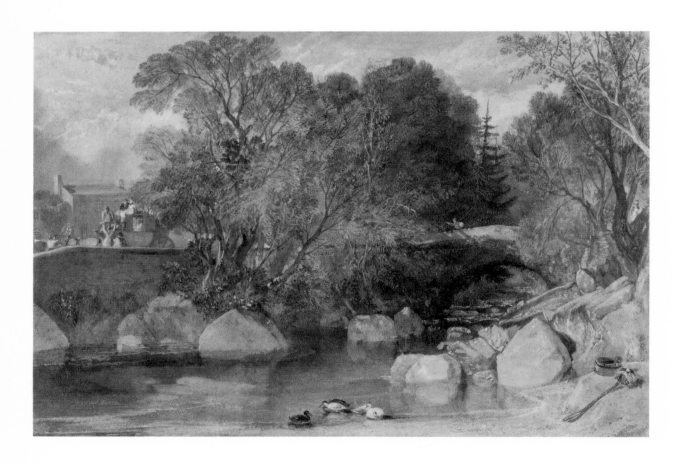

Cat. **29**

The Vale of Ashburnham

1816

Watercolour
37.9 × 56.3 cm
Signed and dated lower right:
IMW Turner RA 1816

W 425
The British Museum, London

PRELIMINARY MATERIAL: Pencil drawing
Vale of Heathfield sketchbook, 1810
(TB CXXXVII, ff. 68v and 69r)

ENGRAVED: William Bernard Cooke,
1816, 'Views in Sussex' (R 131)

Turner made this watercolour for an engraving scheme financed by John Fuller. Ashburnham Place is visible in the distance, with a line of Martello towers guarding Pevensey Bay and Beachy Head beyond it.

Ashburnham Place belonged to the East Sussex ironmasters, the Ashburnham family. Their smelting works at Ashburnham Forge was located behind the trees on the right of this view. Because of the noise and smoke given off by the furnace, Turner must have been aware of the ironworks in 1810, when he made the pencil drawing from which he developed this watercolour.

Iron-smelting required a great deal of charcoal to fuel its furnaces, and Turner organised his composition to stress the fact. An implied connecting line runs down the leading ash tree on the right, around the felled trunks in the centre foreground, along the cattle and men loading chopped timber onto a cart facing downhill towards the forge on the right, and then up a pall of smoke possibly given off by burning charcoal, to arrive at the house itself. By this timber-growing, wood-felling and tree-burning progression, Ashburnham Place is ingeniously framed by the basis of its finances.

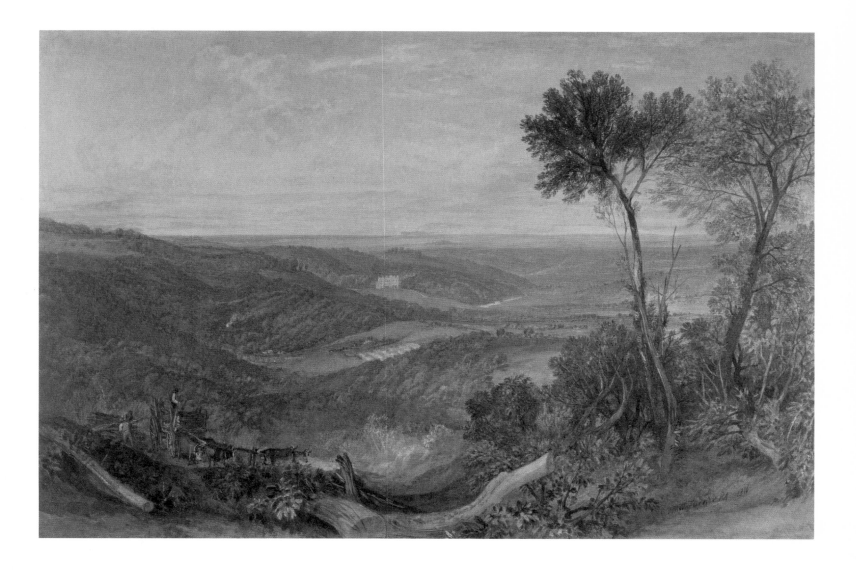

103

Cat. **30**

Crook of Lune, looking towards Hornby Castle

c. 1817

Pencil, watercolour, gouache and scratching-out
29.1 × 42.1 cm

W 575
Courtauld Gallery, Courtauld Institute of Art (D.1974.XX.4)

PRELIMINARY MATERIAL: Pencil drawings *Yorkshire 2* sketchbook, 1816 (TB CXLV, ff. 69, 69v, 70v, 71, 71v and 72) Preparatory colour study (TB CXCVIII)

ENGRAVED: John Archer, 1821 'History of Richmondshire' (R 183)

This watercolour was made for engraving in the 'History of Richmondshire' series, a partwork surveying a county that had embraced areas of Yorkshire and Lancashire in medieval times. The 'Richmondshire' project was conceived by the Revd Thomas Dunham Whitaker, a north-country cleric and antiquarian. Turner was commissioned to make 120 watercolours for the series, and was promised overall payment of 3,000 guineas for his designs. The project immediately proved unprofitable and was cancelled shortly after Whitaker's death in 1821, by which time Turner had made over twenty of the drawings, including *Simmer Lake*, *Weathercote Cave* and *Kirkby Lonsdale* (cats. 31–33). They hardly reflect the fact that when he toured Yorkshire and Lancashire in the summer of 1816 to gain material, the weather was extraordinarily wet because of a volcanic eruption in Asia in 1815.

The 'crook' of the River Lune is located near Caton, Lancashire, about seven kilometres upstream from Lancaster. We look north-eastwards in evening light towards Ingleborough on the horizon at the right, with various light accents leading the eye towards Hornby Castle nearer the centre. The saplings, boughs and trees on the right add a necessary verticality to the composition, and Turner's projection of their inner life augments the loveliness of the image.

Cat. **31**

Simmer Lake, near Askrig

c. 1817

Watercolour and scratching-out
28.7 × 41.2 cm
Signed lower right: *IMW Turner RA*

W 571
The British Museum, London

PRELIMINARY MATERIAL: Pencil drawing
Yorkshire 4 sketchbook, 1816
(TB CXLVII, f. 2v and 3r)

ENGRAVED: Henry Le Keux, 1822
'History of Richmondshire' (R 180)

'Simmer Lake' is the archaic name of Semer Water, in Wensleydale, Yorkshire. The preliminary pencil study from which this design was developed contains no indications of weather, light, figures or animals, and those ancillaries were elaborated in the final design from associations generated by the large boulder seen in the foreground. This is the Carlow Stone, which supposedly fell to earth after the Devil had failed to throw it from one end of Semer Water to the other. Crevices across the top of the rock, indicated by Turner, are reputed to have been created by the Devil's fingers. A black cow with prominent horns and a long tail sits to the right of the boulder. It rests with its rear haunch drawn up in an anatomically impossible, louche manner, which suggests that Turner intended it to allude to the Devil. These references are furthered by a sequence of horn-like shapes aligned across the foreground, including the pointed shadows on a cowgirl's bonnet on the left, and various double prongs on the right.

It is likely that Turner saw Semer Water under leaden skies in 1816, but he created a simmering heat-haze, possibly to augment the Satanic associations of 'Simmer Lake' and of the Carlow Stone.

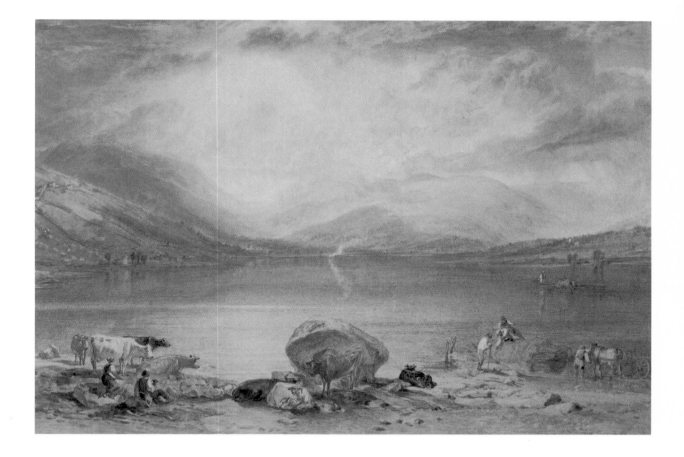

Cat. **32**

Weathercote Cave when half filled with water

c. 1818

Watercolour
30.1 × 42.3 cm

W 580
The British Museum, London

PRELIMINARY MATERIAL: Pencil drawing
Yorkshire 4 sketchbook, 1816
(TB CXLVII, f. 33v)

ENGRAVED: Samuel Middiman, 1822,
'History of Richmondshire' (R 188)

Weathercote Cave is actually a twenty-metre-deep pothole situated about four kilometres from Ingleton in Yorkshire, in one of the most desolate valleys in the north of England. Turner had descended to the bottom of the hollow around 1808, an experience that he was later to develop in a watercolour showing the view looking upwards (w 541, Graves Art Gallery, Sheffield). When he revisited the site in the unusually wet summer of 1816, the basin was almost brimming over with water, as is made evident by the comment 'Weather Cote full' scribbled on the pencil study that formed the basis of this watercolour. Because the artist did not want the pothole to look like a pond in the final design, he depicted it as being only 'half filled with water'.

We look across the scene in evening light, with stormclouds approaching from the north-east. In the centre, water pours from beneath the wedge-shaped limestone rock then known as 'Mahomet's Coffin'. The subtle rainbow near the centre was removed from the underlying colour with a sponge, after which a trace of pink was added to the damp paper. A strong sense of dynamism is imparted to the scene by the rhythmic lines of the tree-trunks and branches surrounding the pothole, and those lines equally augment the sense of pulsing life within the vegetation itself.

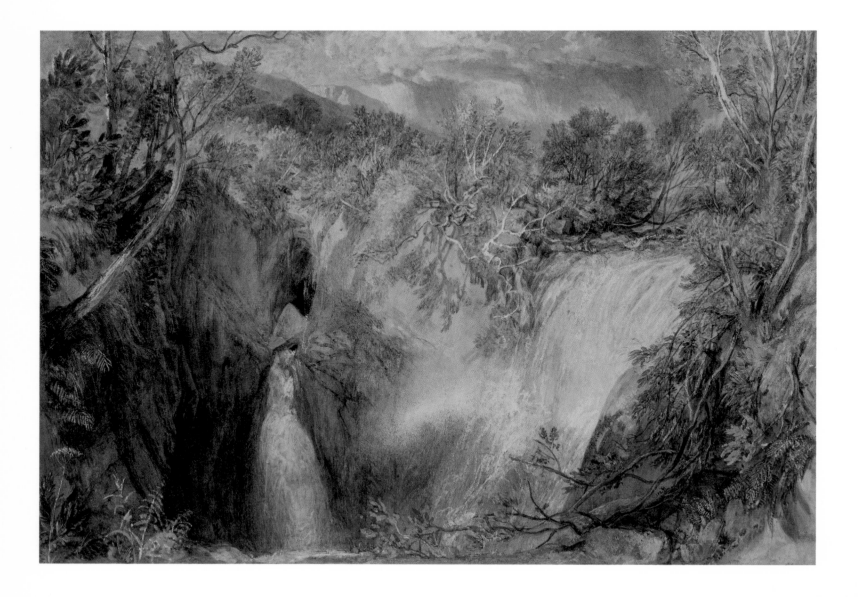

Cat. **32a**
Weathercote Cave when
half filled with water
1822

Copper engraving
19.3 × 26.8 cm

R 188
The British Museum, London

STATE: Engraver's proof

ENGRAVED: Samuel Middiman, 1822,
for 'History of Richmondshire',
1819–23 (Vol. II, p. 342)

Cat. **33**

Kirkby Lonsdale
Churchyard

c. 1818

Watercolour and scratching-out
28.6 × 41.5 cm

W 578
Private collection

PRELIMINARY MATERIAL: Preparatory
watercolour studies,
(TB CXCVI I V and W)

ENGRAVED: Charles Heath, 1822,
'History of Richmondshire' (R 186)

Turner may have developed this watercolour entirely from imagination and memory, for none of the pencil drawings he made in Kirkby Lonsdale in 1816 prefigures the design. It is possible that poor weather prevented him from drawing the view. Given the paucity of factual material, the creation of two fairly large watercolour studies for the final work must have played an important role in its realisation.

We look north-eastwards, with the sun rising above Barbon Fell across the valley of the River Lune. In the background on the left is a schoolhouse with its shutter open. While waiting for school to start, some boys are showing their indifference to both learning and mortality by using their schoolbooks for target practice on a tomb. Their disregard for the sanctity of a grave seems ironic, given their own ultimate fate (which might be burial in this very same churchyard). Such an allusion was well-suited to Whitaker's 'History of Richmondshire', for its author was an ecclesiastic. This is presumably why Turner referred to religious matters and superstitions in other designs; see *Simmer Lake, near Askrig* (cat. 31). It was natural for the painter to have moralised in a graveyard, for he was conversant with a large body of eighteenth-century poetry inspired by such places.

Associations of the eternal peace of the grave are projected by the mist-laden valley, while the eternal renewal of the natural world is signified by trees that both diffuse the sunlight and fully express their inner organic life as they do so.

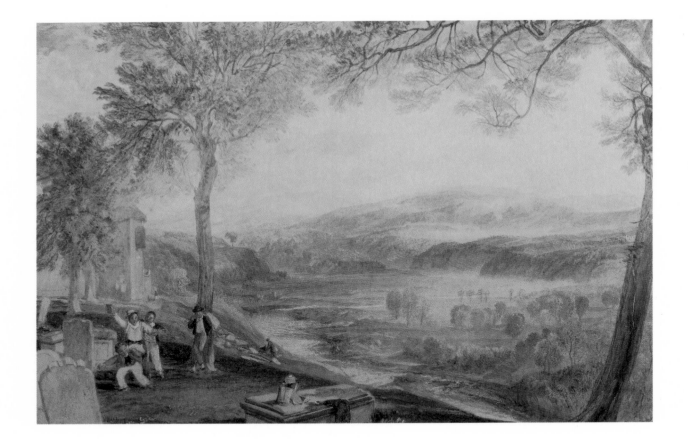

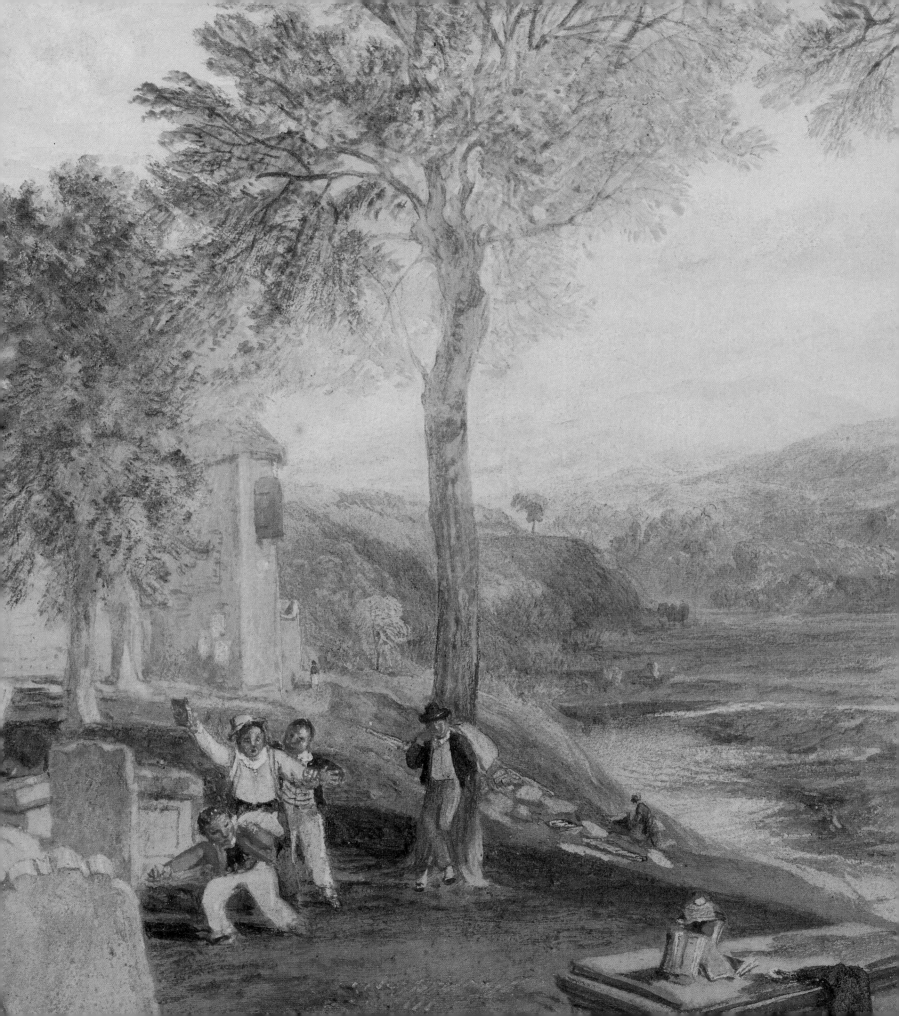

Cat. **34**
Gibside, Co. of Durham,
The Seat of the Earl
of Strathmore
[south-west view]
c. 1818

Watercolour
26.5 × 44 cm

W 557
Bowes Museum, Barnard Castle,
County Durham

ENGRAVED: Samuel Rawle, 1819,
Robert Surtees, *The History of*
Durham (R 141)

Gibside, near Gateshead, belonged to the 10th Earl of Strathmore, and Turner visited the estate in the company of its owner in late October 1817. The painter subsequently made these two views of the house in order to afford his patron a choice as to which of them he wanted engraved in Surtees's antiquarian tome, whose publication he supported. In the event the earl chose to have the south-west view engraved, although he bought both watercolours from Turner.

In the south-west view we see the house in late-afternoon light, with the 46-metre-high Column of British Liberty in the distance on the right; this had been erected in the 1750s by a local MP and coalmine-owner. Nearer, to the left across the valley of the River Derwent, is the neoclassical Gibside Chapel of 1760. The woman in classical-style dress leads the eye to the chapel and, in a typical example of Turnerian visual simile, the

vase on her head amplifies the shape of its dome. To the right of centre a tree on the near bank of the Derwent is vertically aligned with the Column of Liberty, and thereby reinforces its verticality. Probably the rich autumnal colours capture the hues that Turner had witnessed late in 1817.

The complementary portrayal of Gibside from the north is one of Turner's loveliest and most idyllic country-house views. Again we gaze across the Derwent in late-afternoon light, and in autumnal colouring. Here the Column of British Liberty dominates the landscape, and in another vertical alignment the eye is led to the monument from a boy and dog in the foreground, via a farmhouse. The youth peers warily over the edge of the escarpment, possibly because the cliff is as steep as the rockface on the right.

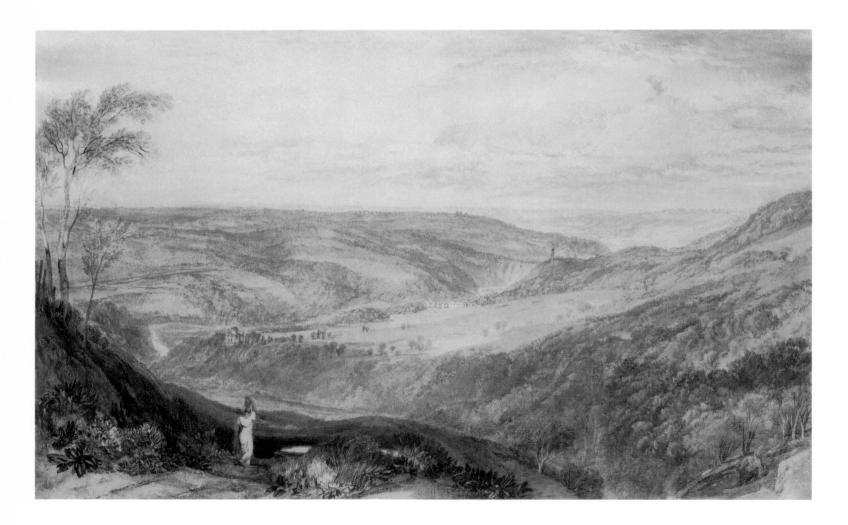

Cat. **35**
Gibside, Co. of Durham,
The Seat of the Earl
of Strathmore
[from the north]
c. 1818

Watercolour
27.5 × 45 cm

Listed under W 557
Bowes Museum, Barnard Castle,
County Durham

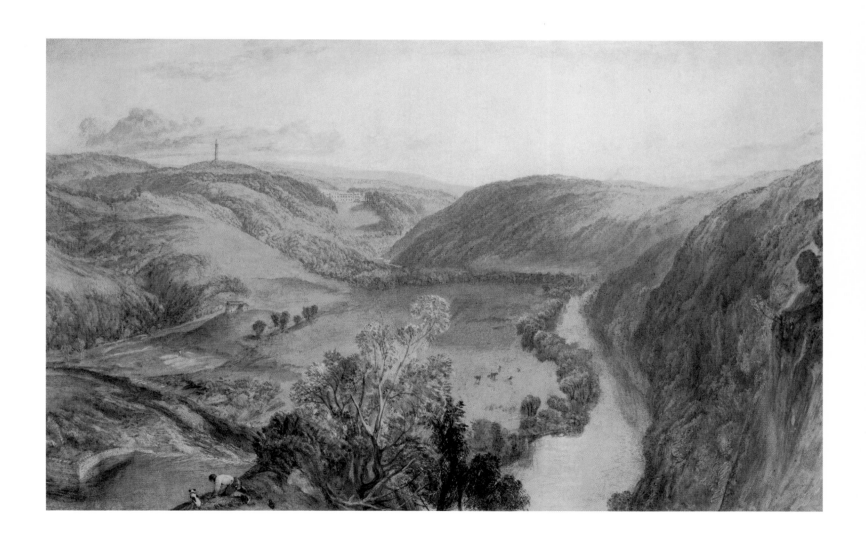

Cat. **36**

Borthwick Castle

c. 1818

Watercolour and scratching-out
16 × 24.9 cm
Signed lower left: *Turner*

W 1060
Indianapolis Museum of Art, Gift in
memory of Dr and Mrs Hugo O. Pantzer
by their children

PRELIMINARY MATERIAL: Pencil drawings
Scotch Antiquities sketchbook
1818 (TB CLXVII, ff. 75v and 76r); and
possibly *Scotland and Venice*
sketchbook, 1818
(TB CLXX, ff. 1 and 2)

ENGRAVED: Henry Le Keux, 1819,
'Provincial Antiquities and Picturesque
Scenery of Scotland' (R 191)

detail pp. 114–5

In 1818 Turner was invited to contribute images to a historical survey entitled 'Provincial Antiquities and Picturesque Scenery of Scotland', to be accompanied by a letterpress text written by Sir Walter Scott. Eventually the painter contributed twelve designs to the project, for which he visited Scotland in 1818 and 1822 (see also cat. 37).

Turner met Scott in November 1818 to discuss both images and text in advance of their creation, which explains why this design appears to take its cue from a metaphor that would later be provided by the writer. In his letterpress Scott would explain that Sir William de Borthwick had built Borthwick Castle upon the very edge of his lands so as to 'brizz yont (*Anglice*, press forward)', or intentionally encroach upon neighbouring territory to expand his domain.[1] Turner must have liked the metaphor, and even more the similarity of the word 'brizz' to the English word 'breeze', for it inspired the

figures, weather effects and curvatures of the trees in *Borthwick Castle*.

The castle dates from around 1430 and is situated about sixteen kilometres south-east of Edinburgh. A strong 'brizz' blows across the landscape, bending almost all the trees with its force, as well as the Highlanders in trews and kilts who press forward across the River Gore. (As in a later view of Norham Castle, cat. 55, Turner placed Highlanders in a Lowland setting, to enhance its identity as a Scottish landscape.)

Just beyond the men and horses stands a mother holding a baby dressed in swaddling; unlike the other figures and the trees, she remains impervious to the force of the gale. Turner here appears to be equating the strength of motherhood with that of the castle.

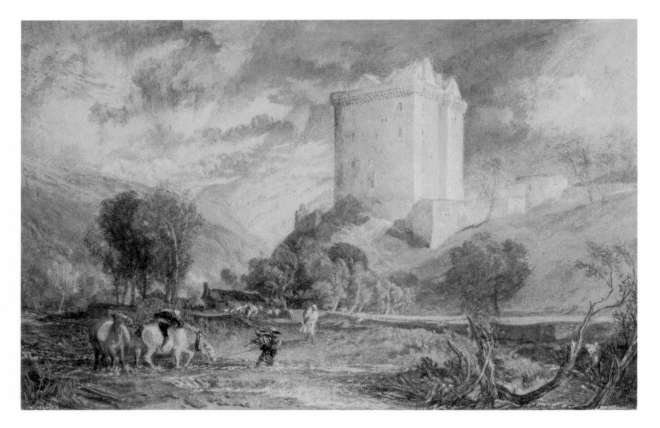

Watercolour
17.5 × 26.5 cm
Signed lower right: *Turner*

W 1065
Indianapolis Museum of Art; Gift in
memory of Dr and Mrs Hugo O.
Pantzer by their children

PRELIMINARY MATERIAL: Pencil drawing
Scotch Antiquities sketchbook
1818 (TB ĊLXVII, f. 66r)

ENGRAVED: W.R.Smith, 1823,
'Provincial Antiquities of Scotland'
(R 196); and reduced replica by W.R.
Smith, Tilt's 'Illustrations to Scott's
Poetical Works', 1834 (R 557)

The publication date of the engraving of this design appears on the print as 1822, while the paper watermark of the drawing is dated 1823. Even though watermarked dates are not entirely trustworthy, it is likely that in this case the promoters of the 'Provincial Antiquities' series wanted to suggest that the engraving was published in accordance with their original schedule, whereas it had been delayed because of financial problems. The engraving date has therefore been adjusted here.

Roslin Castle dates from the fifteenth century and overlooks the River Esk, about eight kilometres south of Edinburgh. Turner visited it in 1818. The watercolour demonstrates his unrivalled ability to draw complex woodland with the utmost clarity but without sacrificing anything of the wildness of natural forms. It has plausibly been suggested that the autumnal, russet colouring was inspired by a passage in Scott's

Lay of the Last Minstrel (1805), which recounts the legend that Roslin's chapel (seen up on the left) appeared to be consumed by flames whenever a member of the family occupying the castle faced death.[1]

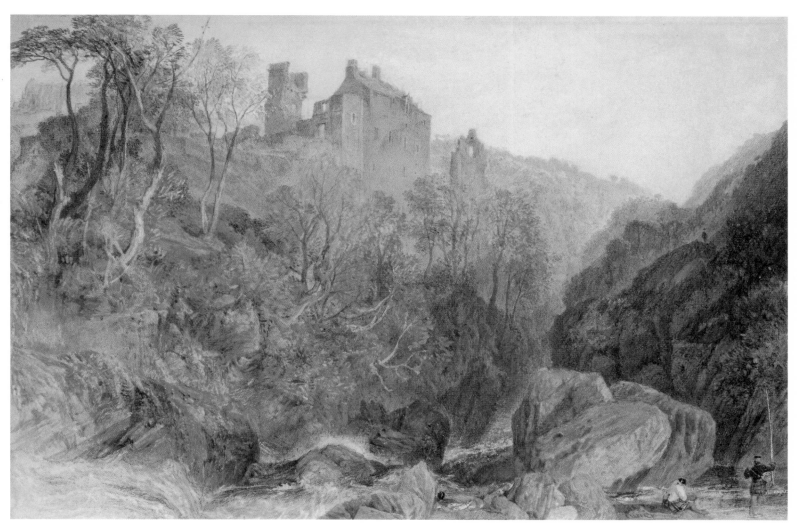

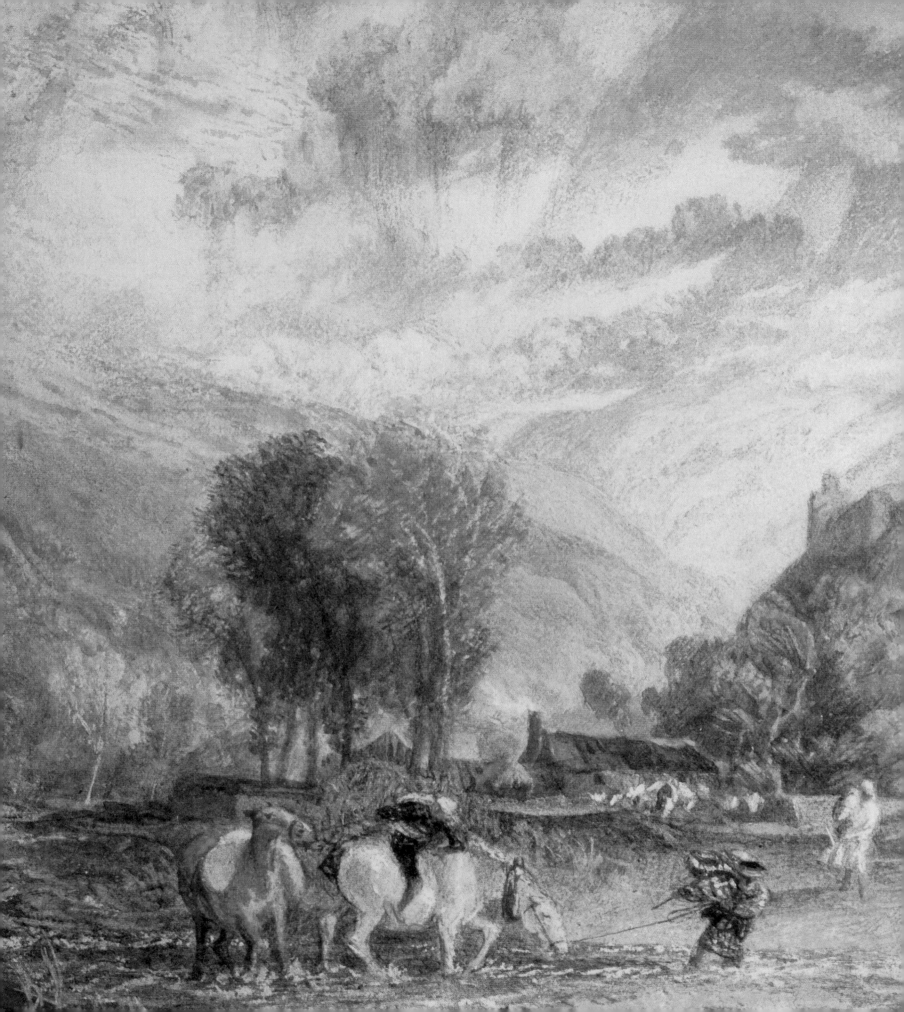

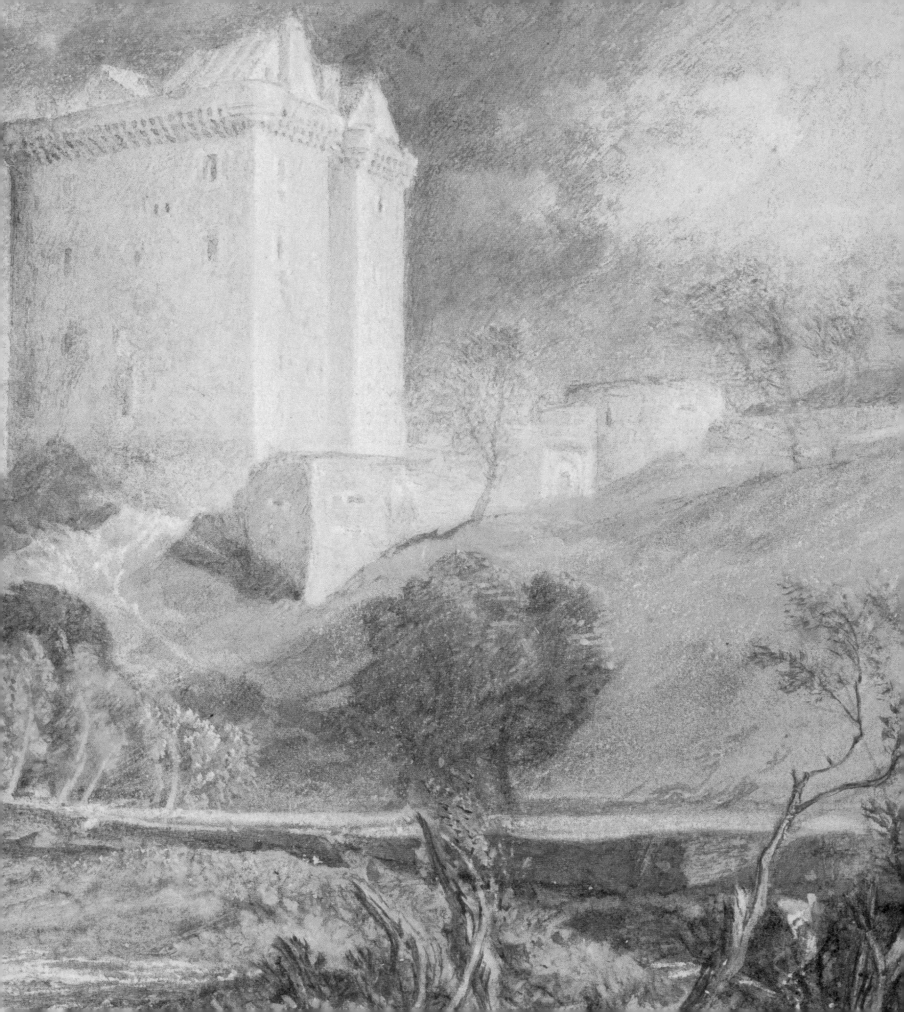

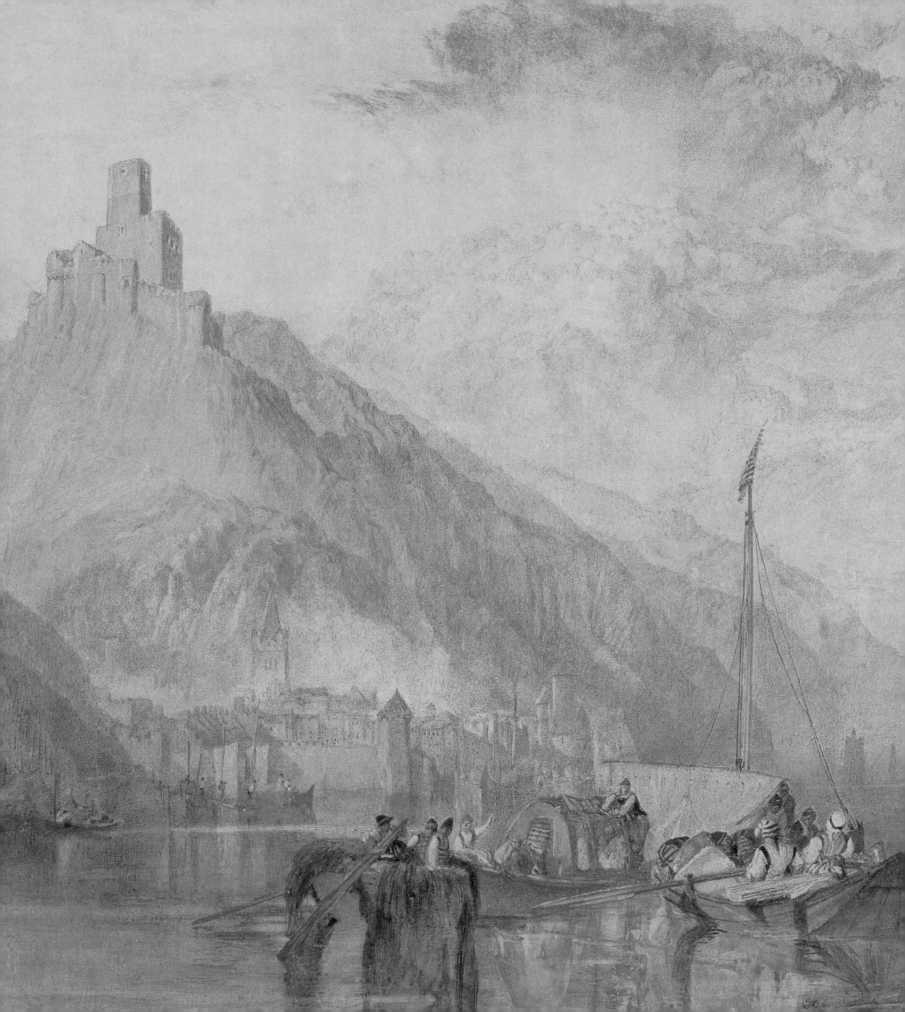

Watercolours Resulting from the 1817 Rhineland Tour

The conclusion of the Napoleonic Wars in 1815 opened up Continental travel to the British for the first time since 1803. In the late summer of 1817 Turner explored Belgium, the Rhineland between Cologne and Mainz, and Holland. In addition to filling sketchbooks with pencil studies and sketches, he made 50 gouache drawings on white paper prepared with a grey wash which he later sold to Walter Fawkes, apparently for £500 (see cats. 38 and 39). Turner's inventive use of gouache on a toned sheet demonstrates his constant willingness to take on new technical challenges. Further finished watercolours that later emanated from the 1817 tour are also included here (cats. 41 and 42).

detail cat. 42

Cat. **38**
The Loreleiberg
1817

Watercolour, gouache and
scratching-out on white paper
prepared with a grey wash
20.2 × 31.2 cm

W 648
Leeds Museums & Galleries
(City Art Gallery)

This work and *Rolandswerth Nunnery* (cat. 39) belong to the set of 50 watercolours of Rhine scenes bought from the artist by Walter Fawkes. The Lorelei rock is located about 35 kilometres south of Coblenz, and it looks down on a particularly treacherous stretch of the Rhine. Turner depicted it six times in the 1817 group alone (the others are w 646, 647, 684, 685 and 686), testament to its dramatic physical form and romantic literary associations. Here we view it in early morning light, and with a Rhine barge being towed upriver against the strong current.

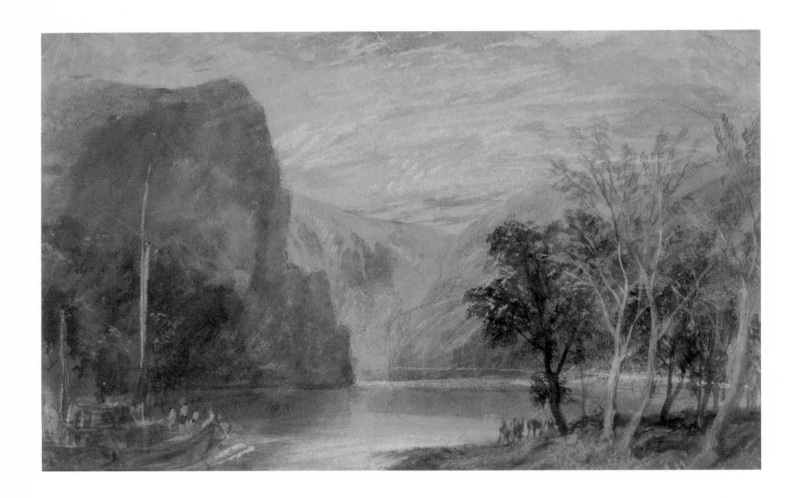

Cat. **39**

**Rolandswerth Nunnery
and Drachenfels**

1817

Watercolour and gouache on white
paper prepared with a grey wash
19.5 × 30.3 cm

W 666
Private collection

PRELIMINARY MATERIAL: Pencil drawing
Waterloo and Rhine sketchbook
1817 (TB CLX, f. 83)

The pencil drawing from which this watercolour was
developed was made on a boat in mid-stream. In the finished
work we have been moved on to dry land provided by an
invented extension of the west bank of the river. As in *The
Loreleiberg* (cat. 38), a Rhine barge is being laboriously towed
against the current. We look northwards, with the village
of Rolandseck on the left and the ruined Rolandswerth castle
above it. The Nonnenwerth convent stands on an island in
the centre, while in the distance on the right is the highest
of the Siebengebirge, the 321-metre Drachenfels.

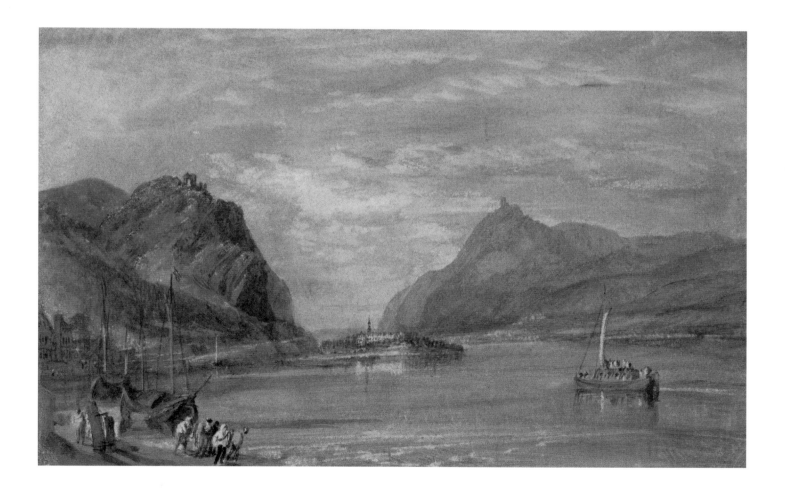

Turner elaborated this watercolour in connection with an 1819 scheme to engrave 36 new designs to adorn a book on Rhine scenery. Unfortunately, a rival publisher rendered the project economically unviable by bringing out a book on Rhenish scenery first; consequently Turner developed only three of the designs. The lengthy title used here was the one given to the watercolour on the only occasion it was exhibited during Turner's lifetime. (The misspelling of Boppard suggests the title derived from the painter.)

We look northwards from just below Boppard across a major bend on the Rhine about 24 kilometres south of Coblenz. Filsen is situated at the tip of the bend across the river, beyond and a little to the left of the boat, while Osterspai is discernible further off in the distance, to the right of the boat's mast. The design derived closely from one of the watercolours on grey-washed paper (fig. 35) that Turner had developed shortly after returning from the Rhineland in 1817. The major difference between the two images is that here the Rhine is extended leftwards, and consequently broadened. That expansion necessitated a steepening of the distant hillsides but it also permitted the inclusion of more of the far bank.

As always in Turner's rainbow scenes, there is a strong sense of dampness in the atmosphere, the bedraggled figures on the foreshore having been caught in a downpour.

Fig. 35
J.M.W. TURNER
Osterspey and Feltzen
on the Rhine: rainbow
1817

Watercolour
21.7 × 32.7 cm

W 674
Iris and B. Gerald Center for the
Visual Arts at Stanford University

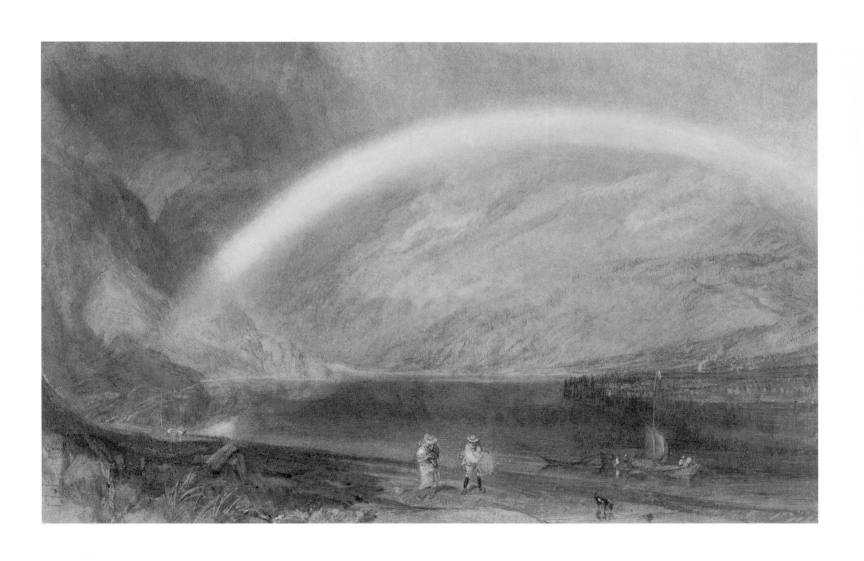

Cat. **41**

Mainz and Kastell

c. 1822

Watercolour and gouache
on white paper
20.8 × 36.5 cm

W 678
Private collection

PRELIMINARY MATERIAL: Pencil drawing
Waterloo and Rhine sketchbook
1817 (TB CLX, ff. 67v and 68r);
possible preparatory watercolour
(see below)

detail pp. 124–5

Although this design has long been thought to belong to the 1817 set of grey-washed Rhine drawings purchased by Walter Fawkes (see cat. 38 above), there are a number of reasons to discount that notion. Importantly, it is on white paper and not grey, as previously thought. Moreover, as Evelyn Joll has persuasively argued,[1] stylistically it appears to date from after 1817; it is somewhat larger than the 1817 watercolours; and its inclusion in the 1817 Rhine set would have brought the total of that group to 51 drawings, whereas it seems much more likely that Turner would have made a round number of works.[2] Furthermore, Walter Fawkes probably purchased the drawing after 1819, for apparently it was not included in the collector's display of his Turner watercolours open to the public in that year, when he would surely have exhibited it along with his other watercolours on white paper if he had owned it by then.

A possible clue to its date resides in a small watercolour in the Turner Bequest (CCLXIII 135, right-hand, sideways image). This is on a sheet watermarked 1822, and was perhaps a study for the work.

We look south-westwards in late-afternoon light, with Kastel on the left, Mainz on the right, and the boat-bridge that joined them in the centre. The clouds in the centre were brushed in while the underlying watercolour wash was still wet, with the result that the pigments were greatly diffused. Before they had dried Turner removed some of the colour with his fingers or thumb, and later added lines to tighten the forms. Much dry brushing of pigment is discernible across the foreground.

Cat. **42**
Kaub and the Castle of
Gutenfels

c. 1824

Watercolour
30.5 × 41.7 cm
Signed, lower right:
J M W Turner RA

W 1378
Private collection

PRELIMINARY MATERIAL: Pencil drawing
Itinerary Rhine Tour sketchbook,
1817 (TB CLIX, f. 77v); watercolour
studies (TB CCLXIII 387 and 388)

Kaub and the thirteenth-century Gutenfels Castle are situated
on the Rhine about forty kilometres south of Coblenz, and
Turner visited the town and fortification on his 1817 tour.
We look southwards soon after sunrise across an unusually
placid Rhine whose banks have been heightened to alpine
proportions. In the original pencil drawing Turner noted the
Pfalzgrafenstein, a fourteenth-century Palatine toll castle
situated on an island in the Rhine just off Kaub, but here he
has moved it about five kilometres upriver (it can be seen on
the horizon to the right of the boat's mast).

For a later, more distant treatment of this same landscape,
see catalogue number 80.

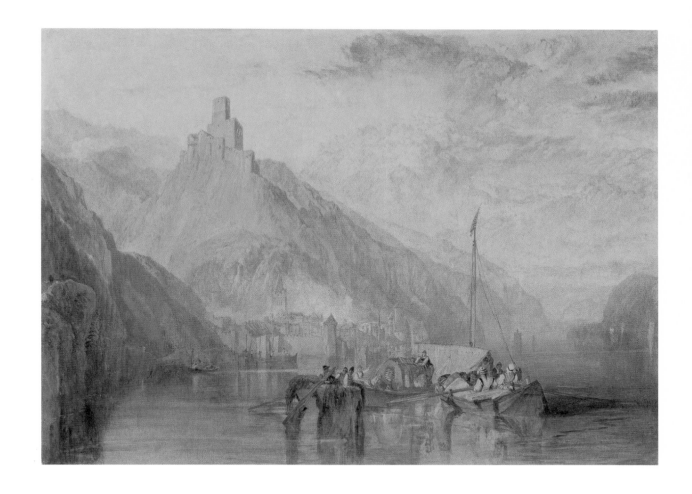

Further Commissions by Walter Fawkes

Walter Ramsden Hawkesworth Fawkes (1769–1825) appears to have met Turner around 1802, and their friendship lasted until the Yorkshireman's death. Politically, Fawkes was a Radical Whig, and this may have created an additional bond of sympathy between the two men. After 1808 Turner became a regular visitor at Farnley Hall, Fawkes's residence in Wharfedale midway between Leeds and Bradford, and a room was even reserved for his sole use there. After Fawkes's death Turner never returned to the house, probably because its associations with his friend proved too poignant.

Fawkes commissioned or bought six oils by Turner, as well as almost 250 of his watercolours. He hung the drawings at Farnley and at his London residence, 45 Grosvenor Place, Belgravia, where he permitted the public to view more than sixty of them in 1819 and 1820 (see pp.12, 37–9 and fig. 20). Turner is known to have worked at Farnley (see cat. 47), and it is highly likely that many drawings of the house, grounds and surrounding countryside were made there too (see cats. 45 and 46). In addition to acquiring views emanating from the 1802 Swiss tour and the 1817 Rhine journey (see above), Fawkes commissioned ornithological studies and literary illustrations (see cat. 50). He also purchased Italian views (see cats. 52–4).

detail cat. 45

Cat. **43**
Bolton Abbey, Yorkshire
1809

Watercolour and scratching-out
27.8 × 39.5 cm
Signed and dated lower right:
IMW Turner RA PP 1809

W 532
The British Museum, London

EXHIBITED: Grosvenor Place 1819 (?23)

ENGRAVED: Edward Finden,
The Literary Souvenir, 1826 (R 315)

Bolton Priory was an Augustinian foundation dating from the early twelfth century, and it mostly fell into decay after 1540. Turner made two complementary views of the ruin for Walter Fawkes in 1809, of which this is one. In the other drawing (w 531, University of Liverpool) we view the building from the south at dawn, while here we see it from the north in evening light. Confident scratching through wet watercolour with the tip of the brush handle is apparent across the foreground.

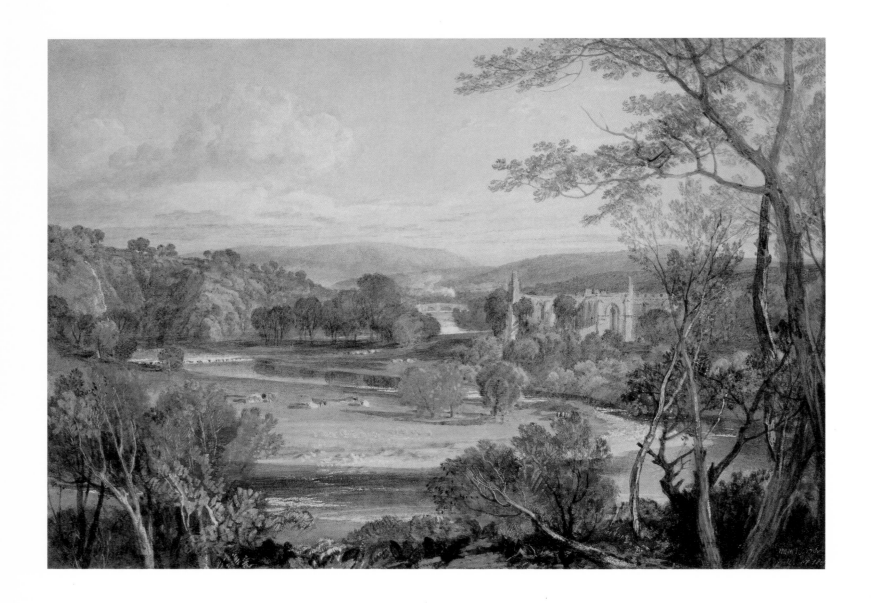

Cat. **44**

**Scarborough Town and
Castle: Morning: Boys
catching crabs**

c. 1811

Watercolour
68.7 × 101.6 cm

W 528
Art Gallery of South Australia
(on long term loan)

EXHIBITED: Royal Academy, 1811 (392);
Grosvenor Place, 1819 (16);
Music Hall, Leeds, 1839 (17)

PRELIMINARY MATERIAL: Preparatory
watercolour study (TB CXCVI C)

detail pp. 130–1

In 1809 Turner made a view of Scarborough for the collector Sir Henry Pilkington (w 527, Wallace Collection, London); it may be that Walter Fawkes was impressed by that work and commissioned this similar, larger and more magnificent design. Certainly he displayed it prominently in his London residence, where it may be seen hanging on the far wall of his East Drawing Room in Turner's 1819 watercolour of that interior (see fig. 20).

We gaze at Scarborough from the south soon after dawn, a viewpoint and time of day shared with the 1809 watercolour and a smaller drawing made around 1825 for engraving in the 'Ports of England' series (w 751, Tate Britain, London). As in the latter work, a brig has been beached for the transfer of cargo to and from carts, a procedure necessitated by the shallow waters at Scarborough. In the distance a bathing-machine has been pulled to the water's edge by a horse. The catching of crabs to which the title draws our attention may explain the framing of the crustaceans by a hoop held by a boy; perhaps Turner intended that circle to suggest their entrapment.

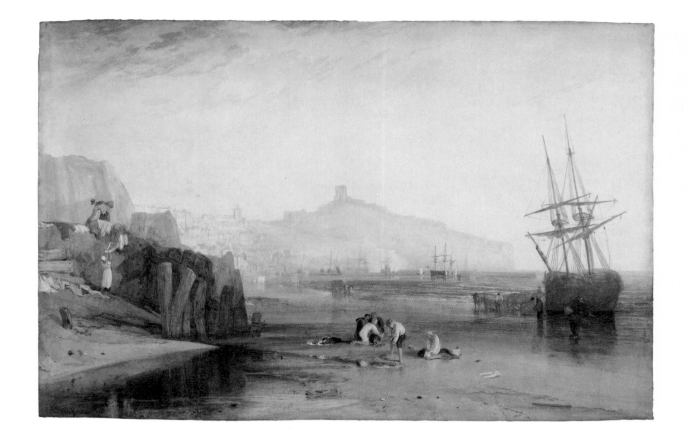

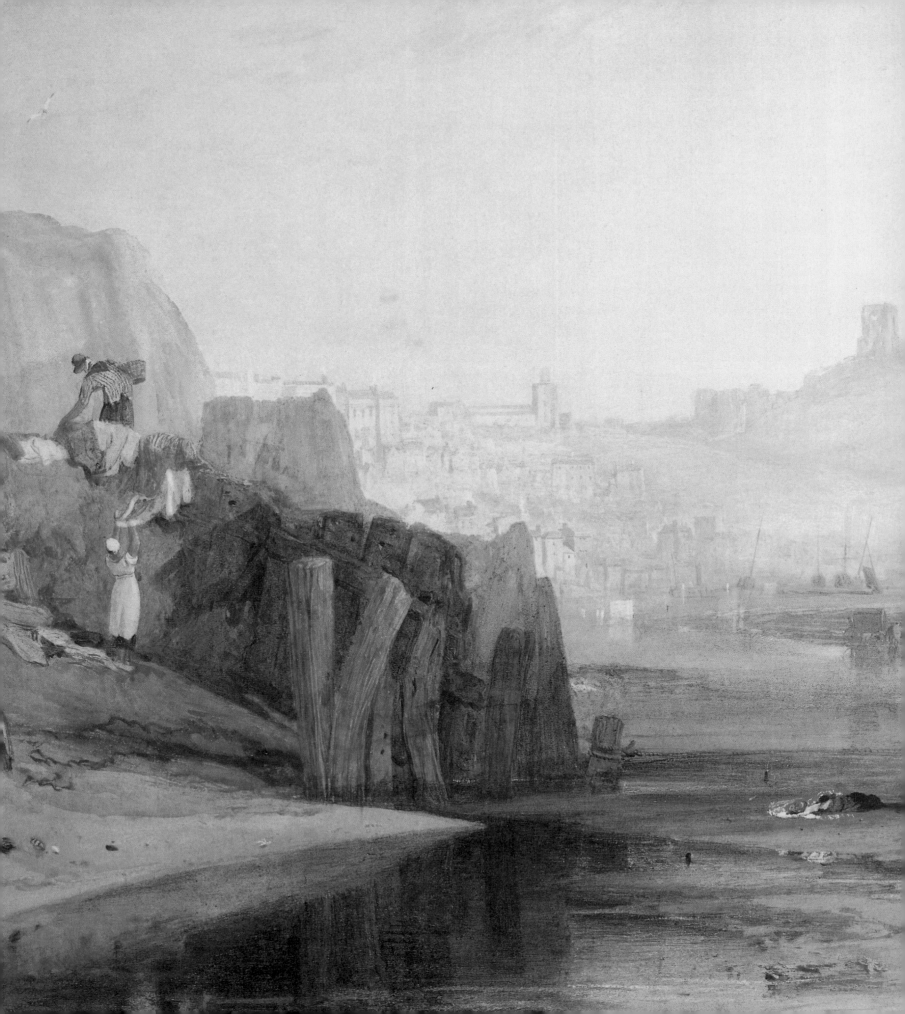

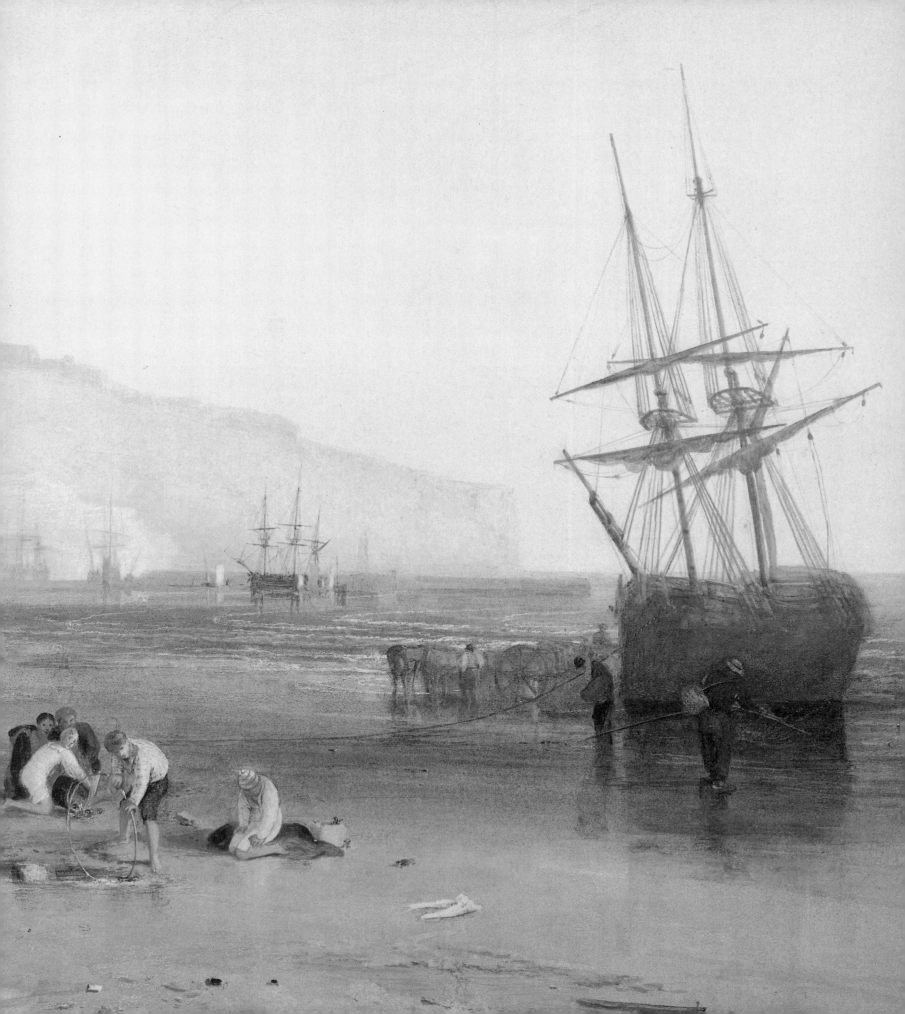

Cat. **45**
The Wharfe, from Farnley Hall
c. 1818

Watercolour and gouache
on grey paper
29.6 × 41.6 cm

W 609
Private collection

Walter Fawkes's country residence, Farnley Hall, near Otley, is situated to the north-west of Leeds. Turner made a large number of watercolours depicting the interior and exterior of the house, as well as views of its surroundings. Many of them are in gouache on medium-sized sheets of grey or brown paper, and all are intimate in mood, as can be gauged from this typical example. Turner's remarkable sense of form can be witnessed in the overall shape made by the far bank of the Wharfe, the curving line of woodland and the lower edge of the nearby hillside.

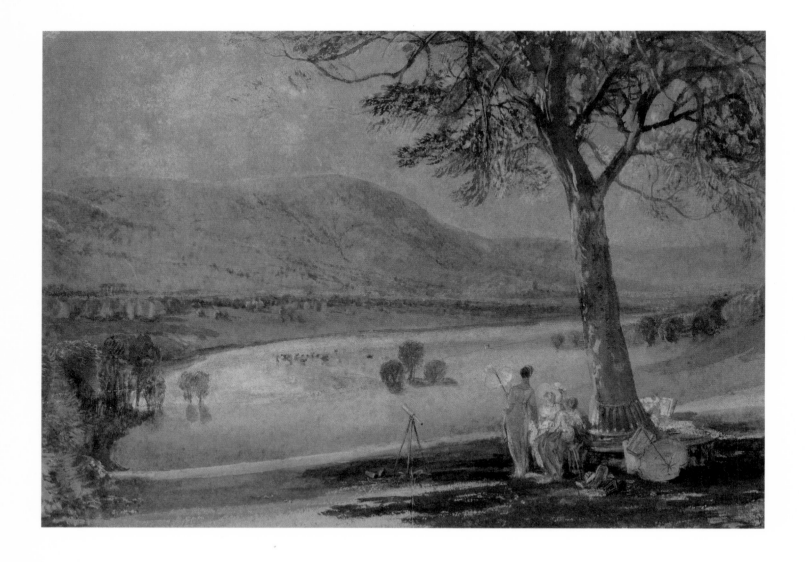

Cat. **46**

Caley Hall

c. 1818

Watercolour and gouache on
buff paper
29.9 × 41.4 cm

W 612
National Gallery of Scotland,
Edinburgh

Caley Hall stood on the north side of the Chevin, a large moor
to the south of Farnley Hall. Both houses were owned by
Walter Fawkes, who used Caley Hall as a hunting lodge –
hence the hunters returning with their quarry. The building
was demolished in 1964.

In the distance, on the right, are the Caley Crags, upon
which may be seen more stags. Although Turner drew the
figures with his customary disregard for academic convention,
they are all fully individualised by their gestures and bearing,
while their dogs are characterful and lively.

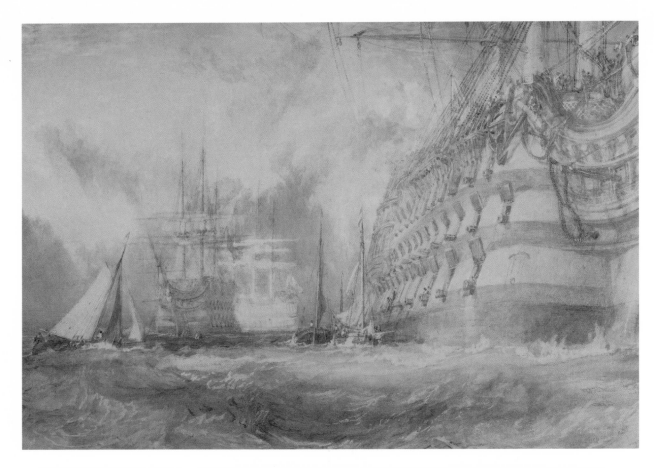

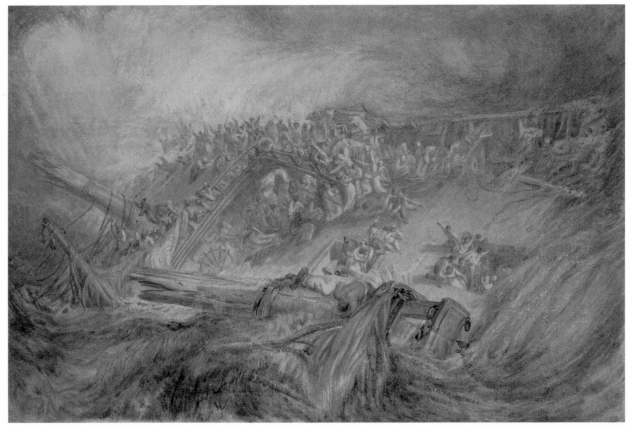

Turner created *First-Rate, taking in stores* in just a few hours in response to Walter Fawkes's request for 'a drawing of the ordinary dimensions that will give some idea of the size of a man of war'.[1] The 'First-Rate' of the title denoted a ship of the line of battle armed with more than 110 guns.

While waiting for its underlying colour-wash to dry, Turner may also have made a study for a pendant to the design,[2] and then the companion itself, in the form of *Loss of an East Indiaman*. The two finished watercolours were first publicly exhibited as pendants in Fawkes's London exhibition in 1819. Thematically they complement one another, for the battleship is at peace, while the merchantman battles with the elements.

In *First-Rate, taking in stores* the man-of-war is made to tower over us by the adoption of a very low viewpoint, and the depiction of merely a corner of the vessel leaves much room for imaginative expansion. The ship's proportions are exaggerated, for its lowest gunports appear to be about three metres high, whereas they would have been less than a third of that size. However, the upper levels of gunports perspectively decrease in size, which helps to make the ship seem larger. The man-of-war is further augmented in scale by the relative smallness of the distant battleships and by the tiny adjacent supply vessels, one of which flies the Dutch flag. In 1818 such colours signified peace, for Holland had been largely inaccessible to British shipping during the long wars with France that had ended just three years earlier.

Loss of an East Indiaman depicts the sinking of a specific vessel, the *Halsewell*, which ran aground on the Isle of Purbeck in January 1786 with over 166 casualties. The mast in the foreground indicates that the main part of the ship to our right has already been smashed to pieces; a freed mast would still be embedded in its base-block only if the vessel around it had broken up. The huge wave about to engulf the people on deck suggests that Turner was here portraying the very moment the *Halsewell* finally sank.

Turner versified the loss of the *Halsewell*,[3] and his interest in the catastrophe was shared by many painters and poets, Byron included.

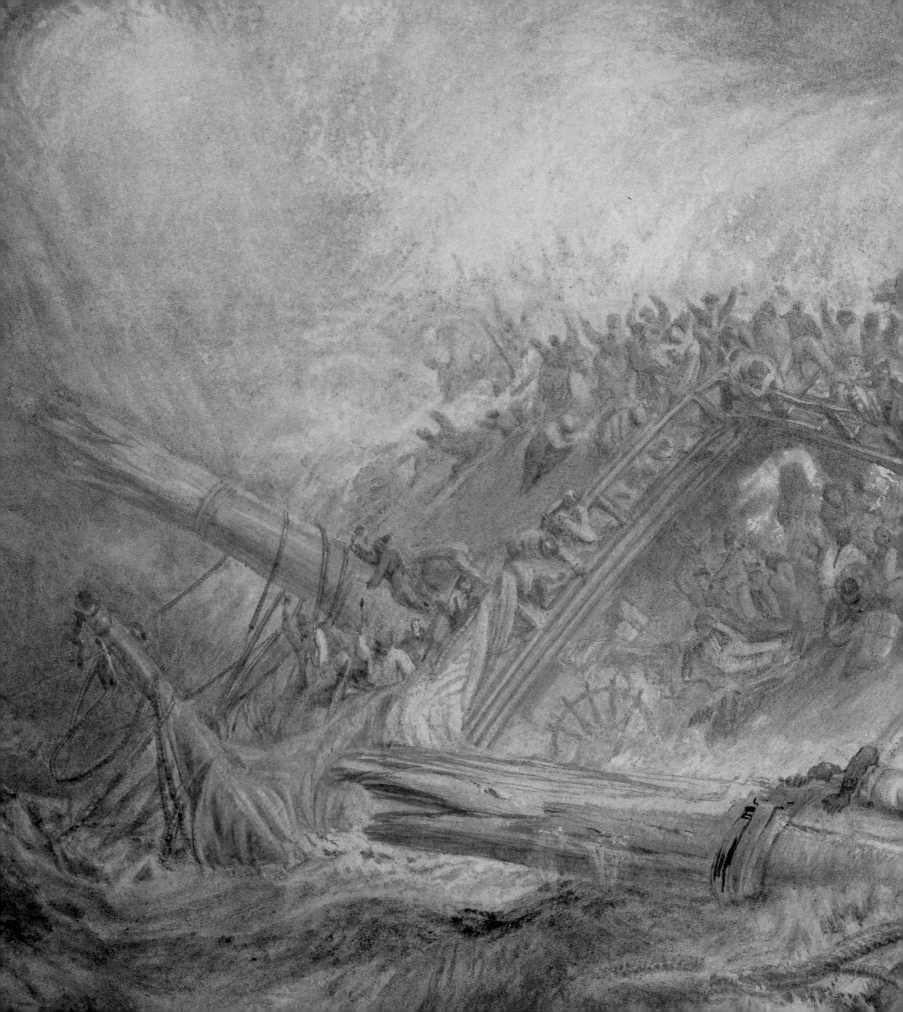

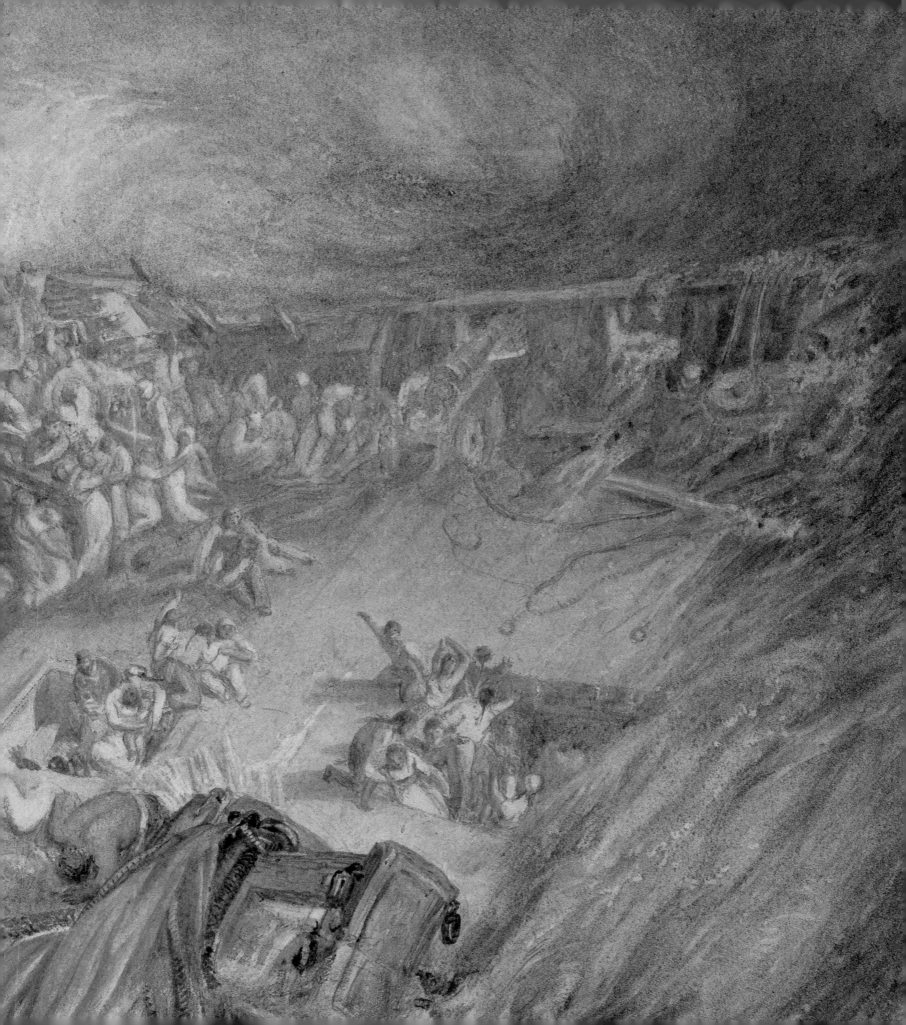

Cat. **49**

Interior of Fountains Abbey, Yorkshire

c. 1818

Watercolour
28 × 39.4 cm

W 546
Private collection

EXHIBITED: Grosvenor Place, 1819 (7);
Music Hall, Leeds, 1839 (52)

PRELIMINARY MATERIAL: Pencil drawing
*Devonshire Rivers No. 3 and
Wharfedale* sketchbook, 1816
(TB CXXXIV, f. 64)

detail pp. 140–1

It has been suggested that Turner made this watercolour to illustrate *A General History of the County of York*, although it was never engraved.[1]

The ruins of Fountains Abbey were incorporated into the gardens of the adjacent estate, Studley, by John Aislabie in 1768, and Turner drew the gardeners employed to maintain the enlarged property in 1797, when he first visited Fountains (see cat. 10). One of the Aislabie family gardeners appears here. We look northwards, in evening light, across the nave towards the base of the tower built by Abbot Marmaduke Huby shortly before the monastery was dissolved in 1539; the end of the day matches the decline of the building. The drawing is outstanding for its colouring and grasp of architectural form.

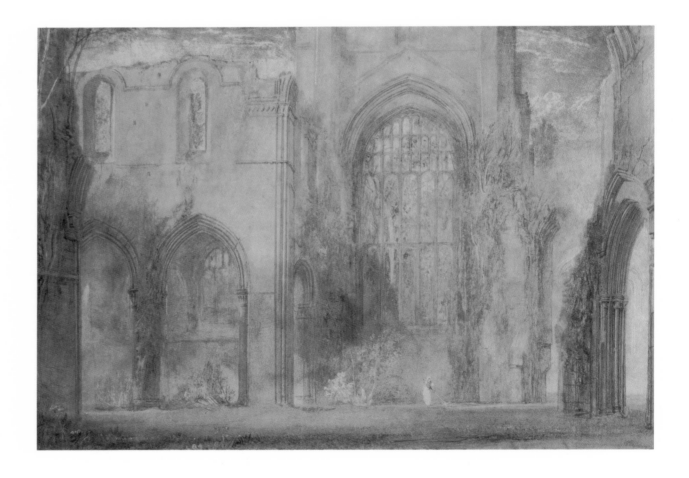

Cat. 50

Melrose Abbey

c. 1822

Pencil and watercolour
19.5 × 13 cm
Inscribed lower left:
Who'er would see fair Melrose 'right
Must visit it by the pale moonlight
Lay of the last Minstrel

W 1056
Private collection

In or around 1822 Walter Fawkes commissioned Turner to make ten watercolours illustrating verses by Lord Byron, Thomas Moore and Sir Walter Scott, as well as a manuscript by himself. The present design is one of four in the group inspired by Scott; it illustrates the *Lay of the Last Minstrel* (1805). In the opening lines of the second canto, which are misquoted by Turner,[1] Scott advises his readers to visit the ruins alone by moonlight, in order to experience fully the melancholy and beauty of the site. Turner's solitary figure seems aptly transported by the intense loveliness of the scene.

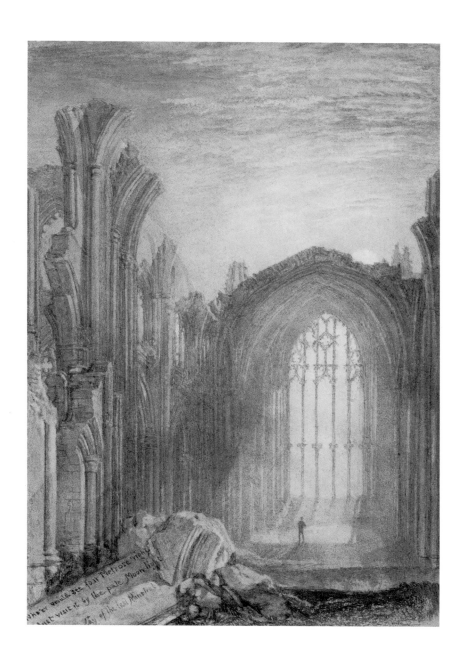

Italy, 1817–20

Although Turner had briefly set foot on Italian soil in 1802, when he explored the Val d'Aosta, he possessed some knowledge of Italian scenery by that time, for at the Adelphi Terrace, London 'academy' of Dr James Munro in the 1790s he had copied many Italian views by John Robert Cozens and others. After 1817 he elaborated a series of watercolours from drawings made in Italy by the architect James Hakewill, in order to illustrate a book on the country by the latter (see cat. 51).

Turner finally toured Italy proper between August 1819 and February 1820, basing himself mainly in Rome and visiting Naples, Florence and Venice. He returned to England laden with over two thousand pencil and watercolour sketches and studies, from which he elaborated a number of fine drawings. The examples discussed here display the new intensity of colour that resulted from his experience of Italian light (see cats. 52 and 53). Another work records an incident on the artist's return journey from Italy in 1820 (cat. 54).

Cat. **51**

Lake of Nemi

c. 1818

Watercolour and gouache
14 × 21.6 cm
Signed lower left: *JMW Turner RA*

W 711
Private collection, courtesy of
Agnew's, London

PRELIMINARY MATERIAL: Camera-obscura
pencil drawing by James Hakewill

EXHIBITED: W.B.Cooke Gallery, 1824
(153)

ENGRAVED: Samuel Middiman and
John Pye, 1819, James Hakewill,
Picturesque Tour in Italy (R 155)

This is one of ten watercolours commissioned by the British architect, James Hakewill,for engraving as plates in his book, *Picturesque Tour in Italy* (1818–20). Turner received 200 guineas for the commission and then created a further nine drawings for the venture. Hakewill supplied Turner with the visual material from which to develop the watercolours, in the form of pencil drawings made in a camera obscura.

Lake Nemi is located about twenty kilometres south-east of Rome, in the Alban Hills. Here we look south-westwards across to the Pontine marshes and Monte Circeo in the far distance. As must have been his practice when portraying places he had never visited, Turner ascertained the geographical bearings of the view from which he worked, for his lighting is accurately orientated for the evening, a time also indicated by the repose of people and animals. The long reflections on the lake add to the sense of stillness.

The image is especially remarkable for its depiction of light diffused through foliage against a darker background. At the lower right the sunlight reflected off a tree was boldly drawn in gouache.

Watercolour and scratching-out
28.6 × 40.6 cm
Inscribed lower right:
ROMA 1820 from Mt MARIO

W 719
Private collection

EXHIBITED: Music Hall, Leeds, 1839 (32)

PRELIMINARY MATERIAL: Pencil drawings
Rome: C. Studies sketchbook
1819–20
(TB CLXXXIX, ff. 31, 33 and 60)

This watercolour and *Rome from San Pietro in Montorio* (cat. 53) form part of a group of eight Italian views that Turner created for Walter Fawkes in 1820 and 1821.

We look south-eastwards at sunset from just below the brow of Monte Mario. In the distance on the right the dome of St Peter's rises above the horizon, and in order to preserve its dominance Turner has made the nearby Castel Sant'Angelo much smaller than it is in reality. On the left the Viale Angelico bisects the plain; beyond the Tiber lies the city of Rome. The girl in the foreground claps a hand over her ear, possibly because her piper friend is playing too badly or loudly.

Both this watercolour and catalogue number 53 are remarkable for their beauty of colouring, but the present work is also outstanding for its representation of complex foliage, as seen at the lower right. Indeed, the area where Turner first laid

down a set of blue touches and then delicately washed further colours around them while preserving the intervening white spaces is a technical *tour de force*.

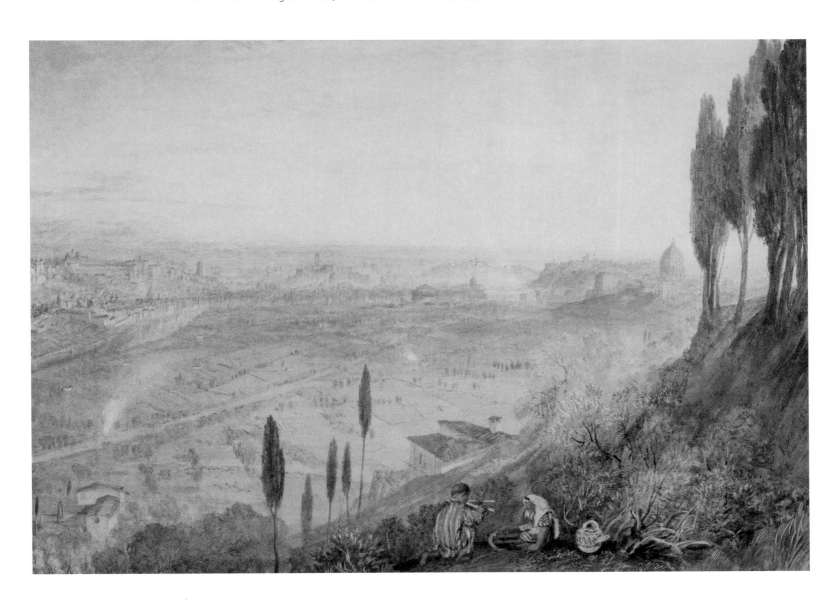

Cat. **53**
Rome from San Pietro in Montorio
c. 1820

Watercolour
28.6 × 41.9 cm
Signed lower right: *JMW Turner RA*
and inscribed: *Rome Pietro memorio*

W 720
Private collection

PRELIMINARY MATERIAL: Pencil drawing
Rome: C. Studies sketchbook
1819–20 (TB CLXXXIX, f. 2)

The church of San Pietro in Montorio stands at the southern end of the Janiculum Hill, on the west bank of the Tiber. In this evening view we look north-eastwards from the piazza in front of the church, across Trastevere towards the Aventino district on the far side of the Tiber, and with the Alban Hills in the distance. Roman work is denoted by the girls in the foreground, while Roman play is represented by the puppet-show further down the hill.

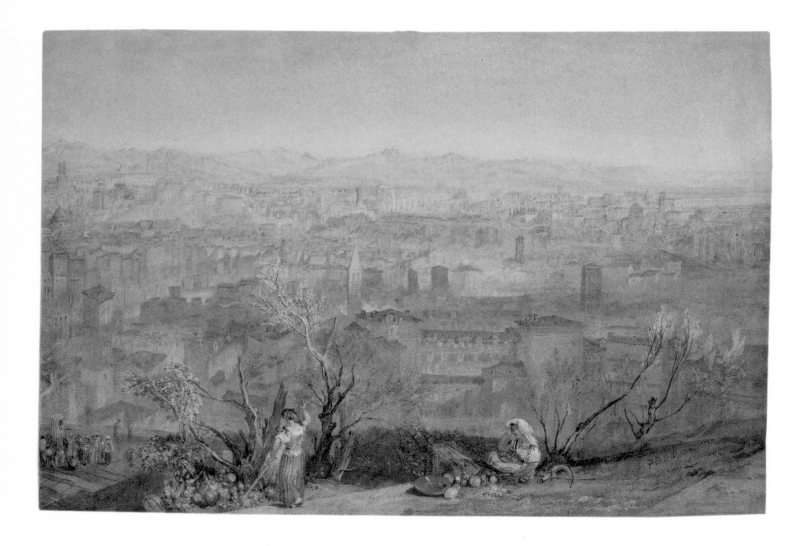

Cat. **54**

Passage of Mont Cenis

1820

Pencil, watercolour and
scratching-out
29.2 × 40 cm
Inscribed lower right: *PASSAGE of
Mt Cenis Jan 15 1820 JMW Turner*

W 402
Birmingham Museums and
Art Gallery

EXHIBITED: Music Hall, Leeds, 1839
(56)

The title given here is the one used for this watercolour on the
only occasion it was exhibited during Turner's lifetime.

On his return from Italy in 1820 Turner's carriage overturned
while crossing the Mont Cenis Pass between Turin and
Lanslebourg. Six years later he wrote to a friend about the
incident, recording that it had occurred at the head of the
pass; that he and a companion had been forced to escape
from the vehicle through its window because the door had
frozen shut; that the driver, guide and officials stationed on
the pass had subsequently begun to fight (the driver later
ending up in prison); and that they had then been compelled
to flounder down to Lanslebourg through knee-high snow,
identifying their route only by the snaking, precipitous sides of
the pass.

In the centre we see men fighting in front of a carriage.
Although it is upright, it may safely be identified as Turner's
1820 vehicle, given his recorded experiences. Another man
attempts to lead its horses forward. On the right, and possibly
because they are startled by the fighting, horses pulling a
driverless coach are turning back to the Italian side of the pass
(presumably their driver has gone off to assist the other
vehicle); as a result, a passenger attempts to open the coach
door. The savage sky and jagged shapes of rock and snow in
the foreground amplify this human discord on a huge scale,
and set its pettiness in cosmic perspective.

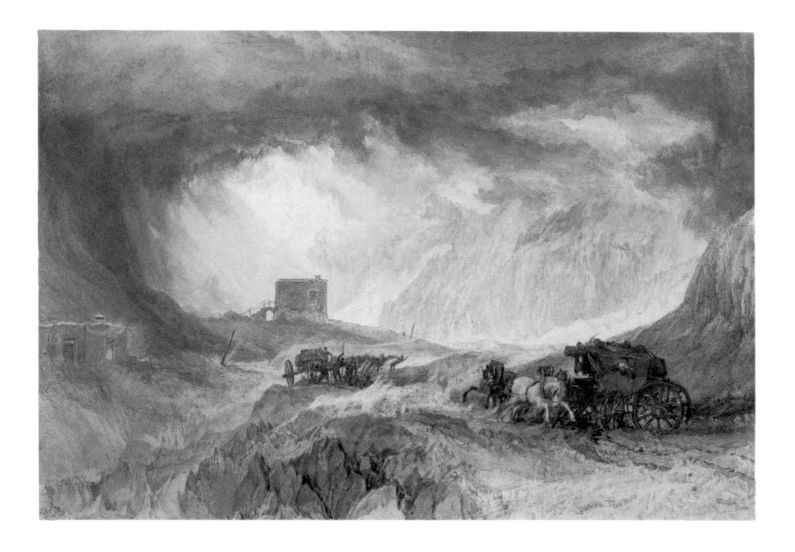

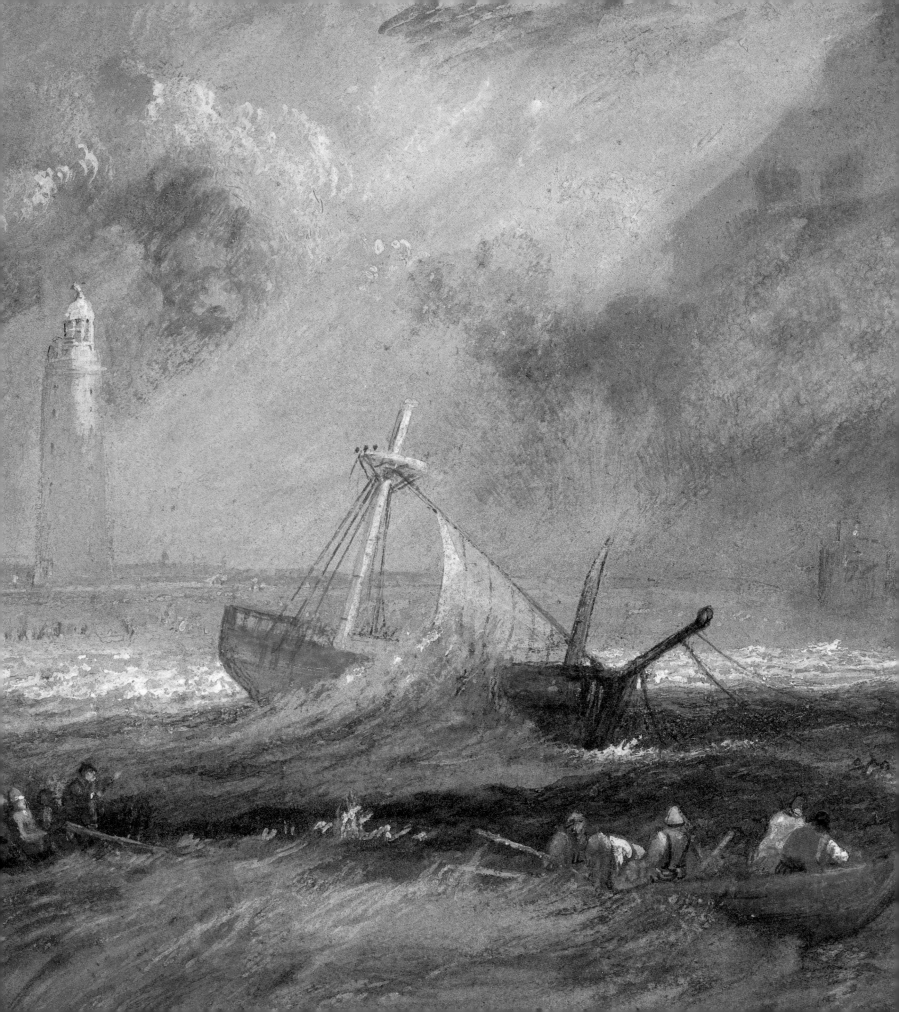

Topographical Projects of the 1820s and 1830s

The commercial and critical success of the 'Southern Coast' series encouraged the Cooke brothers to initiate other topographical watercolour engraving projects, and until Turner quarrelled with them in 1826 they had commissioned almost ninety works, of which they had engraved about half themselves. In order to further the sales of their prints, after 1822 they mounted a series of annual exhibitions in their rooms in Soho Square, London, and many Turner watercolours featured in the 1822, 1823 and 1824 exhibitions, where they were received very favourably by the press (see pp. 39–41).

Until the early 1820s the majority of prints after designs by Turner were produced on copper plates; subsequently they were mostly elaborated on steel plates, the greater hardness of which permitted larger numbers of prints to be produced, thus lowering prices. Many Cooke brothers publications in the 1820s took advantage of the new process. The breakthrough in the use of steel had been effected by the mezzotint engraver Thomas Lupton, whom the Cookes employed to reproduce several designs belonging to a series devoted to English rivers (cats. 55 and 59), as well as a group of magnificent marine views (cats. 56–8). Working on his own behalf Lupton also commissioned a sequence of portrayals of English harbours (cat. 60). The approaching completion of the 'Southern Coast' series in the mid-1820s led Turner possibly to elaborate *Whitby* (cat. 61), and the subsequent break with the Cookes generated the creation of a set of east-coast views in gouache on blue paper (cat. 62). Turner intended to publish the engravings of these himself but finally abandoned the project, probably because of lack of time.

A depiction of an Italian lake made for an aborted topographical project (cat. 63) was later used in a literary annual. In 1831 Turner concluded an agreement with the print publisher Charles Heath to create a series of views of the River Loire. The resulting publication was entitled *Turner's Annual Tour – The Loire* and contained 21 steel-engraved designs (see cat. 64). In 1834 and 1835 this work was followed by two more, uniform volumes devoted to scenery along the Seine (see cats. 65–7). The material for the Loire watercolours was gathered on a tour undertaken in 1826, while the Seine works were developed from studies made on a number of tours undertaken between 1821 and 1832. Turner executed all the finished Loire and Seine drawings in gouache on blue paper, and presumably selected that support because of the colouristic, expressive and technical challenges it offered. The watercolours are very sketchy in appearance, but by the early 1830s Turner could rely upon his engravers to make detailed representational sense of his expressive marks.

detail cat. 62

Cat. **55**

**Norham Castle, on the
River Tweed**

c. 1822

Watercolour and gouache
15.6 × 21.6 cm

W 736
Tate. Bequeathed by the artist, 1856
CCVIII O

ENGRAVED: Mezzotint, Charles Turner,
1824 'The Rivers of England' (R 756);
line-engraving, Percy Heath, 1827,
possibly for *The Literary Souvenir*
but unpublished (R 317)

In 1822 Turner reached an agreement with W. B. Cooke to contribute to a series of mezzotint engravings, to be entitled 'The Rivers of England'. Over the following three years he created seventeen or more watercolours for the project, to which *Totnes* (cat. 59) also belongs.

On the left a boatman by the Scottish bank of the Tweed is dressed in a Tam O'Shanter and kilt, even though such Highland dress would rarely have been worn in the Lowlands (see also cat. 36). The building beyond the Highlander seems equally misplaced, being more Italianate than Borders. Turner makes the castle larger and squarer than it is in reality. The far, English, bank of the river is also greatly heightened. A sail on the Tweed reiterates the silhouette of the prominent tower of the castle, and thereby pictorially reinforces it.

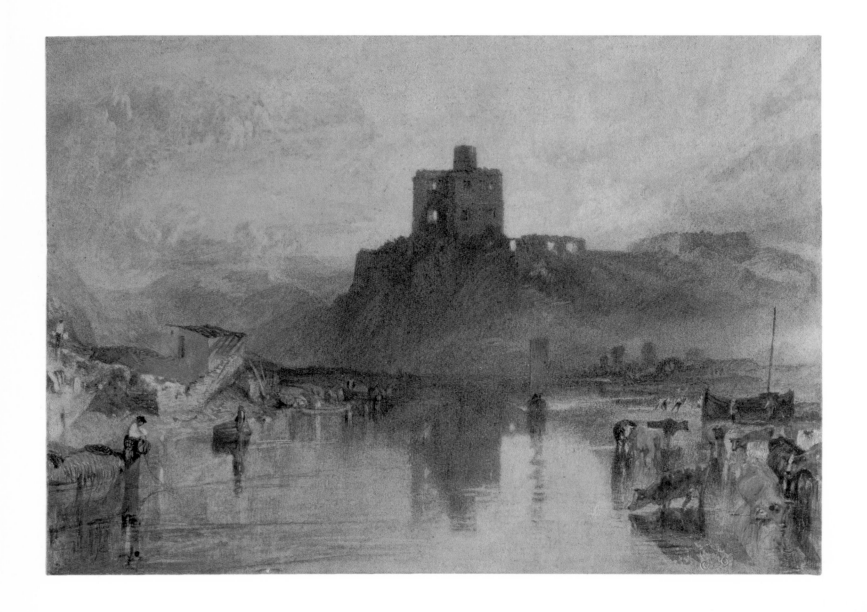

Cat. **55a**
Norham Castle on the
River Tweed
1824

Steel mezzotint
15.3 × 21.7 cm

R 756
The British Museum, London

STATE: First published state
(Turner's copy)

ENGRAVED: Charles Turner, 1824, for
'The Rivers of England', 1823–27
Also line-engraving, Percy Heath,
1827, possibly for *The Literary
Souvenir* but unpublished; R 317

Cat. **56**

Dover Castle

1822

Watercolour and gouache
43.2 × 62.9 cm
Signed and dated:
JMW Turner 1822

W 505
Museum of Fine Arts, Boston.
Bequest of David P. Kimball in
memory of his wife, Clara Bertram
Kimball, 1923

EXHIBITED: W. B. Cooke Gallery, 1823
(26)

ENGRAVED: James Tibbitts Willmore,
1851 (R 666)

In 1822 W. B. Cooke commissioned Turner to make a series of large watercolours to be reproduced in mezzotint and published under the title of 'Marine Views'. Between 1822 and 1824 the artist made seven new drawings for the scheme, as well as a title-page vignette; he also allowed an earlier watercolour to be reproduced. The views of Margate and Folkestone (cats. 57 and 58) belong to the set. Although Cooke intended to have *Dover Castle* copied for the series, it was not reproduced until much later.

Here Turner celebrated the coming of the age of steam. A strong westerly wind is indicated by various flags, and it causes several fishing vessels to reduce sail in order to avoid being blown out to sea. However, an incoming British paddle steamer simply cuts through the wind. The waving and running figures on the north pier illustrate the excitement that this new mode of transport must have provoked in 1822, just a year or so after the inauguration of a regular cross-channel service, and merely six years after the *Majestic* had been the first steamer to sail to France.

The lugger on the left flies a foreign flag and faces disaster, for its helmsman is jammed between a mass of canvas that should have been stowed, and a gallows or mast-supporting frame. As a result, he cannot move the tiller any further to the right, with the likely outcome that his boat will soon collide with a vessel passing immediately before it. Despite the entreaties of his colleagues there is little he can do, especially as the mainsail is being lowered and will shortly add to his difficulties. Turner often scoffed at the poor sailing abilities of foreigners,[1] and by doing so here he expressed pride in the technology that had enabled the British to overcome the tribulations of sail.

The beak-head prow and hull of the steamer reveal her origins as a sailing ship, while the wrecked brig placed just beyond her again underlines the replacement of sail by steam. The foremast and funnel of the steamer are aligned with the towers of the Roman Pharos (or lighthouse) and the church of St Mary in Castro above them. In front of the steamer a tiller and partially submerged rudder resemble an axe in overall shape, and perhaps they were intended to suggest that the steamer is cutting through the wind. The underlying movement of the sea, its reflections, and the dampness of the late-afternoon sunlight are captured with Turner's customary mastery.

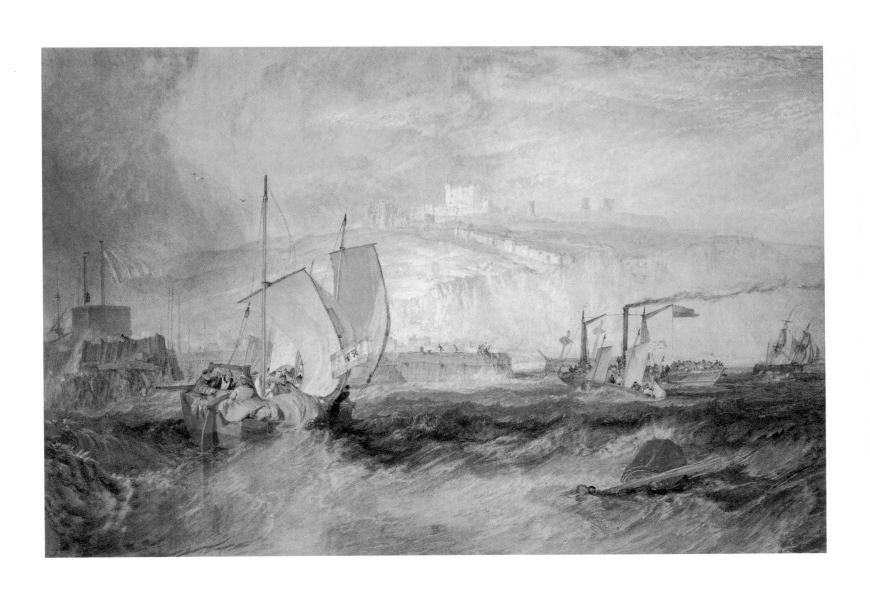

Cat. **57**
Sun-Rise. Whiting Fishing at Margate
1822

Pencil, watercolour, gouache and scratching-out
43 × 64.6 cm
Signed and dated: *JMW Turner 1822*

W 507
Private collection

EXHIBITED: W.B.Cooke Gallery, 1823 (unnumbered)

ENGRAVED: Mezzotint, Thomas Lupton, 1825, 'Marine Views' (R 772); small replica, Thomas Lupton, 1834 (R 774)

Turner had known Margate since childhood, and this is his largest watercolour depiction of the town. The chatter of the fishermen intrudes upon the tranquillity of the morning scene, while in the distance on the left a guardship fires the morning gun, the noise of which shatters the calm. To left and right vessels are bunched together; Turner loved to create such complex groupings of shapes. The reflections on the surface of the water are outstanding, as are the delicate tonalities employed for the depiction of the town and cliffs.

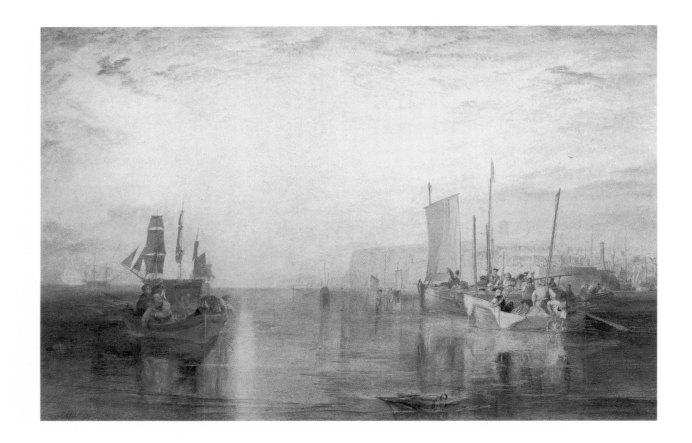

The size, nautical subject and probable date of this watercolour indicate that it was created for the 'Marine Views' series. It was never engraved and remained with the artist in an untrimmed state.

Because of its proximity to France, Folkestone was heavily involved in smuggling; indeed, the boat on the left flies the tricolour. Barrels, probably containing gin, are being tied to a weighted 'sinking-rope' that will be allowed to drop to the sea bed;[1] later, pretending to be fishing, the smugglers will 'creep' the kegs by dragging the bottom with grappling hooks, before sneaking them ashore. Unfortunately for the smugglers, an overcast sky has cleared (and lightened) earlier than anticipated. As a result, they have been detected and are raising sail to speed their escape from customs officers approaching on the right.

Notable features of the work include the heavy swell of the sea; the mistiness of the moon and amplification of its shape by the adjacent foresail; and the shift from coolness on the left, to warmth on the right, where the golden dawn light is reflected by the clouds above Folkestone.

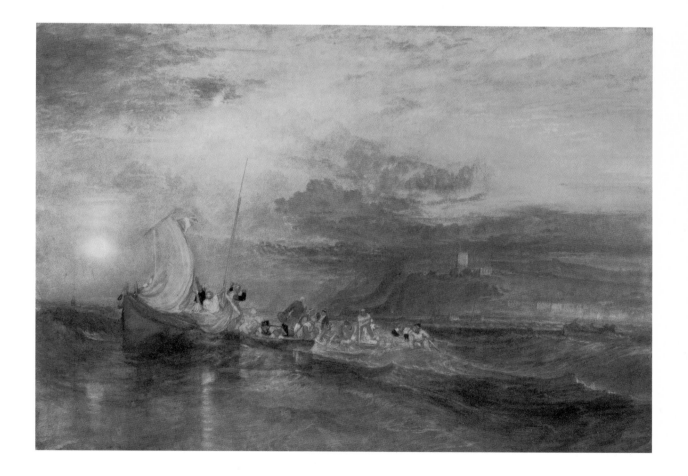

Cat. **59**

Totnes, on the River Dart

c. 1824

Watercolour
16.2 × 23 cm

W 747
Tate. Bequeathed by the artist, 1856
CCVIII B

PRELIMINARY MATERIAL: Pencil drawing
Devonshire Coast No. 1 sketchbook
1811 (TB CXXIII, f. 91v)

ENGRAVED: Mezzotint, Charles Turner,
1827, 'The Rivers of England';
because of inherent defects the steel
plate was subsequently cancelled
(see R 767)

In this 'Rivers of England' watercolour we look north-westwards in late afternoon light. Distant storm clouds move off, leaving the air absolutely still, as the fully extended but slack sail of a hoy on the left makes clear. A subtle pink wash diffused across the area of the river contributes greatly to its frosted-glass sheen.

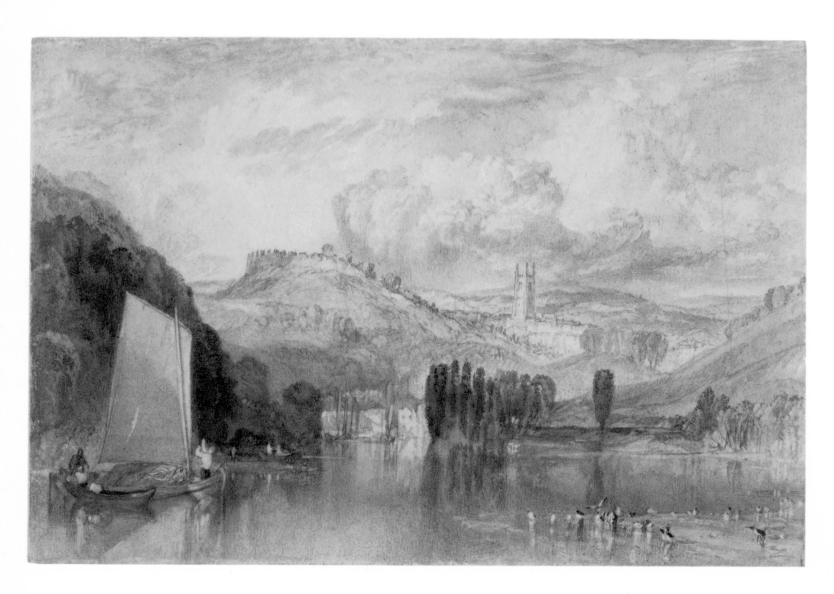

Cat. **60**

Portsmouth

c. 1825

Watercolour
16 × 24 cm

W 756
Tate. Bequeathed by the artist, 1856
CCVIII S

PRELIMINARY MATERIAL: Pencil drawings,
London Bridge and Portsmouth
sketchbook, *c.* 1824
(TB CCVI, ff. 1–3, 5, 9);
preparatory colour study (TB CCIII A)

ENGRAVED: Thomas Lupton, 1828,
'The Ports of England' (R 784)

In 1825 Turner agreed to supply the mezzotint engraver Thomas Lupton with 25 watercolours whose reproductions could be published under the title 'The Harbours of England' (this was changed to 'The Ports of England' when the work appeared). The scheme was terminated in 1828 when Turner and Lupton fell out (although in 1856, after the painter's death, Lupton reprinted the mezzotints he had earlier completed, and published those he had been forced to abandon). By 1828 Turner had made fifteen or sixteen of the drawings.

Control versus disorder is the underlying theme here. Just to the right of the waving sailor, and beyond and above the cutter, is the Admiralty Semaphore Tower. This building supported a signalling device that facilitated rapid contact with the Admiralty in London via a number of relay stations across southern England, and the adjacent sailor underlines the theme of naval communication. The man-of-war to which he gestures is preparing to leave port soon after sunrise. Ruskin noticed that the sails of the vessel are in some disorder.[1] Despite any momentary loss of control, however, the battleship towers over the harbour and town as the embodiment of naval grandeur.

The waving seaman maintains an experienced balance in rough waters and his waving gesture also furthers the mood of optimism. The implied motion of the breaking wave on the left is reinforced by the buoy beyond it, while on the right a counter-rhythm is created by the curves of both the waving sailor's arm and the rear edge of the cutter's billowing mainsail. The powerful sense of ebb and flow in the choppy sea again reveals Turner's profound understanding of the motion of water.

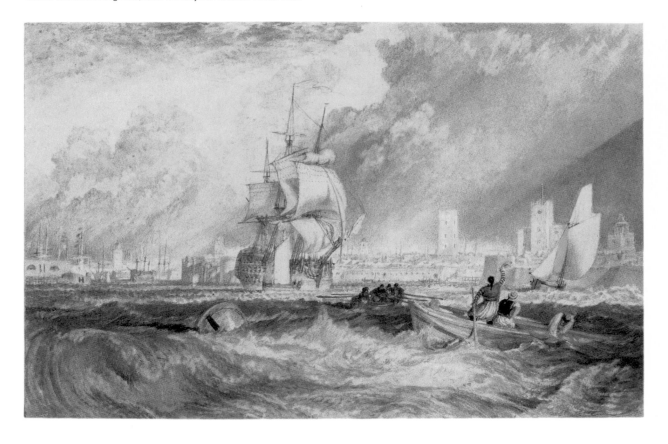

Cat. **61**
Whitby
c. 1825

Watercolour
15.9 × 24.8 cm

W 905
Private collection

ENGRAVED: John Cousen, 1844
'Dr Broadley's Poems', unpublished
(R 639)

As Turner's involvement in the 'Southern Coast' scheme neared its end in the mid-1820s, he gave thought to continuing the project by depicting scenery on the east coast, and probably created this design as a result. However, it would not be engraved until many years later, and even then the print was not published.

We look southwards from Upgang. Judging by the turbulent sea, a storm has recently subsided, leaving wreckage, cargo and a possible survivor clutching a baby on the right. The forms of the distant abbey, hillside and cliffs are softened by a slight mist; this is enhanced by the sharper definition of sea and foreground.

Cool blues dominate the design and their strength is intensified by contrasting touches of red placed across the lower part of the image. The blues diminish the warmth of the late afternoon light and evoke the chilliness that is often experienced near the sea, even in bright sunshine. The dampness and grainy texture of the sand are captured respectively by colour-washes and a mass of stippling.

Cat. **62**

Orfordness

c. 1827

Watercolour and gouache
on blue paper
16.5 × 25.4 cm

W 901
On loan to the Whitworth Art Gallery,
The University of Manchester, from
a private collection

PRELIMINARY MATERIAL: Pencil drawing,
Norfolk, Suffolk and Essex
sketchbook, 1824
(TB CCIX, inside cover and f. 42)

ENGRAVED: J. C. Allen, *c.* 1827, for an
unrealised 'Picturesque Views on the
East Coast of England' scheme
(R 310, unpublished)

The extension of the 'Southern Coast' project to cover the eastern seaboard of England suffered a setback following Turner's quarrel with the Cooke brothers; subsequently he decided to publish the continuation himself. He made four vignette watercolours and six rectangular drawings for the 'Picturesque Views on the East Coast of England' series, all in gouache on blue paper. However, because of more pressing calls on his time, he was forced to abandon the venture around 1828. By then J. C. Allen had engraved six images (none of which was published), leaving two further plates unfinished.

Orford Ness is a nineteen-kilometre-long spit of land that joins the mainland at Aldeburgh in Suffolk. Here we see the High Light and Low Light that stand at its tip. In Turner's day they were the only buildings on the promontory. They were vitally important, for in 1627 twelve ships had been wrecked

at Orford Ness in a single night; the continuing danger had led to the construction of the High Light in 1792.

In the latter half of his career Turner often juxtaposed lighthouses with shipwrecks, emphasising the self-delusion implicit in human attempts to overcome the forces of nature (see cat. 97). In this case the two beacons dedicated to the prevention of shipwreck bracket an abandoned, dismasted brig that has been jury-rigged and wallows helplessly as men attempt to save her. Spectators line the beach, with Orford Castle and church in the distance beyond them to the left.

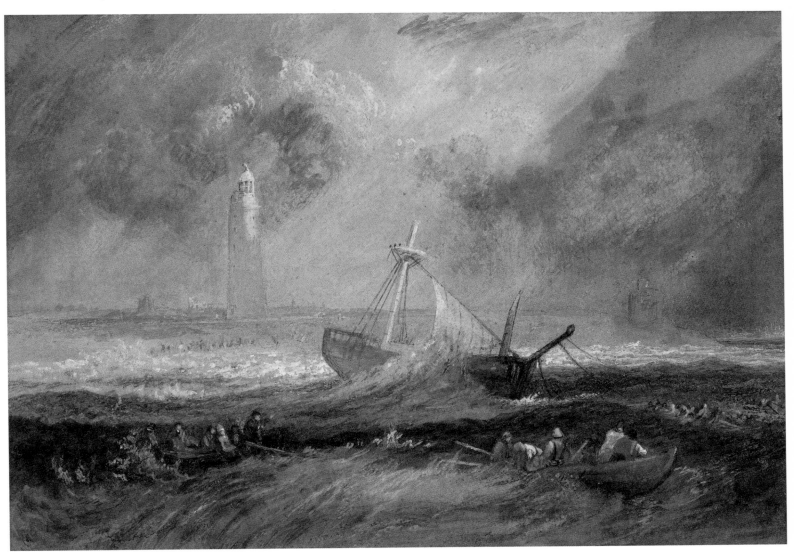

Cat. **63**

Lake Albano

c. 1828

Watercolour and scratching-out
28.6 × 41.2 cm

W 731
Spink-Leger Pictures

EXHIBITED: Egyptian Hall,
Piccadilly, 1829 (32)
Birmingham Society of Artists,
1829 (412)

ENGRAVED: Robert Wallis, 1829,
The Keepsake (R 320)

Although this watercolour was made for engraving in a projected series to be entitled 'Picturesque Views in Italy', that project never materialised. Its prospective publisher, Charles Heath, instead had the design reproduced in his lucrative annual *The Keepsake*.

Lake Albano is a volcanic lake about twenty-nine kilometres south of Rome; the papal summer residence at Castel Gandolfo overlooks it and is represented here in the distance. On the right a country girl and her companion examine the works of a heavily laden artist. As Cecilia Powell has convincingly demonstrated, the companion is dressed in the characteristic garb of a bandit. Large areas of Italy were still subject to brigandage in the 1820s and, indeed, the attacks of *banditti* were frequently depicted by artists.[1] Here, however, the power of art appears to have charmed the outlaw into laying down his rifle. The artist resembles Turner himself, and it seems characteristically witty of the painter to have given us a self-portrait in this context.

Another droll note is the distant pall of smoke on the far side of the lake, for it aligns with the barrel of the discarded rifle, the eye being carried between the two by the ridge line beneath the smoke. The far bank of the lake is covered in tiny, stippled marks that add to the sense of shimmer; the representation of light streaming through the trees there is especially memorable.

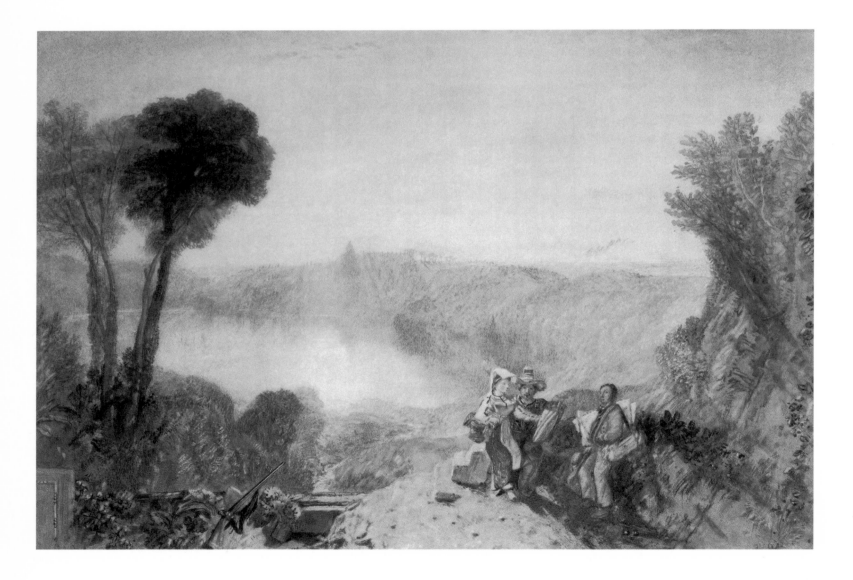

Watercolour, gouache, pen and ink,
and scratching-out on blue paper
13.8 × 18.9 cm

W 945
The Visitors of the Ashmolean
Museum, Oxford

PRELIMINARY MATERIAL: Pencil drawings
Nantes, Angers and Saumur
sketchbook, 1826
(TB CCXLVIII, ff. 9v and 10r)

ENGRAVED William Miller, 1833, *Turner's
Annual Tour – The Loire*, 1833 (R 447)

The lowest stretch of the Loire near Nantes is notable for its
riverside bluffs. Here we look upriver in late afternoon light,
with the distant Château de Clermont indicated by a small
touch of white on top of the hill just to the left of the tallest
mast; in the engraving Turner would detail that building
further, while clarifying the stubble being burnt on top of the
nearer bluffs. The yellows and blues mutually strengthen each
other, with the ultramarine creating an especially subtle
harmony in the shadowed parts of the river banks.

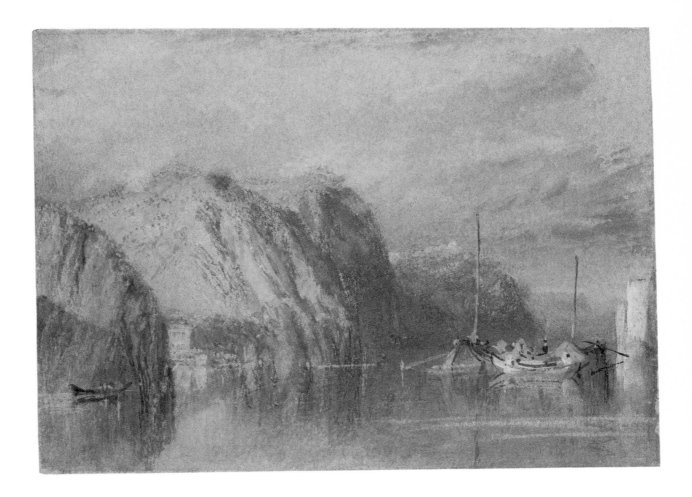

Cat. **65**
Rouen from Mont Ste-Catherine
c. 1832

Watercolour and gouache
on blue paper
14 × 18.4 cm

W 966
Private collection

PRELIMINARY MATERIAL: Pencil drawings
Nantes, Angers, and Saumur
sketchbook, 1826
(TB CCXLVIII, f. 23v, 30);
Rouen sketchbook, 1826
(TB CCLV, ff. 4v, 9, 11)

ENGRAVED: William Miller, 1834
Turner's Annual Tour – The Seine
1834 (R 468)

Turner created four views of Rouen for the first volume of his two *Annual Tours* devoted to the Seine. Two of the other designs represent the panorama looking up and down the river at the city centre, while the fourth depicts the façade of the cathedral. In its engraved form that image later influenced Monet's portrayals of the same subject.[1]

Here we view the town from the south-east in late afternoon light. Numerous white highlights lend sparkle to the scene, and the varied colours and intensity of light across the distant hillsides are especially noteworthy.

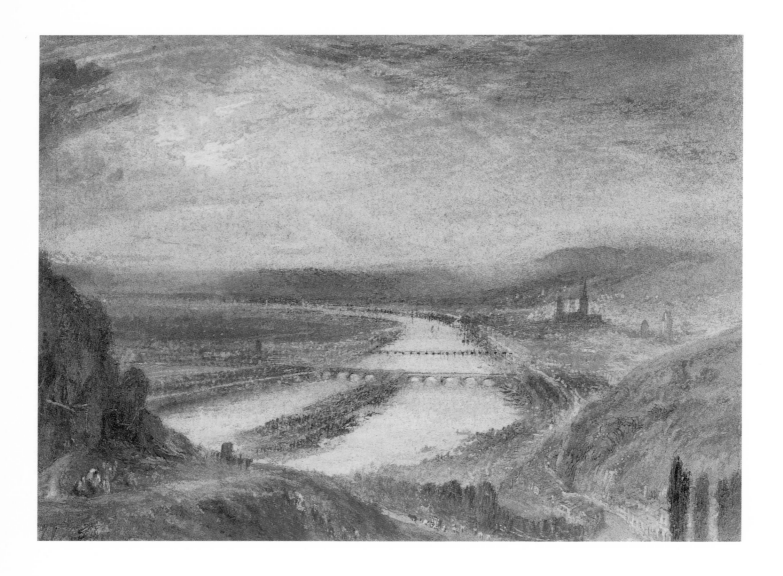

It has been doubted that the bridge seen here is the one at Meulan, to the west of Paris; however, those suspicions have recently been allayed.[1] Although there are no sketches of the bridge in the Turner Bequest, it seems likely that the painter passed through Meulan in 1829, for the damp conditions depicted are present in many of the other Seine watercolours that are known to have been elaborated from sketches of that year.

The regularity of the arches of the bridge is offset by the jagged forms of the men and boys pulling a barge upriver. On the right, directly along our sightline, the curve of one of the arches is reversed by the rounded outline of a woman's skirt below. The bright dab of emerald green on the bank subtly complements the yellows and browns that surround it. Although the pigment (Schweinfurt green) had been

discovered only recently, it features in many of Turner's other watercolours of the period.[2]

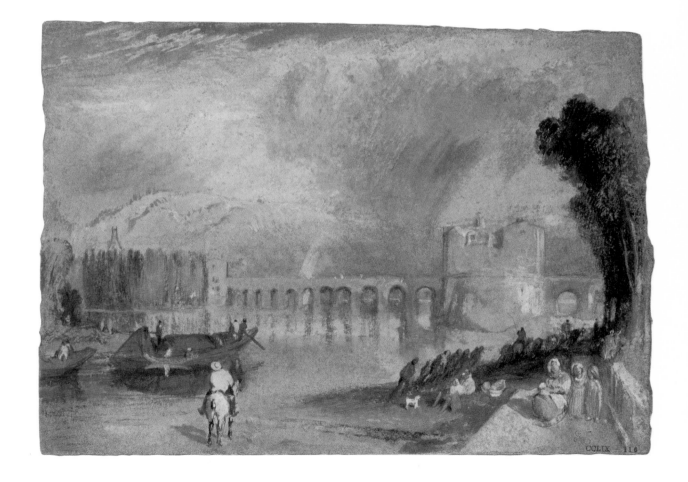

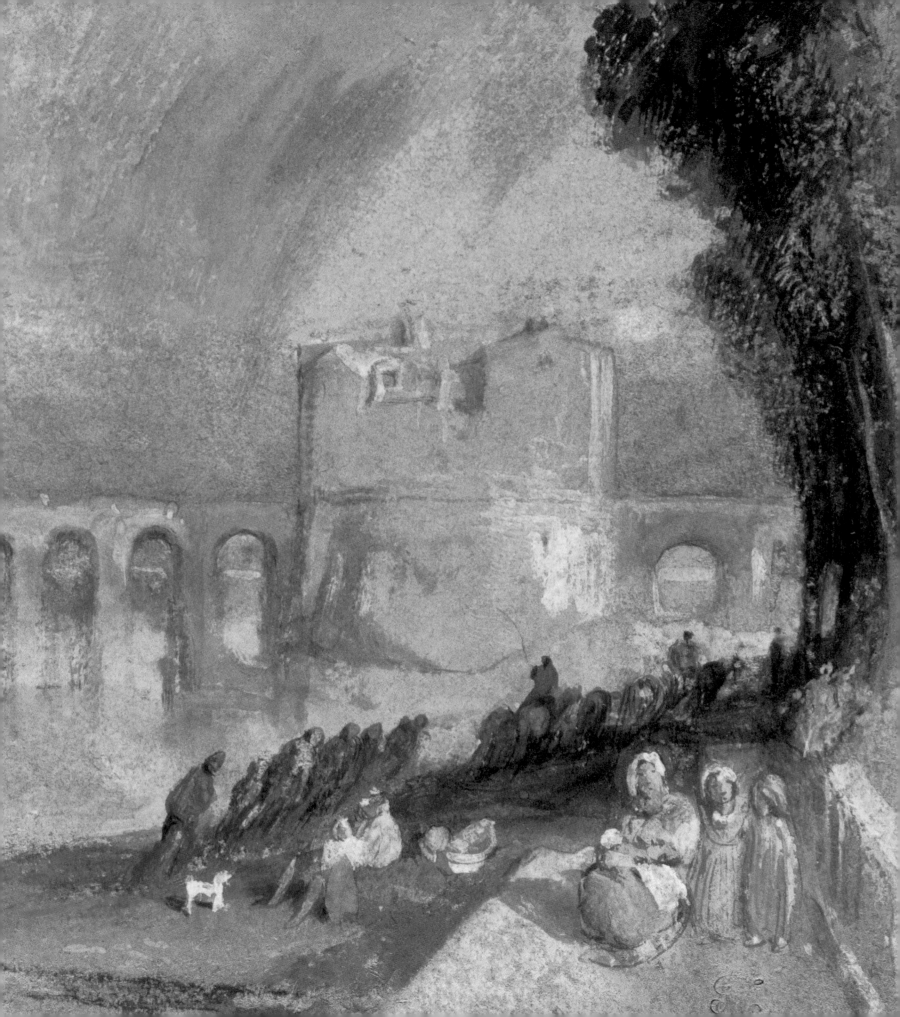

Cat. **67**

Boulevards, Paris

c. 1833

Watercolour and gouache
on blue paper
13.8 × 18.7 cm

W 987
Private collection

PRELIMINARY MATERIAL: Pencil drawings
Paris and Environs sketchbook, 1832
(TB CCLVII, ff. 51 and 52)

ENGRAVED: Thomas Higham, 1834
Turner's Annual Tour – The Seine
1835 (R 489)

Although in recent years this work has been entitled *Paris: Boulevard des Italiens* because of the thoroughfare represented, Turner's original engraving title, used here, indicates that he wanted the view to stand more generally for the streets of Paris. The boulevard des Italiens was one of the most fashionable streets on the right bank of the Seine, and here we look south-west along it in evening light. On the extreme right artists and dealers loll in front of a shop whose façade is covered with pictures.

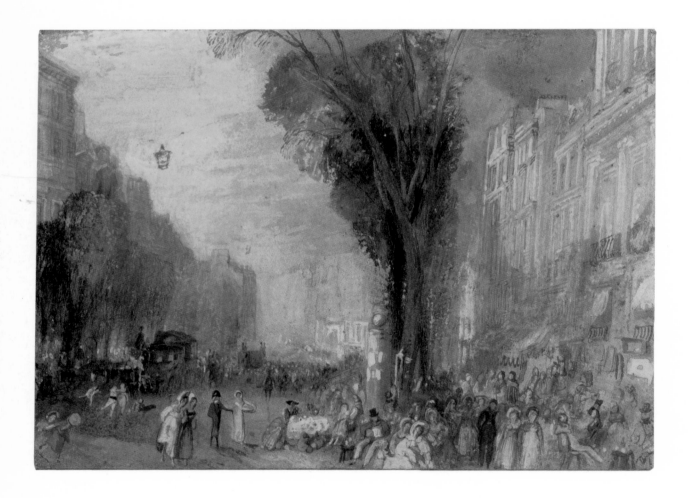

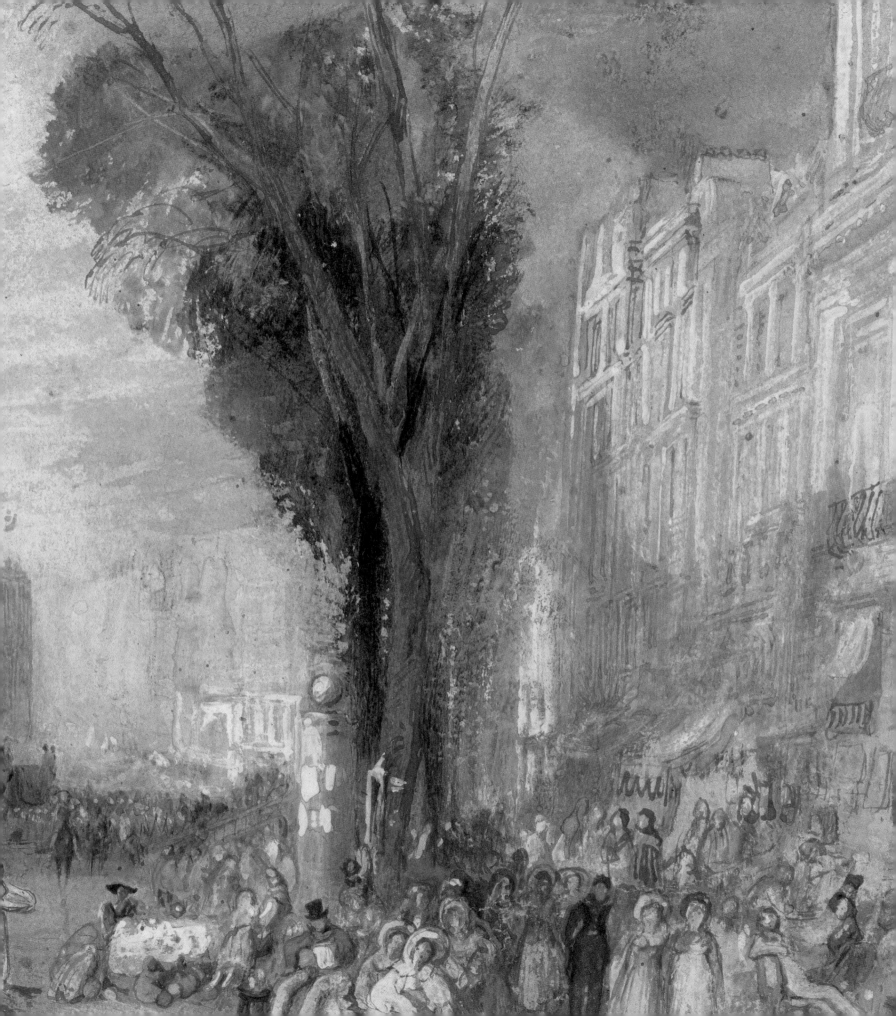

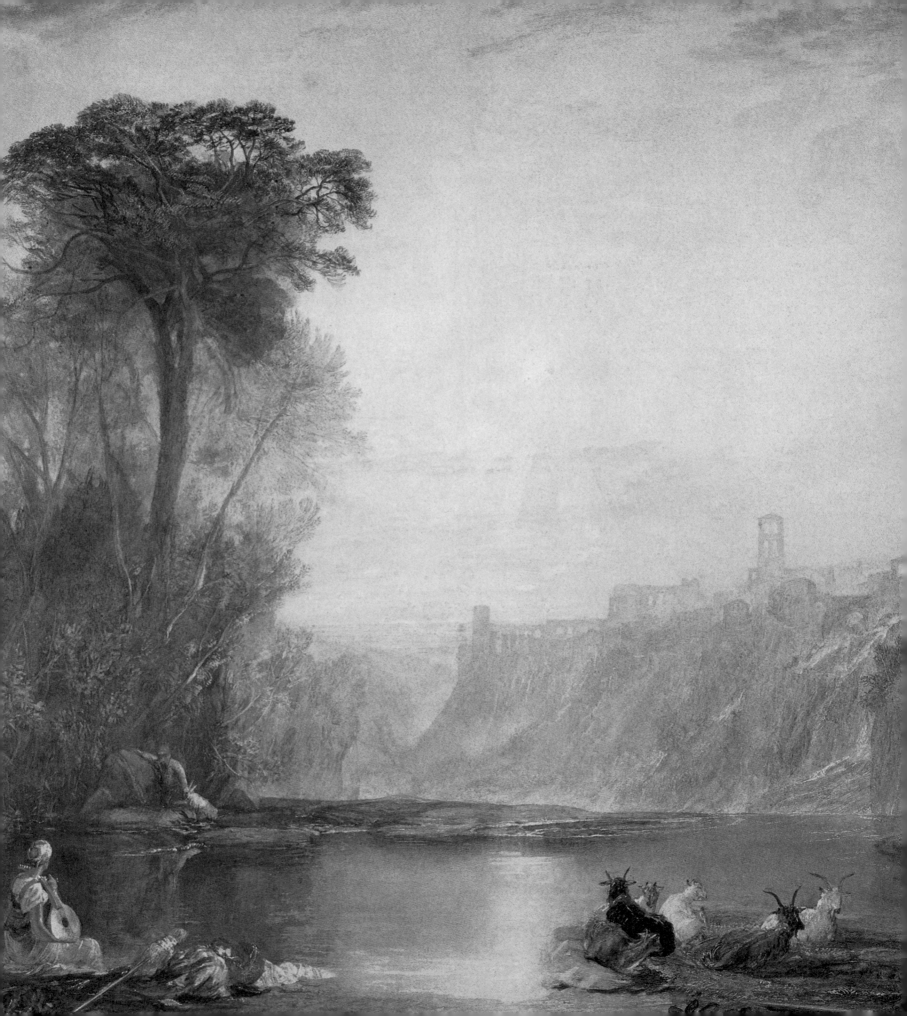

Large Commissioned Works and Exhibition Pieces

In the late 1810s and early 1820s Turner still received commissions for large watercolour landscapes (cats. 68 and 69), and their subjects reflected a shift in patronage, which now tended to emerge from the industrial middle-class rather than the aristocracy. As a result, country house views were replaced by idealised landscapes or foreign views. Turner also occasionally displayed watercolours at the Royal Academy and because they had to compete for attention with growing numbers of watercolours by other artists they, too, were impressive in scale (cats. 70 and 71). For further discussion of these points see pp. 11–12.

detail cat. 68

Pencil, watercolour, gouache,
scratching-out and stopping-out
67.6 × 102 cm
Signed and dated lower right:
IMW Turner 1817

W 495
Private collection

EXHIBITED: Royal Academy, 1818 (474);
Society of Painters in Water Colours,
1823, loan exhibition (88)
PRELIMINARY MATERIAL: Exploratory
watercolour study (TB CXCVII A)
ENGRAVED: Edward Goodall, 1827 (R 207)

Turner had not visited Italy by 1817 when he made this watercolour for a noted London art collector, John Allnutt of Clapham, who had the image engraved.

The distant plain and low sun indicate that we are looking in a westerly direction. However, the nearby landscape has been reversed, for the Temple of Vesta and cliffs of Tivoli are made to face south, whereas in fact they face north (as Turner would later discover when visiting Tivoli). He may have worked from an engraving or sketch supplied by someone else, but perhaps he inadvertently reversed his model. Yet the artist would not have worried about topographical inexactitude, and his inclusion of the words landscape and composition in the title stress that this is a generalised image.

The representation of water slowly gliding towards a cliff-edge slightly to the right of centre is especially adroit, while the bluffs beyond are delineated with delicate stippled marks that convey the sense of shimmering light. On the left the pine trees and foliage fulfil a Claudian compositional role and are imbued with a wonderful diffused light.

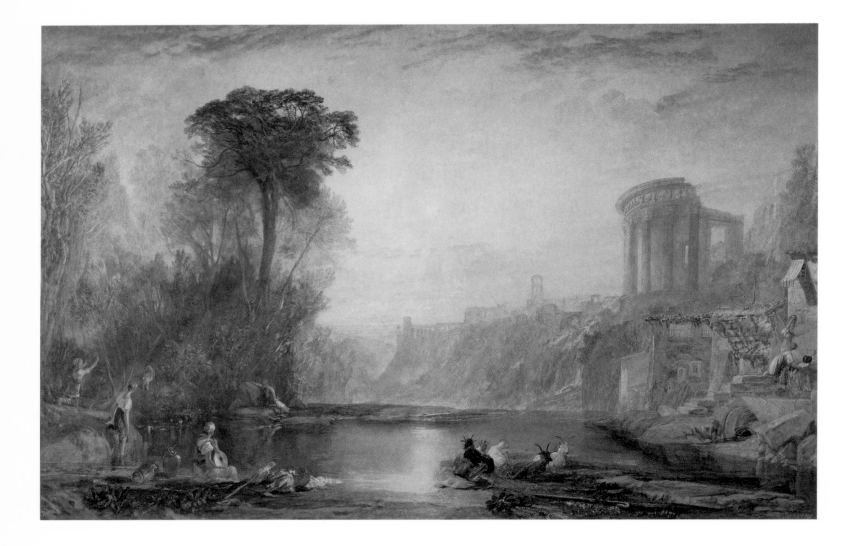

Cat. **69**

Grenoble Bridge

c. 1824

Watercolour, gouache, and
pen and ink
53 × 73.7 cm
Signed lower right: *JMWT*

W 404
The Baltimore Museum of Art:
Nelson and Juanita Greif Gutman
Collection, by exchange
(BMA 1968.28)

PRELIMINARY MATERIAL: Chalk drawing
Grenoble sketchbook, 1802
(TB LXXIV, f. 14)

Turner was commissioned to make this watercolour by the collector Charles Holford of Hampstead, London. A watercolour study in the Turner Bequest blocks out its basic colour areas (TB CCLXIII 368), while two equally large watercolours (TB CCLXIII 346 and 367) may be abandoned versions of the design. Turner stopped work on the second of these when it was at an advanced stage. Another study is CCLXIII 345.

We look north-eastwards up the River Isère in early morning light towards the Pont de Bois. Numerous wooden and stone bridges had existed on this site since Roman times, but they had all been washed away by floods. The bridge depicted was built in 1740 and replaced in 1837 by a metal suspension bridge. Repair work takes place on the left pier of the bridge, beyond which may be seen the snow-covered peaks of the

Alpes Vanoises. Up on the left is the Fort de la Bastille; below is the *PIED A CHEVAL* inn where Turner may once have stayed, tempted by its promise of *BON LOGIS*. The boats and activity on the right were carried over from the 1802 chalk study, although the number of washerwomen was greatly increased.

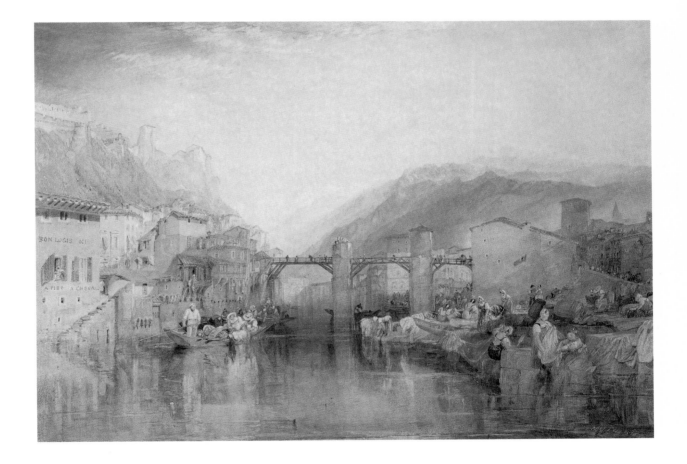

Cat. **70**

**Rise of the River Stour
at Stourhead**

c. 1824

Watercolour
67.3 × 102.2 cm

W 496
The Sudeley Castle Trustees

EXHIBITED: Royal Academy, 1825 (465)

Turner had been visiting Stourhead since the 1790s, and its idyllic gardens, developed by the banker Henry Hoare with the assistance of Henry Flitcroft, helped to form his notions of Ideal Beauty. That profound impact may well explain why he made *Rise of the River Stour at Stourhead* look so Claudian and why he used artistic licence when doing so. Turner accompanied the title of the drawing in the 1825 Academy exhibition catalogue with his own verses specifying that the Stour rises from two springs in 'Stourton's woody glade', and then flows into the lake depicted here.

It has often been claimed that the painter made this watercolour to balance a view of Tivoli (cat. 68), but there is no evidence to support that belief. Although the drawings are almost identical in size and their compositions balance, both works represent sunsets and it would have been uncharacteristic of Turner to have given them similar timings if he had created them as linked images, for he always preferred a contrast. Moreover, there are subtle differences in the stylisation of the dominant trees in both designs, with those in the present work being more streamlined than those in the Tivoli view. It therefore seems likely that Turner created the present watercolour shortly before displaying it at the Academy in 1824, and not in 1817.

We look westwards and the expanse of the vista has been greatly compressed to bring into view both the Pantheon – seen below the sun – and the Temple of Apollo up on the hill at the left. To compensate for this compression the Pantheon has been diminished in size, and hence seems further away than it is in reality. The hill on which the Temple of Apollo stands has been trebled in height, and with its stone pines and cascades appears especially Italianate in its far reaches. In reality the Temple of Flora at the lower left is located around a bend in the lake to the right. However, in the image it is shown twice, to the left and glimpsed in its true setting through the trees to the right.

In the centre foreground is a dam. Water eddies gently towards a controlled outlet in the structure, and then streams down to the left before passing under an invented bridge to flow as the River Stour into the distance. There is indeed a large dam at Stourhead and perhaps the horizon line below and to the left of the Pantheon indicates the top of it in its true position. By showing us water on two levels, Turner reveals something hidden at Stourhead – the fall of the river – and playfully contradicts the word 'rise' in the work's title

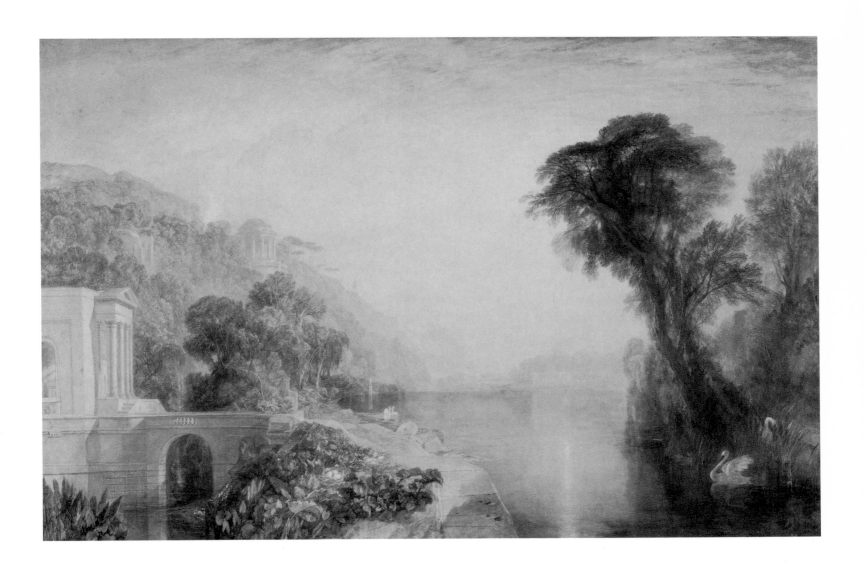

Cat. **71**

Funeral of Sir Thomas
Lawrence, a sketch
from memory
1830

Watercolour and gouache
61.6 × 82.5 cm
Inscribed lower left:
*Funeral of Sir Thos Lawrence PRA
Jany 21 1830 SKETCH from
MEMORY IMWT*

W 521
Tate. Bequeathed by the artist, 1856
CCLXIII 344

EXHIBITED: Royal Academy, 1830 (493)

The portrait painter Sir Thomas Lawrence was President of the Royal Academy from March 1820 until his death in January 1830. He had been a good friend to Turner and, indeed, in 1822 had helped the latter obtain his only royal commission.[1] Turner was a pall-bearer at Lawrence's funeral on 21 January 1830, and the next day he wrote sardonically that many of the great and good had sent their carriages without appearing at the ceremony themselves.[2] A detail in this drawing may compensate for their absence.

John Constable sat next to Turner during the funeral service and saw him turn away in disgust when David Wilkie remarked that the ceremonial made a fine artistic effect.[3] That denial may explain the suffix in the title, for Turner surely wanted to stress that he had not attended the funeral with art in mind, and that this watercolour depicted his memories of the event. Moreover, the suffix may also have been intended to deflect criticism of his principal departure from reality in the work.

In the right foreground a group of onlookers, muffled against the cold, are uninterested in watching Lawrence's coffin being carried through the portals of the distant cathedral. Instead, they gaze at a nearby mourner who has just dismounted and is being saluted by one of the undertakers. This figure, with a mourning band tied around his left arm, wears the full-dress uniform of a field marshal in the British Army. Given his attire, the crowd's interest and the salutation of the undertaker, this appears to be the Commander-in-Chief of the British Army and the current Prime Minister, the Duke of Wellington, who was frequently represented by portraitists, cartoonists and caricaturists of the day in identical dress and often from the rear.[4] The duke had not attended Lawrence's funeral – *The Times* of 22 January 1830 reported that he merely sent his carriage – but Turner evidently thought that he should have been there and made art improve upon life.

The inclusion of the Duke of Wellington is particularly apposite, given that one of Lawrence's finest portraits of the Iron Duke shows him wearing identical garb and standing before the west façade of St Paul's Cathedral.[5] This oil was commissioned by George IV when Prince Regent, and it was exhibited at the Royal Academy in 1815. In the painting Wellington stands with his back to St Paul's, but here he faces it and thus also indirectly looks towards his former portraitist.

The hearse that brought Lawrence's coffin is visible on the left. On the right is the statue of Queen Anne, since moved. At the lower-left a structure resembles a sarcophagus, and its link with a funerary monument is firmly established by its long inscription bearing Lawrence's name. The shadow of a man holding a spear falls across the structure, although, eerily, it has no physical source.

The reproduction opposite shows how Turner mounted his watercolour on a backing sheet, which he also used to absorb excess paint.

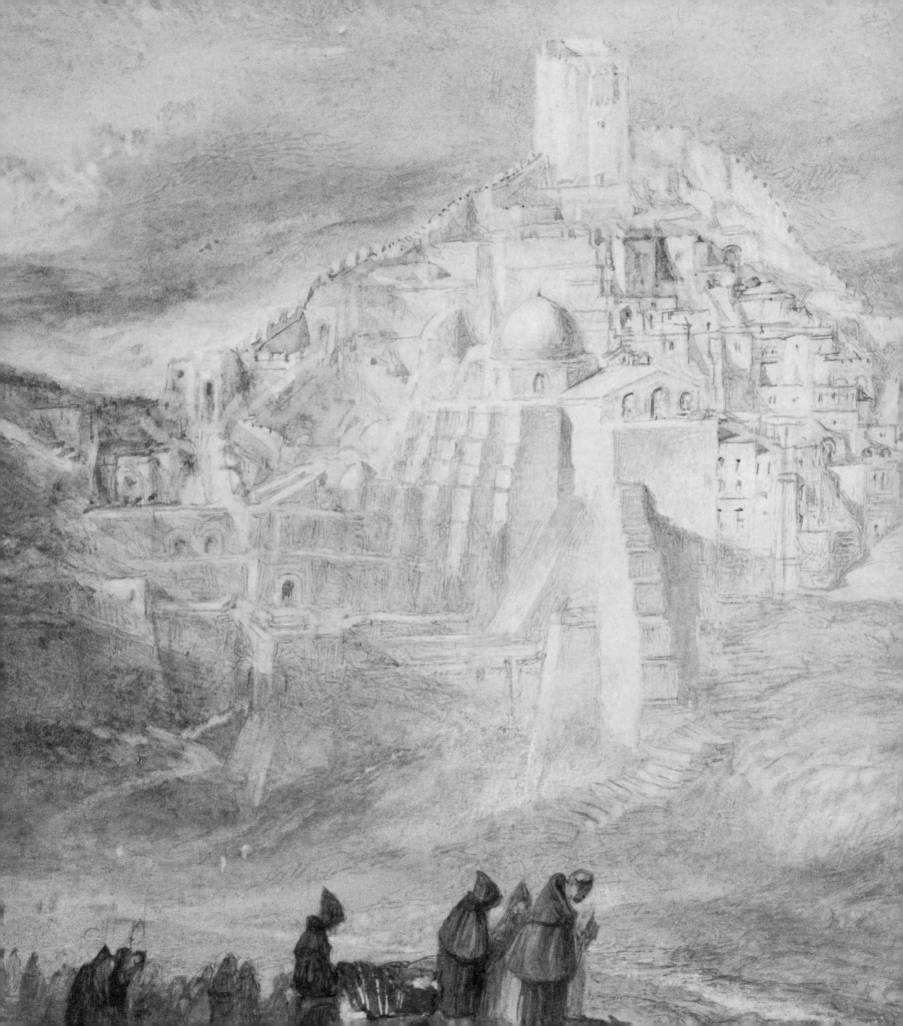

Literary Illustrations of the 1820s and 1830s

Turner's images not only helped sell topographical partworks; they also contributed to the success of literary miscellanies like *The Keepsake* (cat. 63) and *The Literary Souvenir* (cat. 72). The potential of his designs to make even the dullest collections of poetry economically profitable became evident with Turner's illustrations to volumes by the banker-poet, Samuel Rogers (cats. 73–77). In the 1830s the artist was also invited to illustrate collections of prose and poetry by Sir Walter Scott (cat. 78); the life and works of Byron (cats. 79 and 80); and a set of landscape illustrations of the Bible (cats. 81–83). Additionally, a large watercolour made for engraving (cat. 84) may have been inspired by the most famous shipwreck poem of Turner's era.

Large numbers of the watercolours created for these schemes are vignettes (cats. 73–77 and 80). Here Turner's incomparable control of tones from light to dark enabled him to fade out the edges of a design so that the subsequent engraved images and their adjacent texts would meld seamlessly (rather than shift suddenly, as necessarily happens when images appear as sharply defined rectangles on the page).

detail cat. 81

Cat. **72**

Richmond Hill

c. 1825

Watercolour and gouache
29.7 × 48.9 cm

W 518
Board of Trustees of the National
Museums and Galleries on
Merseyside (Lady Lever Art Gallery,
Port Sunlight)

PRELIMINARY MATERIAL: Pencil drawings
Thames sketchbook, *c.* 1825
(TB CCXII, ff. 5v, 6, 6v, 9v, 82, 88
and 88v)

ENGRAVED: Edward Goodall, 1826,
The Literary Souvenir (R 314)

The engraver Edward Goodall commissioned this portrayal
of the celebrated vista from Richmond Hill, Surrey, which we
view in late afternoon light in summer. The composition is
greatly animated by a large number of unifying circles or
semicircles that take their cue from the curve of the river, and
one of the subtlest but most important of them appears in
a cloud to the right of the sun.

In the distance on the right a pall of smoke may indicate
Turner's own presence in the landscape, for it rises above the
spot in Twickenham where he owned a small villa. To the left
of centre a top-hatted gentleman peers in that direction
through a telescope, and thus draws our attention to the
smoke. In the foreground more direct indications of artistic
presence are denoted by the paintbox, palette and pots of
paint, and by the ladies perusing a picture on an easel.

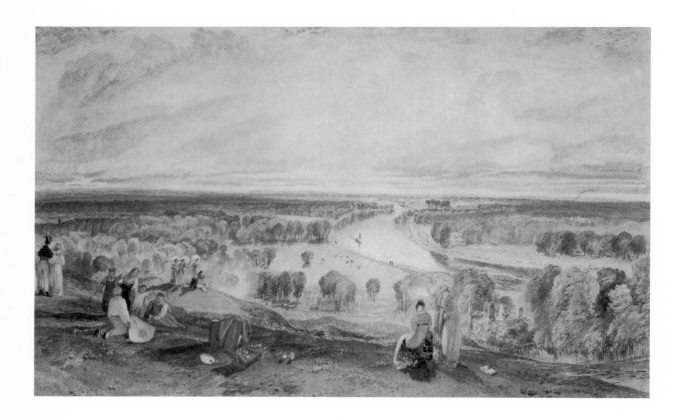

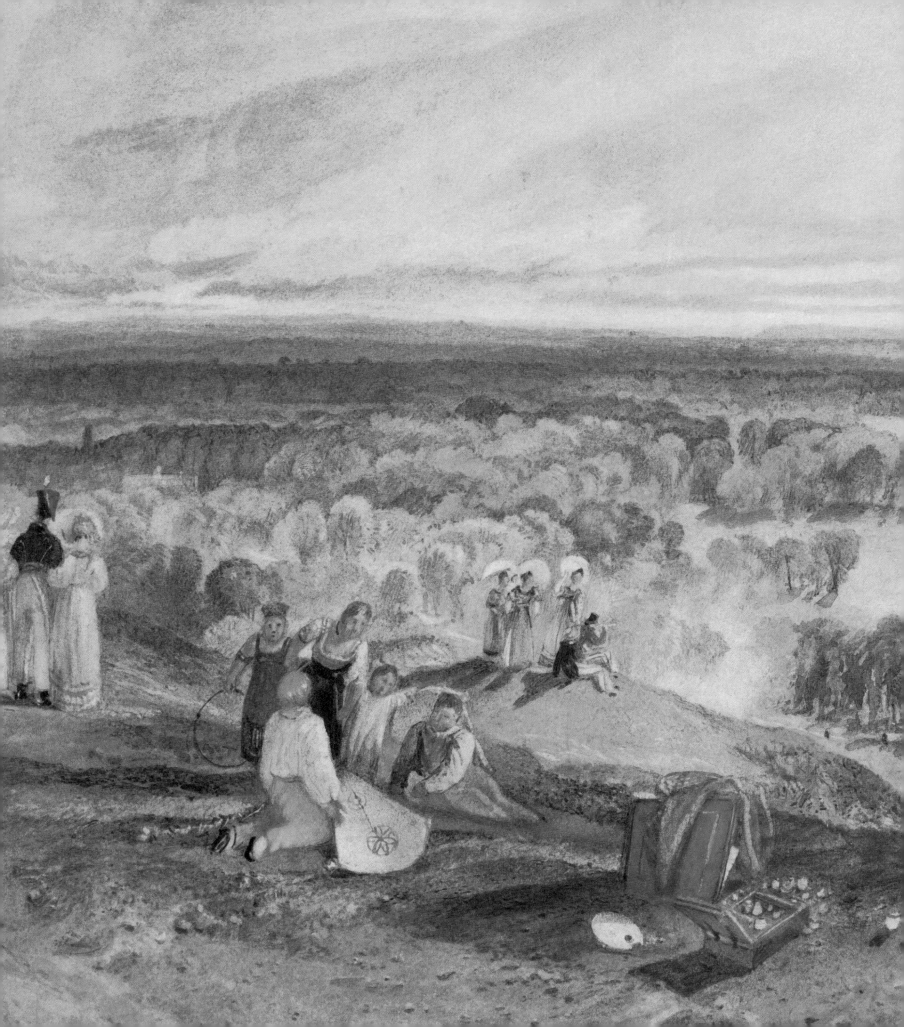

Cat. **73**

Marengo

c. 1827

Pencil, watercolour, gouache and
pen and ink (vignette)
12.5 × 20 cm
Inscribed: *Battle of MARENGO
18 and LODI*

W 1157
Tate. Bequeathed by the artist, 1856
CCLXXX 146

In 1826 Turner agreed to supply the wealthy poet and banker, Samuel Rogers, with 25 watercolours that could be engraved to adorn a new, luxury edition of Rogers's collection of poems entitled *Italy*. The painter was paid five guineas for the loan of each watercolour, which have all remained in his bequest to the nation as a result.

This design appeared at the head of the poem 'The Descent', in which an alpine guide remembers Napoleon leading his troops through the Alps to Marengo. That battle between French and Austrian forces in the foothills of the Ligurian Alps north of Genoa took place on 14 June 1800 and was regarded by Napoleon as his most brilliant victory. In addition to inscribing the name of the battle at the lower left, Turner also alluded to Napoleon's success at Lodi in 1796 (although because 'The Descent' does not refer to that battle,

the reference was not included in the engraving). The portrayal of Napoleon draws upon Jacques-Louis David's famous image of the general crossing the Great St Bernard Pass, which Turner had seen in David's studio in Paris in 1802 (although in 1827 he probably refreshed his memory of it from an engraving).

Strong touches of ultramarine are deployed across the battlefield, where the palls of smoke were alternatively washed out from the underlying colour, or were touched in with gouache. Although the tops of the most distant mountains are outlined somewhat baldly, Turner's understanding of geology is everywhere evident.

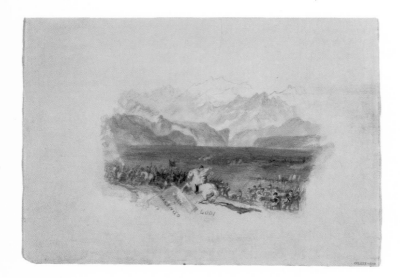

Cat. 73a
Marengo

Steel engraving (vignette)
5.5 × 8.5 cm

R 353

ENGRAVED: Edward Goodall, 1829

From Samuel Rogers, *Italy*
Ex libris J.M.W. Turner
Printed for T. Cadell, The Strand;
Jennings and Chaplin,
Cheapside; and E. Moxon,
New Bond Street, London, 1830
Leather spine with gold edges
20 × 14 × 3.3 cm

Private collection

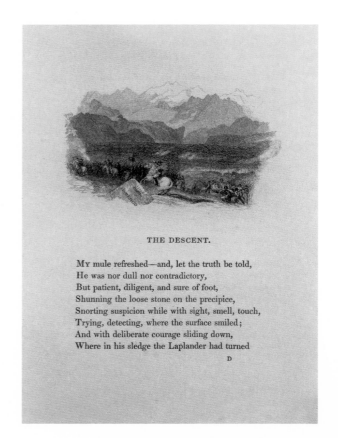

THE DESCENT.

My mule refreshed—and, let the truth be told,
He was nor dull nor contradictory,
But patient, diligent, and sure of foot,
Shunning the loose stone on the precipice,
Snorting suspicion while with sight, smell, touch,
Trying, detecting, where the surface smiled;
And with deliberate courage sliding down,
Where in his sledge the Laplander had turned

D

Cat. **74**

The Forum

c. 1827

Pencil, watercolour,
pen and ink (vignette)
13.5 × 15 cm

W 1167
Tate. Bequeathed by the artist, 1856
CCLXXX 158

The engraving of this design for Rogers's *Italy* was placed at the head of the poem 'Rome'.

Through the Arch of Titus we look north-west across a greatly compressed forum. Nearby are the three remaining columns of the Temple of Castor and Pollux, while between them may be seen the Temple of Saturn, which has been moved southwards and pivoted through ninety degrees in order to fit that frame. Further to the right are the surviving columns of the Temple of Vespasian, while even more to the right is the Arch of Septimius Severus. Monks appropriately proceed up the Via Sacra and, to reinforce the associations of the dead civilisation around them, they carry a coffin. The Capitoline Hill forms a backdrop to the view.

Cat. **74a**
The Forum

Steel engraving (vignette)
8 × 8.5 cm

R 363

ENGRAVED: Edward Goodall, 1829

From Samuel Rogers, *Italy*
Ex libris J.M.W. Turner
Printed for T. Cadell, The Strand;
Jennings and Chaplin,
Cheapside; and E. Moxon,
New Bond Street, London, 1830
Leather spine with gold edges
20 × 14 × 3.3 cm

Private collection

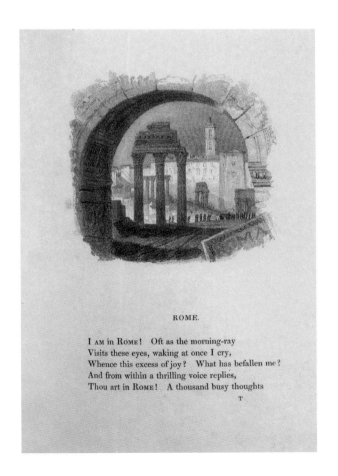

Cat. **75**

Traitor's Gate, Tower of
London

c. 1832

Pencil and watercolour (vignette)
12.5 × 13.5 cm

W 1187
Tate. Bequeathed by the artist, 1856
CCLXXX 177

PRELIMINARY MATERIAL: Preparatory
watercolour (TB CCLXXX 93)

ENGRAVED: Edward Goodall, 1833,
Rogers's *Poems*, 1834 (R 383)

The success of the 1830 luxury edition of Rogers's *Italy* with Turner's illustrations led to a further collaboration between poet and painter. Around 1832 Turner created 33 designs for Rogers's collected *Poems*, of which this watercolour, *Valombré* and *The Alps at Daybreak* (cats. 76 and 77) are examples. Again the artist was paid five guineas for the loan of his vignette watercolours (which ultimately formed part of the Turner Bequest), and once more his contributions did much to aid Rogers's sales.

The present image is one of six illustrations to the poem 'Human Life', which refers to the Traitor's Gate and is set in the 1790s. We see the entrance at that time, with soldiers wearing uniform of the period and contemporaneous ships. Yet the image also contains an anachronism that stemmed from Rogers. At the point in the poem illustrated, the anonymous protagonist faces charges of treason for struggling against political oppression. However, Rogers objects to the name 'Traitor's Gate', for through its portals earlier fighters for freedom such as 'Sidney, Russell, Raleigh, Cranmer, More' had once passed. The last of these was Sir Thomas More (1478–1535), whom Turner portrays in a vessel being rowed by boatmen wearing Tudor apparel and accompanied by an executioner holding an axe. In this manner Turner projects Rogers's assertion that the despotism from which More had suffered in the sixteenth century continued to flourish in the 1790s, when the government had suppressed domestic liberties in response to the French Revolution.

Cat. 75a
Traitor's Gate, Tower of London

Steel engraving (vignette)
8.5 × 8 cm

R 383

ENGRAVED: Edward Goodall, 1834

Samuel Rogers, *Poems*
Ex libris JMW Turner
Printed for T. Cadell, The Strand;
and E. Moxon, Dover Street,
London, 1834
Leatherbound with gold edges
20.7 × 15 × 4 cm

Private collection

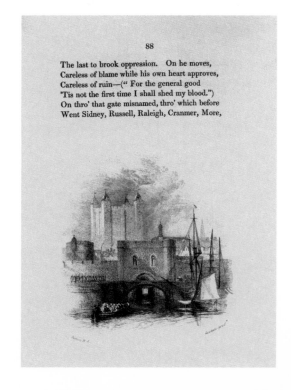

Cat. **76**

Valombré

c. 1832

Watercolour (vignette)
12.2 × 9 cm

W 1191
Tate. Bequeathed by the artist, 1856
CCLXXX 185

Turner created this design as one of three illustrations to Samuel Rogers's poem 'Jacqueline', in which the Provençal heroine runs away from home. As a result, she can no longer while away her time at the falls in Valombré 'Where 'tis night at noon of day', nor wander in solitude through the woods 'Where once a wild deer, wild no more/Her chaplet on her antlers wore/And at her bidding stood'. Although Turner hardly gives us 'night at noon of day', on the left he provides us with a remarkable depiction of light falling through foliage.

It has been suggested that the deer was painted by Edwin Landseer, but there is no evidence to support that supposition. The animal stands forlornly, as if still awaiting Jacqueline's bidding.

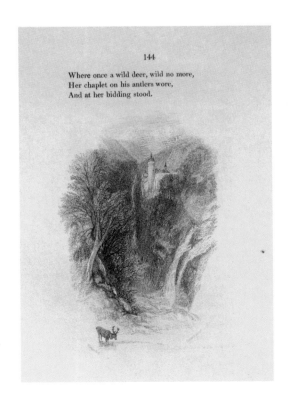

144

Where once a wild deer, wild no more,
Her chaplet on his antlers wore,
And at her bidding stood.

Cat. 76a
Valombré

Steel engraving (vignette)
11 × 7.5 cm

R 387

ENGRAVED: Edward Goodall, 1833

Samuel Rogers, *Poems*
Ex libris J.M.W. Turner
Printed for T. Cadell, The Strand;
and E. Moxon, Dover Street, London, 1834
Leatherbound with gold edges
20.7 × 15 × 4 cm

Private collection

Cat. **77**
The Alps at Daybreak
c. 1832

Watercolour and scratching-out
(vignette)
24.1 × 30 cm

W 1199
Tate. Bequeathed by the artist, 1856
CCLXXX 184

In this headpiece illustration to a Rogers poem of the same name, we see the hunters and their roebuck prey mentioned in the verses, as well as one of the huts that 'peep o'er the morning-cloud/Perched like an eagle's nest, on high'. Turner elaborated this hut from memories of Blair's Refuge above the Mer de Glace in Savoy, seen in 1802. A nearby hunter carries an iron pole mentioned in the poem, while another man bears an alpine hunting horn, also specified by Rogers. No guns are evident, as their noise might 'Rend from above a frozen mass'.

Cat. 77a
The Alps at Daybreak

Steel engraving (vignette)
11 × 7.5 cm

R 387

ENGRAVED: Edward Goodall, 1833

Samuel Rogers, *Poems*
Ex libris J.M.W. Turner
Printed for T. Cadell, The Strand;
and E. Moxon, Dover Street,
London, 1834
Leatherbound with gold edges
20.7 × 15 × 4 cm

Private collection

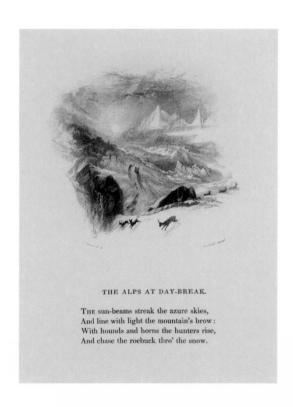

THE ALPS AT DAY-BREAK.

THE sun-beams streak the azure skies,
And line with light the mountain's brow:
With hounds and horns the hunters rise,
And chase the roebuck thro' the snow.

Cat. **78**

Edinburgh from
Blackford Hill

c. 1832

Watercolour
8.6 × 14.6 cm

W 1082
Private collection

PRELIMINARY MATERIAL: Pencil drawing
Abbotsford sketchbook, 1831
(TB CCLXVII, ff. 7v–8r)

In 1831 the publisher Robert Cadell invited Turner to make twelve rectangular watercolours and twelve vignette drawings to adorn a proposed edition of the poetry of Sir Walter Scott (the rectangular designs to act as frontispieces, the vignettes as title-page embellishments). Turner visited Scotland that summer to glean new topographical material for the series. The success of the project led him to make a further 40 regular and vignette watercolours to enhance Scott's *Prose Works*, published between 1834 and 1836. The present design acted as the frontispiece to volume 7 of Scott's poetry, which contains 'Marmion'. A later reprint of the engraving is reproduced below.

Robert Cadell's diary informs us that he and Turner ascended Blackford Hill at about 10 am on Monday 15 August 1831, and that Turner took about an hour to make the preliminary pencil drawing from which this watercolour was later elaborated.[1] Because the painter was weighed down with sketchbooks, umbrella and coat, Cadell had helped him to climb the hill, as is shown at the lower left.

This is perhaps the finest of Turner's many Edinburgh vistas, although it halves the width of the panorama captured in the preliminary drawing. We look in a north-easterly direction towards the Firth of Forth in early morning light. Smoke in the distance on the right indicates that a strong easterly wind is blowing.

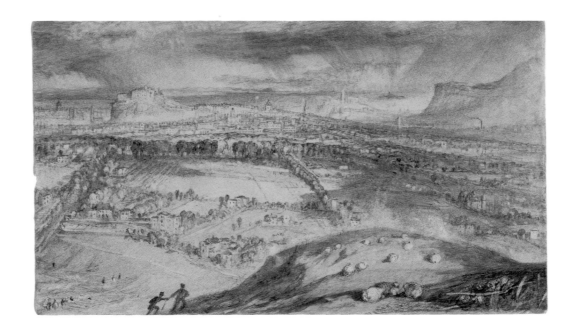

Cat. 78a
Edinburgh from Blackford Hill

Steel engraving
8.6 × 14.6 cm

R 505

ENGRAVED: William Miller, 1833

Sir Walter Scott, *The Poetical Works of Sir Walter Scott, Bart, Complete in One Volume with all His Introductions and Notes; also Various Readings and the Editor's Notes*
Printed for Robert Cadell, Edinburgh, 1851
Leather spine with gold edges
22.5 × 18.5 × 6 cm

Private collection

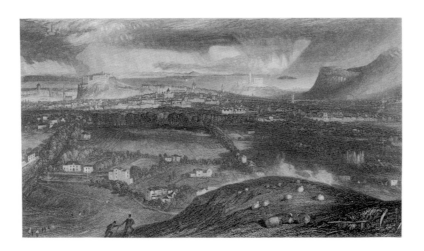

Cat. **79**
The Acropolis of Athens
c. 1832

Watercolour
15.2 × 22.2 cm

W 1212
Malcolm Wiener Collection

PRELIMINARY MATERIAL: Untraced sketch
by Thomas Allason; preparatory
watercolour studies: (TB CCLXIII 214,
253 (two studies) and 290;
TB CCCLXIV 402)

In 1832 the engraver Edward Finden invited a number of artists to elaborate rectangular designs for engraved reproduction in a proposed partwork on the life and works of Lord Byron; Turner made nine drawings for the scheme. The resultant publication appeared between 1832 and 1833. The images were reused by John Murray for a subsequent Byron edition, just as designs commissioned by Murray were also reused by Finden.

Turner never visited Greece, and he developed this image from a sketch by the architect Thomas Allason. In general terms the design was inspired by Canto II of *Childe Harold's Pilgrimage*, which deals with the struggle for freedom in modern Greece. Turner wholly identified with Byron's political idealism, and rejoiced in Greek emancipation from Turkish rule in 1830 (see cat. 96). Here, however, he went back in time.

In the foreground Turkish horsemen race across the Athenian plain towards approaching Greek forces, and the ultimate outcome of their battle may seem indeterminate. Yet the angle of view and its related time offer clear clues: we look north-eastwards, and we may surmise that just as the sun rises above the Acropolis, so it will soon rise on a free Greece.

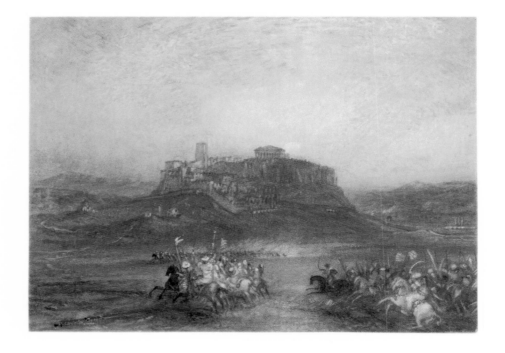

Cat. 79a
The Acropolis of Athens

Steel engraving (vignette)
15.2 × 22.2 cm

R 408

ENGRAVED: John Cousen, 1832

*Finden's landscape Illustrations
to Mr Murray's First Complete and
Uniform Edition of the Life and
Works of Lord Byron (Part V)*
Printed for John Murray, London,
1832–4
Folio 30 × 23.5 cm

John Murray

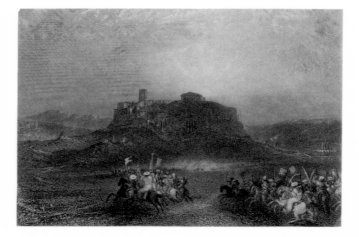

Cat. **80**
The Castellated Rhine

c. 1832

Watercolour (vignette)
16.5 × 21.1 cm

W 1235
Private collection

Although this image was inspired by line 2, stanza LXI of the tenth Canto of Byron's *Don Juan,* which appeared in the sixteenth volume of the poet's *Works,* the engraving was used as the title-page vignette to the subsequent book.

In the section of poem illustrated, Don Juan has travelled across Europe 'until he reached the castellated Rhine', and the poet, moved by the 'glorious Gothic scenes', muses on the relationship between past and present. With his extensive knowledge of Rhenish scenery, Turner was able to blend the 'castellated Rhine' from architectural and topographical elements taken from different locations and periods.

On the left is the town of Kaub, with Gutenfels Castle above it (see cat. 42 for a more topographically correct depiction). In the distance is the Pfalz toll castle, which is actually located on an island in the Rhine just off Kaub. On the

right the town and setting echo those of Oberwesel (see cat. 101). On the river is a Rhine barge, such as appears in earlier Rhine views (see cats. 38 and 39). To the right is one of the massive log-rafts that were floated downriver to burgeoning industrial centres; as these journeys could take weeks, the crews lived in huts on the rafts.

Because of the composite nature of the image there is no way of telling whether it is a morning or an evening view (the sun is too low to be in the south, in which direction we look up the Rhine at Kaub). However, given the elegiac mood of the passage illustrated, it is probably the latter.

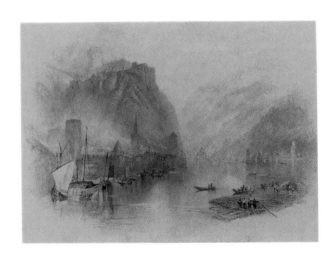

Cat. 80a
The Castellated Rhine

Steel engraving (vignette)
16.5 × 21.1 cm

R 431

ENGRAVED: Edward Finden, 1833

Finden's Landscape Illustrations to Mr Murray's First Complete and Uniform Edition of the Life and Works of Lord Byron (Part XVII)
Printed for John Murray, London, 1832–4
Folio 30 × 23.5 cm

John Murray

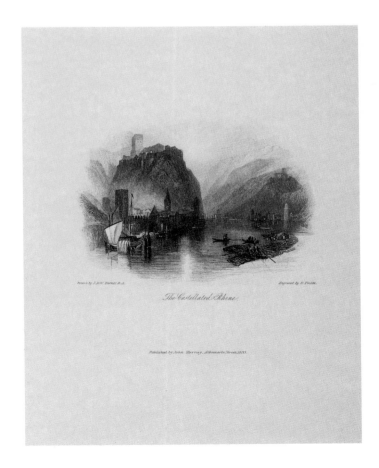

The Castellated Rhine

Cat. 81
Santa Sabes and the Brook Kedron
c. 1832

Watercolour
12.7 × 20.2 cm

W 1242
Private collection

PRELIMINARY MATERIAL: Pencil drawing by Sir Charles Barry (untraced)

ENGRAVED: James B. Allen, 1834, *Landscape Illustrations of the Bible* (R 578)

In 1832 or thereabouts Turner was commissioned by the Finden brothers and John Murray to make 28 watercolours for subsequent engraving in a partwork devoted to the landscapes mentioned in the Bible. This appeared in 24 monthly parts between 1834 and 1836. The prints were then reissued in book form as *The Landscape Illustrations of the Bible* (R 572–97). Turner developed his designs from studies made in Palestine by others, most notably by the architect Sir Charles Barry.[1]

The title that appeared beneath the first published state of the engraving was 'Santa Sabes and the Brook Kedron'. Because it must have derived from Turner himself, it represents the watercolour here.[2] The Brook Kidron crosses the landscape in the centre-distance, and it also appears in *Valley of the Brook Kedron* (cat. 82).

The Wilderness of Engedi is mentioned in the first book of Samuel, in connection with David's escape from Saul (24: 1). The Convent of Saint Sabas is located in that desert about thirteen kilometres south-east of Jerusalem, midway between Bethlehem and the Dead Sea. It was founded by the Byzantine monk Sabas in the sixth century and the remains of the saint are interred in the domed tomb near the centre of the image. Our attention is drawn to it by the monk in the foreground, for his tonsured pate amplifies the rotundity of its dome. The friar heads a procession carrying a corpse for burial, with the absence of a coffin reflecting the lack of timber in the Judean wilderness. In keeping with the need for artistic decorum, recent death is matched by the coming of night.

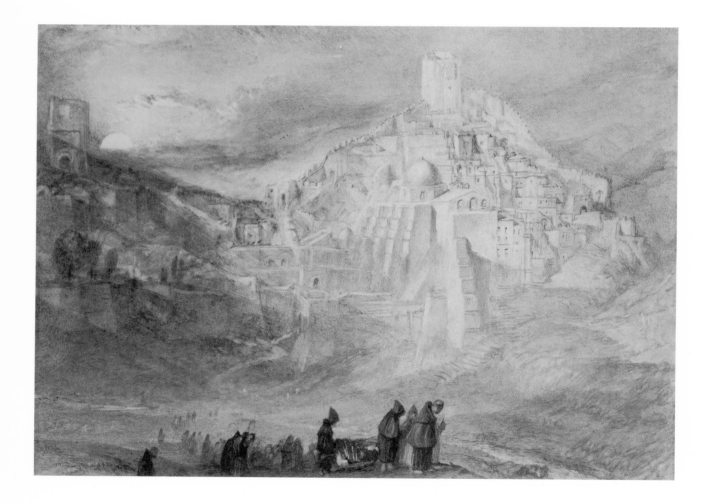

The biblical reference to the brook Kidron occurs in John (24:1) where Jesus crosses it on his way to the Garden of Gethsemane.

We look southwards in evening light down the valley of the Kidron, which is located between the old city of Jerusalem and the Mount of Olives. On the left is a funerary monument dating from the first century AD; this has traditionally been mistaken for the tomb of King David's son, Absalom, and it still survives. At its base a figure appropriately hunches in a traditional mourning pose, with his hands clutching his head. The village of Siloam appears in the distance, with the Judean desert beyond. On the right is the steep limestone escarpment of Mount Moriah, topped by a section of the eastern wall of Jerusalem. At the lower right may be seen the brook Kidron, which is usually dry except in winter.

The foreground is structured by a series of shallow V-shapes pointing to the right, and they take their cue from the large block of masonry at the lower left. The upper edge of Mount Moriah was rubbed away to heighten the glare of sunlight beyond.

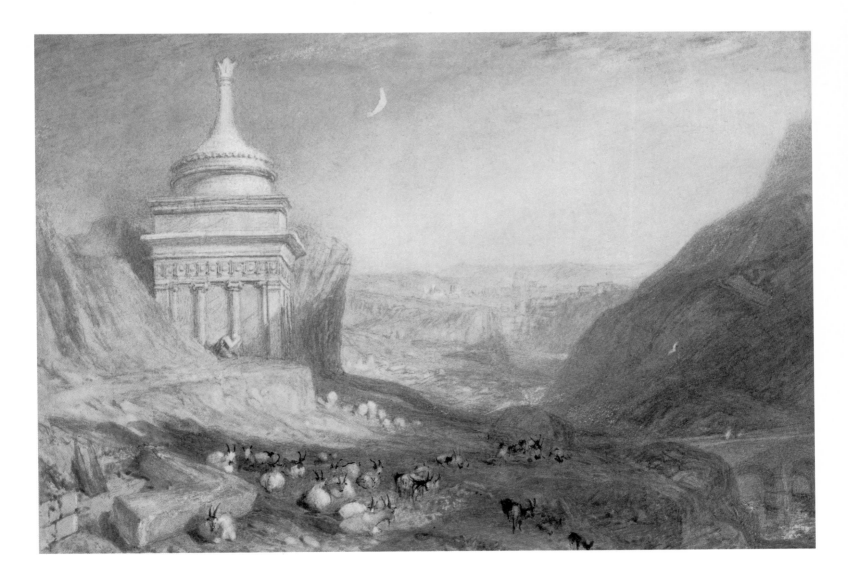

Cat. **83**

Lebanon in Thunderstorm

c. 1832

Watercolour and scraping-out
13 × 20.3 cm

W 1263
Private collection, Europe

The size and subject of this watercolour suggest it was made for engraving in Finden's *Landscape Illustrations of the Bible* but never used.

In recent times the drawing has been entitled *Cedars of Lebanon.*[1] However, there are two images by J. D. Harding entitled 'Cedars of Lebanon' in Finden's *Landscapes of the Bible*, and it seems unlikely that Turner would have been invited to make a third such illustration. Yet clues regarding the true name and subject of the watercolour are provided by the title used for it when it was first publicly sold, by the image itself, and by the Bible.

The watercolour was auctioned in 1863 under the title *Lebanon in Thunderstorm,*[2] and it seems very possible that it was originally acquired from the artist by B.G. Windus under that name. Certainly the image supports such a title, for in both biblical and modern times Lebanon was renowned for its cedars and so we might well be viewing a storm over Lebanon, given the large numbers of windswept cedars distributed across the foreground and centreground of the scene.

In the distance is a seaport; this might be Sidon or Tripoli, harbours that Turner depicted respectively from a beach and offshore for Finden's *Landscapes of the Bible*. However, the siting of the port at the end of a long isthmus suggests that it could be Tyre in Lebanon, which was not illustrated in the *Landscapes of the Bible* and which might therefore have justified a place there. As all harbours on the Lebanese and Palestinian coast face westwards, the landscape is being viewed soon after dawn, for the light falls behind us from the north-east.

Each of the *Landscapes of the Bible* illustrations relate to some passage in the Holy Book. A possible source for the present image is Psalm 29 in the Authorised Version, which opens with the declaration 'Give unto the Lord, O ye mighty, give unto the Lord glory and strength': the man with the outstretched arms in the foreground appears to be making just such an offering. The Psalm also tells us that 'the voice of the Lord is upon the waters'; that 'the voice of the Lord breaketh the cedars of Lebanon and Sirion[3] like a young unicorn'; and that 'the voice of the Lord . . . discovereth the forests'. All these statements seem to have found pictorial expression in Turner's complex composition, in which a powerful sense of energy runs through the trees.

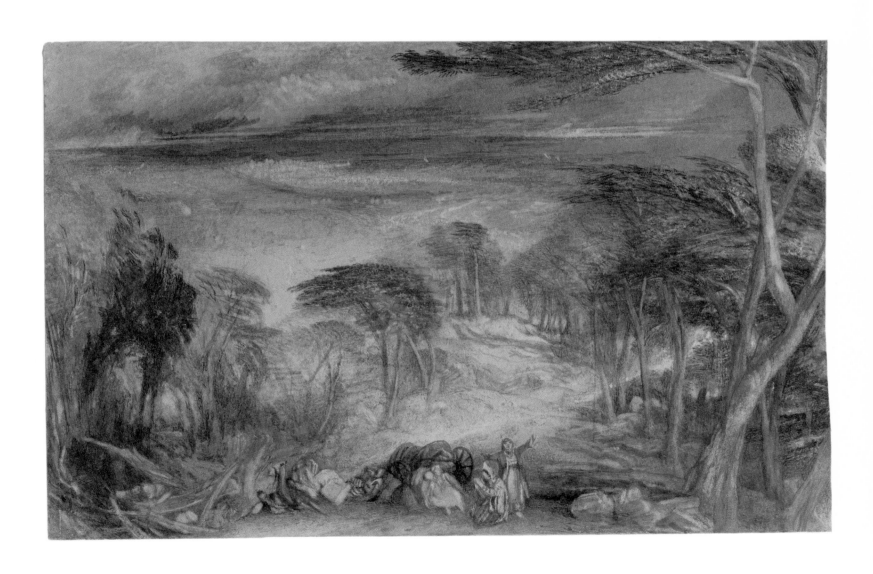

Cat. **84**
Temple of Minerva Sunias, Cape Colonna
c. 1834

Pencil, watercolour, gouache and
scratching-out
37.5 × 58.4 cm

W 497
Tate. Accepted by Her Majesty's
Government in lieu of tax and
allocated to the Tate Gallery, 1999

ENGRAVED: James Tibbitts Willmore,
1854 (R 673)

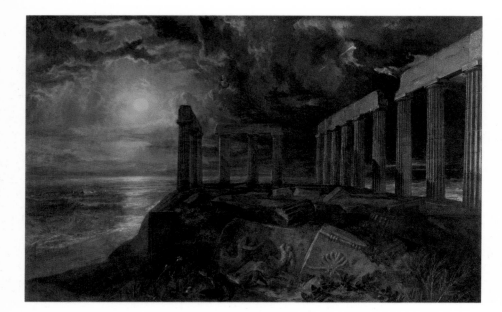

It has been suggested that Turner made this watercolour specifically for engraving by J. T. Willmore but that the latter's domestic problems delayed production of the print and Turner substituted another work for copying by him.[1] The initial part of that hypothesis is supported by the fact that the present design is a moonlight scene, as is an 1828 view of Alnwick Castle also engraved by Willmore (cat. 92). Perhaps Willmore's fine engraving of the Alnwick view spurred Turner to create this watercolour for reproduction by him. In the event Willmore did copy the present design, but not until three years after the painter's death.

The Doric Temple of Poseidon at Sounion, south-east of Athens, was built in the fifth century BC to invoke the protection of the god for shipping rounding the adjacent Cape Colonna, where the Aegean meets the Saronic Gulf and the seas are therefore treacherous. Turner had depicted the ruin in 1832 for the *Landscape Illustrations…to the Life and Works of Lord Byron* published in 1832–3 (W 1213, R 409), and he had based that watercolour on a sketch made at Sounion by the architect Thomas Allason. It seems likely that the architectural data shown here was taken from the same source.

In Turner's day Cape Colonna was famous for its connection with the mariner and poet, William Falconer, who had been shipwrecked there in 1750. From his experiences Falconer composed *The Shipwreck*, which was reprinted no less than 83 times after 1762. Turner knew the poem well, and must have gleaned a good deal of his nautical knowledge from it, for it is filled with technical details.

It is difficult to believe that the ship sinking in the distance was not inspired by Falconer's experience. Two wolves stare at the occurrence and epitomise the wildness and loneliness of the spot, while one of them shrinks from what it sees, thereby projecting an appropriate apprehensiveness. Just behind the wolves a hostile encounter between a lapith and a centaur carved on a fallen metope furthers the mood of violence that is projected by the distant storm. Lightning strikes in the direction of the ruined temple and enhances the meaning of the work, for as Ruskin noted, Turner rarely introduced this feature 'if the building has not been devoted to religion. The wrath of man may destroy the fortress, but only the wrath of heaven can destroy the temple.'[2] And in keeping with the need for artistic Decorum, the imminent death of men is complemented by the coming of night, with the huge moon shining upon the ruins of a dead civilisation.

The highlights on many of the plants in the foreground were scratched out, as were the grainy textures of the temple lintels. All the flutes on the columns were scratched out with a scalpel drawn irregularly along a ruler. The wooden tip of the brush was used to scrape out the white waves at lower left.

194

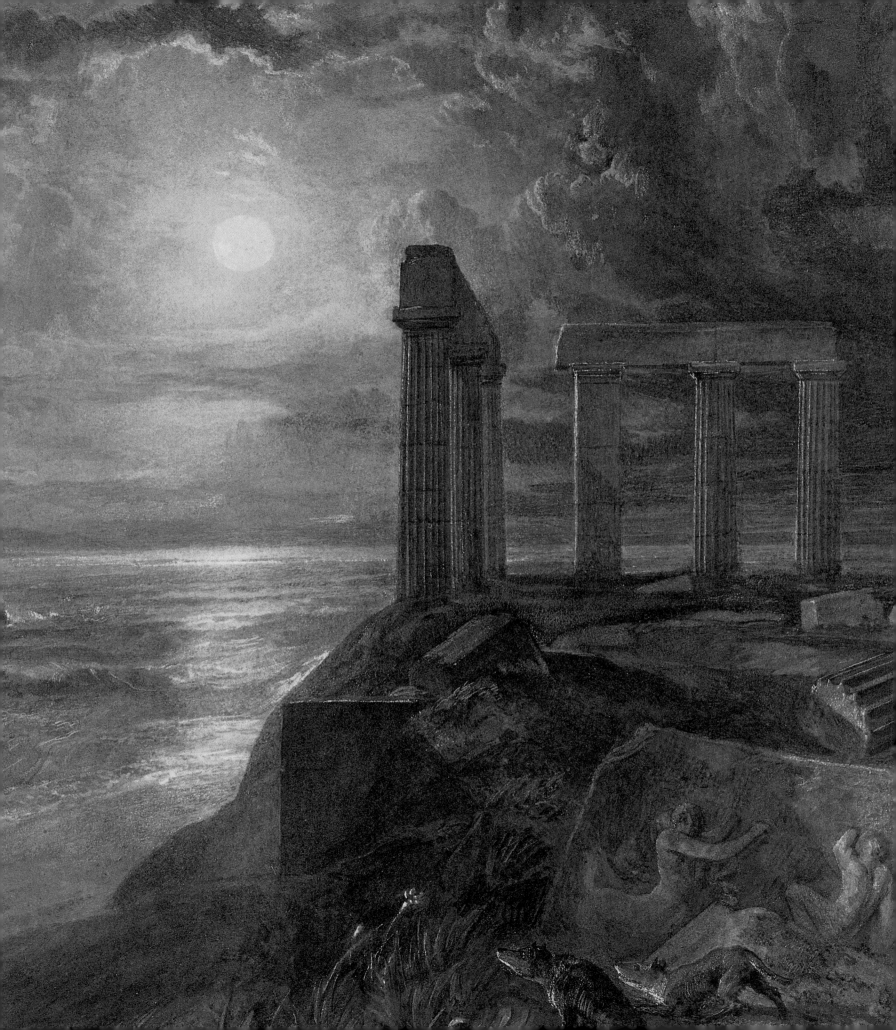

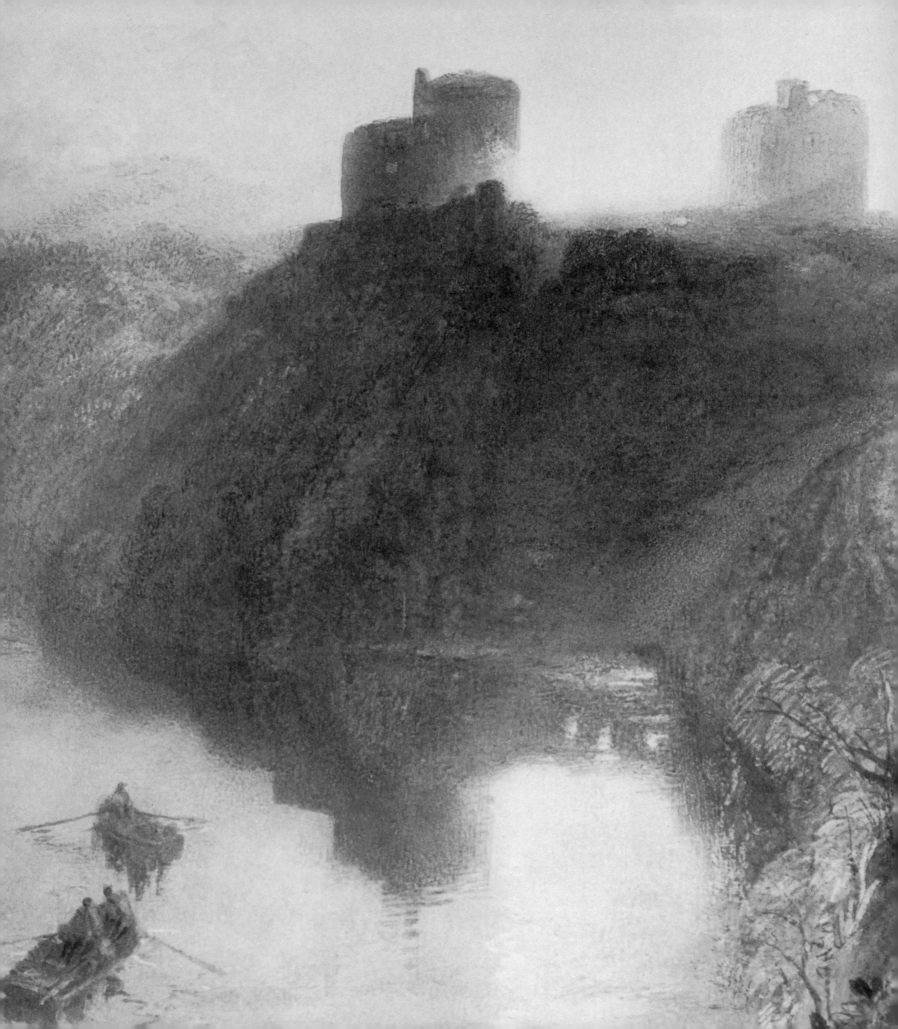

'Picturesque Views in England and Wales' 1824–36

In 1824 the print publisher Charles Heath commissioned what would prove to be Turner's longest-lasting and most ambitious watercolour engraving project, the 'Picturesque Views in England and Wales' series (see cats. 85–100). Like the 'Richmondshire' set, this was originally planned to comprise 120 designs. Overall it proved more successful than its predecessor, for Turner eventually created 100 watercolours for the scheme. Sadly however, it also ended prematurely, firstly because the market was already flooded with topographical engravings (many of them after images by Turner); secondly because public taste was changing; and thirdly because Turner insisted that copper (rather than steel) plates were used for the engravings, thus reducing profitability. The scheme was terminated in 1838. Most of the 'England and Wales' series designs were based on old sketchbook material – some of which had been made over thirty years earlier – but in 1830 Turner undertook a new tour (of the Midlands) in order to gain fresh material for the scheme. The 'England and Wales' drawings are all moderately sized and the painter made an unusually large number of preparatory watercolour sketches and studies for them, which is a mark of the seriousness he brought to the project. Not for nothing have the finished watercolours been characterised by Andrew Wilton as constituting 'the central document of [Turner's] art'. With the exception of the railways, the 'England and Wales' series depicts every aspect of the Britain of Turner's day.

Large groups of the 'England and Wales' series watercolours were exhibited in London: at the Egyptian Hall, Piccadilly in 1829; and at the Moon, Boys and Graves Gallery in Pall Mall, in 1833. For their reception in the press see pp. 41–3.

detail cat. 90

Cat. **85**

Rievaulx Abbey

c. 1825

Watercolour
28 × 40 cm

W 785
Private Collection (from Sir Donald
Currie's collection on loan to York
City Art Gallery)

PRELIMINARY MATERIAL: Pencil
and watercolour wash drawing
Dunbar sketchbook, 1801
(TB LIV, f. 104v)

ENGRAVED: Edward Goodall, 1827,
'Picturesque Views in England and
Wales' (R 209)

Rievaulx Abbey was a Cistercian foundation dating from 1230 that was dissolved in the Reformation. Here we view it in early morning light. Near the top right is the classical temple built by Thomas Duncombe in 1758. The design is underpinned by a compositional X-shape running up the banks of the River Rye and the slopes of Rydale, with the rising mist at the upper left offsetting the symmetry.

It is possible that Turner made this watercolour to balance an 'England and Wales' series view of Bolton Abbey (W 788, Lady Lever Art Gallery, Port Sunlight, Cheshire) for both works portray ruined Yorkshire abbeys in morning light, with fishermen tying bait.

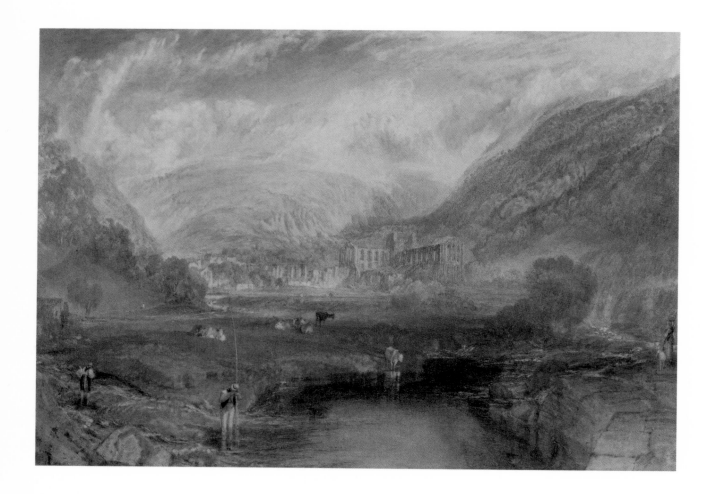

Cat. **86**

Fall of the Tees, Yorkshire

c. 1825

Watercolour
28 × 39.3 cm

W 790
Indianapolis Museum of Art, Gift in memory of Dr and Mrs Hugo O. Pantzer by their children (by exchange), Bequest of Evelyn Fortune Bartlett, Gift of the Alliance of the Indianapolis Museum of Art, the Nicholas H. Noyes Fund, the James E. Roberts Fund, and the E. Hardy Adriance Fine Arts Acquisition Fund

PRELIMINARY MATERIAL: Pencil drawings *Yorkshire 5* sketchbook, 1816 (TB CXLVIII, f. 7v); *Yorkshire 4* sketchbook, 1816 (TB CXLVII, f. 34)

ENGRAVED: Edward Goodall, 1827, 'Picturesque Views in England and Wales' (R 214)

We view upper Teesdale in afternoon light. The sketching figure was recorded in 1816 in the *Yorkshire 4* sketchbook pencil drawing, although he is placed more distantly here.

The pulsing of the Tees in concentric waves vividly communicates the force of the torrent, which must have been considerable when viewed in the extremely wet summer of 1816. Turner gave himself more room to articulate that rhythm by heightening the rockface and falls. As in his other waterfall depictions (see cat. 18), he captured the fine spray given off by a strong body of falling water.

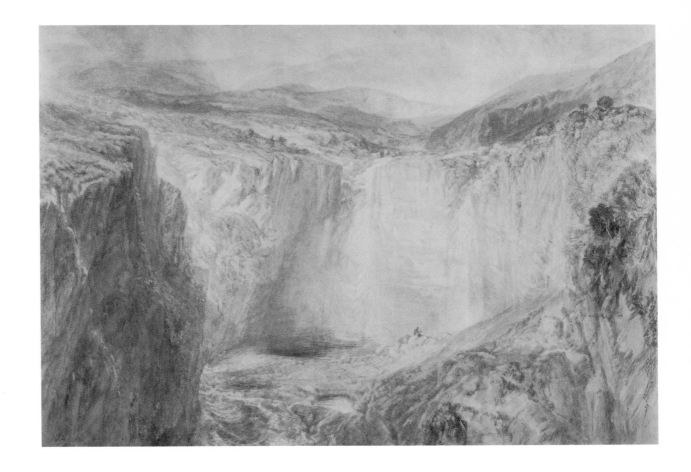

Cat. **87**
Richmond Castle and Town, Yorkshire
c. 1825

Watercolour
27.5 × 39.7 cm

W 791
The British Museum, London

EXHIBITED: Egyptian Hall, Piccadilly, 1829 (29); Moon, Boys and Graves Gallery, 1833 (4)

PRELIMINARY MATERIAL: Pencil drawing *Yorkshire 5* sketchbook, 1816 (TB CXLVIII, ff. 13v and 14r)

ENGRAVED: W.R.Smith, 1827, 'Picturesque Views in England and Wales' (R 215)

Although this work was entitled simply 'Richmond, Yorkshire' when displayed in 1829, the longer title used when it was re-exhibited in 1833 has been adopted here to differentiate it from another 'England and Wales' series depiction of Richmond (w 808, Fitzwilliam Museum, Cambridge).

We view the town in early morning light, with mist rising off the River Swale. Through contrast this silvery haze and the vagueness it creates intensifies the colour and clarity of the town above. Turner could not possibly have seen the vivid autumnal reds on the left when he visited Richmond and Swaledale during the dismal summer of 1816. A girl with a dog – or dogs, as here – is present in all four of Turner's Richmond scenes, and clearly she alludes to the popular song 'The Sweet Lass of Richmond Hill' by James Hook. The words of that ballad were inspired by a girl who had once lived in a house situated just below Richmond Castle, as Turner must have known.

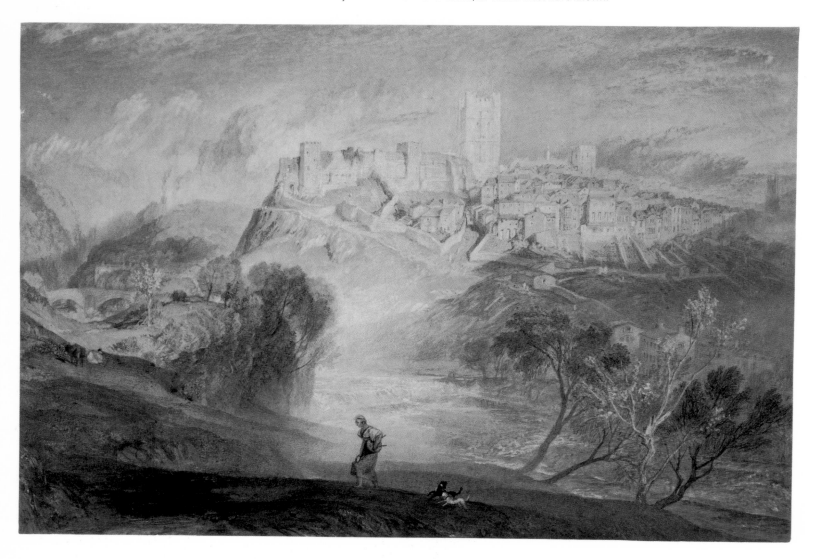

Cat. **87a**
Richmond [Castle and
Town], Yorkshire
1827

Copper engraving
16.9 × 24 cm

R 215
The British Museum, London

STATE: Engraver's proof

ENGRAVED: W.R. Smith, 1827, for
'Picturesque Views in England and
Wales', 1827–38, (Part II, no. 3)

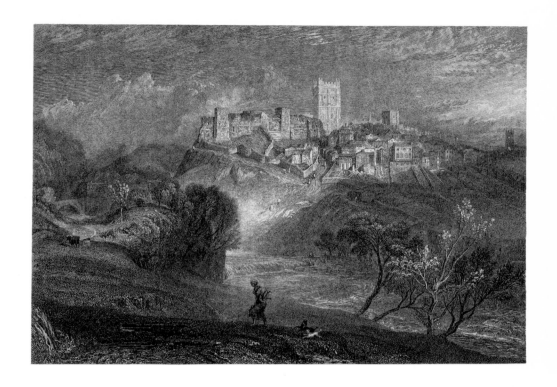

Cat. **87b**
Richmond [Castle and
Town], Yorkshire
1827

Copper engraving
16.9 × 24 cm

R 215
The British Museum, London

STATE: First published state,
more advanced and with two figures
halfway up the bank more clearly
defined

ENGRAVED: W.R. Smith, 1827, for
'Picturesque Views in England and
Wales', 1827–38 (Part II, no. 3)

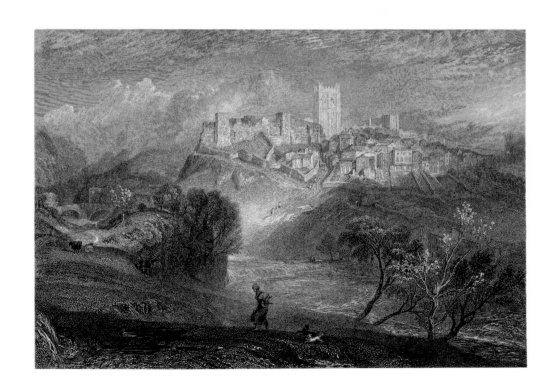

Cat. **88**

Yarmouth

c. 1827

Watercolour
27.9 × 39.4 cm

W 810
Private collection

EXHIBITED: Egyptian Hall, Piccadilly, 1829 (35); Moon, Boys and Graves Gallery, 1833 (19)

PRELIMINARY MATERIAL: Pencil drawings *Norfolk, Suffolk and Essex* sketchbook, 1824 (TB CCIX, ff. 11, 12, 29, 32, 34, 34v)

ENGRAVED: William Miller, 1829, 'Picturesque Views in England and Wales' (R 234)

Yarmouth was the home port of the North Sea division of the Royal Navy, whose ships are moored in the distance beyond the Nelson Monument. This column was built in 1817 to commemorate both the outstanding admiral and his 1805 victory at Trafalgar. Further to the left is the Naval Hospital and the church of St Nicholas.

In the foreground, on a considerably heightened crest above Gorleston harbour, a washerwoman has recently laid out her washing and fish to dry in the peaceful sun. Suddenly, however, a fierce gust of wind has blown away her bonnet, basket and items of wet clothing, indicating the onset of the storm approaching in the distance. Such a dramatic reversal in the weather was surely intended to suggest the transformation of peace into war, with the Nelson Monument and adjacent fleet alluding to the protection provided by the navy. Such an interpretation is supported by the title and

imagery of an 'England and Wales' series watercolour that was clearly made to complement this image, *Dock Yard, Devonport, Ships being paid off* (cat. 89).

At the lower right the wind whips up the waves off Gorleston pier, while at the lower left a pair of herrings, or Yarmouth bloaters, remind us of the town's principal export.

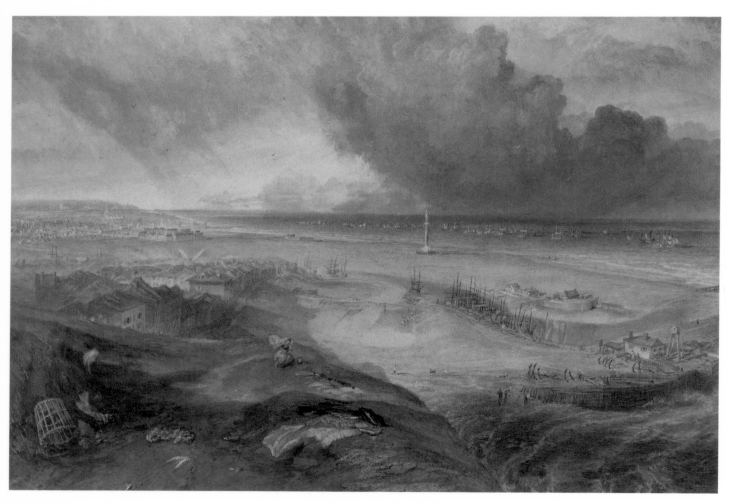

**Dock Yard, Devonport,
Ships being paid off**

c. 1827

Watercolour and scratching-out
28.7 × 43.9 cm

W 813
Fogg Art Museum, Harvard
University Art Museums, Gift of
Charles Fairfax Murray in honor of
W.J.Stillman

EXHIBITED: Egyptian Hall, Piccadilly,
1829 (41); Moon, Boys and Graves
Gallery, Pall Mall, 1833 (7)

ENGRAVED: Thomas Jeavons, 1830,
'Picturesque Views in England and
Wales' (R 237)

The title given here was the one used for this watercolour when it was first exhibited, and it throws light on Turner's meaning.

Naval crews were discharged by being 'paid off' only at the end of hostilities. The large numbers of warships in the Hamoaze demonstrate that Turner was here remembering the anchorage as he had seen it during the Napoleonic wars, in 1811, 1813 or possibly 1814, rather than as it would have appeared at the time he made this drawing. The crews being 'paid off' in this image are therefore being discharged at the end of the Napoleonic conflict. Just by a large vessel on the extreme left an officer and numerous tars embark on civilian life by taking to small boats filled with women who have come out to greet them. In the distance nature parallels the coming of peace, for dark storm-clouds move off to reveal a golden evening sky. It seems likely that this statement about the end

of strife was intended to balance Turner's allusion to the approach of war in *Yarmouth* (cat. 88).

Ruskin owned this drawing and praised it highly.[1] Devonport parish church is visible on the right, and before it are a number of hulks used as storeships, barracks and hospitals, with the 'sheers' or crane of a hulk employed for masting shipping just beyond. The low triangular buildings further off are the gambrel-roofed, dry-dock sheds in which men-of-war were built and then launched through their apertures at one end.

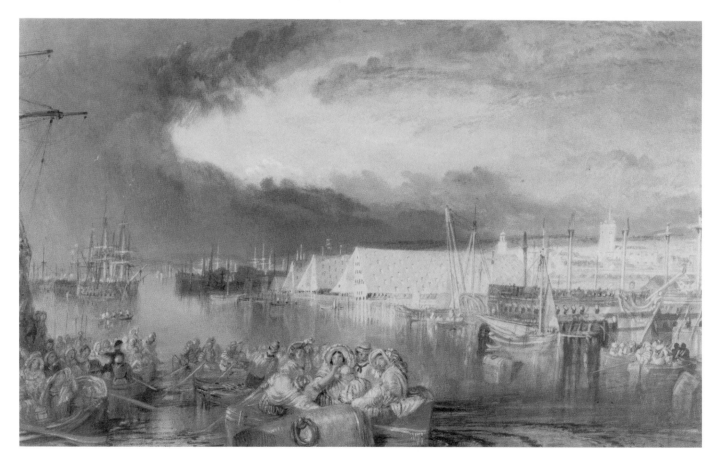

Cat. **90**

Kilgarren Castle, Pembrokeshire

c. 1828

Watercolour
27.9 × 40 cm

W 806
Private collection

EXHIBITED: Egyptian Hall, Piccadilly, 1829 (12); Birmingham Society of Artists, 1829 (345); Moon, Boys and Graves Gallery, 1833 (28)

PRELIMINARY MATERIAL: Pencil drawing *Hereford Court* sketchbook, 1798 (TB XXXVIII, f. 88)

ENGRAVED: James Tibbitts Willmore, 1829, 'Picturesque Views in England and Wales' (R 230)

Cilgerran Castle is seen here at dawn, with morning mists rising above the River Teifi. The happiness of the mother and child playing with a hoop at the lower right focuses the mood of the image, while the security of maternal love contrasts with the ruination of military might.

Turner's observational acuity is demonstrated by the halo of light blinding us to the contour of the leftmost tower, for although photography has conditioned us into taking such circular dazzles for granted, they must have been difficult to perceive before fast camera speeds revealed them clearly.

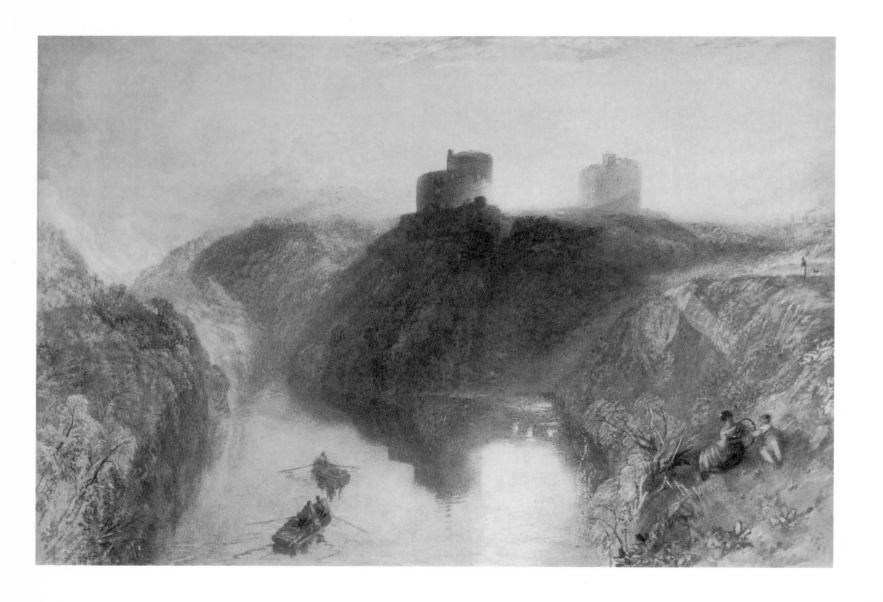

Cat. **91**
West Cowes,
Isle of Wight

c. 1828

Watercolour, gouache, and
scratching-out
28.6 × 41.9 cm

W 816
Private collection

EXHIBITED: Moon, Boys and Graves
Gallery, 1833 (39)

PRELIMINARY MATERIAL: Pencil drawing
Windsor and Cowes sketchbook,
c. 1827 (TB CCXXVI, f. 40v)

ENGRAVED: Robert Wallis, 1830,
'Picturesque Views in England and
Wales' (R 240)

detail pp. 206–7

Cowes Roads still served Portsmouth as a naval anchorage in
the 1820s, and here they are filled with both military and
civilian shipping. In the distance fishing and pleasure boats
clutter the River Medina. Beyond them is the tower of the
church of St Mary; this was designed by Turner's friend, John
Nash, who lived nearby at East Cowes Castle. The painter often
stayed there in the 1820s.

The slack sails on the left indicate the stillness of the evening
air. The highlights on the intermingled reflections of ship and
moon were created by a single, confident scratching of the
paper.

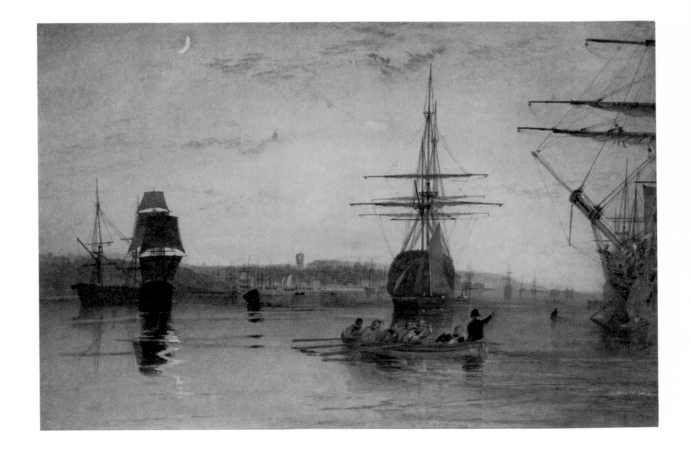

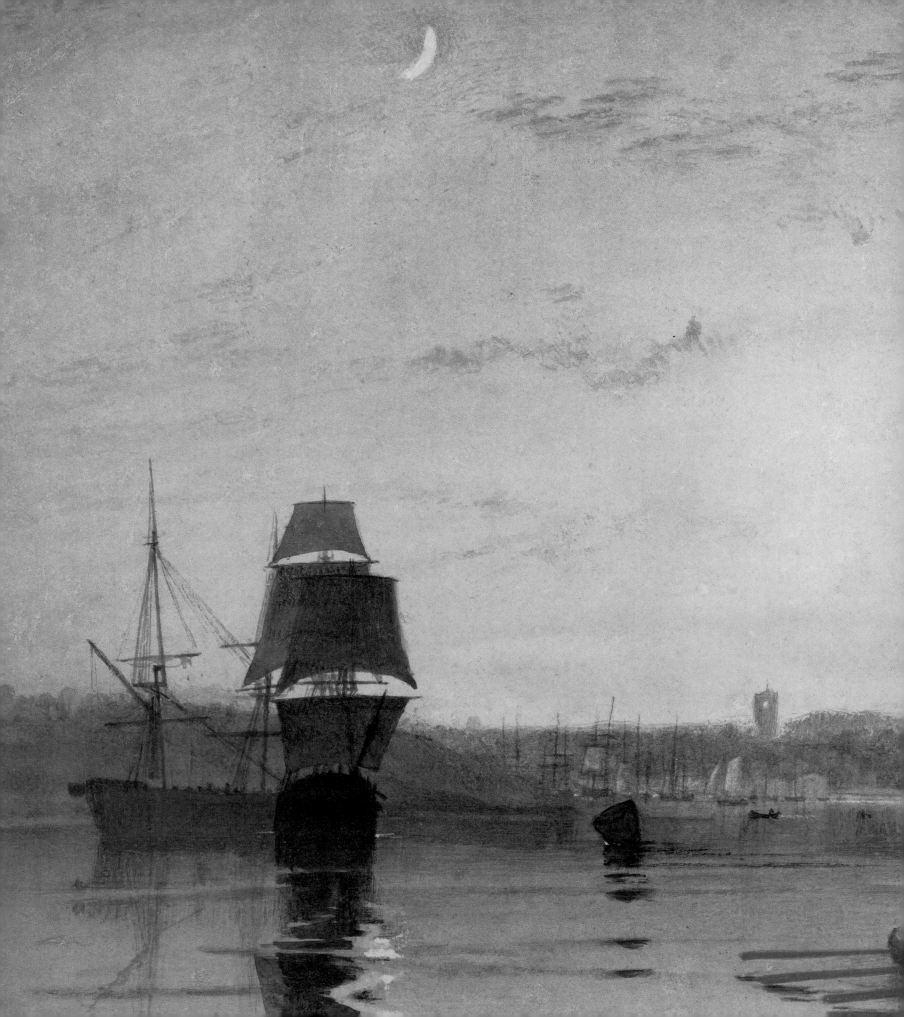

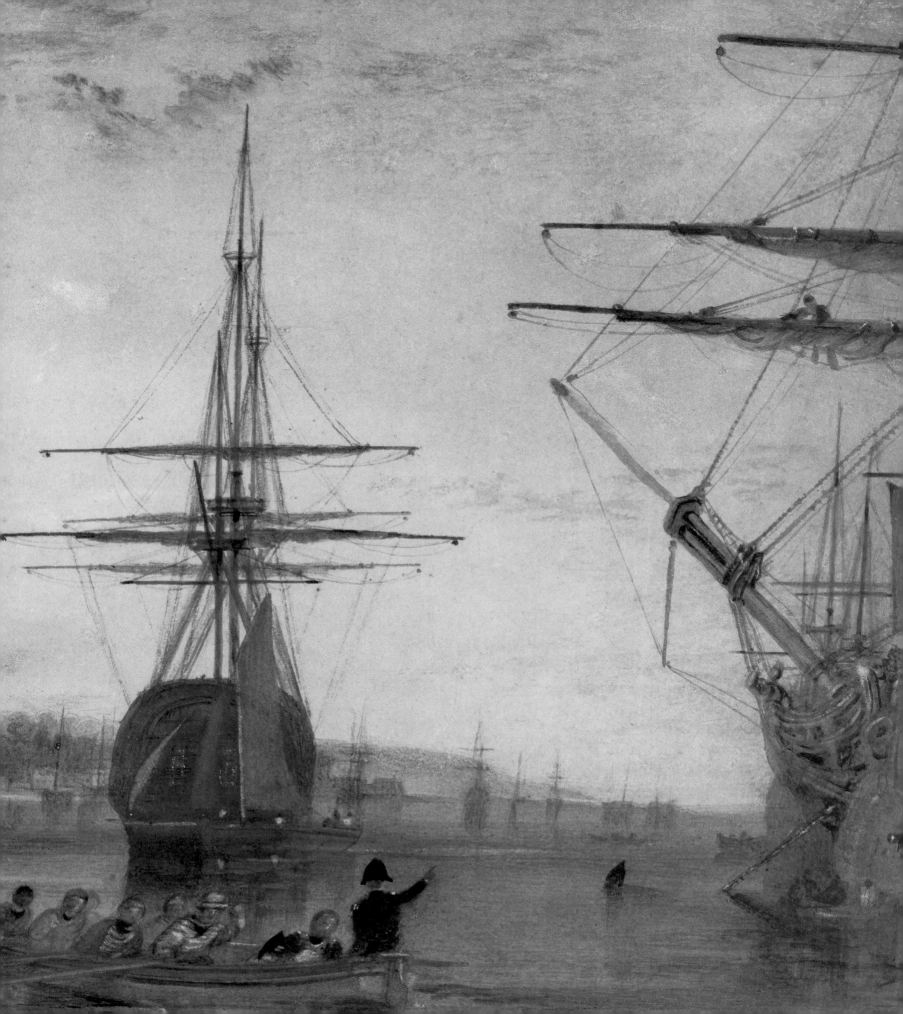

Cat. **92**
Alnwick Castle,
Northumberland
c. 1828

Watercolour and scratching-out
28.3 × 48.3 cm

W 818
South Australian Government Grant
1958, Art Gallery of South Australia,
Adelaide

PRELIMINARY MATERIAL: Pencil drawing
North of England sketchbook,
1797 (TB XXXIV, f. 44)

EXHIBITED: Egyptian Hall, Piccadilly,
1829 (31); Moon, Boys and Graves
Gallery, 1833 (31); Royal Manchester
Institution, 1835 (260)

ENGRAVED: James Tibbitts Willmore,
1830, 'Picturesque Views in England
and Wales' (R 242)

We view Alnwick Castle from the west, across the Lion Bridge over the River Aln. The bridge takes its name from the lion statues that stand on it, symbols of the Percy family who own the castle. The head and outstretched tail of one of the lions are visible just below the moon.

The artist is reputed to have said that this watercolour 'was one of the most troublesome works he had ever done',[1] although the image provides no evidence of a struggle. The draughtsmanship and tonal distribution are confident, the rays above the moon are extremely subtle, the image sparkles with highlights, and stippling lends it textural vibrancy. In a typical Turnerian visual simile, the pronged shapes of the paired statues on the castle turrets are reiterated by the antlers of the deer standing below the bridge.

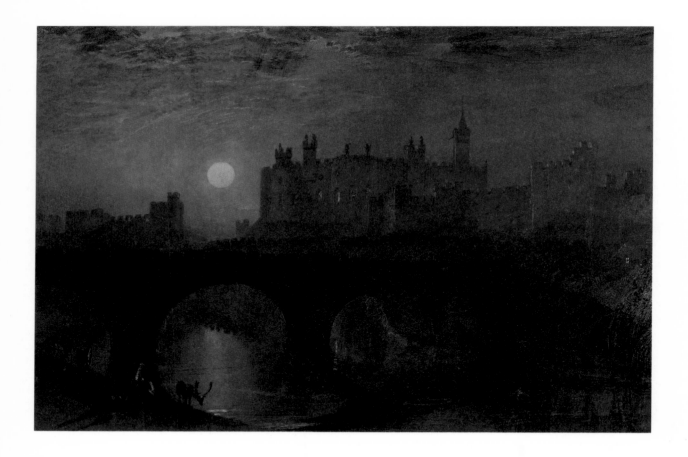

Cat. **93**
Stoneyhurst College,
Lancashire
April–May 1829

Watercolour
28 × 41.9 cm

W 820
Private collection

EXHIBITED: Egyptian Hall, Piccadilly, 1829 (19); Moon, Boys and Graves Gallery, 1833 (37)

PRELIMINARY MATERIAL: Pencil drawing, *Lancashire and North Wales* sketchbook, c. 1797 (TB XLV, f. 42)

ENGRAVED: James B. Allen, 1830, 'Picturesque Views in England and Wales' (R 244)

detail pp. 210–11

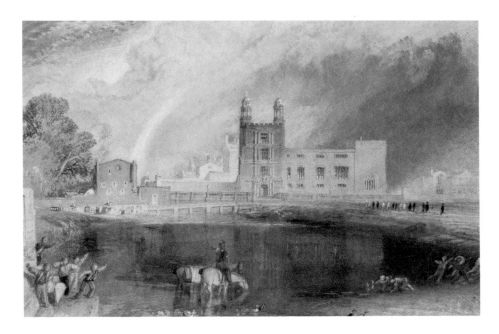

As Turner was undoubtedly aware when he made this watercolour, Stonyhurst College is a Roman Catholic seminary and school. The most momentous event concerning British Catholics during the painter's lifetime occurred in April 1829, when the Roman Catholic Emancipation Act was passed by Parliament. The bill had proposed the abolition of a range of anti-Catholic legislation, and it had been passionately opposed by many Protestants, but especially George IV who had only withdrawn his opposition to it when threatened by civil war in Ireland. The enactment of Catholic emancipation would prove instrumental to the passage of parliamentary reform some three years later, and Turner responded to that process elsewhere (cats. 95 and 96).

Because this watercolour was exhibited in June 1829, it is likely that it was made shortly after the proclamation of Catholic emancipation. The firmest clue to the meaning of the work resides in the crosses Turner placed on the twin cupolas of the Stonyhurst gatehouse. In reality those domes are surmounted by bronze eagles, as the painter was well aware, for he had represented the birds both in the 1797 pencil drawing from which he developed this design, and in a watercolour he made of the building in 1800 (W 293, private collection). The engraving of the latter work (R 60) was subsequently dedicated to the Roman Catholic founder of Stonyhurst, Thomas Weld, possibly at the artist's behest.

Turner surely altered the bronze birds into crosses to signify the greater equality between the two major branches of British Christianity in 1829. Further associative imagery extends the metaphor into allegory. On the right of the Infirmary Pond two boys pull a toy boat from the water; this vessel apparently belongs to the boys on the left who are venting their anger at their loss. The vertical linkage between the boys on the right and the procession of college staff above them suggests they are Stonyhurst pupils, while the boat they grab might well allude to the political power that had just been wrested from a Protestant establishment, as signified by the angry protestants on the left. In the centre the only adult in the foreground turns in his saddle to silence the owners of the boat, rather than forbid the other boys from taking it. His action might therefore be seen to parallel the volte-face that George IV had reluctantly performed in order to bring about peace.

The weather also matches recent events, for a storm moves off, creating a rainbow and bathing the scene in a brilliant sunshine that may allude to a new era of religious tolerance.

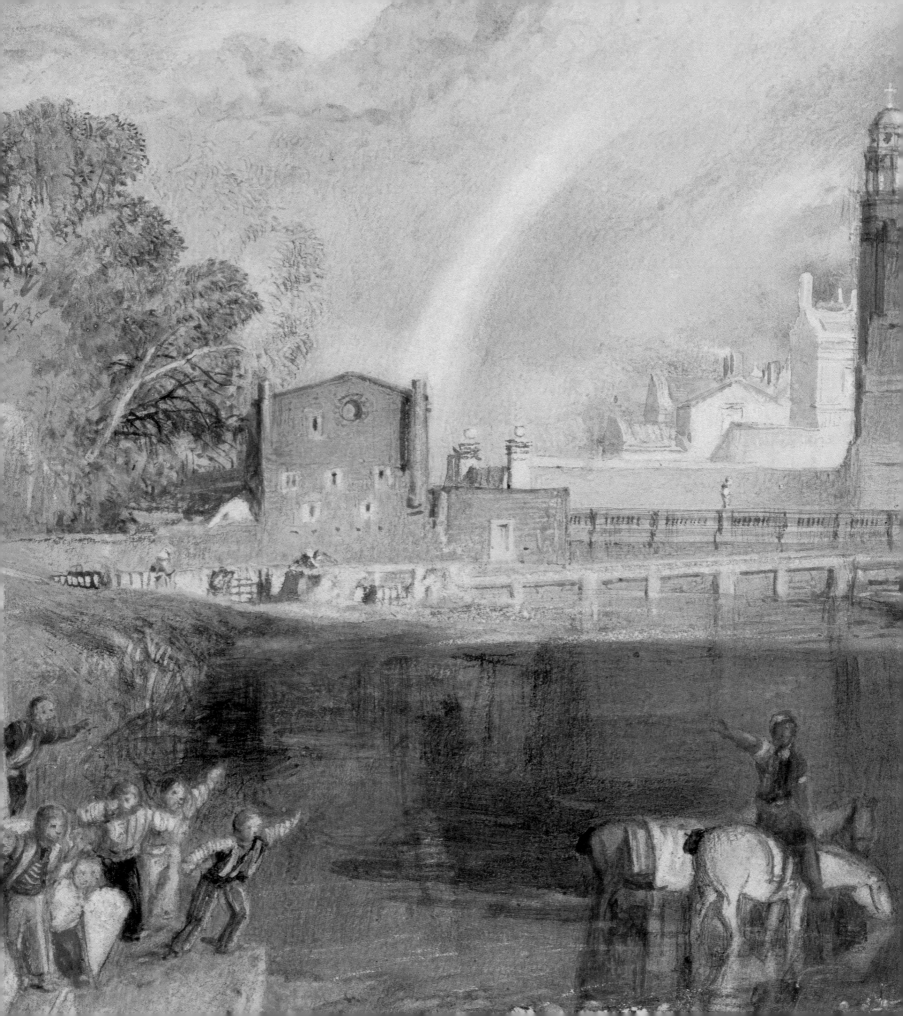

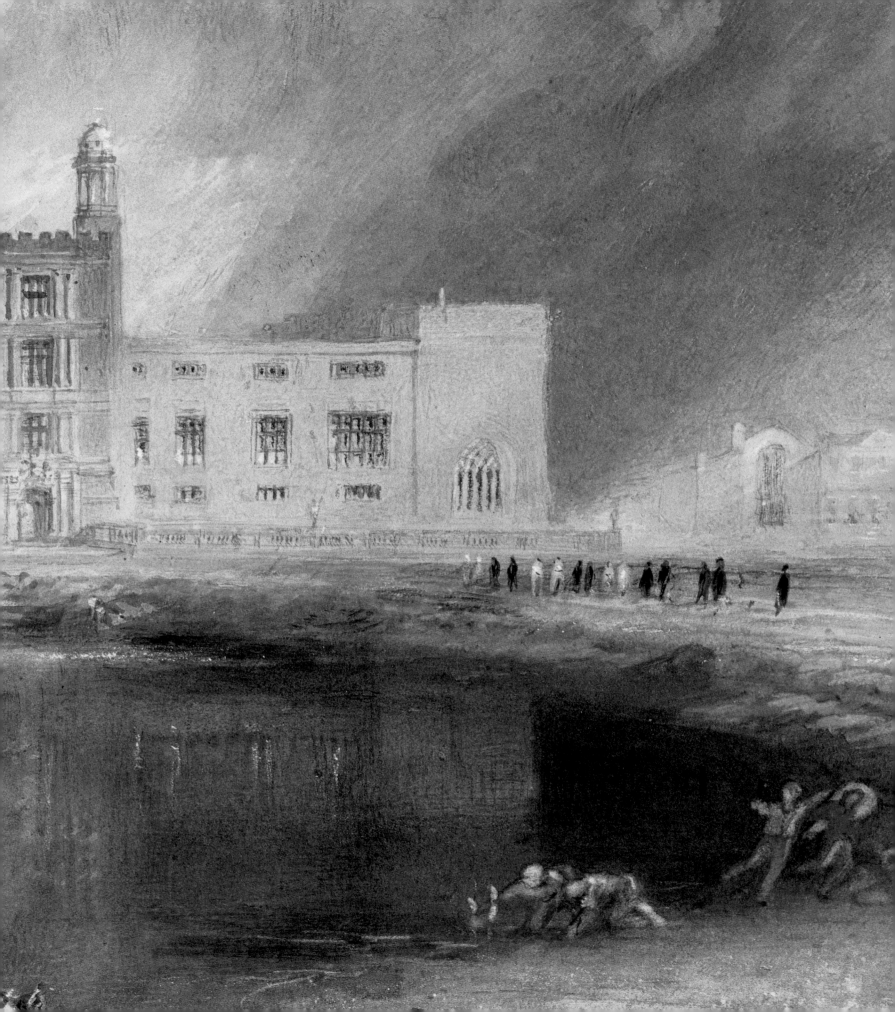

Cat. **94**

Brinkburn Priory,
Northumberland

c. 1830

Watercolour, gouache, and
scratching-out
29.2 × 46.3 cm

W 843
Sheffield Galleries & Museums Trust

EXHIBITED: Moon, Boys and Graves
Gallery, 1833 (46)

PRELIMINARY MATERIAL: Pencil drawing
Fogg Art Museum, Cambridge,
Mass.; probably a leaf from the
Smaller Fonthill sketchbook, 1797
(TB XLVIII)

ENGRAVED: J. C. Varrall, 1832,
'Picturesque Views in England and
Wales' (R 267)

An Augustinian foundation dating from around 1135,
Brinkburn Priory was dissolved during the Reformation.
Turner visited the remains on his first northern tour in 1797.
 We look westwards along the River Coquet whose banks,
together with the hillsides and trees, form an X-shape that
both structures the composition and provides a moral contrast:
nature on the left is abundant and lush, while all on the right
lies ruined and bare.

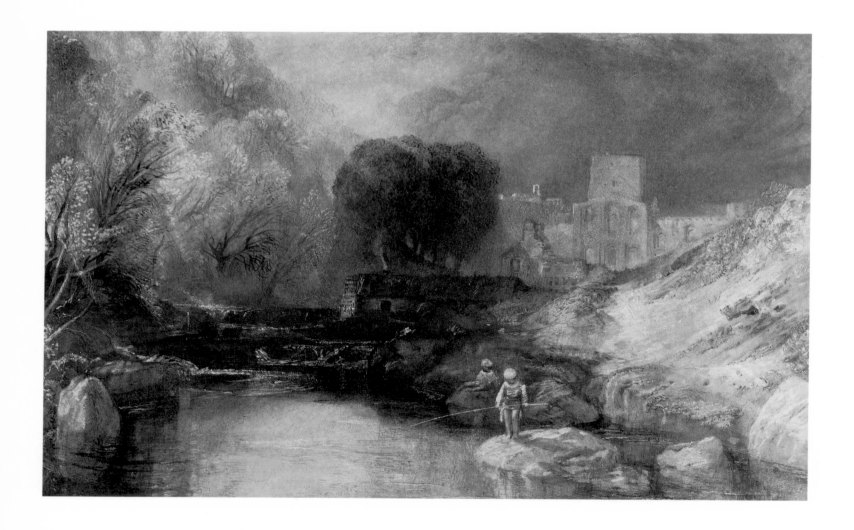

Cat. **95**

Ely Cathedral,
Cambridgeshire

c. 1831

Watercolour
30.2 × 41 cm

W 845
Private collection

EXHIBITED: Moon, Boys and Graves
Gallery, 1833 (53)

PRELIMINARY MATERIAL: Pencil drawing,
1794, Private collection

ENGRAVED: Thomas Higham, 1833,
'Picturesque Views in England and
Wales' (R 269)

The 1794 pencil drawing from which this watercolour was elaborated demonstrates that the figures, pond, weather effects and lighting were all invented.

When this watercolour was displayed in 1833 the exhibition catalogue drew attention to the collapse of the tower of Ely Cathedral in 1322 and its replacement by the octagon depicted by Turner. That information may have been inserted at the painter's request in order to link the stones being thrown by the children in the foreground to the medieval collapse. Moreover, the artist might also have wanted the falling stones to suggest something more.

By 1831 the Church of England greatly feared that parliamentary reform would lead to its disestablishment and it therefore opposed such change. In October of that year the spiritual peers sitting in the House of Lords were instrumental in defeating a second attempt to enact the Reform Bill. As a consequence, bishops were stoned in the streets and had their palaces besieged or even burnt down. Bishop Sparke of Ely was especially singled out for ridicule because of charges of nepotism and abuse of ecclesiastic patronage.[1]

Several palls of smoke issuing from chimneys indicate that the dark clouds on the left are approaching the cathedral, and they might well denote the threat posed by Reform, just as a possible reference to the collapse of 1322 could equally hint at the potential collapse of the established Church in political and economic terms.[2]

Certainly the haymakers on the right seem happy in their work, but since they toil near to the cathedral and presumably live in the cottages that cluster around it, they might stand to suffer from any loss in the temporal power of the Church.[3]

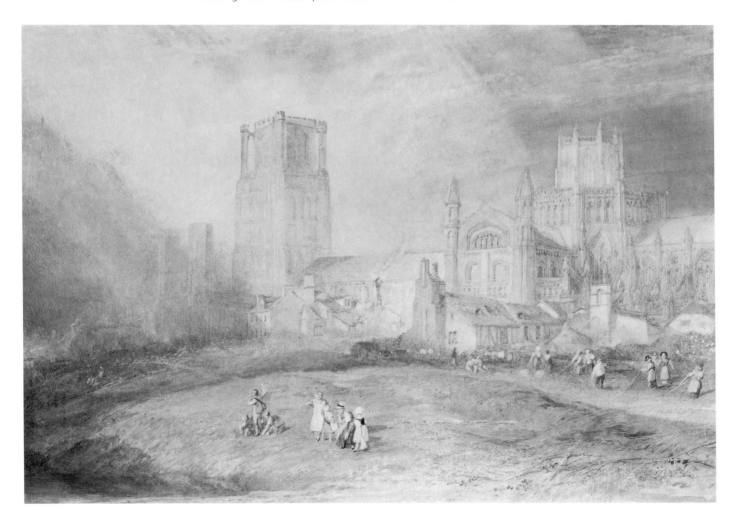

Cat. **96**
Nottingham,
Nottinghamshire
c. 1832

Watercolour
30.5 × 46.3 cm

W 850
City of Nottingham Museums,
Castle Museum

EXHIBITED: Moon, Boys and Graves
Gallery, 1833 (60)

ENGRAVED: William Bernard Cooke,
1833, 'Picturesque Views in England
and Wales' (R 274)

Here Turner subtly celebrated the passing of the Reform Act. In 1832 Nottingham Castle was owned by the Duke of Newcastle, a violent and unprincipled opponent of parliamentary reform; in 1829 and 1830 the duke had provoked widespread anger by evicting tenants who had voted in favour of the measure. Those dispossessions were regarded as infringements of basic political rights. When the second attempt to pass the Reform Bill was narrowly rejected in October 1831, the defeat so infuriated visitors to the annual Nottingham Goose Fair that they stormed the castle and set it ablaze. The burning stubble immediately beneath the building clearly alludes to that fire.

The Reform Bill was finally passed on 7 June 1832, laying the foundations of modern parliamentary democracy, and that momentous event is celebrated here. In front of a castle that stood for opposition to Reform, sails are being hoisted and a dense jumble of boats and people is preparing to move off through lock gates that have just opened, in a symbolic representation of the arrival of liberty. Flying above the sails in the centre is the Greek flag; although such a pennant would not have been seen on the Nottingham Canal, it was a recognised symbol of liberty in 1832, two years after the ancient birthplace of democracy had regained her independence. At the bottom right a rudder resembles a butcher's cleaver, and the similarity is heightened by its blood-red handle – perhaps it was intended to suggest the weaponry of continental revolutions, abandoned here because such arms had not been required. The weather extends the allegory, for a distant storm passes away to reveal a double rainbow, with the town and its churches glistening in the brilliant evening sunlight. The end of the day matches the end of a long struggle.[1]

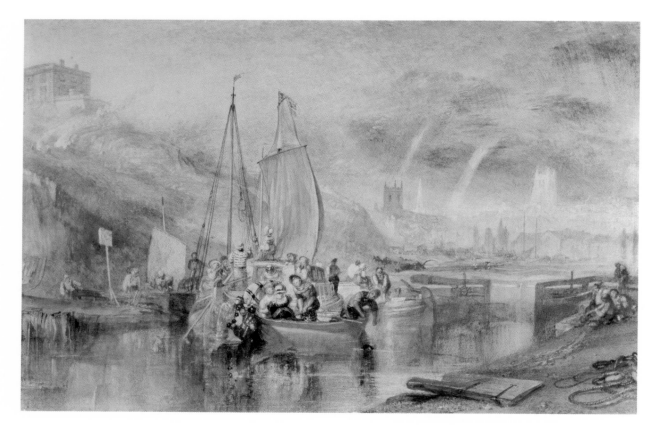

Longships Lighthouse, Land's End

c. 1834

Watercolour and scratching-out
28.1 × 43.2 cm

W 864
J. Paul Getty Museum, Los Angeles

PRELIMINARY MATERIAL: *Cornwall and Devon* sketchbook, 1811
(TB ADD CXXVA, f. 27)

ENGRAVED: William R. Smith, 1836,
'Picturesque Views in England and Wales' (R 288)

When Turner created this drawing the Longships Lighthouse, off the southernmost point of mainland Britain, was still relatively new, having been built in 1794–5. Its erection in such an exposed and dangerous location was regarded as an extraordinary engineering feat.

However, Turner did not celebrate that achievement, for the entire foreground is strewn with wreckage: the lighthouse has failed in its purpose. No survivors are visible, just some torches indicating people who are powerless to save life (although by retrieving debris, they will doubtless prosper in due course from the tragedy).

On the rocks in the centre may be seen the mast of a foundering vessel, and it parallels the mast nearer to hand. Compositional lines running down the contours of the cliffs and up the waves and wreckage lead the eye to the distant lighthouse, while the rising gulls on the right create both a counter-balance and an additional surge of movement. The sea boils with energy, and everywhere the underlying truths of its motion are made evident.

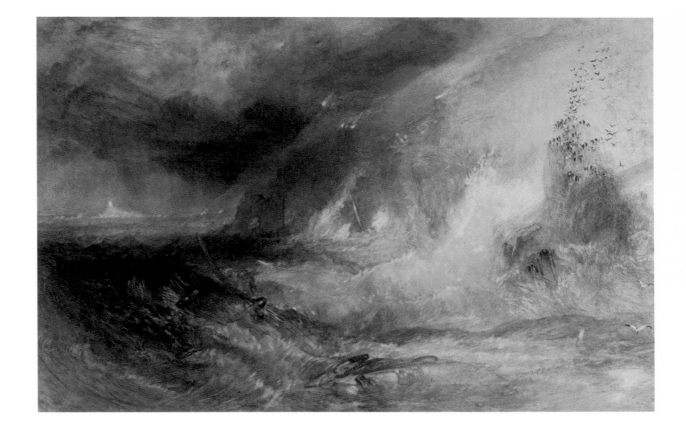

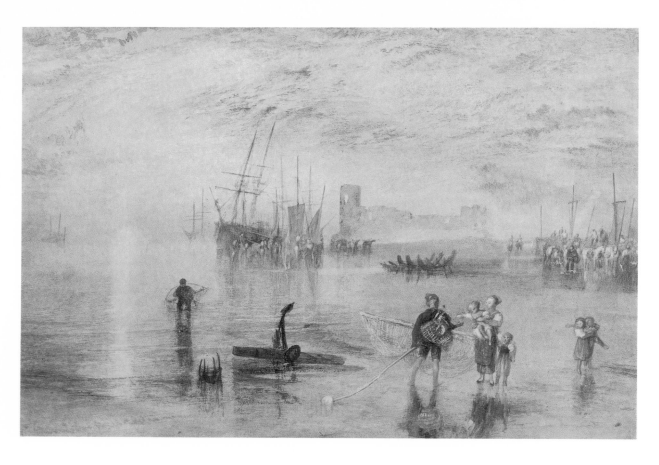

Cat. **98**
Flint Castle, North Wales
1835

Watercolour
27.1 × 40.1 cm

W 868
National Museums and Galleries of
Wales

ENGRAVED: J. H. Kernot, 1836,
'Picturesque Views in England and
Wales' (R 292)

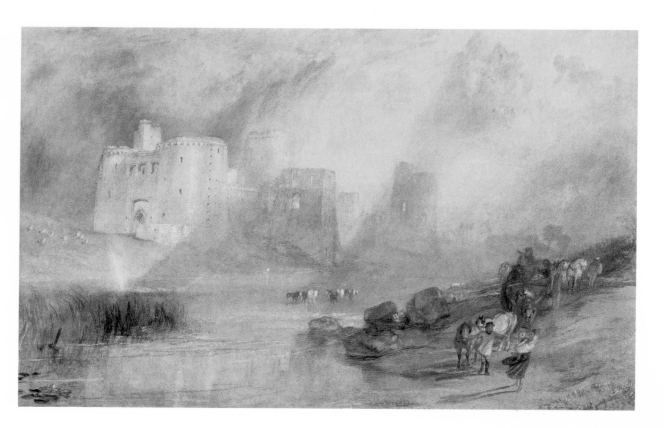

Cat. **99**
**Kidwelly Castle, South
Wales**
1835

Watercolour
28.9 × 44.5 cm

W 870
Harris Museum and Art Gallery,
Preston

PRELIMINARY MATERIAL: Pencil drawing
South Wales sketchbook, 1795
(TB XXVI, f. 16)

ENGRAVED: Thomas Jeavons, 1837,
'Picturesque Views in England and
Wales' (R 294)

These two 'England and Wales' series watercolours are thematically related, for not only do they depict ruined Welsh castles but in their foregrounds working men greet children held aloft by their mothers. In the 'England and Wales' series views of Cilgerran Castle (cat. 90), Dolbadarn Castle (w 806) and Ludlow Castle (w 825), Turner placed mothers with children in front of ruins, so the linkage was a consistent one. Perhaps the artist wished to contrast the ruination of grandiose human ambitions, as represented by the castles, with the continuity of humble family life. In each case the landscape projects an emotional warmth and positivity associated with maternal love.

Turner probably relied upon memory for the Flint view, which is why the Wirral peninsula does not appear on the far side of the Dee estuary, above which the sun rises.[1] The watercolour is one of the finest 'England and Wales' series images, and it demonstrates Turner's technical prowess to the full. With supreme confidence he sponged the sun's reflection from the underlying wash of pale orange, which had previously been floated across the sheet when wet. Similar diffusions of colour underlie the fine detailings of sky and sands.

Because Turner may well have been aware of the use of the word 'shrimp' to denote a small child, the baby at the lower right, possibly taking a shrimp from the shrimper, might embody a play upon words.[2] The strong dabs of red and emerald green around the child set off the softer colours elsewhere, while the dark accents distributed across the foreground augment the tonal delicacies of the distance by contrast. Immediately in front of the medieval ruin stands a modern wreck; Turner frequently created such moral conjunctions (see cat. 61).

In the Kidwelly view the cattle in the middle of the River Gwendraeth are out of scale, surely to make the castle seem more massive by contrast. The ruin looks ethereal in the damp, early morning light, and the outstanding colouring of the drawing lends the scene an unearthly radiance and beauty.

Cat. **100**

Chain Bridge over the River Tees

1836

Watercolour
27.8 × 43.5 cm

W 878
On loan to The Whitworth Art Gallery, The University of Manchester, from a private collection

PRELIMINARY MATERIAL: Pencil drawing *Yorkshire 5* sketchbook, 1816 (TB CXLVIII, f. 6v)

ENGRAVED: William R. Smith, 1838, 'Picturesque Views in England and Wales' (R 302)

In this dramatic view of the Cauldron Snout waterfall in Upper Teesdale, Turner departed radically from the topography he had recorded in 1816. The distant hillside on the left is greatly heightened, while the rather foursquare shape of the limestone gorge is curved to make it resemble a vast, sweeping chasm in the Alps. At the lower left the Tees plummets out of the image into an abyss not indicated in the original pencil drawing.

The river dramatically divides the landscape, and symbolises the chasm between life and death. Areas of light and subtle shadow fall obliquely from the left and connect some grouse nestling in the right foreground with a hunter advancing on the far bank with gun held high. The vitality of the birds is amplified by the abundant foliage that surrounds them, just as the bleak death they face is projected by the empty hillside around the hunter who approaches relentlessly.

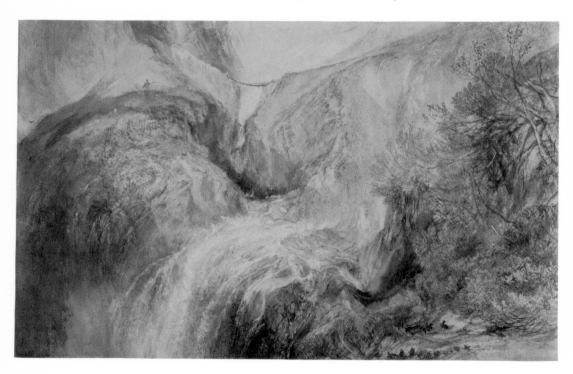

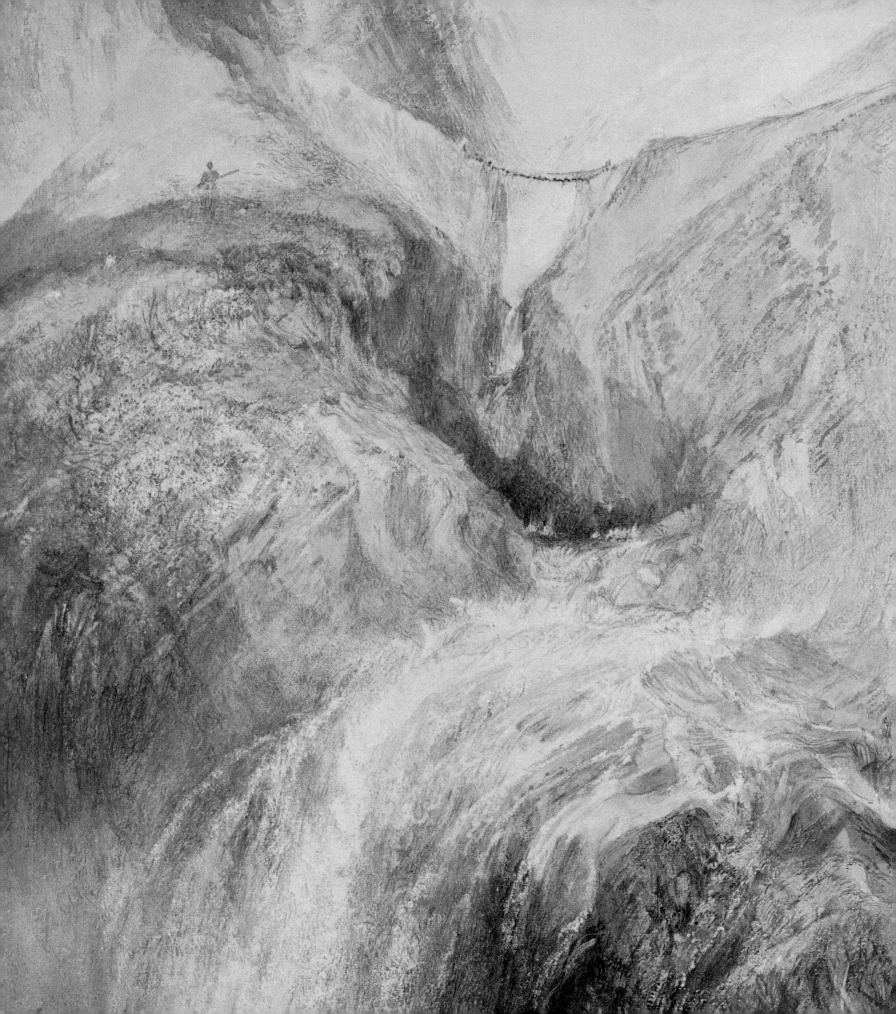

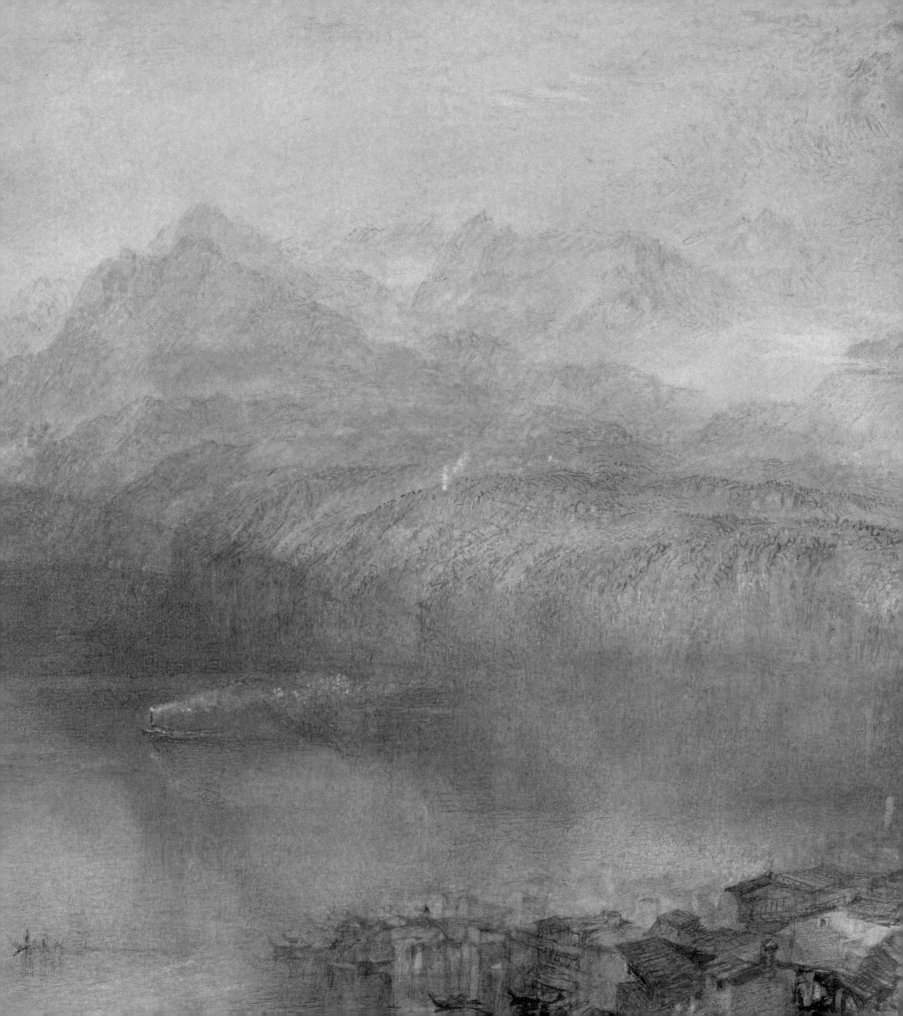

The Late Finished Watercolours: German and Swiss Views, 1840–48

The failure of the 'Picturesque Views in England and Wales' series in 1838 made evident the declining demand for topographical engravings. Although Turner subsequently produced a few watercolours for engraving which were also purchased by such major patrons as W. B. Windus (see cats. 101 and 102), he found an alternative way of selling his finished watercolours. Following his annual tours of Switzerland undertaken between 1841 and 1844, he made groups of rough watercolours (or 'sample-studies') which suggested the appearance of finished drawings to be developed from them. His agent, Thomas Griffith, then showed those studies to collectors in the hope that they would commission the finished works. Although the anticipated support was not readily forthcoming – for Turner's late style did not suit all tastes – the artist was able to produce four sets of finished watercolours between 1842 and about 1848. Many of the drawings were purchased by, among others, Elhanan Bicknell (cats. 104 and 107); James Munro of Novar (cats. 105 and 106); Henry Vaughan (cat. 110); and John Ruskin (cat. 108). Arguably, they constitute his loveliest landscapes in watercolour.

detail cat. 107

Cat. **101**

Oberwesel

1840

Watercolour, gouache and
scratching-out
34.5 × 53 cm
Signed at lower right: *IMWT. 1840*

W 1380
Private collection

PRELIMINARY MATERIAL: Pencil drawings,
*Trèves to Cochem and Coblenz to
Mayence* sketchbook, 1839
(TB CCXC, ff. 55, 55v, 56, 56v,
57, 57v, 58)

ENGRAVED: James Tibbitts Willmore,
1842, *Finden's Royal Gallery of
British Art* (R 660)

This watercolour may have been commissioned by William
Finden for engraving in his *Royal Gallery of British Art*. Turner
here pays homage to Claude Lorrain, although the sparkling
foreground (where a mass of highlights were scratched out),
the dazzling brilliance of the light, and the tonal subtleties in
the distance transcend his model.

Oberwesel is located at the base of the hill to right of centre.
The foliage signifies a summer scene, but as we are looking
due south, the midday sun appears lower than it would be
during that season. As we have seen, Turner often took such
artistic licence, especially in his more idealised landscapes. For
the same reason he widened the vista depicted in the principal
source drawing (f. 56); as a result, the Ochsturm tower near
the lower left has been moved about a kilometre downriver
from the town to which it belongs. Moreover, the ruined
Schönburg Castle that dominates the town, and which is
visible on a distant hill to the right of the church spire, has been
moved upstream and considerably diminished in size.

On the far bank of the river is Kaub and the adjacent Pfalz
toll castle on an island in the Rhine (see cats. 42 and 80).
As in Turner's other views of the island, it is much reduced in
size. A steamer sails between the town and the island, its
smoke drifting lazily in the still air.

It has convincingly been suggested[1] that the woman suckling
a baby in the foreground was inspired by part of stanza XLVI of
the third Canto of Byron's *Childe Harold's Pilgrimage*, with
which Turner was familiar:

> **Maternal Nature! for who teems like thee,**
> **Thus on the banks of thy majestic Rhine?**

Equally, it has been argued that the selfsame mother resting
from the grape-picking on the right was intended to pun
visually upon the name of a German hock, *Liebfraumilch*;
Turner must have known the literal meaning of its title.

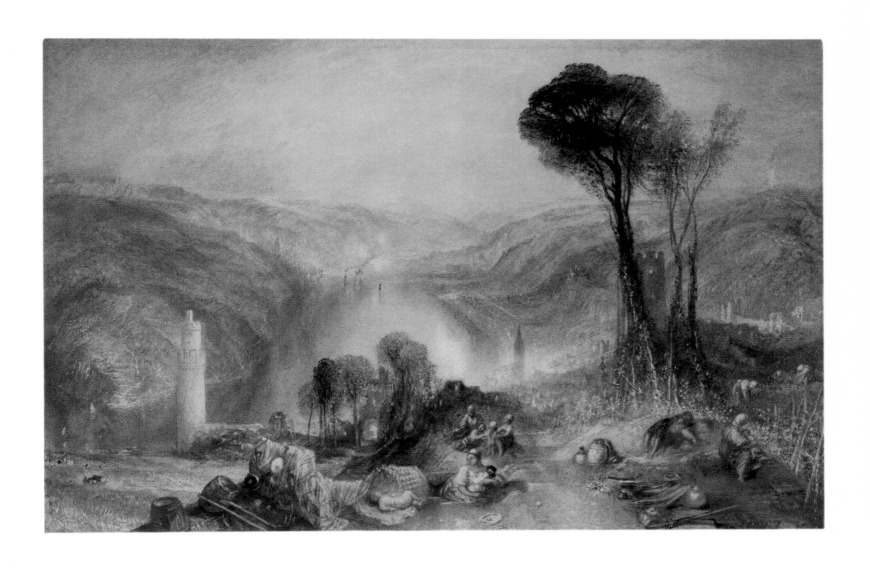

Cat. **102**

**Heidelberg, with
a rainbow**

c. 1840

Watercolour
31.1 × 52.1cm
Signed lower left: *JMW Turner*

W 1377
Scottish private collection

ENGRAVED: Thomas Prior, 1846
(R 663)

detail pp. 226–7

Turner made this design at the instigation of the engraver Thomas Prior, who was in need of work in 1840. The artist charged him 100 guineas for the drawing, which was then sold on to a collector when the engraving process was completed.

Apparently the composition was based upon a sketch by Prior, although Turner already possessed several rough pencil studies of this view.[1] A large colour study (TB CCCLXV 34) may have been made in connection with the present drawing, although the date *10 Mar 1841* inscribed on it suggests that it was elaborated for another Heidelberg depiction (cat. 103).

We view Heidelberg across the River Neckar in morning light. A heavy shower has just fallen on the far side of the river and is now moving off. Stippled marks of an incredible finesse delineate the distant hillside and clouds, while broader touches represent the ripples on the Neckar and the rain still falling beyond the bridge.

The lack of reflections and people sitting on bare ground indicate that the nearby shore is dry. Among the adjacent figures are some young men dressed in Renaissance costume. These may allude to Heidelberg's past or be members of a student fraternity, but equally they could just be in fancy dress.[2] The young man lounging at the left with his pipe, portfolio, palette and tondo print closely resembles the figure of Raphael in Turner's oil, *Rome from the Vatican*, of 1820 (BJ 228, Tate Britain).[3]

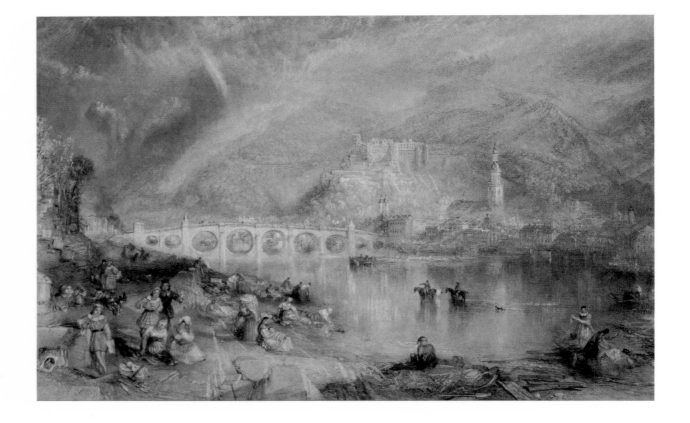

Cat. **103**
Heidelberg: sunset
c. 1841

Pencil, watercolour, gouache
and scratching-out
38.1 × 56 cm

W 1376
Manchester City Art Galleries

PRELIMINARY MATERIAL:
?Preparatory study (TB CCCLXV 34)

As *Heidelberg, with a rainbow* (cat. 102) is a morning view and
the present design an evening one, it is possible that Turner
made the two watercolours to act as pendants. However, it
seems likely that he created the present vista slightly later
than cat. 102, and that hypothesis is supported by the date
of *10 March 1841* inscribed on a colour study (TB CCLXV 34).

It is easy to see how this design was elaborated over broad
diffusions of cobalt blue and ultramarine on the left, burnt
sienna in the lower centre and yellow ochre on the right.
The surface of the River Neckar and its far bank demonstrate
the artist's acute tonal control by the early 1840s, for the
sheen on the water and solidities of castle, town and hillsides
were brought into being by the subtlest variations of the
underlying colours.

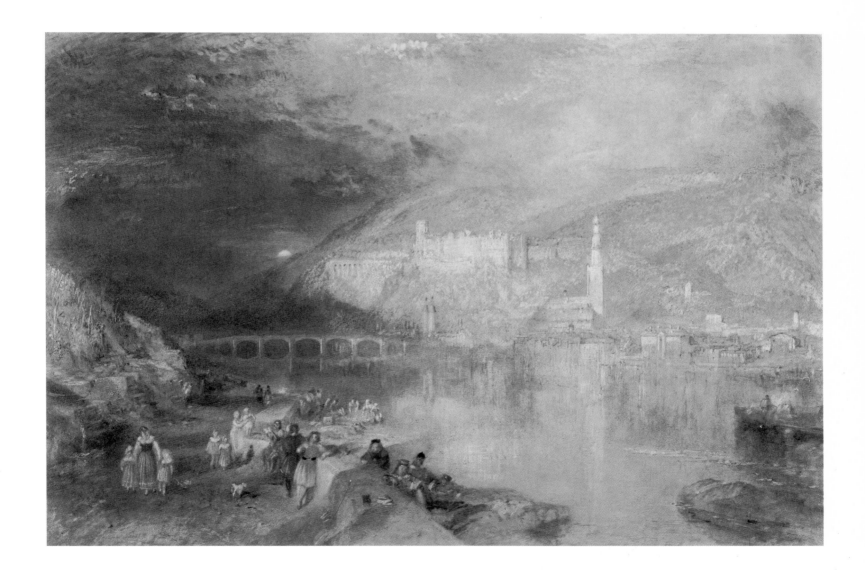

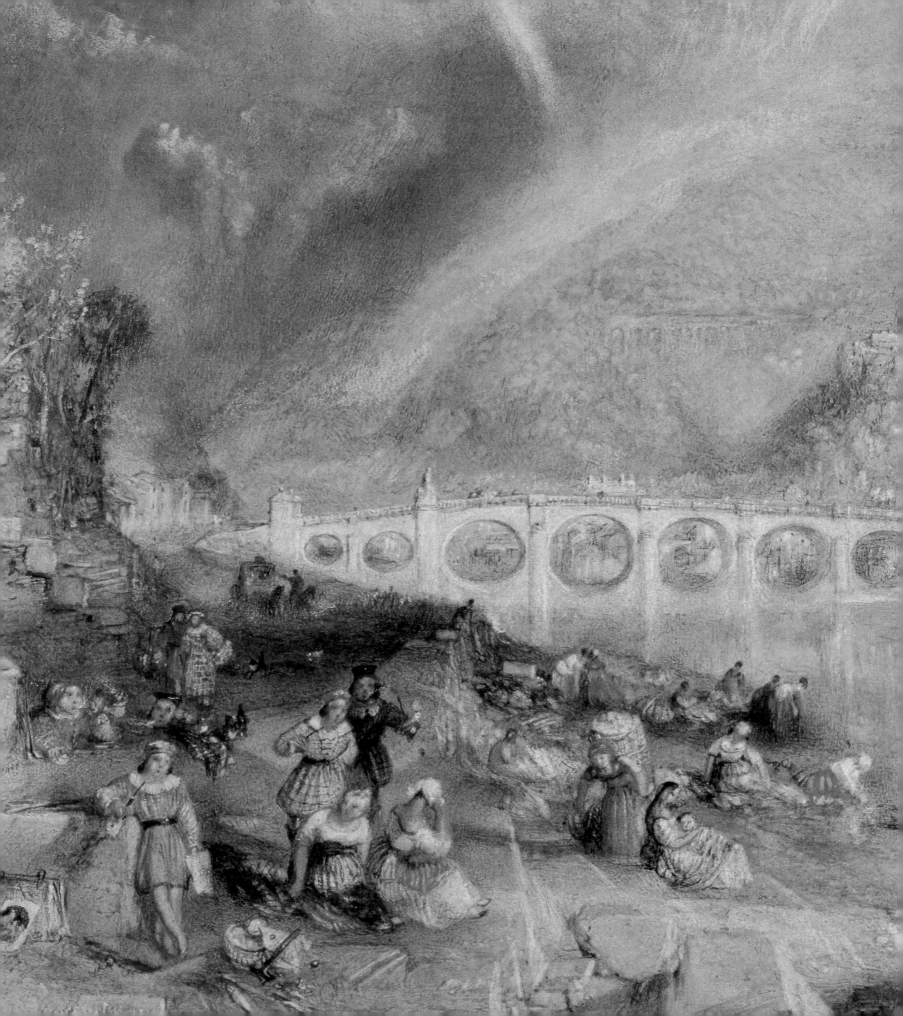

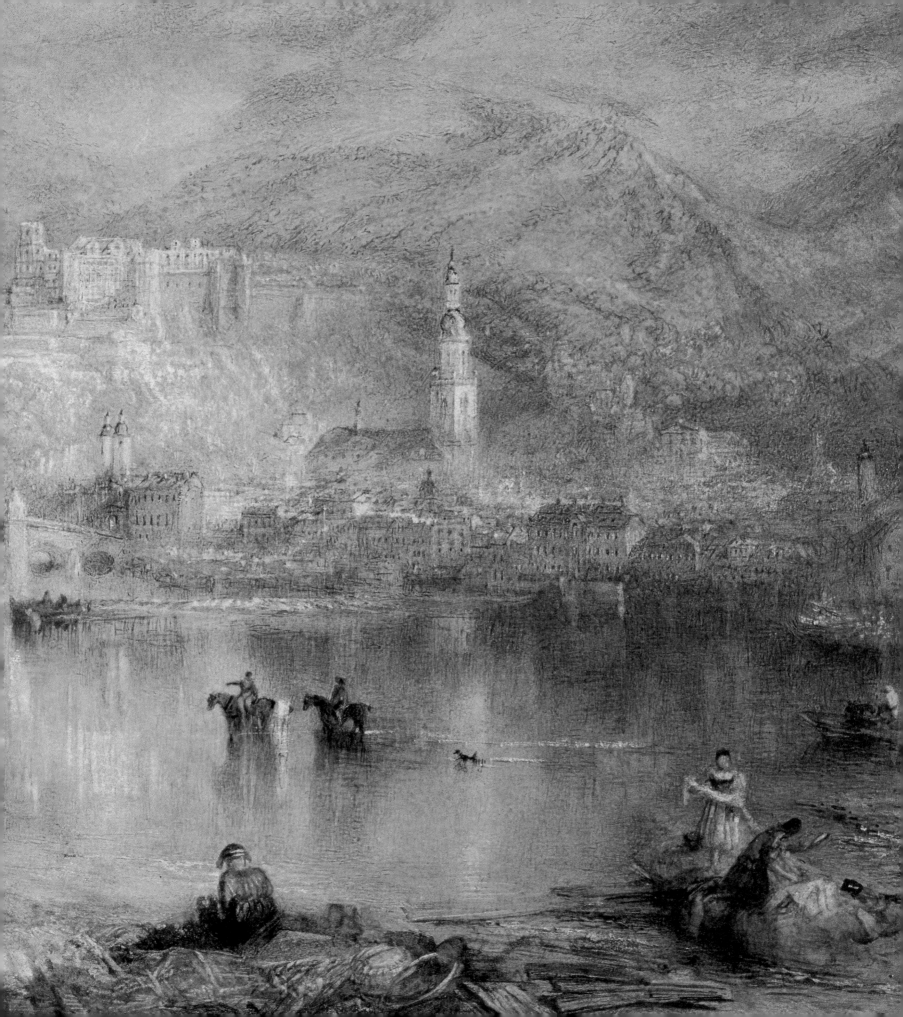

Cat. **104**

The Blue Rigi,
Lake of Lucerne,
sunrise
1842

Watercolour
29.7 × 45 cm

W 1524
Private collection

PRELIMINARY MATERIAL: Watercolour
study (TB CCCLXIV 330)

This watercolour and *The Red Rigi* (cat. 105) belong to the first of Turner's four sets of Swiss drawings made between 1842 and 1848, and they were created speculatively in advance of other watercolours in the group (see also cat. 106). Each depicts the same view of the large mountain to the east of Lucerne, at opposite ends of the day and with appropriate dramatic and pictorial contrasts.

In *The Blue Rigi* the world comes deafeningly to life, for although the landscape seems peaceful, a hunter on the right has just fired at some birds on the left (he has missed, as the splash beyond the wildfowl indicates). To add to the racket, the hunter's dogs plunge into the lake and the birds presumably squawk. In *The Red Rigi* all is peace, as the mountain catches the last rays of sunlight and a slight shower grazes its southerly slopes. In the foreground one of a number

of hunters clutching guns retrieves his kill from the limpid waters of the lake.

In the morning vista the foreground activity is balanced to left and right, while in the evening view it is placed at the centre, thus creating a compositional contrast between the two designs. In both watercolours, as in many of the other late Swiss drawings, tiny stippling imparts textural vivacity and denotes the gentle lappings of water, as well as helping to convey the shower in the evening scene.

The Blue Rigi was bought by Elhanan Bicknell of Herne Hill and *The Red Rigi* by Turner's major late patron and fellow traveller to Switzerland in 1836, James Munro of Novar (see also cat. 106).

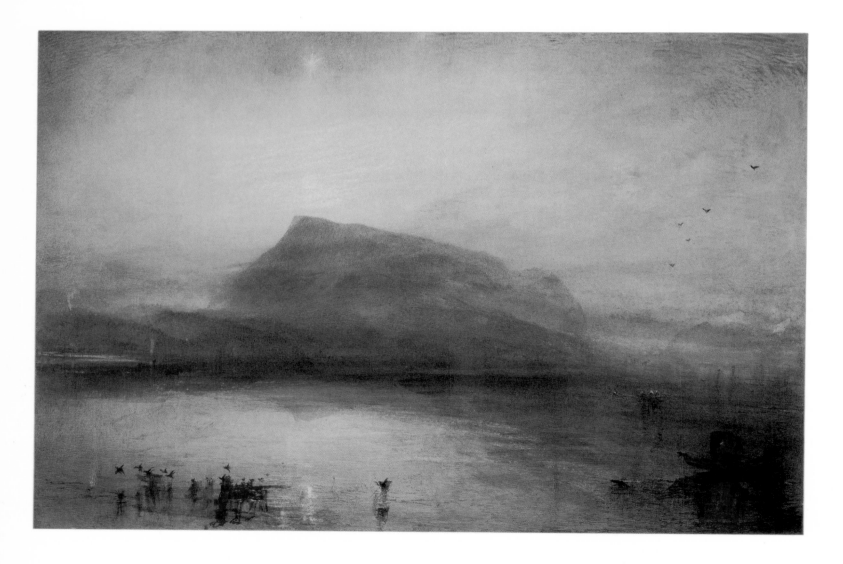

Cat. **105**
The Red Rigi,
Lake of Lucerne,
sunset
1842

Watercolour
30.5 × 45.8 cm

W 1525
National Gallery of Victoria,
Melbourne, Australia, Felton
Bequest, 1947

PRELIMINARY MATERIAL: Watercolour
study (TB CCCLXIV 275)

detail pp. 230–1

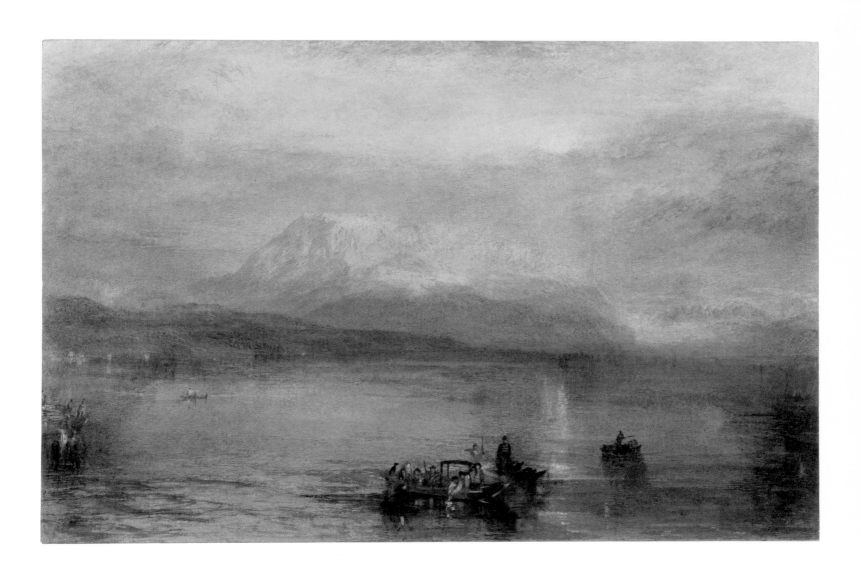

Cat. **106**

Lake Lucerne:
the Bay of Uri from above
Brunnen

1842

Pencil, watercolour and
scratching-out
29.2 × 45.7 cm

W 1526
Malcolm Wiener Collection

PRELIMINARY MATERIAL: ?Preparatory
watercolour (TB CCCLXIV 354)

detail pp. 234–5

The south-eastern, lowermost stretch of Lake Lucerne is known as the Urnersee, or Bay of Uri, and Turner found it particularly inspiring. He portrayed the vista looking down that reach from above Brunnen in three finished drawings. Two are exhibited here (see also cat. 107), and they both date from 1842, while the third was made in 1845 (w 1543, Private collection). Additionally, the painter created another design depicting the vista to the right, looking along the main body of the lake to the west (w 1547, Indianapolis Museum of Art).

Jutting out in the distance on the left is the Tellsplatte promontory, while opposite, on the right, rises the Uri-Rotstock mountain. In front of it the lower heights of the Oberbauenstock also catch the first rays of sunlight. Still nearer on the right is the Seelisberg promontory.

The composition is unified by the great sweep of cloud in the distance on the left, and by the parallel area of shadow on the right. These darker tones make the sunlit mountains in the centre-distance seem even more ethereal by contrast. In the sky at the upper right the painter subtly heightened the typical marbling effects obtained by floating ultramarine pigment on to damp paper, and those touches add further textural variety to the image.

This watercolour was one of four finished 'trial' works created in 1841–2, to be sold by Turner's agent, Thomas Griffith. It was bought by James Munro of Novar, who also purchased *The Red Rigi* (cat. 105) and *The Splügen Pass* (w 1523). The fourth work, *The Blue Rigi* (cat. 104), was bought by Elhanan Bicknell.

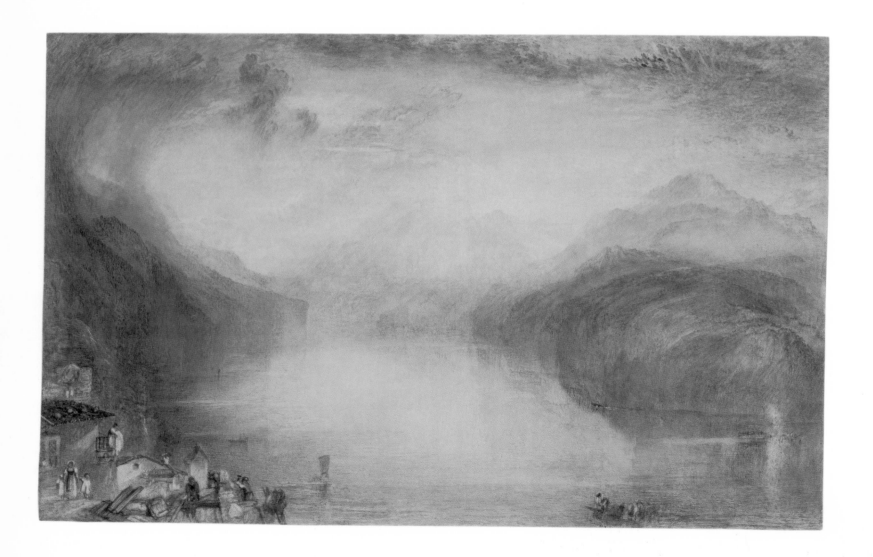

Cat. **107**

Brunnen, Lake of Lucerne

1842

Watercolour
30.2 × 46.4 cm

W 1527
Private collection

PRELIMINARY MATERIAL: Preparatory
watercolour, Private collection
(W 1528)

This work was also owned by Elhanan Bicknell of Herne Hill (see cat. 106). In the distance, to the right of centre, is the Oberbauenstock, with the Uri-Rotstock beyond it, while before them is a considerably expanded Rütli meadow, a hallowed spot in Swiss history. To the left of centre a white sail highlights the far end of the lake at Fluellen, while further to the left a tiny grey accent marks William Tell's chapel at the base of the Tellsplatte promontory. In reality Brunnen stands to the left of our viewpoint. The steamer is also present in the sample study, and it adds both animation and topicality to the scene, for the first such ship to ply a Swiss lake, the *Stadt Luzern*, had only been brought into service on Lake Lucerne in 1837.

As in *Lake Lucerne* (cat. 106), large numbers of tiny, stippled marks denote vegetation and ripplings of water, while adding

textural vibrancy. The blues and yellows strengthen one another by contrast, and convey the polarised temperature of dawn.

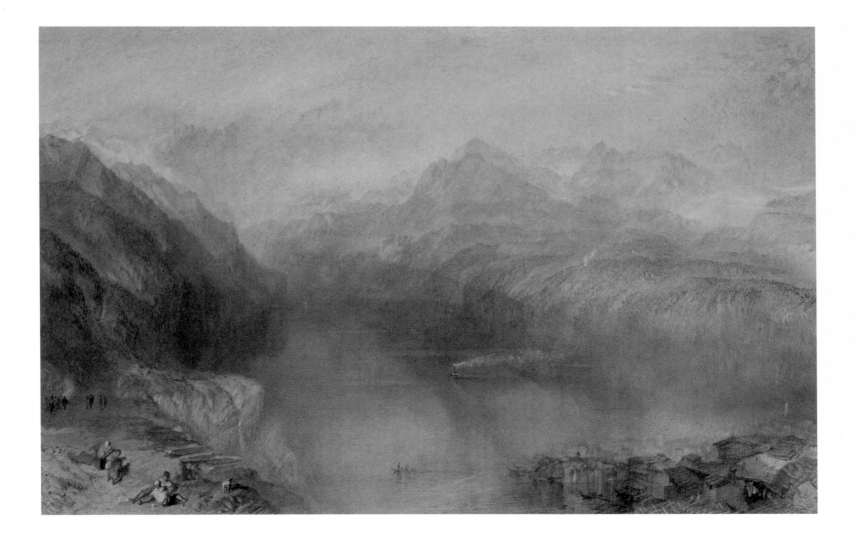

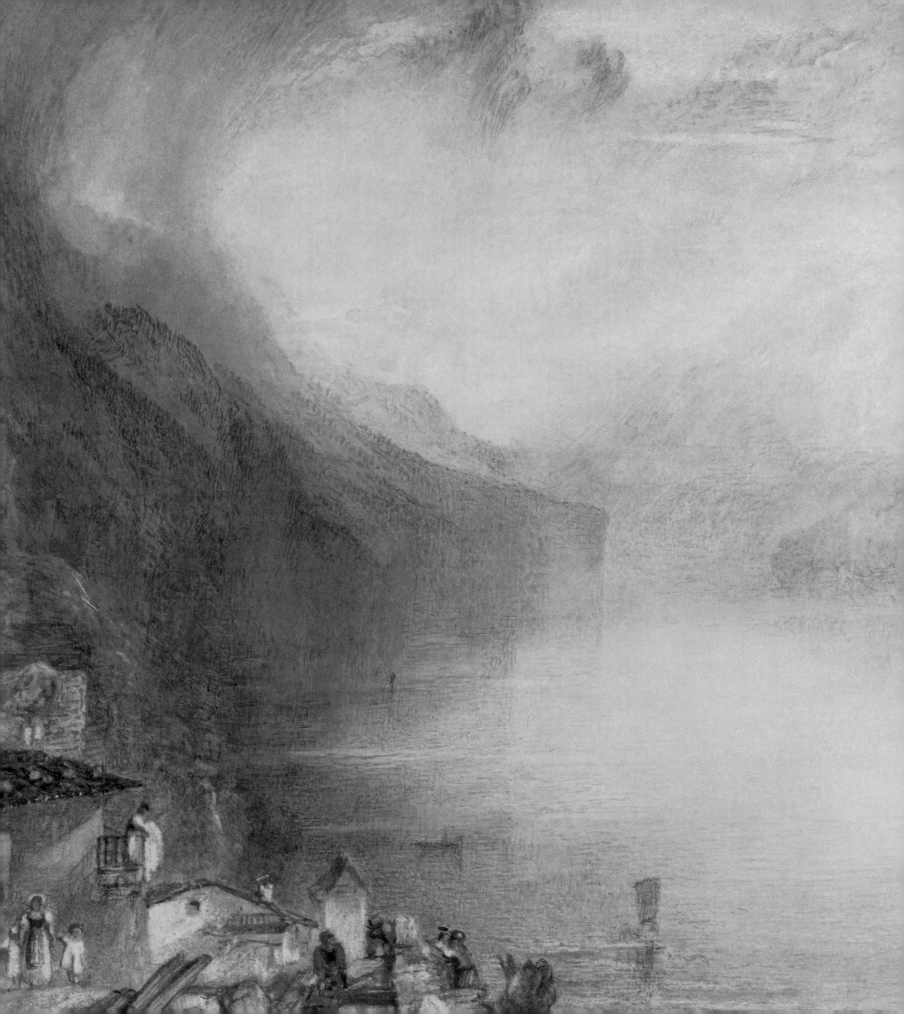

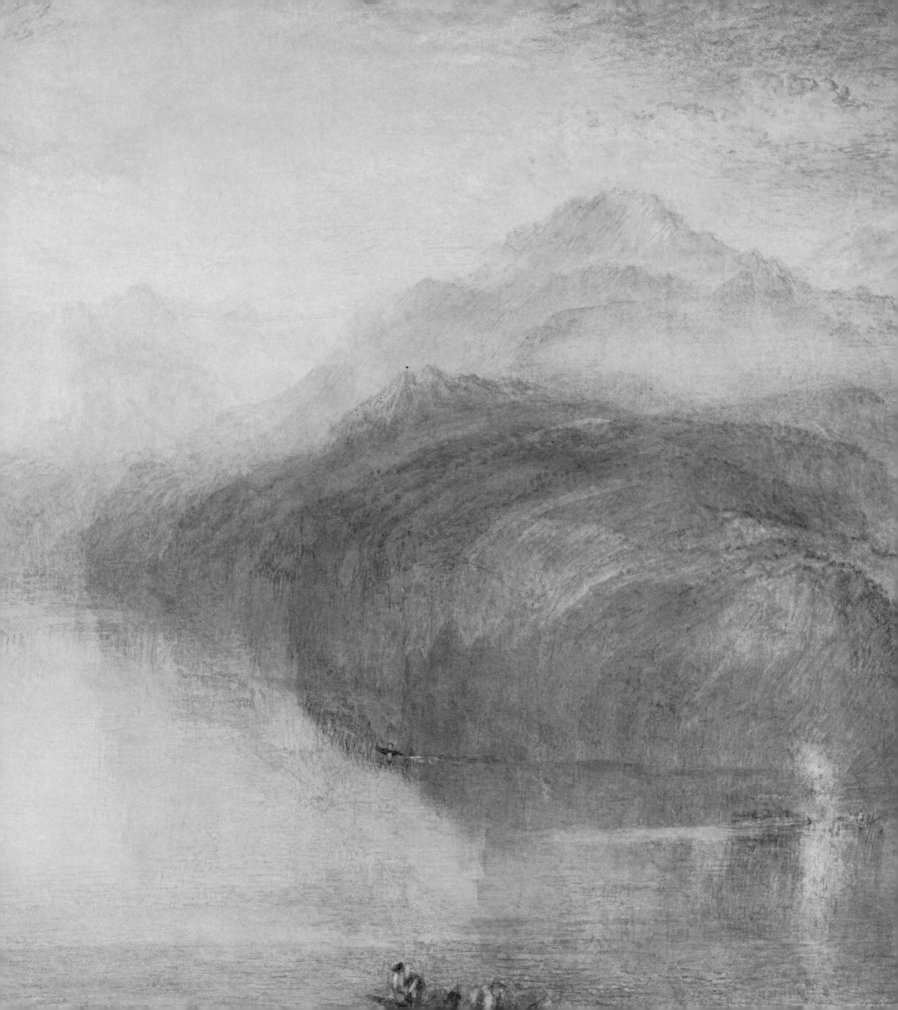

Cat. **108**
Goldau
1843

Watercolour and scratching-out
30.5 × 47 cm

W 1537
Private collection

PRELIMINARY MATERIAL: preparatory
watercolour (TB CCCLXIV 281)

This drawing belonged to the second set of Swiss watercolours, created speculatively in 1843. It was acquired by the youthful John Ruskin in that year, together with another watercolour from the set (w 1538). Ruskin considered *Goldau* to be 'on the whole the mightiest drawing of [Turner's] final time'.[1]

The blood-red colouring of the sunset was inspired by a tragedy that had befallen Goldau on 2 September 1806, when part of the Rossberg mountain collapsed, burying the village and 457 of its inhabitants beneath the boulders seen in the foreground (the new village that replaced it is visible up on the left). In the distance is the Lake of Zug, with the spire of Arth church before it.

Technically the watercolour is notable for the expressive freedom with which Turner painted the crimson clouds; after dragging a brush loaded with semi-dry pigment across the paper, he rubbed out colour in places with a sponge. He probably scratched out the highlight at the lower left with his thumbnail, while the finer lines at the lower right must have been taken out with a scalpel.

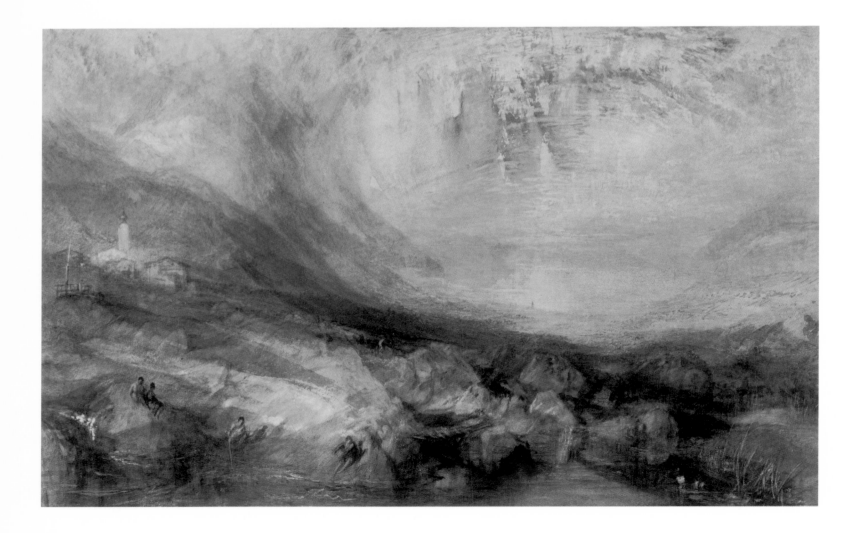

Cat. 109

A Swiss Lake

c. 1848

Watercolour
36.9 × 54 cm

W 1560
Private collection, London, by
courtesy of Alex. Reid & Lefevre Ltd

Like *The Lauerzerzee with the Mythens* (cat. 110), this work appears to belong to a fourth and final set of large Swiss drawings (W 1553–69) made speculatively for sale through Turner's agent, Thomas Griffith. Admittedly, both of the designs shown here are looser in draughtsmanship and handling than the earlier Swiss watercolours, but that lack of precision may have derived from Turner's growing infirmity. Certainly the inclusion of staffage in both works suggests that they were created as finished images rather than simply as sketches.

In recent years the present watercolour has been known as *Lake Nemi*, but that title did not originate with Turner and the topography depicted does not resemble the Italian lake. Given the snow-covered mountains and visual relationship of the design to other late watercolours, a Swiss lake is surely represented, but which one?

The scene depicted bears a strong resemblance to a landscape drawn in a thumbnail pencil sketch on folio 25v of the *Grindlewald* sketchbook (TB CCCXLVIII). This bears a scribbled inscription which might read 'Sarnen', in which case the tiny image – and the present work if developed from it – might portray the Sarner See, about eighteen kilometres south of Lucerne. However, that lake is larger than the one depicted here, so identification of the present subject must remain uncertain, especially as Turner might have distorted the scene topographically, or even invented it.

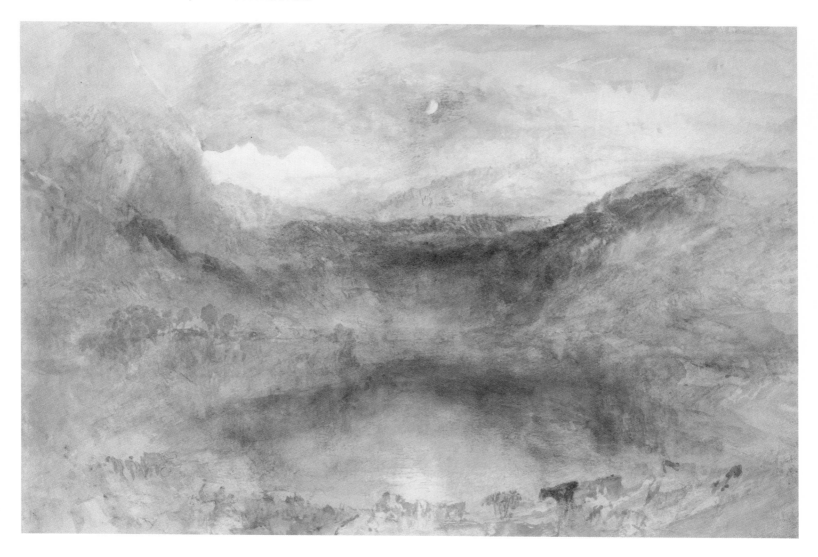

Cat. **110**

**The Lauerzersee,
with the Mythens**
c. 1848

Watercolour, pen and ink, and
scratching-out
33.7 × 54.5 cm

W 1562
The Victoria and Albert
Museum, London

PRELIMINARY MATERIAL: Preparatory
watercolour study (W 1488)
(Private collection)

The Lauerzersee is situated near the town of Schwyz,
about twenty-two kilometres east of Lucerne and not far
from Brunnen. We look south-east towards the Lesser
and Greater Mythens mountains (although Turner has
considerably lowered the higher peak in relation to its
neighbour). In the preparatory watercolour study Turner
included Schwyz at the far end of the lake but here he omitted
the town and considerably narrowed the space between
Schwanau island on the left and the lower slope of the
Urmiberg on the right.

For discussion of Turner's possible expressive intentions
in this work and cat. 109, see p. 25.

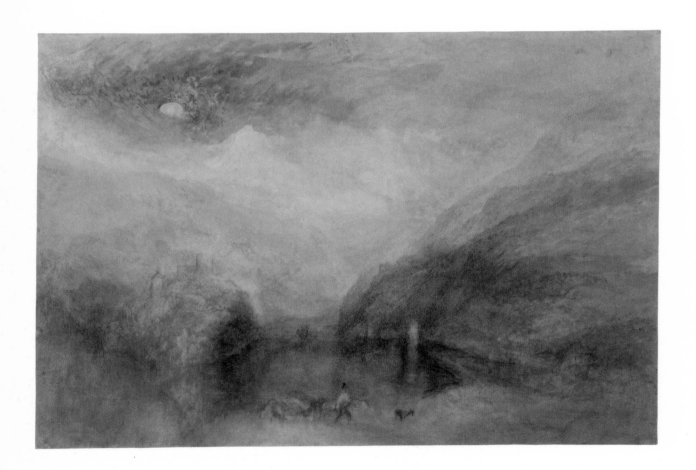

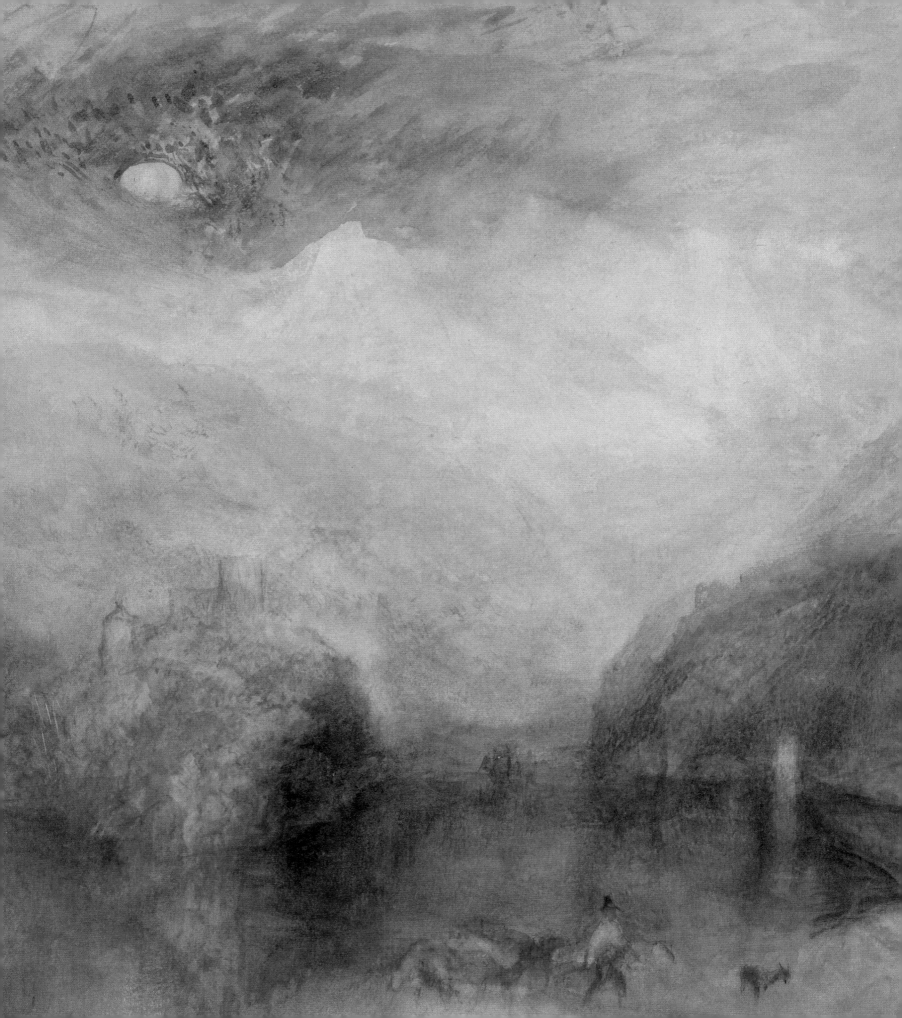

Notes

J.M.W. Turner: The Finished Watercolour as High Art

ERIC SHANES

1 The association of watercolour with amateur artists caused many Academicians to regard the medium as inferior to oil paint. For that reason, no artists who worked solely in watercolour were elected Academicians during Turner's lifetime (or for long afterwards). This condescending attitude contributed greatly to the creation of exhibiting societies devoted to the display of watercolours. Turner would have little to do with those bodies because of their largely amateur memberships.

2 For example, *Hastings from the Sea* (W 504 where incorrectly titled, British Museum, London) which clearly took several months to complete; see Eric Shanes, *Turner's England*, London, 1990, p. 34.

3 See *Letters and Papers of Andrew Robertson*, ed. E. Robertson, 2nd ed., London, 1897, p. 91.

4 See Eric Shanes, 'Identifying Turner's Chamonix Water-colours', *The Burlington Magazine* (November 2000), for a reproduction of Turner's view of the East Drawing Room of Walter Fawkes's townhouse (Private collection), and for a detailed analysis of that image. See also fig. 20 above.

5 Turner made two copies of the Rooker drawing, and in the more elaborate of them (fig. 3) he emulated Rooker's multiplicity of tones, and did so with the section of the image enjoying the maximum tonal range. For further discussion, see Eric Shanes, 'Turner and the "Scale Practice" in British Watercolour Art', *Apollo* (November 1997), pp. 45–51, and December 1997, p. 69.

6 For discussion of these watercolours in the Turner Bequest, see Eric Shanes, *Turner's Watercolour Explorations*, exh. cat., Tate Gallery, London, 1997.

7 They were strengthened by being impregnated with strong gelatine size, which imparted greater surface hardness. The sheets were then compressed in up-to-date hydraulic presses which compacted their fibres and thereby augmented their strength. I am grateful to Peter Bower for this information.

8 Turner's perspective lecture manuscripts are now in the British Library. Reynolds set out his theories principally in his Discourses, which Turner possessed in *The Works of Sir Joshua Reynolds*, ed. E. Malone, 4th ed., London, 1809, but which he must have known far earlier, following their individual publication after each lecture and their first collective publication in 1797. Reynolds had drawn importantly upon the following works and translations which were all definitely or probably familiar to Turner: G.P. Lomazzo, *A tracte containing the Artes of Curious Paintinge,* London, 1598; Franciscus Junius, *The Painting of the Ancients,* London, 1638; C.A. du Fresnoy, whose *The Art of Painting,* London, 1695, was reprinted in the 1797 edition of the collected works of Reynolds; John Dryden, whose preface to that book by du Fresnoy was also available to Turner in the same edition; G.P. Bellori, part of whose treatise *The Idea of the Painter, Sculptor and Architect* was quoted in Dryden's preface to du Fresnoy; Jonathan Richardson, *An Essay on the Theory of Painting,* London, 1715, which Turner owned in its 1792 edition; Roger de Piles, *The Art of Painting,* London, 1716, and *The Principles of Painting*, London, 1743; André Félibien, *Seven Conferences held in the King of France's Cabinet of Paintings,* London, 1740; and Count Francesco Algarotti's *An Essay on Painting,* London, 1974. Other contemporaries of Turner who upheld the theory of Poetic Painting included James Barry, Henry Fuseli, Edward Dayes and John Opie, and Turner was also familiar with their work.

9 For analyses of this exploration see Jerrold Ziff, 'Turner's First Poetic Quotations: An Examination of Intentions', *Turner Studies*, vol. 2, no. 1 (summer 1982), pp. 2–11; and Eric Shanes, *Turner's Human Landscape*, London, 1990, pp. 47–76.

10 See Sir Joshua Reynolds, *Discourses*, ed. Robert R. Wark, London and New Haven, 1975, pp. 135–6. Reynolds was discussing the difference between poetry and prose, with an implied application to the visual arts.

11 John Gage, *Colour in Turner: Poetry and Truth*, London, 1969, p. 132.

12 J. M. W. Turner, RA, Lecture Manuscript, British Library, *Add. MS* 46151, Ms C, f. 9. Turner's capitalisation of the word 'Idea' should be noted.

13 It will be remembered that until 1 March 1815 – when Napoleon crossed to France from Elba – it was thought the wars had ended. *The Battle of Fort Rock, Val d'Aoste, Piedmont, 1796*, which is signed and dated 1815, went on display at the Royal Academy in May of that year, so it could have been completed after hostilities had resumed. Napoleon was finally defeated at Waterloo on 18 June 1815.

14 See John Ruskin, *Modern Painters* vol. 4, in *The Complete Works of John Ruskin*, ed. E. T. Cook and Alexander Wedderburn, vol. 4, London, 1904, pp. 274–5.

15 See Andrew Wilton, *Turner and the Sublime*, London and New Haven, 1980.

16 J.M.W. Turner, RA, Lecture Manuscript, British Library, *Add. MS* 46151, Ms K, f. 14. Turner was quoting Jean-Jacques Rousseau to buttress his belief that 'however collosal [sic] man may be in interlect [sic] he must draw some scale of his inferiority'.

17 Annotation by Turner on p. 58 of his copy of John Opie's *Lectures on Art,* London, 1809, Private collection.

18 For the artist's use of this term, see J. M. W. Turner, RA, Lecture Manuscript, British Library, *Add. MS* 46151, Ms N, f. 23.

19 See J. E. Phythian, *Turner*, London, 1910, pp. 9–10.

20 For a discussion of Reynolds's Platonism, see Hoyt Trowbridge, 'Platonism and Sir Joshua Reynolds', *English Studies*, Vol XXI, February 1939, pp. 1–7.

21 Turner may have heard Thomas Malton Jr discuss Akenside's Platonism when the two went out drawing together in Westminster in 1789 or 1790; see J. M. W. Turner, RA, Lecture Manuscript, British Library, *Add. MS* 46151, Ms M, ff. 25v–26; and Eric Shanes, *Turner's Human Landscape,* London, 1990, pp. 256–7, for an analysis of this possible influence, and discussion of Turner's Platonism in general.

22 For an examination of this evidence, and of Turner's belief, see Eric Shanes, *Turner's Human Landscape,* London, 1990, pp. 275–80.

The Market for Turner's Finished Watercolours in His Lifetime

EVELYN JOLL

1 These prices must be seen against the average agricultural wage of one shilling and fourpence per day at the end of the eighteenth century (see Peter Mathias, *The First Industrial Nation: An Economic History of Britain, 1700–1914*, 2nd ed., London, 1983, p. 195).

2 *The Diary of Joseph Farington*, eds Kenneth Garlick, Angus Macintyre and Kathryn Cave, 16 vols, New Haven and London, 1978–84, vol. 4, p. 1229; Monday, 27 May 1799.

3 Thirty-five were sold at Christie's on 27 June 1890 (lots 1–35); the remainder were sold privately to Agnew's in July 1912.

4 John Gage, *Collected Correspondence of J.M.W. Turner*, Oxford, 1980, p. 67, no. 65.

5 Gerald Finley, *Landscapes of Memory*, London, 1980, p. 55.

6 A. J. Finberg, *The Life of J.M.W. Turner*, rev. 2nd ed., Oxford, 1961, p. 327.

7 William Beattie, *Life and Letters of Thomas Campbell*, London, 1849, vol. 3, p. 237, Journal entry for 28 November 1837.

8 J. L. Roget (ed.), *Notes and Memoranda respecting the Liber Studiorum by John Pye*, London, 1879, pp. 73–4.

9 Epilogue to *Notes by Mr. Ruskin on his collection of Drawings by J.M.W. Turner R.A. Exhibited at the Fine Art Society's Galleries*, London, 1878, pp. 72–3.

10 John James Ruskin to John Ruskin, 20 April 1842, in Van Akin Burd (ed.), *The Ruskin Family Letters…1801–1842*, 2 vols, London, 1973, p. 734.

'The wonder-working artist': Contemporary Responses to Turner's Exhibited and Engraved Watercolours

IAN WARRELL

My research for this essay has been greatly assisted by the manuscript notes of A. J. Finberg, who transcribed many of the reviews for use in his biography of Turner. I am also very grateful to Greg Smith for his advice and generosity in sharing his own pool of articles and clippings, especially those for the group of exhibitions at Cooke's Gallery.

1 Aspects of Ruskin's relationship with Turner are considered in the following recent publications: Ian Warrell, *Through Switzerland with Turner: Ruskin's First Selection from the Turner Bequest*, exh. cat., Tate Gallery, London, 1995; Robert Hewison, Ian Warrell and Stephen Wildman, *Ruskin, Turner and the Pre-Raphaelites*, exh. cat., Tate Britain, London, 2000 . See also Paul Watson, *Master Drawings by John Ruskin*, Northampton, 2000.

2 Martin Butlin and Evelyn Joll, *The Paintings of J. M. W. Turner*, rev. ed., New Haven and London, 1984; a checklist of watercolours outside the Turner Bequest can be found in Andrew Wilton, *The Life and Work of J. M. W. Turner*, Fribourg, 1979. A research project covering responses to Turner's works was announced a few years' ago by Marjorie Munsterberg, but has not yet appeared.

3 See Peter Funnell, 'The London Art World and its Institutions', and Andrew Wilton, 'Painting in London in the Early Nineteenth Century', both in *London: World City, 1800–1840*, Celina Fox (ed.), New Haven and London, 1992. For a history of the development of watercolour painting during this period see Greg Smith, 'Watercolour: Purpose and Practice', in Simon Fenwick and Greg Smith, *The Business of Watercolour: A Guide to the Archives of the Royal Watercolour Society*, Aldershot, 1997, pp. 1–34.

4 See the comments of Thomas Uwins, quoted by A. J. Finberg in his *Life of J. M. W. Turner*, Oxford, 1961, second ed., p. 115.

5 I am grateful to Nick Savage at the Royal Academy Library, who has calculated these figures using the receipts for admissions and catalogue sales.

6 *St James's Chronicle* (13 May 1794).

7 *Morning Post* (24 May 1794), p. 3.

8 Kenneth Garlick and Angus Macintyre (eds), *The Diary of Joseph Farington*, New Haven and London, 1978, vol. 2, p. 518, 2 April 1796.

9 *St James's Chronicle* (20–3 May 1797); quoted by A. J. Finberg, *The Life of J. M. W. Turner, RA*, 1969, p. 43.

10 *Whitehall Evening Post* (2 June 1798), quoted by Finberg 1969, p. 49.

11 *Monthly Magazine* (July 1798). Greg Smith notes that this merit was first observed in relation to Richard Westall's watercolours of historical subjects (Smith 1997, p. 12).

12 The diary of Thomas Green is quoted by Finberg 1961, p. 57. Butlin and Joll quote similar comments from another private document (1984, p. 8).

13 See, for example, the comments made in 1802 quoted by Finberg 1961, p. 79.

14 Garlick and Macintyre 1979, vol. 3, p. 1004, 27 April 1798.

15 Garlick and Macintyre 1979, vol. 4, p. 1154, 9 February 1799.

16 Reprinted in Luke Herrmann, 'John Landseer on Turner: Reviews of Exhibits in 1808, 1839 and 1840 (Part 1)', *Turner Studies*, vol. 7, no. 1 (Summer 1987), pp. 26–33.

17 Gillian Forrester, *Turner's 'Drawing Book': The Liber Studiorum*, exh. cat., Tate Gallery, London, 1996.

18 *Examiner*, no. 181 (Sunday, 16 June 1811), p. 380.

19 See, for example, the reviews in the *Examiner*, no. 353 (Sunday, 2 October 1814), pp. 631–2; no. 363 (Sunday, 11 December 1814),p. 793; and again in no. 471 (Sunday, 5 January 1817), pp. 10–11; and no. 501 (Sunday, 3 August 1817), p.492.

20 *Literary Gazette* (June 1818), p. 394. There are two colour studies for this work (TB CCCLXV 29 and CXCVII A). These were shown at Tate Liverpool between June and October 2000.

21 The drawings exhibited in the East Drawing Room are listed in the catalogue of the exhibition: *A Collection of Water Colour Drawings, in the possession of Mr. Fawkes, 45, Grosvenor Place, London, 1819* (National Art Library, Victoria and Albert Museum, Box 1: 38.YY). Several of the reviews quoted in the following discussion were reprinted in the catalogue. For an account of the identity of some of the works exhibited, see the forthcoming article in the *Burlington Magazine* by Eric Shanes.

22 *Literary Gazette* (10 April 1819), p. 219.

23 *Sun*, no. 8302 (Tuesday, 13 April 1819), p. 2; quoted and adopted in Fawkes catalogue.

24 *British Press* (8 April 1819), p. 3.

25 *London Chronicle* (10 April 1819), pp. 347–8; partly quoted in Fawkes catalogue.

26 *Champion* (2 May 1819), pp. 284–5.

27 *Repository of Art*, vol. 7 (1819), pp. 297–301.

28 *British Freeholder* (1819), pp. 436–7.

29 *Examiner*, no. 425 (Sunday, 18 February 1816), p. 109 n.

30 *Literary Gazette* (10 April 1819); quoted in Fawkes catalogue,

31 *Repository of Art*, vol. 7 (1819), p. 298.

32 *Examiner* (2 May 1819), p. 285.

33 *Examiner* (2 May 1819), p. 285. For the changing status of the sketch, see Greg Smith, 1997, pp. 22–6.

34 *Repository of Art*, vol. 7 (1819), pp. 299–300.

35 *Literary Gazette* (22 May 1819), p. 331; see also the *British Press* (8 April 1819, p. 3; quoted in the Fawkes catalogue), which described them as 'unique of their kind'.

36 *Gazette of Fashion, and Magazine of the Fine Arts* (February 1822), part 1, pp. 46–7.

37 *Literary Gazette* (10 April 1819).

38 *Englishman*, no. 779 (24 February 1822), p. 4. This review also has praise for *Cologne* (w 690) and *Hastings from the Sea* (w 504).

39 *Literary Chronicle and Weekly Review* (4 January 1823), p. 15.

40 *London Magazine* (February 1823), p. 219.

41 *Examiner*, no. 780 (Saturday, 5 January 1823).

42 *Literary Gazette*, no. 313 (Saturday, 18 January 1823), p. 43; *Morning Chronicle*, no. 16,777 (27 January 1823), p. 3.

43 *European Magazine*, vol. 83 (January 1823), p. 56.

44 *Examiner*, no. 780 (Sunday, 5 January 1823).

45 *European Magazine*, vol. 83 (January 1823), p. 56; *Courier*, no. 9737 (Thursday, 9 January 1823), p. 4; *British Press*, no. 6273 (Friday, 10 January 1823), p. 3.

46 *British Press*, no. 6273 (Friday, 10 January 1823), p. 3.

47 *Literary Register of the Fine Arts, Sciences and Belles Lettres* (18 January 1823), pp. 43–4; *London Magazine* (February 1823), p. 219.

48 *Examiner* (9 June 1823), p. 379; *Literary Chronicle and Weekly Review* (21 June 1823, p. 397), however, included a less favourable review.

49 *Examiner* (19 April 1824), p. 246.

50 *Somerset House Gazette* (12 June 1824), p. 143.

51 Twenty-nine works from the Fawkes and Swinburne collections were shown at Leeds in 1825; two at Newcastle in 1828; six at Birmingham in 1829; and a further two the next year; and during the 1830s Turner's drawings were frequently shown in Liverpool, Manchester, Edinburgh and Birmingham, as well as in a substantial showing at Leeds in 1839. There is, however, insufficient space here to consider the responses to these displays. Among those who may have seen Turner's drawings in these exhibitions are the members of the Brontë family, who visited the 1834 show at the Royal Northern Society in Leeds. A work by Charlotte Brontë was included in the catalogue list, just eight names away from one by Turner. (See Christine Alexander and Jane Sellars, *The Art of the Brontës*, Cambridge, 1995, pp. 52, 228.)

52 *Literary Gazette*, no. 440 (25 June 1825), p. 412.

53 *Literary Gazette*, no. 453 (24 September 1825), p. 620.

54 *Literary Gazette*, no. 596 (21 June 1828), p. 394.

55 W. B. Pope (ed.), *The Diary of Benjamin Robert Haydon*, Cambridge, Mass., 1960–3, vol. 3 (1825–32), pp. 370–2.

56 *Examiner*, no. 1115 (Sunday, 14 June 1829), p. 373.

57 *Spectator* (8 June 1833), p. 529.

58 *Spectator* (17 November 1832), pp. 1096–7. It is not clear from the review where the exhibition took place.

59 The show at Agnew's in 1979 was almost as inclusive, with its group of fifty-five drawings from the series.

60 *Spectator* (8 June 1833), p. 529.

61 *Atlas*, no. 370, vol. 8 (16 June 1833), p. 390.

62 *Literary Gazette*, no. 868 (7 September 1833), pp. 570–1.

63 See Cecilia Powell, 'Turner Vignettes and the Making of Rogers' "Italy"', *Turner Studies*, vol. 3, no. 1 (Summer 1983), pp. 2–13; David Brown, *Turner and Byron*, exh. cat., Tate Gallery, London, 1992.

64 Anne Lyles and Diane Perkins, *Colour into Line: Turner and the Art of Engraving*, exh. cat., Tate Gallery, London, 1989, p. 71. See also Jan Piggott, *Turner's Vignettes*, exh. cat., Tate Gallery, London, 1993, pp. 53–9.

65 *Literary Gazette*, no. 823 (27 October 1832), p. 680.

66 For reviews of the *Annual Tours*, see Ian Warrell, *Turner on the Loire*, exh. cat., Tate Gallery. London, 1997, pp. 249–51, and *Turner on the Seine*, exh. cat., Tate Gallery, London, 1999, pp. 72–5.

67 Warrell 1997, p. 197, and Warrell 1999, pp. 71–2, 185.

68 *Literary Gazette*, no. 933 (6 December 1834), p. 818.

69 Selby Whittingham, 'The Turner Collector: B. G. Windus', *Turner Studies*, vol. 7, no. 2 (Winter 1987), pp. 29–35; Dianne Sachko Macleod, *Art and the Victorian Middle-Class: Money and the Making of Cultural Identity*, Cambridge, 1996, pp. 487–8; Hewison, Warrell and Wildman 2000, p. 62.

70 See Warrell 1995, and Ian Warrell, 'Turner's Late Swiss Watercolours – and Oils', in Leslie Parris (ed.), *Exploring Late Turner*, exh. cat., Salander-O'Reilly Galleries, New York, 1999, pp. 139–52.

71 *Art Union*, no. 39 (1 April 1842), pp. 71–2. The piece was signed 'S.R.H.'

72 *Examiner* (4 February 1822), p. 76.

The Legacy of Turner's Watercolours

ANDREW WILTON

1 W. G. Rawlinson, *Notes on the Collection of Drawings by J.M.W. Turner, R.A., at the Winter Exhibition of the Royal Academy, 1887 … published by the Fine Art Society, Limited*, pp. 1–2. Sadly, in the last hundred years much damage has been inflicted on Turner's watercolours, some of it very recently, and a number of works of the highest quality and importance in the history of European art have been effectively destroyed by the negligence and ignorance Rawlinson and others warned so emphatically against.

2 Though innumerable forgeries of Turner's late work in oil were manufactured in the second half of the century. It was these, quite as much as authentic examples, that were acquired by collectors in Europe and America, and, at least until the time of Roger Fry, confused assessments of Turner's achievement. See Fry, *Reflections on British Painting*, London, 1934, p. 12, where he unknowingly discusses a misattributed picture in the course of an unfavourable account of Turner.

3 *Notes by Mr Ruskin on Samuel Prout and William Hunt, illustrated by a Loan Collection of Drawings exhibited at the Fine Art Society's Galleries, 148 New Bond Street*, London, 1879–80, p. 5.

4 John Ruskin, *Lectures on Architecture and Painting, delivered at Edinburgh in November 1853*, 2nd. ed., London, 1853.

5 Edith Mary Fawkes, Typescript deposited in the National Gallery Library.

6 *Gentleman's Magazine* (1852), p. 200.

7 For instance in his letter to John Linnell, 21 February 1838; see Raymond Lister, ed., *The Letters of Samuel Palmer*, 2 vols, Oxford, 1974, vol. 1, p. 115.

8 Lister 1974, vol. 1, p. 113.

9 Letter to John Linnell, 16 December 1838; Lister 1974, vol. 1, p. 255.

10 David Cecil, *Visionary and Dreamer*, London, 1969, p. 21.

11 Palmer, Letter to P. G. Hamerton, August 1872; Lister 1974, vol. 1, p. 852.

12 *Lectures on Architecture and Painting*, p. 179.

13 For a full account of the will, the litigation and the terms of the Bequest see A. J. Finberg, *The Life of J. M. W. Turner, R.A.*, 2nd. ed., London, 1961.

14 *The Works of John Ruskin*, E.T. Cook and A. Wedderburn (eds), 39 vols, London, 1903–12, vol. 3, p. 616.

15 Letter to Hannah Palmer, June 1859, Lister 1974, vol. 1, p. 556.

16 An example is *Fiercely the Red Sun Descending Burned his Way across the Heavens*, c. 1875, in the North Carolina Museum of Art. See Nancy K. Anderson, *Thomas Moran*, exh. cat., National Gallery of Art, Washington DC, 1998, p. 103 repr.

17 Two of Moran's copies after Turner's views on the River Seine, *Jumièges* and *La Chaire de Gargantua* (W 961 and 962), were in the collection of the British Museum Department of Prints and Drawings, but are now unlocated. See also Richard P. Townsend, '"A Lasting Impression": Thomas Moran's Artistic Dialogue with J.M.W. Turner', in Richard P. Townsend, ed., *J. M. W. Turner 'That Greatest of Landscape Painters'*, Philbrooke Museum of Art, Tulsa, Okla., 1998, pp. 15–36.

18 *Works*, vol. 3, pp. 623–4.

19 *Works*, vol. 3, pp. 623–4.

20 *Works*, vol. 5, pp. 173–4.

21 Violet Hunt, 'Alfred William Hunt, R.W.S.', *Old Water-Colour Society's Club*, vol. 2 (1924–5), p. 32.

22 In the Yale Center for British Art.

23 Hubert von Herkomer, 'J.W.North, A.R.A., R.W.S., Painter and Poet', *Magazine of Art* (1893), pp. 297–300, 342–8; see pp. 297–8.

24 Herbert Alexander, 'John William North, A.R.A.', *Old Water-Colour Society's Club* (1927–8), p. 46. See Martin Hardie, *Water-Colour Painting in Britain*, 3 vols, London, 1966–68, vol. 1, pp. 27 note iii, 137–8.

25 *The Diary of Albert Goodwin*, London, 1934, p. 19 (1888).

26 *Diary of Albert Goodwin*, 1911.

27 Ford Madox Brown to James Leathart, 18 July 1864, quoted in Hammond Smith, *Albert Goodwin R.W.S., 1845–1932*, Leigh-on-Sea, 1977 p. 16.

28 See Hammond Smith 1977, pp. 26–34.

29 Whistler sued Ruskin for libel in 1878, after the latter had published a comment on his *Nocturne in Black and Gold: the Falling Rocket* (Detroit, Institute of Arts), that he 'never expected to hear a coxcomb ask two hundred guineas for flinging a pot of paint in the public's face'. For a brief recent account see Richard Dorment and Margaret F. MacDonald, *James McNeill Whistler*, exh. cat., Tate Gallery, London, 1994, pp. 136–8.

30 'Table Talk', in *Under the Hill and Other Essays in Prose and Verse* by Aubrey Beardsley, London, 1904 p. 82. The second sentence does not occur in all editions.

31 *Diary of Albert Goodwin*, 1 December 1918.

32 See Cook and Wedderburn 1903–12, vol. 33, p. XXIV.

33 Goupil Gallery, catalogue of the Brabazon exhibition, cited in C. Lewis Hind, *Hercules Brabazon Brabazon, 1821–1906: His Art and Life*, London, 1912, pp. 85–6.

34 Hind 1912, pp. 88–9.

35 A. W. Rich, *Water Colour Painting*, London, 1918, p. 47.

36 Rich 1918, p. 215.

37 Oral communication with the author, 1974; and see *Auden Poetry/ Moore Lithographs: An Exhibition of a Book Dedicated by Henry Moore to W. H. Auden with Related Drawings*, exh. cat., British Museum, London, 1974, esp. preface by John Gere and introduction by Henry Moore.

Catalogue Notes

Cat. 2

1 Curtis Price, 'Turner at the Pantheon Opera House, 1791–92', *Turner Studies*, vol. 7, no. 2 (Winter 1987), pp. 2–8.

Cat. 8

1 The painting is now in the National Gallery of Ireland, Dublin.

2 A copy of Plate 2 in Piranesi's *Prima Parte di Architettura*, attributed to Turner, is in the Metropolitan Museum of Art, New York; for a reproduction, see John Gage, *J. M. W. Turner: 'A Wonderful Range of Mind'*, London and New Haven, 1987, p. 102.

Cat. 11

1 Kenneth Garlick and Angus MacIntyre (eds), *The Diary of Joseph Farington*, New Haven and London, 1979, vol. 4, p. 1172.

2 See *Turner in Wales*, Andrew Wilton, exh. cat., Mostyn Art Gallery, Llandudno, 1984, cat. 64. One of the drawings is W 253 (untraced); the other was not listed in Andrew Wilton, *The Life and Work of J.M.W. Turner*, London, 1979.

Cat. 12

1 See Eric Shanes, *Turner's Human Landscape*, London, 1990, pp. 62–72, for a more detailed discussion of this work.

Cat. 13

1 The other watercolours are W 269 (Private collection), which may be the earliest; and W 270 (J. Paul Getty Museum, Malibu). The oil dates from around 1803 and is BJ 141 (Private collection).

Cat. 15

1 See Sir Richard Colt Hoare, *A History of Modern Wiltshire*, London, 1823, vol. 1, p. 82.

Cat. 18

1 The names 'Reichenbach' and 'Hasli' were misspelt in the 1815 Royal Academy catalogue but were correctly given in 1819. The later title has therefore been used here.

Cats. 21 and 22

1 *Mont Blanc from Fort Roch, Val d'Aosta*, was bought by Walter Fawkes and became a companion to *Mer de Glace, in the Valley of Chamouni, Switzerland*, which also appears to date from around 1814.

2 *Dido building, Carthage* (BJ 131, National Gallery, London) was displayed in the 1815 exhibition and depicts the rise of the Carthaginian empire, while *The Decline of the Carthaginian Empire* (BJ 134, Tate Britain) was exhibited at the Academy in 1817.

Cat. 24

1 This watercolour is *Battle Abbey, the spot where Harold fell* (W 435 or 436, untraced), known today only through its engraved reproduction (R 825). According to one of Turner's contemporaries, when that drawing was exhibited in Edinburgh in 1831, the artist observed a viewer puzzling over a detail in the foreground and informed him (in his pronounced Cockney accent): '"Ah! I see you want to know why I have introdooced that 'are. It is a bit of sentiment, sir! for that's the spot where 'Arold 'arefoot fell, and you see I have made an 'ound a-chasing an 'are!"' (see William Bell Scott, *Autobiographical Notes*, London, 1892, vol. 1, p. 84). Turner had confused King Harold I (d. 1040) with Harold II (?1020-1066), although his confusion does not invalidate his associative meaning in *Battle Abbey, the spot where Harold fell*. Moreover, the associations of death in that work are augmented by dead trees, an approaching storm, and the dying, late afternoon light. For an examination of the image see Eric Shanes, *Turner's England*, London, 1990, p. 20).

Cat. 28

1 For details of this scheme see Eric Shanes, *Turner's England*, London, 1990, pp. 10, 37–40, 262–3.

Cat. 36

1 Sir Walter Scott, *Provincial Antiquities and Picturesque Scenery of Scotland*, London and Edinburgh, 1826, p. 35.

Cat. 37

1 See *Turner and Sir Walter Scott*, Katrina Thomson, exh. cat., National Gallery of Scotland, Edinburgh, 1999, p. 91.

Cat. 41

1 See Evelyn Joll, *Agnew's, 1982–92*, London, 1992, p. 162.

2 It has long been thought that a watercolour that belonged to the 1817 Rhine set, W 637, is also a view of Mainz, but there is little visual evidence to support that identification (see *Turner in Germany*, Cecilia Powell, exh. cat., London, Tate Gallery, 1995, pp. 101–2).

Cats. 47 and 48

1 Quoted in Martin Butlin, *Turner: Watercolours*, London, 1962, p. 36.

2 This is TB CXCVI N; see Eric Shanes, *Turner's Watercolour Explorations*, Tate Gallery, London, 1997, pp. 34–5; and Eric Shanes, 'Turner and the Creation of his "First-Rate" in a Few Hours', (*Apollo*, March 2001).

3 See f. 56v of the *Devonshire Coast No. 1* sketchbook, TB CXXIII.

Cat. 49

1 See David Hill, *Turner in the North*, New Haven and London, 1997, p. 38.

Cat. 50

1 Scott's verses actually read: 'If thou wouldst view fair Melrose aright/ Go visit by the pale moonlight'.

Cat. 56

1 See *Calais Pier with French poissards preparing for sea: an English packet arriving* of 1803 (BJ 48, National Gallery, London), in which a British vessel nearly collides with a French ship flying a similar flag.

Cat. 58

1 The title of another watercolour made for the 'Marine Views' series, *Twilight-Smugglers off Folkestone fishing up smuggled gin* (W 509, Private Trust), specifies the contents of identical kegs being 'crept' at sunset.

Cat 60

1 Ruskin saw this disorder as proof of Turner's refusal 'to contemplate a ship, even in her proudest moments, but as in some way overmastered by the strengths of chance and storm'. John Ruskin, *The Harbours of England*, in *The Complete Works of John Ruskin*, ed. E. T. Cook and Alexander Wedderburn, vol. 13, London, 1904, p. 64.

Cat. 63

1 Cecilia Powell, 'Turner and the Bandits: Lake Albano Rediscovered', *Turner Studies*, vol. 3, no. 2 (Winter 1984), pp. 22–7.

Cat. 65

1 The other watercolours are W 963–5, Turner Bequest, Tate Britain. For the influence of Turner's Rouen Cathedral upon Monet, see *Turner on the Seine*, Ian Warrell, exh. cat., Tate Gallery, London, 1999, pp. 181–6.

Cat. 66

1 For the doubts, see *Turner en France*, exh. cat., Centre Culturel du Marais, Paris, 1981, p. 446; for a refutation of them, see *Turner on the Seine*, Ian Warrell, exh. cat., Tate Gallery, London, 1999, pp. 207–8 and p. 262 n. 176.

2 See Joyce Townsend, *Turner's Painting Techniques*, Tate Gallery, London, 1993, p. 41.

Cat. 71

1 *The Battle of Trafalgar* (BJ 252, National Maritime Museum, Greenwich).

2 See John Gage (ed.), *Collected Correspondence of J.M.W. Turner*, Oxford, 1980, p. 137. The fact that the letter is wrongly dated to 22 February is confirmed by references to Lawrence's funeral having happened 'yesterday'.

3 Walter Thornbury, *The Life of J.M.W. Turner, RA*, London, 1862, vol. 1, p. 177.

4 I am grateful to MaryAnne Stevens for suggesting I investigate this likeness; and to Georgina Stonor, the Archivist to the present Duke of Wellington, KG, for verifying the similarity.

5 Collection H.M. the Queen, Waterloo Chamber, Windsor Castle.

Cat. 78

1 Gerald Finley, *Landscapes of Memory: Turner as Illustrator to Scott*, London, 1980, pp. 132–3, 136.

Cat. 81

1 Barry's drawing for this work is now in the collection of the Royal Institute of British Architects, London. Turner apparently worked from tracings of the Barry drawings, but their whereabouts are unknown.

2 W. G. Rawlinson, *The Engraved Work of J.M.W. Turner*, London, 1913, vol. 2, p. 305, recorded the alteration on the first published state of the engraving but retained the text title none the less.

Cat. 83

1 See Andrew Wilton, *The Life and Work of J.M.W. Turner*, London, 1979.

2 James Wadmore sale, Christie's, 5 June 1863.

3 'Sirion' is another term for Sidonian, so we might be looking at Sidon in the distance here.

Cat. 84

1 David Blayney Brown, *Turner and Byron*, exh. cat., Tate Gallery, London, 1992, p. 89.

2 John Ruskin, *Modern Painters*, vol. 5, *The Complete Works of John Ruskin*, ed. E. T. Cook and Alexander Wedderburn, vol. 7, London, 1904, p. 191.

Cat. 89

1 Ruskin noted that it reveals 'the breaking up of the warm rain-clouds of summer, thunder passing away in the west, the golden light and melting blue mingled with yet falling rain, which troubles the water surface, making it misty altogether, in the shade to the left, but gradually leaving the reflection clearer under the warm opening light'. He also praised the drawing of the men-of-war, and the characterfulness of the figures. See John Ruskin, *Notes on his drawings by Turner*, 1878, in *The Complete Works of John Ruskin*, ed. E. T. Cook and Alexander Wedderburn, vol.13, London, 1904, p. 439.

Cat. 92

1 Thomas Tudor, unpublished diary, 5 July 1847, Private collection. I am grateful to Dr Selby Whittingham for making this passage available.

Cat. 95

1 If the above interpretation is accepted, it seems reasonable to suggest that this work dates from the winter of 1831–2.

2 The payment of tithes was closely linked to the Reform issue in 1832, as the Church of England feared that disestablishment would diminish its income.

3 For a detailed analysis of this passage in the watercolour see Christiana Payne, 'Boundless Harvests: Representations of Open Fields and Gleaning in Early Nineteenth-Century England', *Turner Studies*, vol. 11, no. 1 (Summer 1991), pp. 10–12.

Cat. 96

1 If this interpretation is accepted, it is possible to date the work to the summer or autumn of 1832.

Cats. 98 and 99

1 The omission of the Wirral has created some uncertainty as to whether the sun is rising or setting here. However, the presence of working shrimpers in the design indicates a dawn timing, and this is supported by the inclusion of a baby, since it would be typical of Turner to match an early time of life to an early time of day.

2 *The Oxford English Dictionary* records that the word 'shrimp' has long been used to denote 'a diminutive or puny person'.

Cat. 101

1 See Jan Piggott, *Turner's Vignettes*, exh. cat., Tate Gallery, London, 1993, p. 68 n. 23. Piggott slightly misquotes Byron but that does not invalidate his claim.

Cat. 102

1 See the 1833 *Heidelberg up to Salzburg* sketchbook, TB CCXCVIII, ff. 14, 14v, 15v and 16.

2 See *Turner in Germany*, Cecilia Powell, exh. cat., Tate Gallery, London, 1995, p. 198. The range of clothing worn by the youths somewhat obviates the possibility that they are fraternity members, as suggested by Dr Powell. The boy in pierrot costume in cat. 103 supports the view that fancy-dress or carnival costume is being worn in both watercolours.

3 This connection was also first made by Dr Powell (Powell, 1995).

Cat. 108

1 'Notes by Mr Ruskin on his drawings by the late J.M.W. Turner, RA', London, 1878, no. 65, p. 54, in E.T. Cook and A. Wedderburn, *The Works of John Ruskin*, London, 1904, vol. 13, p.456.

Further Reading

The literature on Turner is vast, and it falls naturally into several distinct areas. For anyone interested in Turner research a number of manuscripts and publications stand out. Turner's perspective manuscripts extend beyond the particular discussion of perspective to include his views on art more generally (Manuscripts Department, The British Library, *Add. Ms.* 46151 series), while Maurice Davies, *Turner as Professor: The Artist and Linear Perspective* (exh. cat., Tate Gallery, London, 1992), provides a contemporary study and commentary on the discussion of perspective in those lectures. For the insights into Turner's oeuvre offered by John Ruskin, see especially *Modern Painters* (in *The Complete Works of John Ruskin*, E.T. Cook and Alexander Wedderburn, eds., London, 1904). A.J. Finberg, *A Complete Inventory of the Drawings in the Turner Bequest* (2 vols., London, 1909) provides the indispensible guide to the painter's bequest to the nation. W. G. Rawlinson, *The Engraved Work of J. M. W. Turner* (2 vols., London, 1908 and 1913), catalogues the prints reproducing Turner's work.

The first authoritative biography of Turner is A.J. Finberg, *The Life of J. M. W. Turner, R. A.* (London, 1939, 2nd ed., 1961). Also useful is Jack Lindsay, *J. M. W. Turner, His Life and Work. A Critical Biography* (London, 1966). More recent, short biographies that have drawn upon the latest research are Anthony Bailey, *Standing in the Sun, A Life of J. M. W. Turner* (London, 1997), and James Hamilton, *Turner, A Life* (London, 1997). However, because the Finberg book and the three later biographies are all poorly illustrated, perhaps the best balance between life and art is found in Andrew Wilton, *Turner in his Time* (London, 1987), which provides a detailed chronology as well as a good biography, and is handsomely illustrated. Insights into separate aspects of the painter's life and art are afforded by John Gage's well-illustrated *J. M. W. Turner, 'A Wonderful Range of Mind'* (London 1987). On a more populist level, Eric Shanes, *Turner: The Masterworks* (London, 1990; revised edition 1992, as *Turner: The Master Painter*) offers a short, insightful biography linked to an examination of the art. A full understanding of Turner's creative psyche can be found in John Gage (ed.), *Collected Correspondence of J. M. W. Turner*, (Oxford, 1980), which was supplemented by Gage's publication of further letters in *Turner Studies* (vol. 6, no. 1, Summer 1986).

An essential catalogue is *Turner 1775–1851*, published by the Tate Gallery for the major exhibition held at the Royal Academy of Arts in 1974–75 to mark the bicentenary of the artist's birth. Charles Holme (ed.), *The Genius of J. M. W. Turner, R. A.*, (London, 1903), and W. G. Rawlinson, A. J. Finberg and Sir Charles Holroyd, *The Watercolours of J. M. W. Turner*, (London, 1909), are still worth seeking out for their essays and illustrations. Evelyn Joll, *Agnew's 1982–92* (London, 1992) affords insights into works sold by a firm that has handled Turner oils and watercolours for more than a century. Martin Butlin, Luke Herrmann and Evelyn Joll, eds., *The Oxford Companion to J. M. W. Turner* (Oxford, 2001) will undoubtedly act as an indispensable reference work.

The catalogue raisonné of oil paintings is by Martin Butlin and Evelyn Joll, *The Paintings of J. M. W. Turner* (2 vols. New Haven and London, 1977; revised ed. 1984), while the first methodical listing of the watercolour oeuvre is provided by Andrew Wilton, *The Life and Work of J. M. W. Turner* (Fribourg, 1979). The artist's use of both oil and watercolour is examined in Joyce Townsend, *Turner's Painting Techniques* (exh. cat., Tate Gallery, 1993). The vital subject of Turner and colour is best dealt with by John Gage, *Colour in Turner: Poetry and Truth* (London, 1969), while the chapter on Turner in the same author's book, *Colour and Meaning: Art, Science and Symbolism* (London, 1999), places the painter's colour sensibility within a wider historical context.

Turner's initial creative processes are explored in A. J. Finberg, *Turner's Sketches and Drawings* (London, 1910). His so-called 'Colour Beginnings' in the Turner Bequest are the subject of Eric Shanes, *Turner's Watercolour Explorations* (exh. cat., Tate Gallery, London, 1997). The artist's early work is explored in Eric Shanes, *J. M. W. Turner: The Foundations of Genius* (exh. cat., The Taft Museum, Cincinnati, Ohio, 1986). One of the painter's key series of prints was examined by W. G. Rawlinson in *Turner's Liber Studiorum, a Description and a Catalogue* (London, 1878; 2nd ed., 1906), which can usefully be supplemented by A. J. Finberg, *J. M. W. Turner's Liber Studiorum, with a catalogue raisonné* (London, 1924) and by Gillian Forrester, *Turner's 'Drawing Book' The Liber Studiorum* (exh. cat., Tate Gallery, London, 1996). The relationship between Turner, his finished watercolours, the engravers

for whom he worked and the large number of topographical engravings series for which many of his drawings were made are explored in Eric Shanes, *Turner's England* (London, 1990) which expands upon two earlier books by the same author, *Turner's Picturesque Views in England and Wales* (London, 1979), and *Turner's Rivers, Harbours and Coasts* (London, 1981). Katrina Thomson, *Turner and Sir Walter Scott* (exh. cat., National Gallery of Scotland, Edinburgh, 1999), affords an in-depth exploration of the 'Provincial Antiquities and Picturesque Scenery of Scotland' series. That same scheme and further groups of designs made in connection with Scott are also examined in Gerald Finley, *Landscapes of Memory, Turner as Illustrator of Scott* (London, 1980). The relationship between the painter and Byron is the subject of David Blayney Brown, *Turner and Byron* (exh. cat., Tate Gallery, London, 1992). For a highly perspicacious examination of Turner's own literary efforts, see Andrew Wilton, *Painting and Poetry, Turner's 'Verse Book' and his Work of 1804–1812* (exh. cat., Tate Gallery, London, 1990). Jan Piggott, *Turner's Vignettes* (exh. cat., Tate Gallery, London, 1994), examines Turner's use of a specific form of illustrative composition.

Turner's response to the Industrial Revolution is the subject of three works: John Gage, *Turner: Rain, Steam and Speed* (London, 1972); Judy Egerton, *Turner: The Fighting Temeraire* (exh. cat., National Gallery, London, 1995); and William S. Rodner, *J. M. W. Turner, Romantic Painter of the Industrial Revolution*, (Berkeley, 1997).

Turner's engagement with specific geographic regions has been the subject of both books and catalogues. For the artist in various parts of England, see David Hill, *Turner in Yorkshire* (exh. cat., York City Art Gallery, 1980); *In Turner's Footsteps* (London, 1984); *Turner on the Thames* (New Haven and London, 1993); and *Turner in the North* (New Haven and London, 1996). For Turner in the home of one of his major patrons, see Martin Butlin, Mollie Luther and Ian Warrell, *Turner at Petworth* (Tate Gallery, London, 1989), and for the painter in East Sussex, see Eric Shanes, *Turner in 1066 Country* (exh. cat., Hastings Museum and Art Gallery, 1998). The artist's exploration of two geographical areas that helped forge his Romantic sensibility is the subject of Andrew Wilton, *Turner in Wales* (exh. cat., Mostyn Art Gallery, Llandudno, 1984) and Francina Irwin

and Andrew Wilton, *Turner in Scotland* (exh. cat., Aberdeen Art Gallery and Museum, 1982).

Turner's foreign travels are covered in a general way by Andrew Wilton in *Turner Abroad: France, Italy, Germany, Switzerland* (London, 1982). Turner in France is studied more thoroughly in Ian Warrell, *Turner on the Loire* (exh. cat., Tate Gallery, London, 1997) and the same author's *Turner on the Seine* (exh. cat., Tate Gallery, London, 1999). Cecilia Powell's *Turner's Rivers of Europe, The Rhine, Meuse and Mosel* (exh. cat., Tate Gallery, London, 1991) and her *Turner in Germany* (exh. cat., Tate Gallery, London, 1995) explore Turner's trips to important regions of western and central Europe. For Turner in Alpine country, see Andrew Wilton and John Russell, *Turner in Switzerland* (Zurich, 1976); David Hill, *Turner in the Alps* (London 1992); Ian Warrell *Through Switzerland with Turner* (exh. cat., Tate Gallery, London, 1995); David Blayney Brown, *Turner in the Alps, 1802* (exh. cat., Tate Gallery, London, 1998); and David Hill, *Le Mont Blanc et la Vallée d'Aoste* (Regional Archaeological Museum, Aosta, 2000). The essential book on Turner in Italy is Cecilia Powell, *Turner in the South* (London, 1987), which can usefully be supplemented by the same author's *Italy in the Age of Turner* (exh. cat., Dulwich Picture Gallery, London, 1998), as well as by Thomas Ashby's *Turner's Visions of Rome* (London, 1925), by A.J. Finberg's *In Venice with Turner* (London, 1930) and by Lindsay Stainton's *Turner's Venice* (London, 1985).

Many museums owning large collections of works by Turner have published catalogues and books on those holdings, and prominent among them are Luke Herrmann, *Ruskin and Turner ... Turner Drawings in the Ashmolean Museum, Oxford* (London, 1968); Malcolm Cormack, *Turner Drawings and Watercolours in the Fitzwilliam Museum, Cambridge* (1975); Andrew Wilton, *Turner in the British Museum* (exh. cat., 1975); Timothy Clifford, *Turner at Manchester [City Art Gallery]* (1982); Craig Hartley, *Turner Watercolours in the Whitworth Art Gallery* (1984); Barbara Dawson, *Turner in the National Gallery of Ireland* (1988); Frank Milner, *Turner Paintings [and Watercolours] in Merseyside Collections* (1990); Mungo Campbell, *Turner in the National Gallery of Scotland* (1993); and Kim Sloan, *J. M. W. Turner Watercolours from the R. W. Lloyd Bequest to the British Museum* (London, 1998). Significant recent research on Turner

and his works has appeared in *Turner Society News* (1975–) and *Turner Studies* (1980–1993, Tate Gallery, London).

These specific publications may be supplemented by books that offer the reader a way of further exploring the themes and issues raised in the catalogue. The standard work on the history of watercolours, Martin Hardie's *Water-Colour Painting in Britain* (3 vols, London, 1966–68) is now rather dated, but it is still a useful starting point especially when supplemented by Andrew Wilton and Anne Lyles, *The Great Age of British Watercolors, 1750–1880* (exh. cat., Royal Academy of Arts, London, Munich, 1993); by Michael Clarke's *The Tempting Prospect: A Social History of English Watercolours* (London, 1981), which offers a good introduction to themes such as amateur practice, patronage and the watercolour exhibition societies; and by Kim Sloan, *Amateur Artists and Drawing Masters in Stuart and Georgian Britain* (British Museum, London, 2000). The technique of watercolours is covered by Hardie, but this account has been superseded by Marjorie B. Cohn, *Wash and Gouache: A Study of the Development of the Material of Watercolour* (exh. cat., Fogg Art Museum, Harvard, 1977) and the former's treatment of the presentation of drawings has also been overtaken by Pippa Mason, 'The Framing and Display of Watercolours', in *Watercolours from Leeds City Art Gallery* (exh. cat., Leeds City Art Gallery, 1995). Peter Bower, *Turner's Papers, 1787–1820* and *Turner's Later Papers, 1820–1851* (Tate Gallery, London, 1990 and 1999) offers a comprehensive account of the influence of the artist's choice of support.

The literature on artistic theory, both as it relates to Turner and to landscape painting in general during the period is extensive. Peter Bicknell, *Beauty, Horror, and Immensity: Picturesque Landscape in Britain, 1750–1850* (exh. cat., Fitzwilliam Museum, Cambridge, 1981) provides an accessible general account of the subject, while Malcolm Andrews, *The Search for the Picturesque: Landscape Aesthetics and Tourism in Britain, 1760–1800* (Aldershot, 1989) and Andrew Wilton, *Turner and the Sublime* (New Haven and London, 1980) are good introductions to the picturesque and the sublime. Eric Shanes explores Turner's extensive use of association in *Turner's Human Landscape* (London, 1990), while Andrew Hemingway

has dealt with associative readings of landscape in his *Landscape Imagery and Urban Culture in Early Nineteenth-Century Britain* (Cambridge, 1992), a theme that has also been explored in Kay Dian Kriz, *The Idea of the English Landscape Painter: Genius as Alibi in the Early Nineteenth Century* (New Haven and London, 1997). Many books deal with academic theory and Reynolds's writing. John Barrell, *The Political Theory of Painting from Reynolds to Hazlitt* (New Haven and London, 1986) remains arguably the most stimulating, though it needs to be supplemented by an understanding of the workings of the Academy. Sidney Hutchison, *The History of the Royal Academy, 1786–1986* (London, 1986) is crucial in this respect, and many of the themes he explores will be developed in the forthcoming *'A Rage for Exhibitions': The Royal Academy at Somerset House* (David Solkin and Anne Puetz, eds, New Haven and London, 2001).

Jane Bayard, *Works of Splendor and Imagination: The Exhibition Watercolour, 1770–1870* (exh. cat., Yale Center for British Art, New Haven, 1981), explores the impact of exhibitions on the development of painting in watercolours. Dianne Sachko Macleod, *Art and the Victorian Middle Class: Money and the Making of Cultural Identity* (Cambridge, 1996), provides an important context for the diversification among Turner's patrons. Finally, the references in the catalogue entries to Turner's work on specific topographical projects and as the provider of illustrations to various authors might be supplemented by more general works on printmaking and the publishing trade in the nineteenth century. These include David Alexander and Richard T. Godfrey, *The Painter and Engraving: The Reproductive Print from Hogarth to Wilkie* (exh. cat., Yale Center for British Art, New Haven, 1980), Anne Lyles and Diane Perkins, *Colour into Line: Turner and the Art of Engraving* (exh. cat., Tate Gallery, London, 1989) and Anthony Dyson, *Pictures to Print: The Nineteenth-Century Engraving Trade* (London, 1984).

Turner Chronology

1775

23 April, Joseph Mallord William Turner born, London, son of a barber, William Turner and Mary Turner (née Marshall)

1787

Makes first signed and dated watercolours

1789

First known sketchbook (the *Oxford* sketchbook, TB 11)

Informal studies with Thomas Malton

11 December, admitted to the Royal Academy Schools

1790

Exhibits first work at Royal Academy Annual Exhibition (cat. 1); –1796, only exhibits finished watercolours

1791

First West Country tour: Bristol, Bath, Malmesbury

Part-time scene painting at the Pantheon Opera House (see cat. 2)

1792

July–August, first tour of South and Central Wales

1793

Awarded the 'Greater Silver Pallet' for landscape drawing by the Society of Arts

1794

Watercolours at Royal Academy Annual Exhibition attract critical notice

First commission from John Walker for an engraving in his *Copper-Plate Magazine*

Begins copying works by J. R. Cozens and others at Dr Munro's 'academy' with Thomas Girtin (until 1797)

Summer, first Midlands tour to make drawings for engraving: visits Lincoln, Ely and Peterborough, returning via brief incursion into North Wales

1795

c. June–July, South Wales tour

August/ September, Isle of Wight tour

Further commissions for engravings and private topographical commissions, including Sir Richard Colt Hoare of Stourhead (see cats. 15–17)

1796

First oil painting exhibited at Royal Academy (BJ 1; *Fishermen at Sea*, Tate Britain, London); thereafter exhibits oils except in 1805, 1821, 1824, 1848 and 1851

1797

Summer, first North of England Tour, including the Lake District

1798

Literary texts appended to titles in Royal Academy Annual Exhibition for the first time; Turner exhibits *Morning amongst the Coniston Fells, Cumberland* (BJ 5; Tate Britain, London), with a quotation from Milton's *Paradise Lost* and *Buttermere Lake, with part of Cromackwater, Cumberland, a Shower* (BJ 7; Tate Britain, London) with conflation of verses from James Thomson, *The Seasons*

Summer, visits Malmesbury, Bristol and North Wales

1799

August–September, three weeks with William Beckford at Fonthill, Wiltshire

September–October, tour of Lancashire and North Wales

4 November, elected Associate Royal Academician

November/December, moves to 64 Harley Street, London

1800

Attaches his own verses to a painting (*Dolbadern Castle, North Wales;* BJ 12; Royal Academy of Arts, London) and a watercolour (cat. 12) exhibited at the Royal Academy Annual Exhibition

1801

June–August, first tour of Scotland, returning via the Lake District

1802

12 February, elected Royal Academician at the age of 26

Mid-July–mid-October, first Continental tour through France, Savoy and Switzerland: makes sketches and notes in the Louvre, Paris (especially from Titian, Poussin and Claude)

1804

Opens own gallery in his house in Harley Street; exhibits 20–30 of his own works

[Society of Painters in Water Colours established; Turner declines to exhibit]

1805

Summer, oil sketching on a boat on the Rivers Thames and Wey

[British Institution established; first exhibition 1806; Turner shows sporadically]

1806

Embarks on *Liber Studiorum*: eventually makes 100 sepia drawings, of which 71 engraved in aquatint and mezzotint

Exhibits two oil paintings at the inaugural exhibition of the British Institution

1807

First volume of *Liber Studiorum* published (until 1819)

10 December, appointed Professor of Perspective at the Royal Academy

1808

Summer, tour of Cheshire and Wales

First recorded visit to Walter Fawkes at Farnley Hall, Yorkshire; visits regularly until 1824

1809

Summer, visits Petworth, Sussex

Autumn, visits Yorkshire and Cumberland

1810

Before 12 December, moves to Queen Anne Street, London

1811

First lectures on perspective delivered at Royal Academy

Commissioned by William Bernard and George Cooke to create watercolours for 'Picturesque Views on the Southern Coast of England' (completed 1826); tour of Dorset, Devon, Cornwall and Somerset

Embarks upon ambitious epic manuscript poem, *Fallacies of Hope*

1812

Appends quotation from *Fallacies of Hope* for the first time to a painting exhibited at the Royal Academy (*Snow Storm: Hannibal and his Army crossing the Alps*, 1812; BJ 126; Tate Britain, London)

1813

Summer, tour of Devon

'Solus' (later Sandycombe) Lodge, Twickenham, completed to his designs

1814

Summer, ? tour of Devon

1815

Summer, visits Yorkshire

1816

Commissioned by the Revd Thomas Whitaker to create watercolours for 'The History of Richmondshire' (published until 1822)

Summer, tour of Yorkshire and Lancashire, stays at Farnley Hall

1817

Tour of Belgium (including Waterloo), the Rhine between Cologne and Mainz, and Holland, returning via Farnley Hall, Yorkshire

1818

Commissioned to make watercolours of Italian subjects after drawings by James Hakewill for Hakewill's 'A Picturesque Tour in Italy' (published in parts 1818–20)

Commissioned by Sir Walter Scott (together with other artists) to make watercolours for *Provincial Antiquities and Picturesque Scenery of Scotland*

October – November, visits Edinburgh and the Scottish Lowlands

1819

March, eight oil paintings exhibited at Sir John Leicester's gallery, London (again in 1820)

April–June, sixty or more watercolours exhibited at Walter Fawkes's London house in Grosvenor Place (again in 1820)

Enlarges his London house in Queen Anne Street, including addition of a new gallery (completed 1820)

August–February 1820, first tour of Italy visiting Turin, Como, Venice, Rome, Naples, returning via Florence, Turin and Mt Cenis; makes c. 2,000 drawings

1820

February, returns to London

c. 1820

Benjamin Godfrey Windus, of Tottenham Green, London, starts collecting Turner watercolours (owns c. 200 by late 1830s)

1821

Exhibits watercolours at William Bernard and George Cooke Gallery, Soho Square, London

Late summer or autumn, visits Paris and Northern France (Rouen, Dieppe)

1822

February–August, 24 watercolours included in an exhibition at William Bernard and George Cooke Gallery, London

August, sails up the east coast to Edinburgh for George IV's state visit

Commissioned by William Bernard Cooke to create watercolours for 'The Rivers of England' (first mezzotints published 1823; terminates 1827) and for 'Marine Views'

1823

January, eleven watercolours exhibited at William Bernard and George Cooke Gallery, London

Tour along the south-east coast

1824

April, seventeen watercolours exhibited at William Bernard and George Cooke Gallery, London

Summer, tours of south-east England and East Anglia, and of Liège, Verdun, Luxemburg, Trier, Coblenz, Calais and Dieppe

Begins work on watercolours commissioned by Charles Heath for 'Picturesque Views in England and Wales' (96 views published from 1827 to 1838)

1825

Turner agrees to supply watercolours to Thomas Lupton for 'The Harbours of England' (subsequently published as 'The Ports of England')

Possible date of the *Little Liber* mezzotints

Late summer, tour of Holland, the Rhine and Belgium

Death of Walter Fawkes of Farnley Hall

1826

August–November, tour of Brittany and the Loire

Commissioned by Samuel Rogers, banker, connoisseur and poet, to provide 25 illustrations for his poem, *Italy* (published 1830)

Relationship with William Bernard Cooke severed

1827

Visits the architect John Nash at East Cowes Castle, Isle of Wight (late July–September) and Petworth Park, Sussex

First three parts of 'Picturesque Views in England and Wales' published

1828

January–February, delivers last lectures at Royal Academy as Professor of Perspective

August–February 1829, second tour of Italy, visiting Paris, Lyons, Avignon, Florence, Rome, returning via Loreto, Ancona, Bologna, Turin and Lyons

First contribution published to Charles Heath's *The Keepsake* annual (until 1837)

1829

Early June–18 July, 38 watercolours for 'Picturesque Views in England and Wales'; and some Italian drawings exhibited at the Egyptian Hall, Piccadilly, London; some shown later at the Birmingham Society of Artists

Summer, visits Paris and Normandy, possibly meeting Eugène Delacroix

21 September, death of father; draws up first draft of will that ultimately creates the Turner Bequest to the nation

1830

Exhibits a watercolour for the last time at the Royal Academy Annual Exhibition (cat. 71)

August–late September, tour of Midlands

1831

Commissioned by Robert Cadell to illustrate Sir Walter Scott, *Poetical Works* (published 1834) and *Prose Works* (published 1834–36); visits Scotland, stays at Abbotsford

1832

March, twelve illustrations to Scott's *Poetical Works* exhibited at Messrs Moon, Boys and Graves, Pall Mall, London

October, visits the Channel Islands, Paris and its environs

Publication of *Landscape Illustrations . . . to the Life and Works of Lord Byron* (until 1834)

Publication of *The Works of Lord Byron; with his Letters and Journals, and his Life, by Thomas Moore* (until 1834)

1833

June, 67 watercolours for 'Picturesque Views in England and Wales' and 12 Scott drawings exhibited at Messrs Moon, Boys and Graves, Pall Mall, London

Tour through Belgium, Germany and Austria, via Vienna, to Venice

First volume of *Turner's Annual Tour – Wanderings by the Loire*

1834

Second volume of *Turner's Annual Tour – Wanderings by the Seine*

Samuel Rogers's *Poems* published

Illustrations to Byron's poems exhibited at Colnaghi's, London

Publication of Finden's 'Landscape Illustrations of the Bible' (24 monthly parts – until 1836)

Winter, four early oil paintings exhibited at the Society of British Artists

1835

Third volume of *Turner's Annual Tour – Wanderings by the Seine*

Publication of Milton's *Poetical Works*

Summer, tour of Central Europe including Copenhagen,, Berlin, Dresden, Prague, Nuremberg, the Rhine and Rotterdam

1836

Publication of George Francis White, *Views in India, chiefly among the Himalaya Mountains* (until 1837), including seven illustrations by Turner

Summer, tour of France, Switzerland and Val d'Aosta with James Munro of Novar

October, Ruskin's first letter to Turner enclosing a reply to an attack in *Blackwood's Magazine*

1837

Publication of the *Poetical Works of Thomas Campbell*

One oil painting included in the British Institution 'Old Masters' exhibition

28 December, resigns as Royal Academy Professor of Perspective

1839

Exhibition of 42 works from the Fawkes collection, The Music Hall, Leeds

Summer, tour of the Mosel and the Meuse

1840

22 June, first recorded meeting with Ruskin, at the home of Turner's agent, Thomas Griffith

Summer, tour of Southern Germany, Austria and Venice

1841

Late July–late October, tour of Switzerland, visiting Lucerne, Constance and Zurich

1842

Spring, makes fifteen 'specimen' watercolours of Swiss views from which finished watercolours could be commissioned, which he showed to his agent Thomas Griffith: nine eventually sold to James Munro of Novar, Elhanan Bicknell and John Ruskin

Late summer, tour of Switzerland

1843

Five further finished watercolours of Swiss views sold by Griffith to James Munro of Novar (3) and John Ruskin (2)

Publication of the first volume of John Ruskin, *Modern Painters*, intended primarily as a defence of Turner

1844

Summer, tour of Switzerland, Rheinfelden, Heidelberg and the Rhine

1845

Third set of Swiss finished watercolours, sold through Griffith to James Munro of Novar, John Ruskin and B. G. Windus

As the most senior Royal Academican, represents Sir Martin Archer Shee, the ailing President; June, elected Deputy PRA

May, tour of northern France (Boulogne and neighbourhood)

Autumn, visits Dieppe and the coast of Picardy: last tour abroad

Takes new impressions of the *Liber Studiorum* prints, using them as a basis for a set of *Late Liber* paintings (BJ 509-519)

1846

Probably moves to Chelsea

1848

Last set of Swiss finished watercolours created for sale via Griffith

January, oil painting (*The Dogana, San Giorgio, Citella, from the Steps of the Europa* (BJ 396; Tate Britain, London) presented by Robert Vaughan to the National Gallery, London

1850

Exhibits for the last time at the Royal Academy: four oil paintings

1851

19 December, dies at 119 Cheyne Walk, Chelsea

30 December, buried in St Paul's Cathedral

Glossary

Bodycolour (see GOUACHE)

Brush Watercolour brushes (known as 'pencils' in the eighteenth century) were mostly made of the hair of red sable, which is durable yet pliant and firm, and can be readily twisted to a point.

Camera obscura An apparatus that projects the image of an object or scene on to a sheet of paper, ground glass or other surface so that its outlines can be traced. It consists of a closed box (it can also be a room) that admits light through a small hole or lens, projecting an inverted image on the principle of the photographic camera. A mirror is usually installed in order to reflect the image the right way up. The *camera lucida* (patented in 1807 by W. H. Wollaston) is a more portable version of the *camera obscura* with a wider field of vision, and is so-called because it performs the same function in full daylight. It consists of a glass prism that can be revolved on the end of an adjustable arm: the user looks down it with one eye while looking past it with the other at a reduced image projected on to the paper.

Chalk Natural *black chalk* is a mineral, a species of carbonaceous shale whose principal ingredients are carbon and clay. It is very adhesive to paper and makes an indelible mark. Natural *white chalk* is of two varieties: carbonate of calcium, or soapstone (steatite). Although chalk can be sharpened to a point, it quickly wears down, hence it produces a softer line than one made by pencil.

Claude glass A darkened, slightly convex mirror, cased like a pocket-book, that was used extensively in the late eighteenth century to obtain an image of nature. The artist or traveller turned his back to the landscape in order to use it. The low-key reflections of nature in the mirror resemble the landscape effects to be seen in paintings by Claude Lorrain. A silvered mirror was available for days too overcast for effective use of the darkened kind. The claude glass was both a viewing-glass and a popular drawing device.

Engraving General term to describe both the process of working on metal plates for the purpose of printing and the product. Traditionally, metal plates were made of copper, but, after the 1820s, steel became increasingly important.

Gouache Lead white mixed with watercolour pigment to make it opaque. Lead white has a tendency to discolour (it blackens on exposure to hydrogen sulphide), and was gradually replaced by the more stable zinc white ('Chinese White'), manufactured by Windsor and Newton from 1834. A 'watercolour' can be executed entirely in gouache, or the use of gouache can be restricted to highlights, especially white highlights.

Gum arabic A vegetable gum obtained from the acacia tree. It differs from resins in being soluble in water, and is thus well suited for binding watercolour pigment.

Ink Used by some eighteenth-century topographers as the foundation of a 'stained' or 'tinted' drawing, or as a reinforcement to a finished watercolour, ink was applied with a brush, quill pen or reed pen. *Carbon ink* is generally made from soot (or some other easily available carbon) dissolved in water, often with a binder such as GUM ARABIC. *Indian ink* is a waterproof form of carbon ink in which some kind of resin has been dissolved. A more brown ink can be made with *bistre*, obtained from the soot of burning wood, resin or peat. *Sepia* is made from the secretion of the cuttle-fish, although the term is often used to mean dark brown ink in general.

Line engraving Lines are incised into the plate with a burin, or sharp metal rod, light and shade being established by varying the depth and breadth of the incised lines. To print, the plate is inked and then wiped, leaving the ink within the depressions created by the burin, while the un-incised areas remain blank; under pressure of the printing press the ink in the depressions is transferred to the paper.

Mezzotint A form of tonal engraving which, in contrast to LINE ENGRAVING, works from dark to light. The plate is prepared with a dense mesh of small burred dots created by a toothed, chisel-like tool known as a 'rocker'; if inked and printed at this stage, the print would be black. Tonal gradations are achieved by using a scraper to remove greater or lesser amounts of the small burred dots, the areas of most intense light being created by burnishing the plate. When inked, the areas retaining the most burred dots create the darkest zones because they retain the most ink, while burnished areas create the highlights since they can hold no ink.

Paper The basis of all paper is cellulose fibre, which is derived from plants. Until the 1840s, when pulp was introduced, most papers were made from cotton or linen rags. Hand-made paper is made in a mould that has a fine wire grid as its base. The mould is dipped into liquid pulp, and then removed for drying. Until *c.* 1750 all paper made in Europe was *laid* paper, identifiable by the ribbed (or 'chain') pattern impressed by the mould's wire grid. By the end of the eighteenth century watercolourists were beginning to prefer the smoother amd more even appearance of *wove* papers, produced by using a wire mesh woven much like a piece of fabric. The majority of papers used by watercolourists were white, often quite thick and sometimes finished with gelatine size to give a very smooth, less absorbent finish, but some artists, such as J.M.W. Turner, experimented with coloured papers and papers prepared with a coloured wash. Turner also used writing papers, which gave a stronger support, having been developed to withstand the sharpness of the newly-invented steel pen nib.

Pencil Made of graphite, a crystalline form of carbon also known as plumbago, it leaves a shiny deposit on the paper.

Proof A loose term to denote the first prints to be taken from a plate before the regular published edition is printed. An ENGRAVER'S PROOF is one taken during the engraving process so that progress can be monitored and, if necessary, corrections, additions and modifications to the design can be made.

Scratching out Sometimes described as *scraping out*, this is a means of creating a highlight by removing an area of watercolour with a knife, the point of a brush or even a fingernail to expose the paper beneath.

Scumbling A method of dragging almost dry colour (either watercolour or gouache) across the paper in order to obtain a crumbly surface texture.

Sponging out Like SCRATCHING OUT, this is a method of creating a highlight, but by removing an area of watercolour with a soft sponge.

Stipple The application of minute spots or flecks of watercolour using the point of a fine brush, or lifting spots of colour from a wash so as to break up the colour into myriad dots or specks.

Stopping out A method of preserving a highlight by masking a selected area of watercolour pigment with a 'stopping-out' agent, such as gum, in order to prevent that area being obscured or qualified by subsequent layers of wash.

Varnish Watercolours destined for exhibition alongside oils, or intended to compete with oils in size or force, were sometimes varnished, either over the whole surface or in the darkest areas of the composition, especially shadows. Varnishes were usually made from GUM ARABIC, although other recipes, such as isinglass dissolved in water or Zapon mixed with alcohol, were sometimes preferred.

Vignette A form of book illustration in which a small print is placed on the page without definite border lines, and thus appears to 'emerge' from the surrounding paper. Often used on the title page, or as the 'headpiece' and 'tailpiece' at the beginning or the end of a chapter.

Wash An application of colour over a larger field than can conveniently be covered by the brush with one stroke. A wash must be continued and extended while the colour is still wet, and show no joins; great skill is required when laying a flat or, especially, a graduated one. Washes can be broken (or *dragged*) by charging a brush with almost dry colour, and then dragging the brush on its side to deposit particles of pure colour–a useful method for obtaining texture or sparkle. Washes can also be run or 'bled' into one another when still wet.

Watercolour A finely ground pigment combined with a water-soluble binding agent, commonly GUM ARABIC. It is usually distributed either in tubes or cakes. Water is used as the vehicle to spread and dilute the colour, and it subsequently evaporates. It is the gum arabic that binds the pigments to the surface of the support, which is almost invariably PAPER. Watercolour papers tend to have a granular surface that make for variations in the reflective luminosity in the surface of the sheet; the chief source of brilliancy in pure watercolour, however, derives from the white of the paper shining through the transparent pigment. Because the watercolour painting has its technical origins in the 'tinted' or 'stained' drawing, it is sometimes referred to as a watercolour drawing, and thus the terms 'watercolour' and 'drawing' are sometimes used synonymously.

Index

List of lenders

Adelaide,
Art Gallery of South Australia

The Baltimore Museum of Art

Barnard Castle, Bowes Museum

Bedford,
Trustees of the Cecil Higgins
Collection

Birmingham Museums
and Art Gallery

Boston,
Museum of Fine Arts

Cambridge (MA),
Fogg Art Museum, Harvard
University Art Museums

Cardiff,
National Museums and Galleries of
Wales

Edinburgh,
National Gallery of Scotland

The Earl and Countess of Harewood
and the Trustees of the Harewood
House Trust

Indianapolis Museum of Art

Leeds Museums & Galleries
(City Art Gallery)

London,
The British Museum

London,
Courtauld Gallery, Courtauld
Institute of Art

London,
Spink-Leger Pictures

London,
Tate

London,
Victoria and Albert Museum

Los Angeles,
The J. Paul Getty Museum

Manchester City Art Galleries

Manchester,
The Whitworth Art Gallery,
The University of Manchester

Melbourne,
National Gallery of Victoria

Board of Trustees of the
National Museums and Galleries
on Merseyside (Lady Lever Art
Gallery, Port Sunlight)

John Murray

New Haven,
Yale Center for British Art

Nottingham,
City of Nottingham Museums,
Castle Museum

Oxford,
The Visitors of
the Ashmolean Museum

Plymouth City Museum
and Art Gallery

Preston,
Harris Museum
and Art Gallery

Providence,
The Museum of Art, Rhode Island
School of Design

Sheffield Galleries & Museums Trust

The Sudeley Castle Trustees

The Duke of Westminster OBE TD DL

Malcolm Wiener Collection

Wolverhampton Art Gallery

York City Art Gallery

*and those private collectors who
wish to remain anonymous*

Photographic credits

All works of art are reproduced
by kind permission of the owners.
Specific acknowledgements are
as follows:

Amsterdam: Rijksmuseum, fig. 26

Andrew Barrett: cat. 49

Bedford: Trustees of the Cecil
Higgins Art Gallery, cats. 47, 48 /
photo by Nick Nicholson, cat. 18

Birmingham: © Birmingham Art
Gallery, cats. 15, 54

Boston: © 1999 Museum of Fine
Arts. All Rights Reserved, cat. 56

Brighouse: Larkfield Colour Group
Ltd., cat. 45

Cambridge, MA: © President
and Fellows of Harvard College,
Harvard University / photo by Rick
Stafford, cat. 89

Robert Chapman Photography:
cat. 68

Peter Dawes Photography: cat. 42

Edinburgh: National Gallery
of Scotland, fig. 5

Roy Fox: cats. 57, 73a, 74a, 75a,
76a, 77a, 78a, 80a, 83

Harewood House: fig. 20

Grahame Jackson: cat. 52

Leeds: Museum and Galleries
(City Art Gallery) The Bridgeman
Art Library, cat. 38

Liverpool: Board of Trustees of
the National Museums and Galleries
on Merseyside (Walker Art Gallery),
cats. 26, 72

London: Chris Beetles Gallery,
figs. 32, 33

London: © The British Museum,
cats. 25a, 29, 31, 32, 32a, 43, 55a,
87, 87a, 87b; figs. 4, 8, 9, 11, 23, 28

London: © Christie's Images Ltd.
2000, figs. 30, 34

London: Guildhall Library,
Corporation of London, figs. 21, 22

London: courtesy of the National
Portrait Gallery, fig. 1

London: Prudence Cuming
Associates Ltd., cats. 41, 63, 79, 93,
101

London: © Royal Academy of Arts,
figs. 2, 17

London: courtesy Sotheby's Picture
Library, fig. 24

London: © Tate, cats. 2, 3, 12, 22,
28, 55, 58, 59, 60, 66, 71, 73, 74,
75, 76, 77, 79a, 82, 84; figs. 3, 7

London: V & A Picture Library, cats.
5, 11, 17, 110

Manchester: Manchester City Art
Galleries, cat. 103

New Haven: © 2000 Yale Center
for British Art / photo by Richard
Caspole, cats. 19, 20, 23, 25; figs.
10, 27, 29

Nottingham: City of Nottingham
Museums and Galleries; The Castle
Museum and Art Gallery, cat. 96

Oxford: © Ashmolean Museum,
cats. 27, 64

Charles Passela: cat. 97

Antonia Reeve: cats. 46, 78, 104

Sheffield: © Sheffield Galleries and
Museums Trust, cat. 94

Southampton: Southampton City
Art Gallery/Bridgeman Art Library,
London, fig. 31

Stanford, CA: Iris & B. Gerald Cantor
Center for Visual Arts at Stanford
University, 1972.59; Purchased with
funds given by Josephine Grant
McCreery in memory of her parents,
Joseph and Edith Grant, fig. 35

Stoke-on-Trent: The Potteries
Museum and Art Gallery, fig. 25

Rodney Todd-White: cat. 88

Royston Walters: cat. 33

John Webb: cat. 39

York: York City Art Gallery, fig. 14